Arts and Artists from an Economic Perspective

Original title:
Arts et artistes au miroir de l'économie
Translation: Latika Saghal and Xavier Greffe

Published jointly by the United Nations Educational, Scientific and Cultural
Organization (UNESCO),
7, place de Fontenoy, 75007 Paris, France
and Editions Economica
49, rue Héricart, 75015 Paris, France

ISBN UNESCO 92-3-103834-6
ISBN Economica 2-7178-4362-0

Ouvrage publié avec le concours du Ministère français chargé de la culture
– Centre national du livre.
This publication received a translation grant from the French Ministry of Culture
– Centre national du livre.

Xavier Greffe

Arts and Artists from
n Economic Perspective

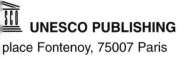 **UNESCO PUBLISHING**
place Fontenoy, 75007 Paris

ECONOMICA
London • Paris • Genève

PREFACE

In our post-modern economy where the creation of signs, designs and new shapes and patterns is an important factor, arts are relevant not only because they affect the economy but also because they can promote development.

This book identifies the economic factors capable of explaining the emergence, the reliability and the disappearance of artistic activities. It starts with the core analysis of the artistic markets where the players cannot be measured by the usual economic yardsticks: users are initially unaware of the kind of satisfaction they can gain from unknown works of arts; producers do not know whether their costs will be covered or not; artists are more concerned in utilizing their talents than in performing predefined services. Then, the various dynamics which animate the development of this artistic sector are developed: a revolving compromise between heritage and creation; a continuous passage between an original work of art and the products of cultural industries; a permanent shift between profit and non-profit institutions.

No matter how indispensable, the economist's approach must be discreet. He should be able to explain both the development and the creation of creative movements, but his efforts will be justified only if he refrains from judging the existence of works of arts only in terms of economic logic.

Xavier Greffe is Professor of Economics and Arts and Media at the University of Sorbonne, Paris. His most recent books are: *Managing our Cultural Heritage* (Paris and New Delhi, 1999), and *L'emploi Culturel à l'âge du numérique* (Economica, 2000). He has served as manager of artistic training programmes at the European and French levels.

TABLE OF CONTENTS

INTRODUCTION

The arts have a positive effect on the economic and social development of society as they create jobs, open new markets, improve the quality of life and promote social integration.[1] However, economists have never actually included the arts in their studies. Accustomed as they are to dealing with profit and loss and occasionally venturing into the realm of what is right and what is not so right, they are hardly ever interested in differentiating between what is beautiful and what is not. Since their profession inclines them to determine the usefulness, value and price of various goods and services, they are incapable of dealing with those activities whose utilitarian value is not quite clear. When the dividing line between artists and craftsmen was indistinct, economists could at least treat artistic activities on par with the crafts. With the passage of time, economists have been confronted with new theories like Art for Art's Sake and the growing importance of aesthetics and the rising prices of works of art, and have to willy-nilly take cognizance of other uses and values. In view of these circumstances, how can we explain the economic dimension of art and relate it to the functioning of the economy as a whole without committing the fallacy of *petitio principii*, i.e. the fallacy of assuming the conclusion in the premiss and attributing intentions instead of basing ourselves on facts?

* *
*

André Breton[2] tells us that 'a work of art is valuable insofar as it vibrates with the reflexes of the future', while Walter Benjamin claims that 'one of the essential responsibilities of art has always been to create a demand at a time that was not quite ripe for it to be fully satisfied'.[3] But how do you evaluate things that were never known earlier, or things that are difficult to identify, since economic reasoning presupposes a relationship between aesthetic goods and other kinds of goods and thus also an enhancement of their value? This is precisely the challenge posed by economics to art. Ascertaining the aesthetic value of an artistic good is not an easy task in an unconventional market that is influenced by the artist's creativity, the deliberate destabilization of taste and the critics' confidence in the goods.

Are other approaches to the notion of value likely to improve the prospects? The *development value* depends on the beneficial effect of the arts on the overall development. From the economic point of view, the arts help to create new references, models and products and also give rise to creativity-based industries. The arts create certain skills that, when used in non-artistic sectors, lead to an improvement in the latter's quality. They enhance the appeal of the place where they are found. Some people even believe that in some areas of activity such as the company theatre they provide a means of improving the management of human resources. From the social point of view, artistic activities are supposed to strengthen the individual's identity and build social relationships. From the regional viewpoint, artistic creations can improve the surroundings, build up the region's reputation and create an atmosphere receptive to new ideas. The *activity value* defines yet another approach. Since the enjoyment of any artistic good or service involves spending on transport, eating out and the purchase of goods, its value would depend on these activities and lead to its gradual inclusion in the leisure and entertainment industries. Looking at the usefulness of arts from this angle enhances their economic possibilities but increases the difficulty of determining their aesthetic value, owing to other problems such as the intervention of pressure groups or bringing artists under state control. Consequently, the study of the market for artistic services is all the more complicated. While analysing

demand, we are challenged by the difficulty of judging the novelty and quality of artistic goods and associating the direct demands of artistic taste with the indirect demands of development. Analysing supply is a risky matter due to its uncertainty and the considerable hidden costs. Hemmed in by the interplay of these diverse factors, the artist is the first to experience these constraints on the development of the arts, no matter what his status – a celebrity or a starving artist. He will find himself at the confluence of different theories of valuation determined by artistic, political and commercial considerations.

Artistic production stands to gain if it is considered in a dynamic manner, because it can then overcome these constraints and rectify imbalances at the cost of other constraints and imbalances. These opposing forces are subjected to three types of tension. First, there is the tension between creation and heritage. An existing heritage, and the desire to prolong its life, inspires each artistic creation. Artistic activities will always maintain a certain distance from heritage, the distance being greater in the case of the performing arts compared to painting and the plastic arts. Even monuments and museums cannot be isolated from this controversy, since it is advisable to bring them to public view and to reinterpret their messages according to the need of the hour. This raises the problem of artistic or cultural income. Is such an income justified when, for example, it is in the form of a copyright or a succession right? Will its control not lead to a conflict when it comes to deciding which works of art will be categorized as heritage? The second tension pertains to the opposition between an original work of art and the products of culture industries. If an original work of art is mass-produced like any other canned product, we will have to value an artistic creation according to current tastes. This pressure from below has increased with the advent of digitization and the Internet, where the new corporations that manage these changes are less concerned about the distinctiveness of the artistic product than the duration of the messages they can convey through them. Its value is derived from its display, and though it makes advertising profitable, it diminishes the appeal of a work of art. The third tension relates to the opposition between public intervention and the logic of the market. Some people believe that the production of artistic goods cannot depend on the market for a variety of reasons, the two main

reasons being the presence of external elements that need to be controlled and the absence of productivity-based gains, which leads to a disarray in the costing mechanism. As opposed to this cultural pessimism, others believe that the market respects the diversity of tastes, brings together artists and potential buyers in the most favourable circumstances and encourages artistic innovation. Many artists, e.g. Chardin, Mozart, the Brontë Sisters, Tolstoy, the Impressionists and the Blues composers, were in direct contact with the contemporary public during the most creative part of their lives. They were in a position to expand their following, unlike official artists whose works are admired only by the state and the ruling coterie. P. L. Courier's famous comment that 'what is encouraged by the state languishes and what it protects dies'[4] seems to apply perfectly to official artists.

* *

*

Before establishing a connection between these dimensions, it is advisable to point out the nature of the relationship between economics and the arts. Economists have become interested in the arts because there is increasing reference to the economic aspect of the arts. In our post-modern economy, where the creation of signs, designs and new shapes and patterns is an important factor, arts are important not only because they affect the economy but also because they can promote development. An economy based on the arts must, therefore, identify the economic factors capable of explaining the emergence, reliability and disappearance of artistic activities. At all events, the economics of art does not claim that it can explain why the arts appear, change and disappear. This would inevitably encourage us to prejudge artistic logic for the sake of economic logic. The price of such an error would be very high, as heritage sites would then be classified according to their potential as tourist attractions, more importance would be attached to imitations than to original works of art, shows would be cancelled because of poor receipts, etc. Keeping these advantages and constraints in mind, it is necessary to adopt an economic approach to the arts in order to explain the underlying arguments to the public at large. The public can then decide for itself if these artistic activities

contribute to development or are a waste of resources, whether they embody undisclosed conflicts between vested interests and whether they should be beyond the control of pressure groups; the public can also decide on how to involve themselves in such activities and derive appropriate returns.

Having defined the purpose, it is necessary to determine the method. Should the performing arts, heritage sites, plastic arts, literature, the media, etc. be considered separately or taken as a whole? An integrated approach would enable us to go to the very heart of the problem of ascertaining the value, uncertainty and risks, and it would not be necessary to plunge right away into the particular aspects, which are most often used as a screen by pressure groups. We will, therefore, opt for the integrated approach instead of separating at the outset the economics of music from the economics of cinema, street arts, etc.

CHAPTER 1

THE ECONOMIC FOOTPRINTS OF THE ARTS

Determining the value of a good or service is central to economic thinking. In the case of artistic activities, this is evident from the viewpoint of a person buying a painting, but it is not relevant to the street arts or heritage conservation. Nevertheless, determining the value of an artistic creation is the first step in the attempt to find out whether a creator, a consumer, a patron of the arts or a government should use their resources to fund an activity or, at a more general level, whether these resources can be more effectively used for social welfare.

To answer this question, economists generally start off by claiming that all goods are useful inasmuch as they satisfy certain needs. This line of reasoning is evidently difficult to accept when it comes to goods that do not seem to satisfy any real need or, better still, do not compete with other goods of the same type to satisfy a given need. And that is exactly where artistic goods come into the picture. So economists, or those who have to make a choice, will try to extend the usefulness of arts beyond their aesthetic value. They can do this in two ways. Firstly, by determining their development value, i.e. their role in the economic and social development of a society. The arts, which are considered here as an intermediate and not final consumer product, can contribute to economic development by stimulating skills, by providing references and models for non-cultural goods, by making the areas where they are available

more attractive, etc. Similar arguments can be advanced in the case of social development where they promote social integration. Secondly, by determining their activity value since artistic activities acquire a greater value as they give rise to subsequent economic activities. For example, artistic activities gain in value with the foreign exchange collected from tourists visiting a monument or taking part in a festival. This approach has become so popular that it has given rise to the expression 'non-artistic demand for artistic goods', and it is growing in importance even though it tends to favour certain vested interests and, in the worst possible scenario, destroys artistic resources.

Thus, the aesthetic, development and activity values of an artistic good define the modern approach to the economics of an art. However, it is important to point out at the outset how past economic studies have dealt with this problem.

A challenge to economic thinking

Classical economists left out the arts, which were considered to be unproductive, by basing political economy on a rigid distinction between productive and unproductive work. They even recommended that the arts should be developed for other purposes such as strengthening social values, creating an identity, etc. Whereas Smith looks upon art as a means of humanizing individual behaviour, Ricardo sees in the development of art a cause for the decrease in the wealth of nations because art uses wealth without creating it.

By eliminating the distinction between productive and unproductive work and by laying stress on their usefulness, neo-classical economists were better equipped to analyse the arts. They claimed that the arts could satisfy certain needs. But their concept of utility was functional, and notions such as impartiality and aesthetics hardly found any place in their scheme. As Cournot wrote, 'The law of numbers eliminates the aesthetic dimension from individual behaviour; individuals are classified according to objective considerations.'[1,2] Besides, the marginalists based their analysis on stable utility functions, thereby ignoring changes in taste that are an intrinsic part of the aesthetic approach. Pareto made a significant contribution by taking into account several types of uses, citing the

example of a mountain-climber whose satisfaction is different from that of the guide. Whereas the former experiences a genuine pleasure, the latter is satisfied with the monetary gain. It is, therefore, possible to explore a kind of satisfaction other than a monetary one. Marshall too opens up new avenues for the analysis of cultural consumption, which can improve the consumers' understanding and enable them to derive greater satisfaction from future consumption: 'The more a man listens to music, the greater his liking for music.'[3,4] Marshall also recognizes that aesthetic services can have positive external effects on the society as a whole by improving the capacity of each person to create and to perform: 'The development of artistic abilities becomes an agent of industrial efficiency.'[5] But all these were not the foundations of the economics of art that modern economists are now trying to develop.

The first approach is based on the concept of collective goods. Unable to explain the demand for artistic goods in terms of individual demand, an attempt has been made to treat it as a collective demand. For this, it is necessary to show that artistic goods have two characteristics that are peculiar to collective goods. Firstly, they must be indivisible in the sense that their consumption by a person does not reduce the quantity available to other consumers (indivisibility and lack of competition). Because of the first characteristic, they have to be non-exclusive in the sense that their producers cannot set a price for a consumer, who would like to consume free of cost the quantity that has already been made available to other consumers. Moreover, if all consumers tend to behave in this manner, producers will never be able to find enough consumers who are willing to pay for the goods, which they expect to consume free of charge. However, these two characteristics do not appear to be satisfied in the case of artistic goods. In some cases, such as large monuments, they are relatively indivisible, although just looking at such monuments can give rise to exclusion if not divisibility.[6] But in many cases, as in the case of private collections, they are perfectly divisible. Some people may say that art is collective because it gives rise to an emotion that is shared by all, but the collective goods are the result of a collective choice and not its basis. Is the second characteristic better respected? The principle of exclusion by the market applies to a large number of artistic goods whether it be live shows, heritage

services or audio-visual entertainment. So economists pose the problem differently, considering the fact that some values of artistic consumption do not obey the principle of exclusion and that this can lead to the absence of private production.[7] Let us take the example of a visit to a monument. Some visitors will be willing to pay to go inside because they expect to gain satisfaction in terms of emotion, relaxation, education, etc. This type of value can be effectively disclosed in the market and the principle of exclusion can be applied to it. But some consumers would let others pay for values such as the option value (a person may not want to visit the monument on that particular day but may find it more advantageous to visit it the following day) and the existence value (a person may not visit the monument either that day or the next but he or she may be interested in it for itself). The exclusion principle does not work any more and if one wants the artistic goods to exist, it is advisable to treat them as a collective good.

 This view of an artistic good as a collective good does not explain much. So the collective goods approach rapidly makes way for the merit goods approach. Artistic goods are recognized as private goods but voluntarily changed into public goods once they are placed under state protection. Two arguments are used to explain why they are placed under state protection and to concede that individuals left to face the market by themselves do not always make the right choice, either for themselves or for the society as a whole. In the first place, individual preferences are distorted because individuals do not know in advance exactly how much satisfaction they will obtain from these goods. For example, persons who have never been to the opera are not likely to know beforehand what emotions they will experience or what satisfaction they will gain in order to make proper financial decisions. In the second place, individuals may make a wrong choice not so much because they are not aware of their own interests, but because they are not aware of the effects of their consumption on the well-being of other individuals. Hence they consume less of the goods than desirable, because the value of the good for society is higher than the value attached to it by the individual on his own account. An example of this is seen in the field of heritage conservation. When an individual employs a craftsman to restore his heritage, he is helping the restorer to

maintain his skills, which may later prove to be beneficial to others. But if he feels that the cost of restoration is too high, he may decide to do without him, and the society will be the ultimate loser because the restorer is deprived of the opportunity to maintain his skills. The only way to rectify this drawback in the market is for the government to step in and subsidize the use of these skills. This analysis, which limits the specificity of artistic goods to their external effects, is less skewed than the earlier one. But some economists know how to multiply the external effects to justify government intervention. The risk of this approach lies in engulfing the consumption of artistic services in a mixture of paternalism, elitism and corporatism, giving rise to a bitter paradox. Even as they ask the state to intervene, some artists would like to legitimately escape being judged and condemned by the majority rule.

A concept different from the ones mentioned above is that of semiotic goods. An object can have two points of reference: practical and reflective.[8] A large number of artistic goods are not always born as works of art but they become so over the years. Banxdall, in his book *L'œil du quattrocento*, has shown how works of art are often born as utilitarian or functional objects and the price determined by the cost of production. But some works lose their practical value and exist only in the reflective mode. At that point of time, we find ourselves dealing with special goods that are often regarded as elements of social differentiation or distinction. Jean Jacques Rousseau held that the possession of artistic goods was the result of strategies of social differentiation, inexorably leading to an increase in their price.[9] This tradition was taken up by Bourdieu in his theory on the economics of symbolic goods.[10] However, these symbolic goods can go beyond social differentiation and follow an endogenous logic. So we espouse the semiotic tradition of Barthes, especially his theory of fashion, where the message conveyed by the good is totally imaginary or purely intellectual.[11] This approach to semiotic goods has been explained by Santagata and Barrère,[12] who combine the two possible definitions[13] of a work of art:

> an essential definition based on the fact that artistic goods display a specific essential quality … and a conventional definition according to which a good is artistic due to the effect of a social convention which decides whether a particular good is artistic.

Artistic goods would then be an extreme case where they have lost all their functional value and retain only a semiotic value. How can it be explained why sometimes the semiotic dimension prevails over the functional dimension and at other times it is just the reverse?

Contrary to the preceding approaches, the one adopted by Baumol and Bowen is supply-sided and based on the structural deficiency of the benefits of productivity.[14] Artistic activities are seldom, if ever, subjected to a change of their original production functions over a period of time. Thus a Schubert quintet needs the same number of musicians today as it did earlier. Similarly, a play by Molière generally requires the same number of actors and the same time of performance as it did earlier. Productivity gains are achieved by the substitution of variable costs by fixed costs and of work by capital, but such a reorganization of work to reduce its volume eludes the arts. This does not mean, as it is often believed, that artistic activities have no source of productivity gains, because when a play is staged before a thousand persons instead of only a hundred, as it was earlier, there is definitely a gain in productivity. But artistic activities do not benefit from productivity gains at the same rate as the rest of the economy. These activities then find themselves on the horns of a dilemma. Either they can pay their workers at the same rate as other sectors, which compensate for their high wage costs through their high productivity gains, in which case this increase in the cost of production will be reflected in an increase in price and a lowering of demand. Or else, they can refuse to increase their wages, in which case their artists are likely to leave and join other sectors, where they can hope to earn higher wages with the same qualifications. No matter which solution they opt for, the result of this cost disease is saddening, and there is no other option for arts but to choose between a smaller audience or fewer artists. The almost immediate reflex is to counterbalance the insufficient productivity gains with government subsidies, thanks to which it is possible to pay the artists adequately and charge an entry fee that is within the reach of a larger number of consumers. But accepting this solution will lead to the bureaucratization of culture. By becoming dependent on government subsidies, culture becomes dependent on collective and administrative decisions.

Aesthetic value

When Salomon Reinach started writing his famous *Histoire des arts*, he was struck by the fact that human industry is the daughter of necessity and art is an expression of taste[15]:

> A work of art is intrinsically different from the products of human activity which fulfil life's immediate needs … [because] … the distinctive nature of art is added to the quality of usefulness. In the case of a statue or a picture, its usefulness is not apparent but its artistic nature stands out. This element, which is sometimes added and sometimes distinct, is itself a product of human activity, but an activity that is totally free and disinterested which aims not to fulfil an immediate need but to arouse a strong feeling or an emotion such as pleasure, admiration, curiosity and sometimes terror.

According to Reinach, it is essential to understand that behind this gratuitous appearance, which seems to belong to the domain of luxury or speculation, there is a social dimension according to which 'one may make a tool for one's own use … one decorates it to please one's fellow-beings or to win their approval'.[16]

Pleasure, emotion and expression

The analysis of *disinterestedness* is central to philosophical reflections on art.[17] Three approaches are traditionally used to define the usefulness of art: pleasure, emotion and knowledge. The oldest approach is that of pleasure, where Hume associates art with the gratification it provides.[18] The problem is that every activity that is likely to give pleasure can then compete with art. In addition, we find ourselves in a paradoxical situation:[19] if a work of art gives more pleasure than another, this could be set right by consuming the second one longer than the first. To find a solution to this problem, it is necessary to prove that the pleasure provided by the first is of a higher quality than that provided by the second, which again raises a whole new problem.

The second approach is that of emotion: art is important because of the emotions it arouses. This is Tolstoy's point of reference. He says: 'Art has this special quality; it enables some to arouse in others, with the help of signs, emotions that it has itself encountered.'[20] But emotion can encompass a wide range of feelings, some of which can hardly be compared to art. Others

have tried to go beyond this point by claiming that there is something more than emotion, perhaps imagination or even magic! In fact, the magic of art is the result of this close association between emotions and imagination, but here again it is difficult to describe fully the usefulness of art.

According to the third approach, the specific purpose of art is to promote a better understanding of the world and society. Art lies beyond imagination as it is usually associated with experience. As we proceed in this direction, it is necessary to question the relationship between art and science, because this understanding of the world and its people is the very object of scientific endeavour. Although it is difficult to insist on a boundary, it may be said that art generally tends to develop an organic vision whereas science follows the path of analysis and looks for unity between form and content (which has given rise to the expression 'poetic truth') and introduces an element of imagination into this organic vision.[21]

Aesthetic judgement

The aesthetic value of a good is the result of a judgement of its quality. According to Kant, the adjective *beautiful* is related to the recognition of a non-functional trait. This is a pure judgement as opposed to a practical judgement, a quality which distinguishes between what is useful and what is not useful; it is also opposed to an ethical judgement, which makes a distinction between right and wrong. The aesthetic characteristic may be useful but we cannot bring in the notions of usefulness and fairness.[22] This aesthetic judgement arises both from the creator and the viewer, but it is tentative. When an artist begins a new work, he generally does not know how the piece of art will look when it is completed. The person looking at the work is also in a quandary; he should be able to interpret it in order to understand it and establish a rapport with it. This process of understanding is not something fixed because the creator's purpose is not apparent to the viewer at once.

Analysis of the *flâneur* will help explain the basic principles and show what is at stake in such a judgement. In *Paris Spleen*, Baudelaire portrays the stroller as somebody who derives aesthetic satisfaction from the sight of the crowd in the streets of Paris: 'The crowd is his realm, just as the air is the realm of the

bird or water that of the fish. His intense desire is to melt into the crowd that he is watching.'[23] As a matter of fact, this man always abandons his private world, with the desire of giving a meaning to the world at large. He is not a man in the crowd, but he is one with the crowd as he understands its meaning. It is a short distance from the stroller to the poet: the stroller is in fact a poet who knows how to interpret the faces in the crowd and give them meanings that he thinks are fit. He is the supreme spectator who goes all over the city to enrich his views and give more meaning to his life, which he knows to be dull and dreary.[24] Baudelaire's vision has been taken up by at least three other writers. In Sartre's *Nausea*, Antoine Roquentin is also a kind of stroller who wants to escape the drabness of his private life and he gives it a meaning based on the observation of others: 'I reach Rue Tournebride and I just have to take my place there to see people greeting one another.'[25] In *L'homme sans qualité*, Musil describes how, in the crowded streets of Vienna, individuals try to give a meaning to their life by meeting others. For Walter Benjamin, there is nothing much left to discover through these daily observations, because the merchandise imposes a single meaning on all the interpretations of the city: 'The city is only a mnemonic sign that helps a stroller to remember something from his childhood, his own past. What they are looking for has disappeared and that is the tragedy of strollers.'[26] All that he wants to watch are no more or have changed: the numbering has only standardized the houses, photographs of the streets only heighten their banality, alleys that were once free of vehicular traffic have disappeared. This theme of the disappearance of alleys that were once the stroller's domain has an important place: 'In these passages the stroller felt at home, he was one of the many strollers who had all agreed to keep their secrets to themselves.'[27] The disappearance of these alleys reduces the stroller to the level of a consumer and there is no place for the stroller 'now that the street has become a dead place'.[28]

Benjamin's message is quite pessimistic and we may ask ourselves if the stroller is not also similar to a poet. He first tries to figure out the world in which he lives, and while doing so he makes an aesthetic demand. The stroller is not just a curious onlooker. He is more of a detective, a player who wants to know how the world functions. If the streets are dead, other areas,

both public and private, can provide him with the same opportunity. If worse comes to worse, some areas will undergo change so that he can continue to dream, because it is the dream that becomes the reality. Today, this is exactly the purpose of many parks, theme-parks as well as leisure-parks. The new stroller is no longer as free as the one portrayed by Baudelaire, and he follows the rules of the game in order to understand the symbols and the idealization of reality. The right to invent the rules of interpretation has been taken away from him. Even in his private space, the stroller has become something of a nomad guided by his screens and antennae:

> The stroller wants to play his game and in Baudelaire's and Benjamin's works it was he who decided whether to wear an overcoat that he could take off at any time. ... But it is the fatal nature of the contemporary world that tends to turn the overcoat into an iron cage.[29,30]

However, Disneyland and digital woodlands are not the only places available for strolling, and he may leave them in search of other unforeseen emotions. Although modernization is responsible for the elimination of many spots earlier used for strolling, nothing can prevent the stroller from setting off to conquer new spots. Strolling becomes an attitude and every individual can express his need to understand and interpret the things that he sees and the joy he experiences while doing so. The stroller learns things while on the move, and he believes that there is always something to observe in the city and elsewhere, beginning with other cultures. He is on the look-out for what is always hidden from him: the permanent element in that which is new, the profane in the mythical and the past in the present. This underlines the fact that what is described as an aesthetic need should not concentrate only on sophisticated culture but on all human creativity.

Direct and indirect values

Even if it is assumed that it is possible to identify the aesthetic value of an object for a particular person, it is still advisable to find out if the value refers to its direct, indirect or deferred use. When it is a case of deferred satisfaction, the person expresses an option value. The possibility of using it later can be considered to be beneficial to others too, perhaps his or her children, in which case the person expresses a legacy value. Finally,

he or she may attach a value to the object simply because it exists, it is there, and therefore becomes associated with a certain number of intangible elements that improve his or her surroundings or quality of life. In such a case, the person expresses an existence value. This phenomenon is similar to patronage but it is also different because a patron is more interested in expanding the consumption of artistic goods, for a variety of reasons such as the desire to democratize the access to culture, an attempt to regain reputation or purely for tax benefits.

Membership to an association is a good indicator of such values. Often, people become members when they visit a cultural site, as this is a way of expressing their attachment to its existence. Experience shows that membership to an association is an indication of sympathy and support rather than a means of saving money during later visits.[31] Option, legacy and existence values are even more important than the aesthetic value, which depends on the duration. This makes it difficult to invoke them in the case of live shows but they are certainly valid in the case of heritage monuments.

Cultural, display and algorithmic values

In the age of digital reproduction, one wonders if the components of aesthetic judgement described above are not changing and whether they need to be more clearly defined. Works of art can always be reproduced, as human beings are capable of remaking what others have made earlier. The novelty, however, lies in the almost unlimited possibilities offered by modern technical reproduction methods. While we depended earlier on simple processes like metal-casting and engraving, we now have access to processes that cannot only reproduce but also manipulate. According to Benjamin, this wider range of options does not deprive the original of its authentic character (what he calls the *here and now*), which later reproductions lack. Nevertheless, after its reproduction, the work of art does lose its *here and now* quality, or *halo*, and it also loses its value as evidence or its cultural value and its *aura*, retaining only its display value.[32]

The work of art that lends itself to reproduction loses not just its aura. It is meant to be reproduced. It somehow leaves 'its parasitic existence bequeathed upon it as a part of a

ritual'.[33] On losing its ritualistic base, the work of art may adopt other bases, starting with politics which underpins its display value. As Benjamin explains,

> the picture of a man drawn on the wall of a cave during the Stone Age is a magical instrument. This picture was certainly exposed to the eyes of his fellow-men but it was mainly intended for the spirits.[34]

On the contrary, if we take a photograph, its cultural value is totally ignored in favour of its display value. The role of an artist as a member of the audience will be modified accordingly. As for the artist's own role, it suffices to look at the difference between a stage actor and a cinema actor. In a play by Pirandello, for example, the former gives a live performance before a live audience retaining all the magic of *here and now*, whereas the latter performs before a camera and cannot experience the excitement of *here and now*.[35] As for the audience, they weigh the values quite differently because, after having lost its cultural value, art acquires a greater value as entertainment. Why, asked Benjamin in the course of an argument that is not fully verified, does the general public prefer Chaplin to Picasso? Because the former is more closely associated with the pleasures of entertainment and has a greater display value than the latter.

There is nothing to prevent us from going further. As opposed to Benjamin, who considered the reproduction as a derivative of the original, we can ask ourselves whether the original is not a result of a combination of reproductions of hybrid or hybridized elements. When a work of art becomes an algorithm, the notion of aesthetic judgement must be considered in the proper context. Today, the work of art is becoming more and more virtual and its boundaries represent, at the most, a point of time for special audiences, who are capable of modifying its contents. The artist's power is now shared by the viewers. That is also the case with the writing of electronic novels on the web or with the numerous manifestations in contemporary art. If necessary, each person can decide the *here and now* and the economist will treat the consumption of art as an investment by the public rather than as consumption. The factors related to the search for leisure or originality will share it with aesthetic feelings, which serve as a basic reference rather than a sieve when analysing behaviour.

Development value: its economic aspect

Art acts as a lever for economic development on four counts. It stimulates the creative talents of entrepreneurs, promotes skills that benefit all sectors of the economy, contributes to the management of human resources within enterprises and enhances the attractiveness of a place for consumers.

From art to creative industries

In our modern economy, there is a competition between goods and services both in terms of the quality and the price. The quality depends on the novelty of form and content and is often derived from artistic sources. The economic world wants distinctiveness, novelty and originality from the artistic world to create new markets and achieve standards that enable it to triumph over other competitors lacking in imagination. Creative activity is therefore central to the modern economy and we are witnessing the emergence of widespread creativity in various production sectors (e.g. fashion, design, media) and services (e.g. hospitality, communications, consultancy, engineering). Artistic activity becomes a kind of applied intellectualism, representing the end of a continuum rather than a break.[36] Let us take some examples from the fields of fashion and design.

In the *fashion industry*, designs and patterns alternate constantly between art and industry and between creation and reproduction, and artists have always inspired fashion. Raoul Dufy and the Bauhaus inspired new fashions and a creator like Saint Laurent has always admitted that his creations bear the imprint of Mondrian and Braque.[37] The division between art designers and industrial designers falsifies this view to some extent but it is difficult to maintain this distinction in practice. More often than not, those in charge of collections surround themselves with designers to execute their ideas regarding the selection of textiles, shapes and colours. The effect is heightened by fashion photography, which has made rapid strides from the simple taking of pictures to becoming a creative art. A creator like Man Ray promotes a garment through a mixture of painting and photography, and while some designers create rebellious styles, others are more subdued.[38]

Design is 'considered as a discipline aimed to create objects of day-to-day use and works of graphic art ... that are functional, aesthetically appealing and comply with requirements of industrial production'.[39] As an element of competition among enterprises, a design's success depends on the ability to differentiate between various products and promote corresponding brands. Since it requires imagination, it is as much evident in the finished product as in its drawings and preliminary sketches.[40] It follows different directions in different fields, ranging from furnishings to textiles and from textiles to surfaces. According to a survey conducted among hundreds of enterprises in France, design enables them to organize their supplies (83 per cent), to be different from others (78 per cent), to create value-added products (71 per cent), to diversify,[39] to penetrate new markets (45 per cent) or improve their position in existing markets (45 per cent).[41] The economic results of all these activities are very important. If we take a look at textile designing, we see that it is the designers who are responsible for embroidery, lace, knitwear, printed materials, woven materials in the clothing, furnishing, household linen, automobile upholstery and other sectors.[42] What are the sources that serve as a reference for these designers? There is no point in taking an excessively artistic view of design. In most cases, clients' demands are given top priority, but they are enriched or reprocessed on the basis of references taken from museums (13 per cent of enterprises), rival collections (23 per cent), catalogues (39 per cent) and fashion shows (65 per cent).[43] Even though museums do not occupy a dominant position, many designs are inspired by ideas based on a wider concept of heritage that is gaining popularity among the fashion houses.[44]

The development of artistic activities for the benefit of creativity has led to the reorganization of conventional cultural institutions. Museums are getting ready to collaborate with groups of enterprises who believe that the conservation of models and products has become indispensable. We can cite examples of many such museums such as the porcelain museum in Limoges, the costumes museum in Moulins and the cutlery museum in Thiers. In Limoges, a special heritage zone has been set up in association with companies manufacturing porcelain and enamelware, where the museum authorities also display other related heritage objects (a combination of industrial and

conventional museums), together with sales outlets. Theoretically, it has to be seen how a national heritage can be put to good use, while the creative activities of business enterprises are enriched and presented to tourists and visitors. But this zone has other advantages because it enables us to redefine urbanization by reorganizing the town around these traditional activities, to give it a strong public image and make it more attractive to its residents as well as visitors.[45] The case of Moulins is slightly different because the tradition of manufacturing costumes had been submerged by numerous other activities, most of which are now under consideration. The town therefore decided to make arrangements for the display of fairly large collections of costumes from national theatres, thus turning the new museum into a place for the study of and research on costumes and a catalytic agent for getting specific orders for local manufacturers. The case of Thiers is simpler inasmuch as the town is built around a traditional activity, which encouraged the town authorities and private manufacturers to set up a cutlery museum, to which was added the 'House of Cutlery-Makers', a showroom-cum-laboratory displaying products that are original and creative. The most significant result of this idea of bringing together a museum and a laboratory is the innovative use of new materials in the place of old ones that have become too costly and the regular participation of the cutlery industry from Auvergne in all international exhibitions.[46]

The archives of enterprises can also join in the movement of economic creation. The memory of a manufacturing company and its products can become a permanent source of inspiration and provide reference material for the development of new designs and products. An interesting example of this is the recent industrial reconversion of the new German *laenders*, particularly Thuringia. There were a large number of porcelain manufacturing units in Kalha and Iena that had failed to modernize and adapt themselves to the changing times.[47] As a result of the economic and geopolitical changes in the 1990s, they found themselves to be quite non-competitive.[48] The authorities and local workers were wondering how to reverse the trend. When the porcelain factories were about to close down, it was decided to draw up a list of the designs and colours used in this area during the past few centuries. This could be called a backward-looking attitude. But those who tried out this experiment

wanted to find references to which they could apply the latest technology to produce designs that were both new and competitive. The experiment undertaken four years ago still continues, albeit with the support of public and private funding. The example of Kalha is not the only one of its kind in Europe, and the attention paid by enterprises to archival materials and museum collections underlines the value of heritage as a source of competitiveness.

Generally speaking, the development of such an interaction between art and industry emphasizes the importance of these *creative industries*. The term is fairly recent and it made an appearance simultaneously in political and academic debates, especially in the Blair government's political rhetoric in Britain.[49] Creative industries are industries whose products and services display noticeable artistic or creative qualities. These industries are characterized by a number of traits, which are more or less those of artistic production. The first of these traits is the uncertain demand and therefore the uncertain value of the product. The second is the high cost, which cannot be recovered if the industry is forced to close down due to a non-acceptance of the new product.[50] The third characteristic is the association of very specialized artistic qualifications with very ordinary qualifications. This leads to specific management methods, which are likely to affect the decentralization and flexibility of production processes. The fourth characteristic is the interest shown by the holders of artistic qualifications in the nature of the product and the role they expect to play in its final design and shape. The last characteristic needs to be highlighted because it is related to the mode of payment. Holders of artistic qualifications would like to have a share in the added value of the product, in the form of intellectual property rights or a share in the profits.

Art as a producer of new qualifications

The development of artistic activities can raise the level of qualifications in other sectors of the economy. Let us look at the effect of cultural activities on the construction sector in the light of the policy adopted by training programmes in Spain (*escuela-taller*).[51] When improving a place, such as restoring old buildings or even flower gardens and rural landscapes, a training

programme is conducted on the site. The young girls and boys recruited for the purpose receive both theoretical and practical training, and at the end of three years, which is the normal duration of the course, they can get jobs in other sectors of the economy such as construction projects. They can thus put to use the skills acquired during the training programme on these work sites. This system serves three purposes: restoration of heritage sites, creation of practical skills and technical know-how and improvement of the quality of work in all sectors of the economy through the spread of artistic know-how.

An interesting example can be seen on the Great Canary Island where tourism is destroying its heritage and natural environment.[52] The damage is visible not only along the coast but also in the inland areas, though in a more subtle fashion, due to the misuse of hoardings, internationalization of local crafts, haphazard proliferation of small hotels and restaurants showing no respect for local architectural traditions and damage to a rare species of flora. Since it was impossible to put an end to large-scale tourism, a new strategy was devised to supplement the dominant form of tourism with a new type of tourism based on the improvement of heritage. This involves the development of villages, restoration of heritage monuments, protection of rare species of flora and promoting organic farming whose products are likely to find a ready clientele in the tourist areas along the coast. Specific training programmes were designed to restore the urban and rural properties of ethnic or architectural value, to protect the local flora (laying out gardens and cleaning rivers), to undertake renovation works in rural areas (gravelled paths, walls, hedges, traditional granaries, etc.) and to revive handicrafts that had suffered due to migration of local craftsmen and the appearance of cheap machine-made goods in places frequented by tourists. The training programmes did not stop once the initial goals were achieved, since they were aimed at reviving the traditional trades and crafts in order to provide top quality goods and services in a wide range of sectors like construction, gardening, pottery, lace-making, etc.

These training programmes, generally supported by public funds, were criticized because the trainees did not set up their own enterprises nor did they always find employment. Thus the very first criterion of success was not fulfilled. However, the

results here are not very different from what they are in other fields. On the other hand, studies conducted by OECD show that the second criterion was fulfilled.[53] As a matter of fact, the programmes were doubly successful because they not only created job opportunities but also improved the quality of human resources.

Is artistic production a new method of managing human relations within an enterprise?

Another use of art in the economic field is reflected in the new methods of personnel management and particularly in the appearance of the *company theatre*.[54] It is easier to make the workforce aware of certain challenges (need for horizontal communication, adjusting to a new accounting system or a new organization chart) through the use of company theatre than through lectures, instructions, circulars, etc. The effects of the company theatre are seen in a greater mobilization of the staff, better memorizing of messages and better adaptation to the prescribed behaviour.[55] It made its appearance in France in the early 1980s with a play called *Pertes et profits et le mystère des coûts cachés* (Profit and Loss and the Mystery of Hidden Costs). But in Quebec, this form of theatre has been there much longer. It started with the setting up of the first theatre company called *Théâtre à la carte*, and its development led to the creation of a festival of company theatre.

Company theatre is responsible for the creation of a real market. It is not a cultural activity organized by business committees but a communication method aimed at spreading messages within an enterprise. It does not identify itself with a specific audience, which may consist of the staff or outside associates, or with a particular place. What it really does is to dramatize an enterprise by using stage methods in an aesthetic space that separates the actors from the audience. The stage performance dramatizes the institution or enterprise, its rites and practices, customs, codes and jargon with the help of a written script or improvised dialogues spoken by actors, and it is addressed to either all or some of the staff members.[56]

Company theatre aims not just at enhancing the value of the enterprise or glorifying it but at solving human problems through the use of humour, farce and satire and the portrayal of

incompetence and maladjustment through subtle caricatures. It serves to spread information within the enterprise in an implicit manner and by highlighting the tacit aspects of the enterprise's culture. One of the specialities of this theatre is its method of staging separate plays to treat particular problems. The theatre company prepares the script after collecting information within the enterprise and discussions with the staff. After the play is written, it is discussed with the *client*, a term which often detracts from its creativeness and creates tension among the actors. The artistic merits of company theatre are questioned because professional actors hesitate to act in it, leaving the field open for young actors who opt for it for good.

Company theatre assumes many forms. There is a turnkey theatre consisting of plays staged by professional actors for several enterprises to expose their common problems and suggest possible solutions; then there is a tailor-made theatre which satisfies the requirements of a particular enterprise and deals with a problem peculiar to it after a detailed analysis of its culture; there is also an improvised theatre where the actors suggest ideas or solutions on the spot in response to questions put by the audience; there are, in addition, a practical animation theatre which helps enterprises to stage theatrical performances, and an action theatre where the employees of the enterprise join the actors or are invited to give their suggestions regarding the play's ending. What is common to all these forms is the actors, spectators and the performance space, accessories such as sets and costumes being generally absent. So the theatre is used as a vector for communication and catharsis in a given setting. A survey carried out in France among eighteen enterprises showed that these plays were well received and appreciated by the audience. But 60 per cent of the personnel felt that they did not contribute much as compared to other methods of communication. The remaining 40 per cent felt that the theatre helped to highlight the messages that were sought to be conveyed and made them easy to remember.[57]

The use of art to make consumption more attractive

Art is now used to encourage consumption. There is a growing tendency to rearrange commercial spaces – be it shopping malls, departmental stores, pleasure boats, casinos, etc. – in such a

manner that they encourage visitors to spend as much money as possible. They are true temples of consumption assuming a magical or even sacred aura in the eyes of consumers. But to attract the customers, this magical quality has to be sustained all the time.[58]

Weber's theory of disenchantment enables us to understand how art can create this magical quality. According to Weber, the capitalist economy is a highly organized and rational economy, so much so that all its structures, including consumption, end up exerting a strong hold on the people living in it. The quest for rationalization creates a dull and decorous society, which needs to be re-enchanted to make it more agreeable. So, it is necessary to bring in magicians and fantasy as Campbell tells us in his book *The modern forms of consumption*.[59] The places of consumption must be treated as sacred. The layout of the *Bon Marché* store in Paris, established at the end of the nineteenth century, is a fine example. The description of the store by Rosalind Williams shows how the shape and the interior of the store were designed to create an osmosis between the sales counters and regular customers and a fairy-tale world of romance and prestige.[60] The same ideas are evident in the layout of the casino-hotels in Las Vegas, which are actually no more than places of consumption. But it goes without saying that these attempts at enchantment are also subject to rationalization and there has to be a constant effort of imagination to maintain their fairy-tale-like atmosphere. This is done by holding exhibitions, personalizing the interiors and presenting shows. Artists are totally integrated into the process: they are in fact actors engaged to stimulate consumption even though their roles would have been presented to them somewhat differently.

Development value: its social aspect

Apart from its economic aspect, the development value of art also has a social aspect, which fluctuates constantly between the desire to let individuals decide their own future and the desire to bring them together through the values they share in common. However, this reasoning is not without its ambiguities and it is possible to confront it with another interpretation of the social aspect of art. Art can give rise to manipulation, and

its aim to serve as a social bonding factor does not always lead to *democratic assimilation*. Benjamin has shown very effectively how fascist regimes used art to create the illusion of unity among the people without changing the land ownership pattern which divided this society, declaring in the end that 'the logical consequence of fascism is a more aesthetic political life'.[61] Recently, during the debate on the value of contemporary art, some like Clair[62] declared without any hesitation that this art had been used to manipulate the masses. Similarly, manifestations of a positive effect are found in artistic productions that are often original and marginal as compared to established practices.

Integration by strengthening identity

According to one approach, artistic activities can strengthen identity and instil confidence in people living on the margin of society by providing them with the opportunity for self-expression and to associate themselves with collective works or do creative work on their own. There are many illustrations and we will select three that are quite different from one another. The first one shows how identities and places can be reconstituted in order to enable individuals assuming these identities to look at their immediate surroundings more attentively. The *Cavern experiment* in Cork encouraged young people to prepare audio-visual programmes that presented a more positive picture of themselves as a group, quite unlike the programmes they generally see on the cinema and television screen, which often tend to belittle them.[63] Once they have created this positive picture of themselves, they tend to look differently at their social and economic environment, take note of its peculiarities and plus points and become totally involved in its improvement. These projects are aimed not only at young people but also at adults like the numerous programmes for assimilation through cultural activities meant for the long-term unemployed.[64]

The second shows how individuals, especially the young, can define themselves in relation to the history of their area and understand their role in society. The Bologna municipality was faced with serious problems of discontent, identification and assimilation among the youth. Unable to resort to traditional methods that depend largely on the conventional job market,

the municipality decided to provide more opportunities to the young for setting up their own enterprises in the cultural field. This was a departure from the usual cultural policy of the municipality, which until then had concentrated on boosting tourism and was therefore dependent on an exogenous demand. Since the early 1980s, the municipality has adopted a new cultural policy aimed at developing capabilities related to local supply, identification and consumption.[65]

The third illustration is that of an attempt to open up new areas where individuals can give expression to their creativity. Such areas are not normally found in a market-based economy which values only acquired skills. *Friche Belle de Mai* is an unusual cultural facility in Marseilles based on the principle of geographical proximity for the development of creative and cultural activities.[66] To begin with, an association called *Système Friche Théâtre* was set up in 1992 in a part of the premises vacated by a tobacco factory in the *Belle de Mai* district of Marseilles. Its basic principle was to put artists and people belonging to artistic professions at the core of a system that allows them to produce artistic works and come into contact with the public. *Friche Belle de Mai* extended its activities very gradually, since that was how it wanted to proceed, by entering the urban milieu. With the help of associate and activist networks, it set up new centres for creation and exchange, meeting and assimilation as well as information centres for marginalized groups, boxing rooms for the young and workshops for the pursuit of artistic activities such as music. Artistic activities are not the only ones to set such processes in motion, but they do act as a powerful lever because they disseminate the symbols and mechanisms of communication that are common to all the fields of activity under consideration. Norms and plans are evolved step by step for the participants of the programme as well as for others they come across in their usual surroundings, to enable them to find paid work and join the mainstream. By assuming a role in deciding his future, the individual can contribute to the emergence of alternative cultures, which spread creative skills. The itineraries are diverse: some move from the production of small urban shows to the production of official shows, whereas others continue to remain in their narrow fields where only a part of their skills are utilized. Today, *Friche Belle de Mai* is in the process of diversifying and consolidating its activities. Where the old tobacco factory

stood earlier, there are now workshops for restoring heritage objects, a centre for producing television programmes, a centre for training archivists and a multimedia centre.[67]

Art as a creator of social spaces and social bonds

Art can also create social bonds by disseminating commonly shared values. On the face of it, this claim contradicts Bourdieu's theory of social distinction. There is no doubt that cultural consumption reveals a person's desire to distance himself from others and maintain his individuality, but it is certainly not the only motivation in the post-modern age where consumption is governed by complex motives. The emergence of the post-modern society has led to a social restructuring:

> The self does not amount to much but it is never alone, it is enmeshed in the texture of relations that are more complex and more mobile than ever before.[68]

Individuals may try to keep together by becoming members of micro-groups, which are called *tribes* by some sociologists. These groups no longer have a contractual or rational base as in the case of groups, categories and institutions conceived by modern society, but they are based on 'a more complex process consisting of attractions, aversions, emotions and passions'.[69] These communities based on affective bonds need a place where they can meet; they also need common references, and artistic activities can create a meeting ground and give rise to a feeling of belonging. Aesthetic sentiments will then take over the role played in the past by great ideologies. Of course, artistic activities are not the only ones to create social bonds, and a thinker like Eco would rather believe that religion is the true lever.[70] Nevertheless, artistic activities do allow these interactions to materialize in a positive form.

In keeping with the tradition of the jugglers in the Middle Ages and child acrobats, *street arts* are once again coming into their own. They are also called *hybrid arts*. They bring together the elements that appeal to post-modern consumers such as eclecticism, freedom and shared emotions. They are short-lived but more open than organized performances in terms of seasons:

> the festive nature of these cultural events presents moments that should not be missed … their unfolding … helps through a training value to bring down the barrier that separates [people] due to lack of habit or opportunity.[71]

Some observers find in them a means of recreating the agora or a public space, the base of all collective life, which will belong to all and to nobody in particular. For this space to exist, it is necessary to find both material and symbolic bases for it. Street artists help to create such a space, but not in the same way as politicians or highflyers; they do it as a duty and at the cost of a belief, because they want each person to be able to interpret for himself. Public space is created here by joining together to produce something meaningful or to declare universal support for it. It thus becomes a place having a universal significance where people are indifferent to differences, where what is lost in the form of identity is gained in the form of democracy. Several themes are omnipresent: revitalizing towns, repeating events in order to leave behind a collective memory, creating a cohesive society out of an audience and not vice versa, changing the attitude of people or forcing people to look differently at things and persons right in front of them.[72] This artistic shift is considered to be an instrument of social change, but such a change can be effected only by changing the rules of commercial behaviour, which can lead to both segmentation and passivity.

This phenomenon is far from new and some people consider it to be the product of the changes that occurred throughout the twentieth century. They refer to the agit-prop theatre for which art ceases to be just a stage setting, but it must also create functional objects that should be socially effective.[73] Art should be functional, a social condenser, a short-lived utopian experiment: 'In the street futurists, drums and poets.'[74] The movement that is happening believes in the same idea[75] that art should be out of phase with day-to-day life and try to shock the senses. Popular plays like Marcel Duchamp's *Bicycle Wheel* were raised to the level of works of art only because the artist wanted it to be so, a choice that the viewer was forced into. As for urban space, it can be dramatized by proper packaging (Christo). Other examples can also be added such as what is known as the radical theatre, whether it is the Bread and Puppet Theatre or Milan's Piccolo Teatro.[76] This has not prevented the officialization of the street arts by the government and we may cite as an example the events organized in Paris to celebrate the bicentenary of the French Revolution or the Winter Olympics in Albertville.

Productivity or counter-productivity?

It is believed that facilities like cultural centres, museums, etc. act as catalysts for references, which provide space for the formation of new cultural bonds. Having taken note of these initiatives, it is important to verify their results. Is it possible that the benefits of cultural facilities or heritage monuments will outweigh the effects of the malfunctioning of other facilities, like training and employment, intended to promote integration? There are at least two types of integration mechanisms, but what happens when they do not function in unison? It is possible to imagine social integration without cultural integration, as in cases where the absence of unemployment is accompanied by the continuation of inequalities, particularly in the cultural domain. However, the opposite situation, where the lack of social integration coexists with a very strong cultural integration from the outset even though in a near-explosive manner, is much more delicate. On the one hand, there is an increase in unemployment and poverty; on the other, there is a tendency towards the homogenization of cultural practices and aspirations. Such a situation is explosive because it implies an aspiration to equality that is systematically refused in the long run. Because of this, the mechanisms of cultural integration are considered as a fraud. Social non-assimilation ends up sooner or later by turning into cultural non-assimilation and the suburb becomes a ghetto, and equality within the community becomes an open rift.

Many towns are fast approaching the state where a combination of social rejection and pseudo-cultural integration ends up in cultural exclusion and segregation. Let us take the example of the evolution of graffiti and the significance it has acquired today. Earlier, graffiti was appreciated for its content, as it conveyed an explicit message of political or ideological dissent and gave expression to the class struggle in the post-industrial society. Later, it became a form of abuse defacing advertisements in order to denounce the dreams and illusions promised by them. Today, graffiti has turned into a series of urban hieroglyphs whose only purpose is to affirm the existence of its creators. It does not demand material advantages, only space, a demand which present-day institutions are not in a position to fulfil. That is why the primary targets of this graffiti

are transport facilities, police and education. The city's bound-
aries are being redefined and public spaces privatized. Those
who cannot get assimilated redefine a new urban space for
themselves. There is a general confusion with each person seek-
ing to express himself in a contradictory fashion. Following the
mutual demarcation of spaces by those who have rights and
those who are deprived of them, we find ourselves thrown back
into the realm of culture.[77]

Development value: the regional aspect

Artistic activities are also used to improve the surroundings
and the image of the areas where they take place. Activities
related to the restoration of heritage sites are in the forefront,
but festivals can also produce the same result. Towns that
experienced serious reconversion problems had to resort to the
promotion of artistic activities as a sign of their willingness to
change and assimilate communities belonging to different
cultures. For the residents, it is a means of regaining con-
fidence in their development potential and looking forward to
the improvement of community life in their area, an incentive
to set up new projects and slow down the migration of the
younger generation. For those who live outside, it is an evid-
ence of the area's new-found confidence and its ability to enter
the global economy in a positive manner and to improve the
quality of life of its inhabitants. There may be two possible
motivations behind this development value. Firstly, the renova-
tion of some parts of the town in the hope that these activities,
initiated in the public domain for the renovation of monuments
of symbolic importance, will be pursued by the owners of pri-
vate properties forming a part of the local heritage, and sec-
ondly, the gradual introduction of artistic activities, which will
make the area a sign of development.

Urban renovation activities

The Temple Bar district of Dublin is a fine example of the
relative success of these strategies.[78] This district spread over
14 hectares in the heart of Dublin had deteriorated considerably
during the 1970s, largely due to the neglect of real estate in the

area. So the authorities decided in 1991 to redevelop it by turning it into a cultural district. It was kept in mind that town-planning, cultural development, stabilization of population, improvement of the quality of life and creation of job opportunities are all closely interrelated. The basic idea was to allow private agencies to develop the area although public funding was made available through national and local agencies. Among the cultural activities proposed were artists' workshops, provision of musical equipment, exhibition galleries, a national photographic archive, a film-club and a centre for film-making, a centre for applied arts, a theatre and a centre for the interpretation of heritage. The exercise was not only aimed at improving property values in the area, but it was also hoped that the contiguity of diverse cultural activities would encourage the emergence of new activities.[79] However, this strategy is debatable because not only has it led to speculation in real estate, but it has also driven away the district's original residents and traditional occupations. This is generally true of all renovation schemes, which tend to give more importance to cultural tourism than to culture industries.

Glasgow is a good example of how a city can use its culture to leverage not only its consumption but also its production. Glasgow is the archetypal industrial city, which has seen almost half of its industrial activities disappear over a relatively short period and had to rebuild a post-industrial economic system. As a result of the disappearance of these activities, industrial wastelands sprang up in the very heart of the city in the early 1980s. Although the city did not then figure on the tourist map, its only attractions being a science museum and a street with many buildings characterizing the nineteenth-century industrial architecture, it made an attempt to attract visitors by highlighting certain cultural activities, its heritage and its performing arts. Theatre and music festivals (Mayfest and Garden Festival) were organized and a gallery of contemporary art, the Burrell Gallery, was opened in 1983 in a building exemplifying avant-garde architecture. In 1990, after some political upheavals, Glasgow was named the cultural capital of Europe and how to take the utmost advantage of this label was not clear. It could certainly use this opportunity to publicize its activities and that is exactly what it did: the success of its *Glasgows'mile Better* campaign is a feather in its cap. But it must be kept in mind that

the effects of cultural tourism are limited and that the develop-
ment of art can also give rise to creative activities and quali-
fications which can boost local production in terms of design,
fashion, multimedia, etc. The 1990s thus became the decade of
creative industries, and the Glasgow municipality went about
creating the necessary infrastructure for the development of
these industries such as building sites, fairs, art schools, etc.
Between 1991 and 1997, more that 14,000 jobs were created in
this sector.[80]

During the last few years, urban renovation schemes based
on artistic and cultural activities have given rise to a debate on
their objectives. One of the questions asked is whether the town
should be turned into a monument or whether the community
should be encouraged to promote local development? Monument
locations spurred a large number of activities. The idea is to
extend their impact on the town, first by defining the protective
perimeters, and then by looking within for other perimeters to
plan the town's future development. The results follow almost
automatically: speculation in real estate and gentrification, loss
of traditional activities, reorganization of urban space with a
view to encourage tourism at the cost of the local population.
Turning the town into a monument is not the only solution
when you consider the needs of the local population that must
stay on. Some activities like repairing buildings and other infra-
structural facilities will continue. Others, like providing support
to small-time economic activities such as crafts, will be added.
But, essentially, the spirit behind them will change. Whereas
earlier urban renovation was done through planning, with pur-
chases followed by sales, currently incentives are offered and
efforts are made to spur community development. Monuments
are no longer treated as a reference but as a lever, and the
town's attractiveness is considered as much from the point of
view of its residents as that of tourists. It is very interesting to
follow the different phases of the French *Pactarim* programme
for the renovation of buildings, which is based on the success-
ful extension of the monument protection system and effective
mobilization of interested communities in rich countries. But
the programme had to be modified when it was transposed to
developing countries by providing incentives for economic and
community development in order to produce positive results, as
in the case of Quito or Santo Domingo.[81]

Rural areas too can use artistic activities to leverage regional development. Over the last few years, Umbria has lost a large number of its traditional industrial jobs, especially in Spoleto.[82] Having decided not to rely on artistic resources as the only means of redevelopment, the local authorities of Spoleto and their associates took steps to create more jobs. Three main lines of action were followed: creation of a network of museums by opening new ones and renovating the old ones; making maximum use of the annual Spoleto festival *Festival dei Due Mondi*, resulting in the creation of 350 full-time jobs at the preparatory stage and during the festival, which in turn will lead to human resource development in other sectors like hotels and restaurants; making use of the experimental lyrical theatre (*Teatro Lirico Sperimentale*) to set up a training centre for the lyrical arts, thereby bringing together on a permanent basis more than forty people (half of them trainees and the other half teaching staff).

Cultural districts

Recent studies have highlighted the effects of artistic activities and their nearness on the development of an area.[83] The districts studied were quite different from one another. Some were spontaneously created by the players themselves, namely artists, craftsmen, publishers, producers, etc., whereas others were intentionally created as a result of political action. The former do not enjoy any kind of protection, whereas the latter have the advantage of a label, a sort of *appellation contrôlée*, which serves as an intellectual property right. While some districts are not subjected to any restriction with regard to location, on account of the demand for their resources (publishing, crafts, designing, etc.), the others had to endure such restrictions. Some concentrate on the production of a particular cultural good, whereas others live in symbiosis with more conservative industrial districts (e.g. fashion and garment industries, designing and furniture, etc.).

The first type of cultural district is the result of a slow developmental process, involving the regrouping of geographical areas and capitalizing on their contiguity. It is difficult to find a better illustration of such a *cultural-cum-industrial* district than Hollywood, although the more recent Babelsberg is also very interesting.[84] In the beginning, the only reason why film studios,

then located on the East Coast of the United States, decided to move to Los Angeles was its excellent climate and the availability of land at a low price. Thanks to California's sunny climate, films could be shot outdoors throughout the year (although before long most of the shooting was done indoors). Besides it was possible to acquire vast tracts of land in the hills of Hollywood at a very low price. This gathering of several studios soon created an employment market for artists and technicians where jobs were readily available, and this enabled producers to speedily find the necessary resources. It is somewhat paradoxical that the economic image attributed to Hollywood was that of an organization similar to Fordism, whereas in fact it was essentially an open-air market where adjustments were made almost instantly as they are even today. This logic also applies to the multimedia districts involved in the production of technical equipment, computer software, resources in the form of pictures, film scripts and audio-visual techniques, and finally, the finished products. Nevertheless, the cultural components of these activities (resources in the form of pictures, scripts and audio-visual techniques) can also act as a bottleneck.

Another type of district analysed by Walter Santagata depends on the legal recognition of the specific character of its cultural products and of the surroundings that further their creation.[85] By giving recognition to certain local products (textiles, furniture, agricultural products and wines) through legal measures, the public authorities grant real property rights, akin to intellectual property rights. Consequently, the region can be suitably publicized and this publicity also benefits its products. A good example of this course of action is the use of government certification to guarantee the quality of a product, especially wine. This certification, which assures legal protection, is given to regions producing a specific product that has its roots in the local know-how and lifestyle.

Finally, there are districts that are more conventional in their method of development. They resort to restructuring of their real heritage sites and museums in response to popular demand. This involves creation of new attractions and the renovation of inherited resources. These districts generally have an important monument or an area that can be considered as a heritage site. In this type of development, the voluntary element comes into play when the renovation is taken up by public

bodies, and it is also seen in the layout of protected areas, demarcation of the boundaries of areas needing renovation, earmarking of areas for development, pedestrian streets, etc. Such measures attain their objective of boosting cultural tourism, but the local population has to pay a very high price in terms of destruction of a part of its traditional activities, speculation in land, etc. Over the years, these changes have led to rethinking on the subject and, with the consent of the local population, it was decided to highlight heritage sites that were perhaps less prestigious, but formed an integral part of their local economic life. In France, two types of heritage districts were promoted one after the other and later flourished side by side. In 1962, on André Malraux's initiative, *protected areas* (*secteurs sauvegardés*) were created mainly because they contained important monuments. Then, in 1983, it was decided to create *zones for the protection of architectural, urban and natural heritage* keeping in mind the social dimension.[86]

Activity value: art as the starting point of a chain of activities

The contribution of art to the development of transport, hotels and restaurants, manufacture of souvenirs, insurance business, etc. is highlighted a little more every year. Since arts promote the activities related to festivals, museums and shows both upstream and downstream, they are assessed according to the success of these activities. There is a great risk in stressing only this contribution of the arts and neglecting others, which are generally less visible but have a more lasting effect.

The cultural tourism network: a testimony to the economic importance of art

Tourism is becoming more and more dependent on artistic activities and resources. Earlier culture was considered mainly as a way of spending one's free time or as an educational pastime, but currently it is more a means of leveraging the development of tourism. The concept of *cultural tourism* has become a kind of open sesame for areas going through economic difficulties. Such areas always manage to find a heritage monument or organize a festival to attract more tourists. The

importance of cultural tourism increased when it was discovered that it has significant quantitative effects. Thus museum tourism provided almost 40,000 jobs in the city of Paris alone.[87] Better still, these effects are not purely fortuitous but a result of the conjunction of lasting phenomena.

The first of these phenomena is socio-economic change. In European countries, we find that there is a growing demand for leisure activities due to a rise in the standard of living. Life expectancy has increased to reach an unprecedented level (80.1 years for women and 73.7 years for men), and retired persons who are younger and more active now swell the number of visitors. We may further add the increase in the rate and average period of schooling, which tends to facilitate the use of cultural services by school-going children during their leisure time, and the availability of more free time, a part of which is spent on learning (40 per cent) and a part on leisure activities (36 per cent).[88]

A change in the concept and function of leisure is the second phenomenon that explains the rise in cultural tourism. If we leave out the old practice of undertaking a *grand tour* of the Continent, which was prevalent only in the upper classes, we find that tourism is a modern social trend based on the practice of organizing leisure according to the principles of functionalism, positivism and pluralism. The function of leisure is to satisfy the need for rest and relaxation and it is defined by a specific time and space. It can also help to neutralize antisocial behaviour and improve the quality of life. Leisure is in some ways a by-product of work, a safety-valve which protects a person from the physical and psychological pressures of modern life. This approach to leisure, which could be qualified as conservative, has changed under the influence of new interpretations, especially the regulationistic approach, according to which the type of consumption must be in keeping with the forms of production, and the development of leisure activities for the masses should contribute to the development of mass consumption. Leisure is no longer just a by-product of the modern economy. It has market potential and is a condition for proper regulation.[89] No matter which of the two versions is accepted, it is evident that leisure does not necessarily contribute to the ramification of an individual's needs, but only provides temporary satisfaction. When consumerism is applied to leisure, it opens up the possibility of individual discovery and satisfaction without guaranteeing their materialization. Some

will go even further in their criticism, like Marcuse who says,

> Leisure and reality are not in phase. ... Activities which tend to provide
> entertainment never attain their object. ... These pleasures are never a
> part of it because they are implicitly led in directions which are not the
> desired ones and actually make men less free than they think.[90]

According to some observers, modern society values every-
thing that changes, and this need for development and change
permeates all its activities including leisure. What is sought
here is transitory, ephemeral. This alternative approach to
leisure is illustrated by two examples. Firstly, by the example of
the carnival, which celebrates a temporary freedom from the
established order, and where official culture is ridiculed and
caricatured in a grotesque manner to show that it is not really
as established as it is believed. Secondly, the example of
Baudelaire's stroller, described earlier, who is on the look-out
for impressions and emotions as he strolls through the streets
and exposes himself to many sensations:

> for the stroller, it is a great joy to find a place in the hearts of others, in
> the midst of the transitory and the infinite ... to be the centre of the world
> while remaining outside it ... to be a conscious kaleidoscope noticing
> and reproducing movements ... being an I with an insatiable appetite for
> being a non-I.[91]

Several new trends have appeared in post-modern society: the
spread of communication systems, feminism, environmental-
ism, redistribution of jobs on a worldwide level, etc., trends
which are reflected in touristic practices. Tourism is not a sub-
stitute for or a complement of a central value, namely work, but
it is valued for itself. Impressions and emotions are as import-
ant as objective experiences, which give signs and symbols a
central place in tourism. The opposition between specialists
and non-specialists, those who know and those who do not, or
even things and their imitations, need not exist any more. This
approach rehabilitates *homo ludens* and puts him on a par with
homo faber, and it treats tourism as a realm for experiment,
self-discovery and self-fulfilment. For this reason, it will
increasingly borrow cultural practices and procedures.

Ambiguity about the activity value of art

Tourism officials, who are dependent on marketing tactics, find
cultural tourism a practical means of creating interest among

the potential consumers who are bored with other types of tourism. If we look at tourism from the point of view of the arts and ignore the usual arguments about how it promotes the exchange between and understanding of different cultures, we may ask what it offers us today.

One argument is concerned with the nature of the fresh influx of visitors or users of culture. Do they represent an express demand or a sporadic behaviour pattern that can be subject to manipulation and the latest trends? A study on cultural tourism draws our attention to three types of persons.[92,93] First there are the specialists who are directly motivated by culture when making their travel plans and they represent 10–15 per cent of the total number of tourists surveyed. Then there are motivated tourists who do not travel for purely cultural reasons, but are prepared to make significant changes in their itinerary to include cultural sites, and they represent 30–40 per cent of the tourists surveyed. Finally, there are casual or occasional tourists, basically vacationers, who in the course of their holiday may periodically indulge in cultural tourism if the site is within a distance of 50 km from where they are staying. They constitute 45–60 per cent of the tourists surveyed.[94] The casual tourists do not express a demand for culture, but they undertake visits to cultural sites either because it is trendy or under the influence of others who recommend it. This could lead to a distortion of the demand for culture and the real instigators of this are local players interested in increasing the clientele of their restaurants and hotels rather than the local users.

The second argument is concerned with the long-term negative effects of this development. The development of cultural tourism leads to an increase in prices, which in its turn encourages speculation in land prices and the undesirable displacement of the local population.[95] At the same time, some of the older districts have to be restructured at the cost of displacing their traditional craftsmen and affecting the atmosphere, as a result of which everybody suffers in the long run. From the marketing point of view, the promotion of more profitable sites or tourists at the cost of other types of sites or tourists can lead to the privatization of artistic spaces, selective access to them and wastage of investments. Finally, once the number of tourists visiting a site exceeds a certain limit, the site is likely to suffer irreversible damage. This is a problem caused by exceeding the *carrying*

capacity of a tourist spot. It is defined by the largest number of tourists that a site can accommodate without affecting the quality of the visit, the nature of the site as a whole and the quality of life of the people living in the surrounding area. But since the behaviour of tourists varies considerably, it is very difficult to define the carrying capacity.[96]

But the real problem is to find out whether these practices affect other practices, particularly the life of local residents. More and more artistic sites now encourage interaction with the local community. They serve as a kind of public interactive space today since the municipal garden, the church and the local market no longer serve the purpose. It is possible that the potential demands of the local population may not correspond to the demands for maximizing the influx of tourists. Whether it is the conditions related to access, entry, signage, layout of interiors, organization of activities taking place there, we are faced with a growing number of conflicts. The problem is to decide if we should choose right away between these conflicting demands, that of the local community on the one hand and that of the tourists on the other, while keeping in mind the community's long-term interests.

Chapter 2

An Indefinable Quality

How much is an individual or a household willing to pay to acquire or use an artistic good or service? The field of art does not lend itself easily to such questions and the answer lies generally in the prevailing market price that the consumer is actually willing to pay. Artistic goods are often offered free or at a price much lower than their real cost. It is therefore difficult to judge the degree of consumer satisfaction on the basis of the price-tag visible in the market. The payer is not always the user and this increases the distance between the demand and the price. However, it is necessary to find an answer to the above question, as it will enable us to recognize the importance of a good or service in the eyes of its users and the returns that can be expected from it.

Three things need to be considered to answer the question. First, we must know how the user recognizes the quality of the good or service, because his expenditure will depend on it. Secondly, we must take into account the element of dependence that may creep in, since it is likely to influence the role of price. Having defined these conditions, we ask how willing is the user to pay. Finally, we must examine the problem of indirect users of cultural goods and services.

From uncertainty to the interpretation of artistic quality

Artistic goods and services are creative in nature even though their originality may be visible only in a part of the product, as in the performance of a play or a musical composition. The demand for artistic services will thus depend on the capacity of potential consumers to interpret or understand the creative value or quality of the previously unavailable services. The information that is sought may be obtained from four sources: the current market price, the label, certification by critics and the existence of prior conventions.

Interpretation on the basis of price

The quality of a service is expected to be better if it is more costly. A concert by the three tenors having à high entry fee is considered *ipso facto* as a very high quality product. However, what we are doing here is inverting the generally accepted causal relationship, namely that the quality of a good determines the price, instead of the price determining the quality.[1]

This approach tends to favour the suppliers of goods and services. Artists and providers of artistic services are prompted to raise their prices so that they can increase their earnings, even though the higher price may not correspond to an actual improvement in the quality of services on offer. Due to what Mossetto calls the Pavarotti effect with reference to other artists,[2] concert organizers tend to raise the price of their tickets substantially in the hope of convincing the public of the high quality of their product, despite a lack of change in the quality of the product, which may even be inferior. This interpretation of the quality based on the price enhances the snob value or social positioning of a good or service, a possibility envisioned by Jean Jacques Rousseau and generally accepted by all those who study cultural behaviour, namely that consumers demand more of a service when its price is higher as they want to impress others. But this approach can also turn against the suppliers when more experienced consumers refuse to accept the price increase as an indication of a better quality, and the latter are more likely to consider it as a loss of productivity. Suppliers are then obliged to suffer a loss, instead of making the anticipated profit. This division of consumers depends on how

much information they have on the subject and also their faith on the managers of cultural shows and artists. If they assume that they are honest, they will agree to the higher price, but if they do not trust them, they will take it as an attempt to exploit consumers.[3]

Interpretation on the basis of objective differentiation:
the label and price list

Interpreting the quality of a book on the basis of objective differentiation would depend on its label, its inclusion in a special series brought out by a publishing house, its being listed as a 'best-seller' or being the recipient of an award. Whatever the criterion, the main thing is to find out if this differentiation is based really on artistic content or merely on commercial gain.

In the publication of a work such as a book, a record, a concert tour, etc., under a particular label, objective information is provided about the value of the artists who have contributed to it, once the producer has acquired a certain reputation. Whenever necessary, producers bolster the publicity campaign by buying a time-slot from the distributor for displaying the product.[4] Nobody will deny the commercial importance of labelled products, but it would be too risky to treat the label as a guarantee of their artistic value. As in any marketing operation, the producer will select for labelling that product which is most suited to the targeted market. Consequently, he will make the least possible effort to promote works that are more creative but whose success he is not sure of. The labelling of works by producers is not always to the artist's advantage. They are often given less attractive contracts because of the risk involved, and they may be bound by the contract to produce more works for the same producer within a specified period. They may also have to give him the first right of refusal; in other words, they have to show him every new work and the producer will be free to take it or leave it.

The inclusion of a work in the 'hit-parade', or among the first fifty or ten best-sellers, is a great help because it distinguishes a small group of works among a range of already labelled products. This ought to strengthen the case for the artistic quality in contrast with commercial gain, but the criteria used for compiling such lists are not always clear. In some cases, they are

blatantly commercial, as the lists include products having the highest sales. In other cases, descriptions such as 'products that we liked best' may conceal complex compromises. More often than not, these descriptions help to launch a product by highlighting the impact it has already had on the public. A subtler method is to ask the consumer to try out the product before buying it. This strategy is commonly used for selling books and it was introduced for the first time in 1926 by the Book of the Month Club. A group of literary critics selected a certain number of books, making sure that the selected titles would not upset the market. Despite this precaution, this expeiment was widely criticized as it tended to single out the books that are likely to appeal to the 'average' reader, neglecting more innovative works whose chances of success declined as a result. The reader tended to accept without question the interpretation handed out to him, thereby reducing beforehand, the value of the experience that he would gain from reading.[5] The list of world heritage monuments brought out by UNESCO is an action of this type (see Chapter 5).

Awarding prizes is, by definition, the most prestigious method of differentiation for enlightening potential consumers,· especially when the works of a given time-span are arranged in a hierarchical order decided by a jury whose reputation serves as a guarantee of their quality. From the producers' point of view, winning such an award is a tremendous advantage because it bestows a certain distinction on the product and helps its publicity campaign, and it also gives a tremendous boost to less-known works. It remains to be seen if the relationship between the artistic value and commercial gain works out in favour of the product, and this brings us back to the problems of independence, quality and the work of juries. Juries for literary awards, like the Goncourt Prize in France, are notorious, because the major publishing houses manage to get some of the prize-winning authors published by them in the past to be appointed to the jury, as they tend to select books brought out by the same publisher. This does not mean that the quality of the award-winning books is questionable, but with the same quality, there is a better chance of winning the prize if the author is backed by the right publishing house. The procedure followed by the Academy of Motion Picture Arts and Sciences in Hollywood for awarding Oscars is more interesting

and was certainly less biased in the early stages. The Academy was set up in 1927 for the purpose of solving technical and commercial problems faced by professionals in the film industry and to give adequate representation to them. A few years later, it was decided to award prizes to honour these professionals. The Academy now has 5,300 members, 25 per cent of whom are actors. All the members are allowed to vote freely to select the nominees. Then they select the prizewinners from among the candidates placed on the shortlist of nominees. As a result, candidates who have the strongest support attract the largest number of votes. Contrary to popular belief, the system does not endorse just commercial success, nor is it manipulated by a few big studios. There are many factors that support this claim: Oscars are awarded only after several nominations, which is a sign of progress; foreign films are not neglected, because the tally of 26 per cent Oscars for foreign films is clearly higher than the share of foreign films exhibited in the American market (but it is a fact that English-language films claim the lion's share among award-winning foreign films).[6] There is perhaps a more mundane explanation. Hollywood studios now produce fewer films, but they are still the main distributing agents. This means that they are not so keen on promoting their own films for the awards as on benefiting from the fall-out, which they will in any case. Receiving an Oscar is a great commercial advantage for small films whose promotion campaigns cannot otherwise compete with the blockbusters. This commercial advantage is all the more important because this 'double-booster' (nomination followed by Oscar) system draws the attention of the public and makes it a part of the process, even though it does not enjoy voting rights. This double-booster system has proved to be so effective that it is now followed by other awards like the prestigious Booker Prize in Britain[7] and the Césars, the French equivalent of the Oscars.

Interpretation by critics

The quality of a work of art can also be interpreted by a particular agent such as the critic. He has no official standing nor does he take part in market transactions, although there is still some confusion in this regard, e.g. in the market for plastic arts or when an art dealer gives his own interpretation. The critic is

generally a specialist who has made a considerable effort to acquire knowledge about the arts and who earns a living by offering his services in the field of art.[8] He shoulders a great responsibility because, in the best of circumstances, he guarantees consumers that they will get a quality product or service, and producers that they will get customers. By creating or explaining the market, he can legitimately claim payment for his services. Is this payment a rent or a commission for rendering a service? Some treat it as a rent because the critic does nothing to change the nature of the product. Others look at it as a commission given to an indispensable intermediary. But the effects of a critic's intervention are not limited to providing knowledge and earning an income. By attesting to the value of a product, he may prompt others to copy or duplicate it. The incentive to produce fakes is very strong, and if an artist expects to benefit from the income created by the critic, he will restrict the supply. A. Marshall recognized this problem, which is known today as the 'Kitsch effect'. He believed that it could be avoided in exceptional circumstances:

> Technical education can yet save much natural artistic genius from running to waste … when a great deal of excellent talent is insensibly diverted from high aims by the ready pay to be got by hastily writing half-thoughts for periodical literature.[9]

The real problem, however, is the critics' competence and the validity of their interpretation. Although it is easy for critics to enter the market, ensuring the quality of their services will take time, as consumers have to endorse the choices suggested to them. When there are a large number of novices in the market, it will take some time to differentiate between opportunists eager to make money, who are more likely to flatter the consumer instead of interpreting the work of art, and critics who have worked hard to acquire their qualifications and whose efforts will be wasted if they are ultimately eliminated (the Mandarin effect). Producers of works of art may find it advantageous to 'buy' critics. This can be done either openly, as in the case of newspapers pandering to the needs of a particular section of the reading public, or more subtly, by providing certain services. In the field of plastic arts, we find that the position of many critics is rather ambiguous as they are also art collectors.[10] In the late nineteenth century, the American critic Bernard Berenson worked for the international art dealer Joseph Duveen.

At a time when many critics smacked of charlatanism, he intro-
duced a certain amount of precision in the interpretation of
classical Italian painting. The only snag was that he signed
an agreement with Duveen who gave him a 10 per cent, and later
a 25 per cent, commission on the sale of Italian paintings.
Thanks to this agreement, the art dealer got to meet celebrities
known to the critic. But some chance incidents exposed this
secret partnership. Berenson certified a painting as a Bellini
knowing very well that it was a Basaiti, as he had written about
this particular painting many years earlier. On the other hand,
Berenson persuaded a collector to pass off a painting as a
Giorgione, although he himself had first deemed it to be a copy.[11]
 What then are the conditions needed to ensure that a critic
does his job properly? There should be no confusion between
the functions of the critic on the one hand and the art dealer,
critics on the payroll of a newspaper group, etc. on the other.
The critic should be 'exposed' by giving publicity to the differ-
ences between his interpretation and the consumers' long-term
judgement, to mitigate the effects produced by fads or bargains.
Once these precautions are taken, critics can play a positive role
in the emergence and recognition of new artistic trends.
Cubism would not have gained such rapid recognition had it
not been for the criticism of Léonce Rosenberg and Guillaume
Apollinaire.[12] Similarly, American expressionism was supported
by the critics before it won the approval of galleries, museums
and buyers.[13]

Interpretation based on conventions

If there is uncertainty about the quality of a work of art, we can
refer to the conventions or time-tested rules regarding quality in
order to define its value and reference price. Although they are
erroneously believed to be of recent origin, ways of deciding the
right price of a painting are alluded to even in seventeenth-
century writings.
 In his treatise on paintings *Arte de la pintura* written in 1649,
Pacheco, a painter from Seville and a senior member of the
company of artists, wonders how to decide the price of 'con-
temporary' paintings.[14] He did this in the course of a debate
launched by the Salamanca University on the right price of
various goods, including the so-called luxury goods that do

not satisfy our essential needs.[15] Pacheco knew intuitively that although a painting is a luxury good, it is also subject to the principle of the right price. In other words, it is a good whose price differs from the right price under the influence of bids from interested buyers. Reference to the right price subsists and may even prevent buyers from making mistakes. In support of his thesis, he makes a distinction between the two types of 'nobility' in a pictorial work, namely intrinsic and extrinsic. Intrinsic nobility also means value and refers to a set of precise criteria: knowledge or the way a painter uses existing assets such as themes, drawings, colours (*Invencion y colorido*) and the way he uses proportion and contrast (*debuxo*) in his drawings and paintings. According to Pacheco, in addition to possessing these criteria, some painters are more qualified than others and this is bound to affect the intrinsic nobility and the basic price of the painting. He distinguishes between three types of painters:

> painters of the first level who are capable of copying existing works and changing them a little if need be ... those of the second level who combine a variety of sources and references and show real originality and creativity ... and those of the third level who use their genius to define their work....[16]

This gradation is based on the painter's ability to go beyond the stock of existing paintings or maintaining it without adding anything new to it. The extrinsic nobility of a work of art can be decided only by the buyer and depends on his taste. It also determines the final price of a work of art based on its price as defined by its intrinsic nobility. But Pacheco advises buyers estimating the price of a painting to take into account the elements of intrinsic nobility, and the price can then be determined on the basis of prevailing conditions to avoid unpleasant surprises.

This concept of convention has been dealt with extensively during the last few years, especially for fixing the price of paintings.[17] It is believed that in the first part of the nineteenth century an academic convention determining the price of a picture according to its type, subject and style of painting was dominant. The multiplicity of standards led to a certain order, which changed, but slowly and only when necessary, at the time of exhibitions. Whatever the nature of the potential buyer, it was possible to fix a standard price that was susceptible to change.

This convention was succeeded by another based on originality where there is no order of any kind regarding these criteria and interpretation rules. This convention opposes genius to the average and novelty to what is commonplace. Economists explain that this change from one convention to another was the result of the invention of photography, which lessened interest in true-to-life reproductions, or imitations, which were the artist's main source of income. Others looked at it as a transition from the artist–craftsman to a totally free artist influenced by liberal ideas. It may be noted that these analyses are largely based on conjecture and they define artistic creativity simply by rejecting what is already known. Besides, one may wonder what is the advantage of adopting this convention based on originality since it rejects any objective basis to solve the problem of determining a 'normal price'.[18]

From rationality to dependence on the consumption of artistic goods

When analysing demand, economists assume that preferences are stable. This leads to the surmise that marginal utility diminishes with consumption, that the price a person is willing to pay comes down with the quantity consumed and that, after some time, there is a state of equilibrium. This hypothesis is essential because, if a good's usefulness increases with its consumption, consumers will end up spending all their money on the acquisition of a single good, no matter what its price – a really tragic situation. Also, tastes are taken to be fixed and stable, and as two Nobel laureates have said, *'De gustibus non est disputandum'* [you cannot dispute tastes].[19] Economists analyse the influence of price and income variations on demand without any reference to the change in tastes, even though it may be an interesting point. [20,21]

Dependence: stable tastes but increasing productivity of consumption

In the case of artistic goods and services, these hypotheses are not verified. Preferences may become stronger as a result of consumption, marginal usefulness may go up and the phenomena

of dependence, obsession or collection mania are likely to appear. One solution would be to accept the fact that tastes and preferences can change with the times. This implies that the utility function is unstable and that it is necessary to give up standard economic methods and turn to sociology instead. Keeping in mind the position mentioned above, economists prefer to assume that preferences and the utility function remain stable, but that variables must be redefined in order to account for behaviour influenced by obsession and collection mania. From the latter viewpoint, the usefulness of a good increases in relation to its consumption, not because tastes change in its favour but because it becomes more capable of satisfying them.

The first person to have looked into this problem seems to be Alfred Marshall. Analysing the consumption of music, Marshall says that when we look at the law of diminishing marginal utility, we must understand that we are looking at a continuous span of time without realizing that it may be a succession of periods and that individual characteristics can change from one period to another.[22] Therefore, there is nothing astonishing about the fact that listening to music increases a person's liking for it.[23] Thus the more you listen to music at a given point of time, the greater the demand for it in the future. Tastes do not change, but you acquire a capital or an aptitude, which allows you to turn to greater advantage, at a later period, the time devoted to music or to reduce the time and cost needed to organize the consumption of music. Marshall attributes this 'capital–aptitude' to previous experience in this field. What some may consider as a change of taste in favour of music is the result, provided that there is some taste to start with, of an increase in the individual's ability to benefit from listening to music. He becomes more productive in satisfying his need for music by reducing its cost as compared to the fulfilment of other needs, but his tastes do not change. We can then confront Marshall[24] with the following argument: why is it that elderly people – at least those who enjoy listening to music – do not devote more and more time to it and why do some young people, who have less experience of music, devote more time to it? As a matter of fact, this tendency to listen to music takes up a lot of time and its cost will depend on the capacity of the individual and the opportunities available to him. On the other

hand, this analysis answers another question: why are young people more susceptible to changes in taste or fashion than older people? Probably because their accumulated capital is small, which makes it cheaper for them to change from one interest to another.

This theme has been dealt with in Becker's model of positive dependence. It is based essentially on the principle that by consuming an artistic good you strengthen your aptitude to benefit from it. But typical of all capital, this aptitude has a tendency to get used up or become obsolete as, for example, when new types of music or new fashions emerge. The growing dependence stops when the amount of newly added capital becomes lower than the used capital. This argument is 'wonderful', because not only does it justify the idea of dependence but it also limits its scope. The concept of capital depreciation allows us to explain the volatility of tastes and consumption in the case of some people. As long as the accumulation of capital or aptitude remains lower than its destruction, the individual is prevented from becoming dependent. In such a context, the higher the price of the artistic good, the higher the required capital stock. On the contrary, a fall in the price makes the consumption less dependent on the required capital and can usher in a phase of capital and aptitude accumulation. This analysis can lead to the justification of artistic development policies favouring a reduction of prices.

Learning, frustration and cultural capital

From the economist's viewpoint, an individual gains information through consumption, which will increase, in future, the satisfaction he obtains by consuming the same quantity. The simplest thing would be to assume that he is learning by himself. But that is not the only way of dealing with this problem. According to a more psychological approach, every individual has his own level of intellectual curiosity and, having reached it, it makes him want to learn more and more. A diachronic viewpoint explains this behaviour: consumption, which satisfies a need at a given point of time, presumes that there will be more consumption during a second phase. In this context, the satisfaction obtained during the first phase becomes secondary in relation to the dissatisfaction appearing during the second phase

(opposite process), and only more consumption will put an end to the distress inherited from the past. There is, finally, a third possible explanation for this special feature of artistic consumption and it is known as cultural capital. Admitting that some people have greater access than others to cultural consumption because they have more opportunity, experience or information, amounts to recognizing that each person consumes in proportion to a pre-existing capital that is there even before the effects of learning are felt. The base of this capital is sociocultural.

Explaining how tastes are formed,[25] Bourdieu refers to education in specific sociocultural contexts. He says,

> The similarity observed between differences in social positions and lifestyles is due to the fact that similar conditions produce interchangeable habits which, in their turn and according to their peculiar nature, give rise to infinitely diverse and unforeseeable practices as far as their singular details are concerned, but always confined within the inherent limits of the objective conditions that have produced them and to which they are objectively suited.[26]

It therefore follows that taste formation is not the result of an individual's actions but of the sociocultural context of his education, a dynamic process that begins right from childhood. While economists emphasize the level of income at a given point of time when explaining the nature of a demand, Bourdieu underlines the differences in education. He points out,

> Strictly speaking, it is not the level of income that decides whether behaviour conforms to these means, but it is taste, be it for simple things or for luxury, which is responsible for a lasting change in the nature of the demand which can be fulfilled because of the availability of these means.[27]

We must go further and demonstrate how knowledge plays a part in the formation of taste:

> When faced with legitimate works of art, those most lacking in a specific skill apply the universal norms of appreciation of their ethos to judge them, the very norms that colour their perception of other objects in this world, paying only cursory attention to form since they do not possess the ethical screen which prevents them from seeing them as such and especially because they do not possess the means to understand the distinctive characteristics of the subject matter and the style which distinguish it from other forms... they can only appreciate the object that is depicted, wonder what it means and refuse to attach any value to it if it does not perform its primary function of saying what it has to say or represent what it represents.[28]

In other words, a person having no artistic or technical knowledge will evaluate things according to their usefulness and also according to their aesthetic appeal because the primary function of any work of art is to be beautiful. On the contrary, anyone having a proper artistic knowledge will judge the work according to artistic, and not aesthetic, criteria.

This theory has been disputed. While laying stress on the cognitive aspects of cultural codes, one should not ignore hedonistic values, which influence emotions as well as likes and dislikes.[29] Further, the claim that tastes are determined entirely by social differences does seem rather ambiguous. For example, when you apply Bourdieu's theories to music, they seem to work in the case of nineteenth-century music but not so well for the twentieth century. Adorno, who has often been quoted by Bourdieu's disciples, stressed that social relationships cross music diagonally with many fragments of social classes joining together in the case of certain types of music. Finally, on the basis of the examples he uses to elucidate his theories, Bourdieu's analysis appears to be permanently biased due to an opposition between forms of culture that correspond, by definition, to recognized hierarchies; this can lead to redundancy as well as most traditional value judgements on high-brow culture as opposed to popular or mass culture.

At this stage, it is but natural that attempts should be made to verify this theory in the field of modern and contemporary art, since the demand for works of abstract art clearly brings out the quantitative difference between different types of viewers.[30] In his survey of visitors to the Museum of Modern Art in Lodz, Matuchniak-Krasuska (1992) has pointed out how viewers react to the works of three contemporary artists: Himmler, Strzeminski and Mondrian. There are two types of reaction. In the first type, knowledgeable viewers interpret the painting in a scholarly manner, remarking on its style and its finer points. This interpretation is iconological. But the general public has a totally different approach, as it tries most of the time to look for the title of the painting. This is a semantic approach. Thus artistic knowledge not only explains behaviour but it also influences practices. Classification of viewers according to their appreciation of paintings such as Balthus's *Painter and Model*, Andy Warhol's *Red Jackie*, Dubuffet's *Bird Catcher*, Yves Klein's *Blue Monochrome*, etc., reveals a close link between the choice

of paintings and the level of education. Dubuffet's painting is usually appreciated by educated persons working in senior positions or belonging to intellectual professions, whereas Balthus's work appeals, by and large, to less educated viewers and Combas's paintings to young people. Hence, according to Nathalie Moureau,

> while emotional response and aesthetic reaction take precedence in the case of a neophyte who spontaneously declares his preference for the more traditional figurative works, the artistic reaction is dominant when an educated person comes into contact with ... works known to be difficult to understand.[31]

The willingness to pay for artistic services

When there is no ready market and the information available is incomplete, how does one know how much the users are prepared to pay and whether artistic productions will be able to recover their costs through sales? There are four methods of finding this out.

The contingent value

In the contingent valuation method, potential consumers are approached directly and asked how much they would be willing to pay to gain access to a particular good or service. This method, though widely criticized, is often used at the international level and we may quote as examples the studies conducted by Navrud on the Trondheim Cathedral (1992),[32] Willis on the Durham Cathedral (1994),[33] Martin on the Musée de la Civilisation in Quebec,[34] Hansen on Copenhagen's Royal Theatre (1997)[35] and Santagata and Signorello on the city of Naples, to show how it has been applied in different cases.

So, how willing are people to pay for enjoying a good that they do not yet possess, or how willing are they to accept compensation for losing a good that they already have? These two questions must be treated separately as they do not have the same answer, apart from the fact that they refer to totally different situations. It is not the same thing to ask a person what price he would be willing to pay to see an opera or what compensation he would demand for agreeing to the construction

of a building that would block his view of a monument. Three reasons explain why the willingness to accept is higher in terms of absolute value, than the willingness to pay. When a person accepts, he not only loses the good, but his real income will also decrease, which means that he will expect a higher compensation. There is no substitute in this case. In the case of willingness to pay, a person may have several alternatives. But a person willing to accept is very demanding because he has no alternatives.[36] If a person is averse to taking risks, he will hesitate to give up a good that cannot be replaced. But this problem does not arise when the person has to choose, from among a number of existing goods, the one that he does not have.[37] To overcome this difference between these two kinds of willingness, economists have suggested a third method called the method of paired comparison. A person is asked to choose between a good and money, and it is believed that if the person is indifferent, the value of the desired good is exactly the same as the amount offered.[38] Because of this method, it is possible to avoid setting a buyer against a seller and to compare more homogenous situations, as will be shown later.

The contingent valuation method uses a questionnaire that is supposed to help in determining the *ex ante* value of a good for its user,[39] who is supposed to be rational and capable of deciding between several offers. Much depends on how the questionnaire is worded, especially if the person answering it is not familiar with the concerned product. There are many ways of measuring values. It is possible to ask an open question, or take the help of credit cards which reveal the financial standing of the person being questioned, or ask a closed question with the person saying only 'yes' or 'no' to the proposed value, or resort to bidding, which would lead to the desired value by successive approximation, but with the risk of seeing the questioned persons holding firmly to the initial value.[40] If the question is open, we can find the real value ascribed by a person to the concerned good. Nevertheless, there will be a problem regarding the treatment of extreme values; these can bring about sharp differences between the base and median values but improve if they are 'eroded'. Another problem concerns the treatment of values equal to zero, where zero may refer either to a refusal to answer or to the inability to determine a value. If the question is closed, the relevance of

the collected information is doubtful because it is not known if the individual agrees with the value suggested in the beginning.[41] Finally, there may be 'control questions' to ensure that the answer is genuine. For example, the affirmation of a greater willingness to pay may be verified by analysing the person's past behaviour in similar circumstances.

At the same time, a number of biases make the interpretation of such surveys difficult.[42] The hypothetical bias, or over-representation of extreme values at the cost of the base or median values, occurs quite frequently. Laboratory analyses show that on an average the reply to a hypothetical questionnaire reveals differences in intensity that are five times more than what is evident in the market. The inclusion bias, related to the earlier one, presumes that people who are questioned add a moral dimension to the importance they give to their own material well-being, for example, if they feel that they are helping a good cause by answering the questionnaire. Some economists believe that these two biases are explained by the collective nature of artistic activities and that it would be better to consider the willingness to pay as a collective rather than as an individual trait. Others think that these two biases can be explained by the transitory nature of some events, as permanent goods do not give rise to such changes in preferences. The third set of economists feel that keeping in mind these over-estimated values, the willingness to pay should be corrected by the weight of the components that have already been paid for, such as taxes and expenses incurred for gaining access. Finally, it is advisable to know if the questioned persons have already used the product on offer. A study conducted on the Colon Theatre in Buenos Aires shows that habitual theatre-goers showed a willingness to pay up to €5.80, while those who never went to the theatre were willing to pay €8.80.[43]

Having taken these factors into consideration, we would like to give three examples to demonstrate the advantages and limitations of these studies when making decisions about investment in heritage sites and objects. The first example shows how this method leads to the reformulation of the initial policy, the second shows how it helps to improve neglected areas and the third brings out the dangers of wanting to measure existence values.

In the analysis proposed by Kling, et al.,[44] the contingent valuation method is applied in a very original manner. A law

passed in 1992 safeguarding the rights of taxpayers in Colorado State lays down that municipalities wanting to increase taxes above the sanctioned level should hold a referendum before taking any decision. The other alternative is to prepare a specific budget to stabilize the fiscal pressure and refund any budget surplus that may eventually arise. When faced with such a situation, the Fort Collins municipality decided to offer its citizens a choice between refunding a part of their taxes or spending the amount on the renovation of a historical monument – the Northern Hotel where stage-coaches halted in the old days. The municipality ordered an opinion poll to get an idea of the results of the referendum and to find out the contingent value ascribed by citizens to the renovation of the Northern Hotel. They were asked two questions: firstly, whether they were willing to accept an additional tax to finance the renovation of the monument, and secondly, whether they wanted the municipality to spend the amount collected by way of excess tax on this renovation project or refund it to them? As a matter of fact, the first question corresponds to the more classical approach to contingent valuation, namely the willingness to pay, while the second corresponds to the more subtle approach of pair comparison.[45] The taxpayers proved to be much more demanding when the question was asked in the form of a pair comparison rather than in the form of their willingness to pay a particular price. Faced with a choice between lower taxes and renovation, the majority refused the renovation when it was presented to them as a project that would require a rise in taxes. They were not willing to forego the money to which they had a right in order to pay for a certain amount of renovation. The municipal authorities took note of it and decided to present a revised project financed through normal budgetary allocations.[46]

In their well-known study of the *Napoli Musei Aperti*,[47] Santagata and Signorello used the method of contingent valuation to find out the use and non-use values of services provided by the city of Naples to its inhabitants. The city offered free of charge a service called *Napoli Musei Aperti*, which consisted of renovating, providing road-signs and markings and generally turning the spotlight once a year on some of the old districts in the town centre like Decumano, Scappanapoli and the Spanish district. The municipality was

keen on replacing its subsidies with a service financed by contributions from the locals and visitors. The citizens were asked how much they would be willing to pay if they wanted to continue availing of the service provided free by the municipality if the latter were not in a position to finance it. To ensure that this question did not increase the citizens' apprehensions about the efficiency of the future management, it was clearly explained that the new management would be in the hands of a non-profit private agency. The questionnaire had four types of questions relating to practices followed earlier by visitors, the costs borne at the time under consideration, their willingness to pay and the use of their budget. These questions were so worded that the municipal authorities could find out if the replies were realistic and also what would be the eventual effect of substituting various types of expenses with others. It was found that some were willing to pay even though they had never used the service before, while others who had used it were not willing to pay. But both these cases had to be rejected in order to make a correct assessment. Of those who answered the questionnaire, 48.3 per cent (226 out of 468) refused to pay as a matter of principle. This refusal to pay can be explained by the fact that the service had been provided free until then. In contrast, others expressed their willingness to pay more than the cost of the service. But the two effects did not offset each other. Another interesting result was that persons with a lower income were more willing to pay than those with a higher income. Several explanations can be advanced for this phenomenon, the simplest being that, contrary to the general belief, cultural goods are not necessarily superior. According to the second explanation, which is more interesting, cultural products have neighbourhood and network values to which the working classes are more attached.[48] According to a third explanation, working class people live either in the districts where the cultural service will be provided or very close to them and are therefore more interested than others in its continuation.

In 1997, the World Bank undertook a project to evaluate the advantages of renovating the medina of Fez. Its purpose was to determine the value assigned by visitors to the renovation of Fez and the existence value ascribed to the renovated Fez medina by tourists who visit Morocco, but do not go to Fez.[49] A survey

based on sixteen questions was conducted among tourists who were provided with documentation on the salient features of the medina before and after renovation. This documentation stressed the fact that in the absence of renovation not only would there be a physical deterioration of the medina, but even the more intangible features like traditional craftsmanship and atmosphere would be affected, leading to a depreciation of its value as a whole. On this basis, visitors to the medina were asked if they were willing to pay a surcharge for visiting Fez, which would be collected as a tax commensurate with the class of hotel in which they were staying. Tourists visiting Morocco but not Fez were asked if they were willing to pay a 'duty' before leaving the country for the maintenance of the medina, which they had not visited. The amount to be paid was defined discreetly: the lower bracket was fixed at US$25, while the higher bracket was substantially more for visitors to Fez as compared to others (US$200 versus US$100). The survey revealed an average willingness on the part of visitors to the medina to pay US$70, which would provide a total income of US$11 million. Other tourists were willing to pay on average US$30, amounting to a total income of US$47 million. This difference in the average willingness to pay is quite logical, because tourists visiting the site are likely to be more affected by the effects of its deterioration and the results of its renovation. However, the attitude of tourists not visiting Fez is more perplexing. They seem to assign a higher existence or option value since they may visit Fez at a later date; but it is necessary to know if these tourists are genuinely willing to pay for a site that they are not familiar with and have no intention of visiting.

The 'Have you got value for your money?' method

More and more investigators are trying to find out if a performance or a visit provides visitors with at least as much satisfaction as the expense they have incurred.[50] It is no longer the practice to ask potential consumers what value they would assign to a good; instead, actual consumers are asked about the satisfaction they have obtained. If they answer in the affirmative, the value is taken as being at least equal to the price and vice versa. There are, however, two problems regarding this method.[51] Firstly, what should be considered as the actual

payment – just the entry fee or all the expenses incurred including transport, eating out and the entry fee? Secondly, should the question be asked *ex ante* or *ex post*? The problem is not the same in both cases, because *ex post* the consumer will have benefited from the actual experience, or may possess information that he did not have *ex ante*.

This method is used more frequently in recent times. Its main advantage lies not so much in the answer itself but in its clarification of the factors that justify it, provided that they have been anticipated in the questionnaire. A study carried out in the Beamish Museum has brought out all the factors that possibly determine the satisfaction obtained by visitors, such as the time spent within the museum, the distance between the museum and the visitor's home, the extent to which services provided by the museum were used, the number of adults and also the number of children present in the museum during the visit, the degree of congestion in the museum, whether the person has visited the museum earlier and the visitor's socio-economic position.[52] The study has shown that the degree of satisfaction varies directly according to the number of hours spent in the museum, inversely with the cost of transport, directly with the facilities used, negatively with the congestion, positively with the fact of having visited the museum earlier, rather positively with the proportion of adults and rather negatively with the proportion of children among the museum's visitors. This type of study helps the management to know how to arrange the museum and organize visits.

A study conducted in Lisbon's museums provides us with another illustration of the advantages of the 'value for money' method.[53] The survey was conducted on visitors to two museums, which were quite different from each other, namely the *Chiado* and the ethnological museum, the former being a general museum and the latter a specialized one. In both cases, the value for money to the visitors was found to be negative, as visitors felt that their actual value was less than the price paid. But the majority of the same people felt that the price charged was normal. This difference between the price actually charged and the price that they would like to pay seems to be due to the fact that they also include the social value of the good. Even if the price charged is right for them, they feel it is prohibitive for

others. The value for money includes in this case an evaluation of the social use of the good in comparison with the value of its private use.

The hedonistic price method

Instead of directly asking the users about their willingness to pay, this can be found out indirectly by analysing their behaviour in the market. Let us take the example of a heritage site, which is better suited to this method. If, in a particular situation, residents are willing to pay more to live near a heritage good, a landscaped park or the site of an archaeological excavation, it is presumed that this difference in price expresses the value of the heritage monument from their point of view. The hypotheses underlying this reasoning are restrictive as the sites should be comparable: not only should the residents value the nearness of the heritage site, but they should value their nearness to a particular heritage site and the statistical data should be reliable. This method of hedonistic prices is often used for deciding real estate prices.[54]

The study conducted by the World Bank for the renovation of the historic centre of Split illustrates these difficulties.[55] The Split site, which figures in UNESCO's list of world heritage monuments, is built on the ruins of the ancient palace of the Roman emperor Diocletian. Around it are remains of monuments belonging to the medieval and baroque periods. Owing to their constant deterioration and lack of maintenance, they have been closed to the public, thereby depriving the town of its artistic resources. In collaboration with the Croatian government and the Split municipality, the World Bank has undertaken the project, which includes the restoration of Diocletian's palace, the construction of an archaeological and ethnographic museum, the renovation of access roads and paths within the complex and the consolidation of the temple of Jupiter. The method of contingent valuation was used initially to find out the benefits obtained by tourists and prepare on this basis a suitable plan for financing the project. A survey was conducted among tourists and local visitors to find out how much they would be willing to pay as an entry fee. The results indicated that the project was worthwhile, though the return would be lower than expected. Subsequently, all the benefits that the local

residents would gain from the project were added to the above results and the method of hedonistic prices was used for this purpose. However, the final results were mixed, owing to the absence of an active real estate market for reasons such as lack of security, low standard of living and an abundance of rules and regulations, so that they were not considered to be significant enough to influence the final decision.

The transportation costs method

The evaluation of transport costs is a method commonly used to judge the willingness of people to pay an entry fee to visit a cultural site or watch a performance. It is based on a very simple idea. When it is difficult to find out how much they are willing to pay as an entry fee, it can be estimated indirectly by measuring the effort made to reach the site. It is assumed that the effort they have actually put in by accepting transport expenses is an indication of the effort they will be prepared to make to enter the site or watch the performance. In the first stage, the costs are borne by individuals wanting to visit a site or watch a performance. The visitors are classified according to the zones from where they have come and each one of them has to pay a different cost to reach the venue. In the case of homogenous groups within each zone (for example, for each block of one thousand inhabitants), it is noticed that there is a variation in the number of visitors because of the distance or the cost of transport. It is thus possible to calculate the demand function for access to the site. In the second stage, this elasticity of demand in relation to the cost of transport is used as the elasticity of demand in relation to the entry fee. For each zone, we find that the number of visitors varies according to the entry fee to be charged. We will thus obtain for each original subset a specific demand function, which will be aggregated in relation to the price to obtain the demand function for entering the site or watching the performance.

This method, first used by Clawson and Knetsch[56] to determine the degree of preference for entry to American national parks, is quite interesting. Contrary to the preceding methods, it is based on data that are easily available and not subject to dispute, but it tends to underestimate some restrictive hypotheses. In the first place, all visitors are supposed to have the

same type of reaction, whether it is a foreign tourist who has travelled thousands of kilometres to visit a museum or a local resident living only a few miles away. It is generally believed that the longer the distance the greater the willingness to pay, no matter how much is charged. Thus tourists represent an inelastic demand and local residents a rather more elastic demand.[57] This method presumes that the motivation to travel is purely cultural. If it were not so, it would be impossible to use this information to find out what would happen at the entry to a site or a performance. This reservation would be strengthened by the existence of a value for travel for its own sake, because individuals would then be willing to spend only for the pleasure of travelling just as they would to reach a particular destination. Moreover, if there were several sites or performances, then the cost of the journey would have to be divided between them. Also, one of the most interesting possibilities suggested by this method is the analysis of the demand for creating a group of related monuments and the introduction of a single ticket to cover the whole group. Finally, the effects on income are presumed to be the same for everybody, which is acceptable when the entry fee constitutes only a small part of the income.

Indirect demands for cultural goods

Indirect demands for cultural products come from three types of players, namely patrons of the arts, corporations and the government. We will leave aside the government for the present, as there is a special chapter in this book dealing with public policies.

Demand from patrons

Patrons express demand for cultural goods by supporting or enabling artistic activities. Their actions could be motivated by many factors, which range from altruism to snobbery, including the projection of a positive image of themselves or devising a commercial strategy.[58] Can economists explain the costs and benefits of such actions? Normally an individual is expected to maximize his own welfare, but he may want to add to his own utility function his usefulness to other individuals. The patron is

thus an individual who influences the consumption and satis-
faction of other individuals in a logical manner for his own
satisfaction and acts as an 'interested altruist'.[59,60] This type of
behaviour can be represented with the help of standard methods
by adding to the quantity and price of goods consumed by the
patron the quantity and price of goods that he puts at the disposal
of other people. Another variable that must be considered is the
one that reflects the balance between one part of his income that
he consumes for his own benefit and the other that is used for
sponsorship, i.e. for the social esteem he expects to derive from
his patronage. Given a particular amount of social esteem, a pos-
itive variation in the patron's income will benefit the consumers
of cultural goods and a decline in the price of these artistic goods
will also enhance the patronage. This calls attention to a conclu-
sion that is often ignored by fiscal policies related to sponsorship.
There is no reason why there should be an upper limit on fiscal
benefits, because the increase in the patron's real income or the
fall in the cost of artistic goods is reflected in a rise in the
expenses incurred by him for sponsorship.

Patrons can also be discouraged when, over a period of time,
society reduces the value that it ascribes to their patronage,[61]
and some members of society feel that undue advantages are
given to some who have fewer needs than others.[62] The patron
may also reconsider his earlier commitments, which he had felt
would benefit the community, because he feels that the amount
he spends on patronage is no longer as effective as anticipated.
This may happen when the intended beneficiaries do not make
use of these resources as, for example, when people do not
participate in artistic or cultural events organized by a patron.
It would be even more disastrous if the patronage benefits
persons who have the means to access such artistic activities
but still want to make the most of this golden opportunity.

To avoid discouraging patrons, it would be more advantageous
to persuade them to form non-profit organizations in which they
can hold important positions, e.g. as members of the governing
council.[63] In a study relating to the end of the nineteenth century,
Di Maggio asserts that patrons do not provide an optimal solu-
tion for financing, because artistic activities then tend to become
dependent on the continuance of their patronage.[64] Since then,
many institutions have tried to make patronage more permanent
by inviting patrons to join management bodies, whose working

they can influence. Patrons finding themselves in such a situation have shown themselves to be excellent patron-hunters. In a city like Boston, the fine arts museum and the symphony orchestra were able to make a name for themselves in terms of both artistic quality and economic viability because they changed their management system by including patrons.

Indirect demand from non-artistic enterprises

Non-artistic enterprises may demand cultural services in many different ways. They may demand them as the ultimate consumers when they want a show to be organized for them. They may also demand them as intermediate consumers when such services help them to improve the competitiveness of their products or their business reputation. These enterprises can also demand artistic activities, as they expect their outcome to be advantageous to them. The demand is really indirect when the enterprise does not consume a service directly but benefits from its consumption by others. The entire sector of what is called cultural tourism is based on this principle, which is why we talk of the non-artistic demand for artistic services.[65]

If we consider the traditional description of demand as the relation between price and quantity, the demand coming from such enterprises appears to be quite singular. The price they would agree to pay would be determined by the quantity of the artistic good or service and we would have a positive quantity–price relationship, reflecting a causality that is directly opposite to the causality of traditional demand. The higher the number of cultural tourists, the greater the satisfaction derived by merchants and traders. A second characteristic owes its origin to the fact that this demand would emerge only after it crosses the minimum level of artistic consumption, i.e. the level at which the variation in the number of cultural consumers brings about a positive variation in their activity.

The problem with this method evidently lies in the fact that these enterprises may not necessarily pay the price and would be quite content to act as stakeholders or pressure groups. Being taxpayers, they will ask the government to look after the satisfaction of real or presumed artistic needs. Political leaders, both at the local and national level, are quite happy to satisfy these needs if they can manage to retrieve a part of their

investments through various mechanisms. In some cases, the enterprises will make their demand known to private owners of artistic goods, even if this involves entering into a partnership with them by which the latter offer them some related services. We may even witness the merger of these partnerships as when the producers of the artistic goods decide to manage on their own either all or some of these activities, e.g. the production and sale of souvenirs or running restaurants. In France, châteaux like Vaux le Vicomte, Cheverny and Breteuil have adopted this strategy. But it is more common to form lobbies and pressurize the government to develop such cultural sites or artistic activities purely for the purpose of tourism.

There are generally two reasons why enterprises prefer to act as pressure groups rather than as payers or even partners. Since they consider themselves as taxpayers, they feel that they have already paid for this development. For example, when there was a proposal to create pedestrian areas in old town centres, the local merchants felt that they were not obliged to pay a special levy even though this change was going to benefit them. Further, some enterprises choose to behave like hitch-hikers: they do not express any preference so that they can avoid paying their share of the levy, hoping all the time that others will declare themselves in favour and agree to pay. This demand is nevertheless very strong in view of the benefits of the renovation of historical sites and festivals in terms of added value and creation of new jobs in the concerned areas. We will give two very different examples, one of museum tourism in Paris and the other of the historical sites of Petra and Wadi Rum in Jordan.

In 1996, almost 12 million tourists visited Paris for a variety of reasons – cultural tourism, business visits, pleasure trips, etc. Cultural tourists are defined as those who had visited at least three museums or similar monuments. In view of the difficulty of distinguishing these visits, depending on whether the entry was free or not, two hypothetical figures were taken – the lower figure of 2.98 million tourists who had visited the Louvre Museum, the palace of Versailles and either La Villette or the Orsay Museum, and the higher figure of 4.2 million tourists who had visited the Eiffel Tower, the Louvre Museum and the palace of Versailles. These tourists behave very differently depending on whether they are French nationals or foreigners. They do not spend the same number of nights in Paris (on an average,

French tourists spend two nights and foreigners spend three nights) and their daily expenditure also differs according to the country they come from. The ratio of French visitors to foreign tourists was 30:70. This means that when the total number of tourists was 2.98 million, foreign tourists spent 6.3 million nights and French tourists 1.8 million nights, whereas when the total number of tourists was 4.2 million, the corresponding figures were 8.6 and 2.6 million nights. A French tourist would spend on an average €121.96 per day for lodging, transport and entry fees, while a foreign tourist spends about €152.45. However, there are considerable variations between individual cases with the Americans and Japanese being the highest spenders and compensating, to a large extent, the relatively meagre spending by tourists coming from low-income countries. The total expenditure was calculated to be €1.18 billion at the lower end of the scale and 1.63 billion at the higher end. It becomes necessary to apply the multiplier coefficient to calculate the effect of this spending on the local income because when the income created by this expenditure is spent, it benefits people working in other sectors of the economy. The multiplier coefficient selected in this case was the one proposed by Myerscough for London (1.4), which is considered to be the most sensible. So the total expenditure was €1.65 billion at the lower end of the scale and €2.28 at the higher end.

We must also add to this expenditure the money spent by tourists on souvenirs and luxury goods which are not generally produced in Paris and cannot therefore have a multiplier effect on the Parisian region, but which can create more jobs in the country as a whole. On the basis of the same study, it was surmised that a French tourist spends on an average €45.73 on souvenirs, whereas a foreigner spends €76.22. This means a total expenditure of €1.85 billion at the lower end and €2.66 at the upper end of the scale. If the cost of creating a job in the services sector is about €60,980, it means that the total number of jobs created or maintained was 43,000. But if we take a more modest figure of €30,490, we arrive at a figure of 86,000 jobs. The first figure appears more appropriate, because from the total expenditure we have to deduct, in advance, the amount spent on equipment. The real result of this type of analysis based on a multitude of hypotheses, each of which reduces the reliability of the final result, is that the sum of these expenses

and the number of jobs created are both very significant. For the year under consideration, the budget for Paris was higher than that for other heritage sites all over France and the number of jobs represented about two-thirds of the number of jobs in the state-owned hospitals in Paris.

Two sites in Jordan figuring on the UNESCO World Heritage List, namely Petra and Wadi Rum, were the subject of an impact study conducted by the World Bank. Since these two heritage sites are situated in the middle of the desert, their development was unlikely to have significant repercussions on the local economy. The Jordanian Government had selected these sites, which have a great artistic and historical value, since they would attract a large number of tourists and this would have a notable effect on businesses in the area around these sites as well as in the rest of the country.[66] It was a comprehensive project having both artistic and economic targets. The latter were difficult to evaluate as they encompassed a network of scattered small enterprises. A study was undertaken to find out if the income from the influx of tourists would justify the economic investments made in creating a tourist infrastructure. In fact, it was necessary to find out the break-even point, keeping in mind that those who financed the project were not necessarily those who reaped the benefits of the money spent by tourists. Beginning with the income from the new entry fees that went to the state treasury (US$1.5 million from local tourists and US$30 million from foreign tourists), the study went on to evaluate the income from value-added taxes on food and lodging that was earned by the Jordanian Government and finally computed the total expenditure incurred by tourists. Although the latter may not have visited the historical sites as such, the benefit to the Jordanian economy was to the tune of US$51 per day at Petra where there are many services on offer, whereas at Wadi Rum it was only US$13 per day as fewer services are available there. It was thus shown that the money brought in solely by new foreign tourists justified in a large measure the money spent on improving the sites for their benefit.

The demand for artistic activity has found in the concept of the multiplier effect a convenient tool for measuring the entire range of effects produced by tourism and exerting a questionable pressure on officials preparing the state budget to force them to invest more money for promoting the arts. Three types of

benefits can be observed. Firstly, those that correspond directly to the expenses incurred to access a cultural good. Secondly, there are indirect benefits that correspond to the amount of money spent by visitors or spectators on hotels, restaurants, etc., at the time of using the cultural goods. And finally, the money spent by local residents who have benefited by the two major kinds of expenditure mentioned above. The multiplier principle consists in finding out the ratio between the total expenditures and the visitors' expenses, a ratio known as the expenditure multiplier. It is also possible to include primary and secondary jobs created by the influx of visitors when calculating the employment multiplier and to include the exchanges between industries when determining the activities multiplier.

This concept, though it may appear almost magical, has a very accurate base, which warns us against its excessive use. The multiplier effect is valid only for a particular area and it wants new visitors to 'import' money into the area, as it will not only increase the income of its residents but also multiply it.[67] We must however point out right away three important limitations to the use of this concept. The first relates to the exclusion of certain types of expenditure. If the expenditure is incurred by someone living in the area in question, there will be no multiplier effect. Thus if a resident of Seville visits the *Museo de bellas artes* (Fine Arts Museum), he will spend there what he may have otherwise spent in a bookshop, in a football stadium or some other place in the city. There will, therefore, be no multiplier effect in the area in question but only a change in the pattern of spending of its residents, unless the money spent comes out of 'idle' reserves. If, on the contrary, a Parisian were to spend his money in the same museum, this expenditure would have a multiplier effect, as it would inject new funds in the area that would benefit its residents. While some will benefit from the multiplier effect, others will experience effects of eviction. The second limitation is the possible flight of money because it is spent outside the area in question. If the fine arts museum is obliged to import a book on art from France to satisfy the Parisian's demand, the money earned from the sale leaves the country immediately, except for the portion covering the service provided to the tourist by the museum shop. So the multiplier effect does not work in this case. This phenomenon of flight of income is very important

as it explains why some areas, in spite of having a lot of visitors, do not earn as much as expected from their consumption of artistic goods and services. To be more precise, it would be advisable to separate from the total expenditure incurred by visitors, the expenses on items produced by the mobilization of local resources and the expenses on items produced by the mobilization of resources outside the area concerned. The third limitation deals with price effects. The artistic development of an area may induce price speculation, which will destroy the competitiveness of this very area. These price effects are usually ignored in multiplier analysis, but they must be taken into account. In some specific situations, we may even obtain negative multipliers.

The multiplier effect does not appear so wonderful when you consider these limitations. While some economists claim impressive coefficients of 3 or 4, intensive studies have revealed that the real multiplier coefficient is much lower, but more reasonable – in the range of 1.3–1.5.[68] But this does not in any way diminish the value of this tool; it only shows that it cannot be used without answering the following questions: What is the exact area covered by the study? On whose behalf is the study being conducted? What is the exact nature of the visitors and their expenditure? These difficulties, which are inherent in the concept of the multiplier effect, have prompted some economists to opt for a less risky method of analysis, namely effect or impact analysis. This method consists of identifying and measuring the positive effects of a particular artistic project without combining them in a common scale. Impact analysis resembles a miscellaneous catalogue, but it does not allow us to compare these effects with the effects of other projects and use them as a basis for special procedures. Further, this method is biased. The effects envisaged in detail at the time the project is conceived may not necessarily be felt with the same intensity throughout its lifetime. Finally, this analysis is excessively partial to big projects at the cost of small ones, because it is concerned more with the consequences than with costs and it neglects the problem of efficiency.[69]

CHAPTER 3

PRODUCERS PLAGUED BY
UNCERTAINTIES

Providing artistic goods and services is a very risky business, because it implies the production of new goods without knowing how they will be received and whether their costs can be recovered through sales. Producers are forced to employ a diversity of means to ensure that the product will be acceptable to the buyers and also to minimize their own risks. They try to raise funds through various sources and employ different methods of management, the most common in the artistic field being non-profit management. The two basic requirements of management in the artistic field are, therefore, the creation of an efficient marketing machinery, a task that is both difficult and ambiguous, and fixing a price that has little to do with the cost of production.

Risky products and producers at risk

'Nobody knows' could well be the leitmotif of production of artistic goods and services, because it is very difficult to predict how the buyers will receive goods that have not been produced before. This uncertainty is part and parcel of artistic production, and a somewhat similar phenomenon is observed in the case of pilot products. When an enterprise decides to introduce a new product, it first launches a pilot product to test

the market before going in for large-scale production. The making of a pilot product entails certain costs, but they can be recovered later through large-scale production. However, in the artistic field, the pilot product itself is considered the 'final' product and any mistake at this stage means that the producer has to forego his expected profits and write off even the costs incurred in producing it.

Prevalence of risks

Although the situation may differ according to the type of artistic goods involved, the element of risk is always present. This is especially true in the case of the performing arts, where the best solution is to choose the more familiar items of the repertoire, supported by a well-known cast and presented in a conventional style. The safest way out is to select a piece that has been successful earlier – a stratagem frequently used by many cultural institutions. When faced with the curtailment of subsidies during the 1980s, American dance companies concentrated on the most popular items in their repertoire; *Cinderella* and *Nutcracker* figured in more than half of the performances.[1] Other methods can also be employed to avoid risks, such as the introduction of season tickets to ensure that the failure of one show does not affect others, changing the seating arrangements so that a hall can be easily adapted for a smaller audience, or employing those artists who have gained popularity through the media.

In the case of the visual arts, the risks are easier to bear because these artistic goods have a long life and it is possible to count on their future success despite their initial failure. Recognizing the quality of a work of art and determining its economic value is a slow process. Let us take the example of Abstract Expressionism, which made its appearance in the United States in the 1940s and 1950s. Artists of this school like Jackson Pollock, Robert Motherwell and Max Reinhardt, who are famous today, were closely associated with the Surrealists and shared their ideas, but the images of these artists were more primitive and devoid of historical context. They began to produce their works in the 1930s mainly in New York. They soon split into various streams, but their work retained its 'local' character and failed to gain recognition in the art market.

However, during the Second World War and later, there was a growing demand for their works, either because European works of modern art did not reach the United States or because the prices of the latter were exorbitant. Art dealers like Peggy Guggenheim played a major role in the popularization of expressionistic art by giving it greater exposure. Another reason for the success of expressionistic art was its use in industrial design and fashion magazines. Abstract expressionism gained acceptance as a school of art and competed with other schools on an equal footing in art exhibitions. Gradually, the movement became institutionalized, leaving the later innovators no choice but to start a new movement, namely *pop art*. But *pop art* had to wait for almost twenty years before gaining economic recognition.[2]

In the field of music, which acts as an interface between the performing arts and cultural industries, we come across a similar process of waiting and experimenting but with recording companies playing a more and more dominant role, as in the case of *rock and roll*. In the 1950s, in the southern part of the United States, there was a tradition of *rhythm and blues* confined mainly to the Black community. The White population was more inclined towards *country and western* music.[3] The two streams did not undergo a natural process of osmosis and their fusion took place only in the Broadway version of European operettas. Following the emigration of southern Blacks to the major American cities, the demand for *rhythm and blues* increased and it caught the eye of recording companies. The two musical styles drew closer and recording companies started looking for artists who could fuse them. As one producer at a recording company declared at that time, 'If only I could find a white man having the musical tastes and the feelings of the Blacks!'.[4] The man sought was Elvis Presley, who immediately got production contracts from recording companies. Small recording companies were quick to show their interest in this new music, but many artists, like Bill Haley, preferred to produce their own records. This movement grew very rapidly, as it enjoyed the benefits of major technical innovations.

The film industry presents the most striking illustration of the risks to which both products and producers are exposed. The product is exposed to three major risks. First, every film is a pilot product and its production costs are not easy to control. *Intolerance, Waterworld, Titanic* and *Les Amants du Pont Neuf*

are examples of the films whose producers exceeded their original budget by more than 50 per cent. Secondly, preparation for a film and its production may take several years; this is quite incompatible with its demand, which is fickle and uneven. Finally, the competitive environment is difficult to evaluate. The producer is exposed to risks because of the uncertain nature of the product, and this risk is reflected by low performance in the box office as compared to the high cost of production. This risk is a relative one, because even if a film is a hit with the public, the receipts may still not cover the production costs. Hence, the producer safeguards himself by involving funding agencies, which are likely to cushion the blow if the film is a disaster. In France, a producer's risk is considerably reduced on account of two mechanisms. Pre-financing a production through advances against future receipts protects a producer from failure as the advances are recovered only if the film is successful. Further, production and distribution quotas imposed on television companies guarantee a substantial inflow of funds and information. Care is taken to make the product less risky by ensuring that the film will appeal to the public at large. This can be done by choosing a popular theme and actors or by devising an appropriate marketing strategy. Even though the film may not be a box office hit, it is possible to make a profit through exports and the sale of video and television rights. According to Eisner and Wells, Disney Studios are the best illustration of this kind of management.[5] In this case, film production is the tip of an inverted pyramid and sales are promoted by setting up entertainment parks and through merchandising.

It is extremely important to choose the right type of film and the choice is dictated by the times. As a result of numerous changes (tie-ups between top studios, conglomerates and television companies) in the 1960s, the United States witnessed the appearance of films that were produced individually instead of the assembly-line products of Hollywood studios. The film ceased to be part of a series; instead it was treated as an entity. This marked the transition from the 'studio system' to the 'package unit system'. As an alternative to the humdrum fare available on television, the film industry felt that more imposing and spectacular films were needed, which would draw the viewers away from their television screens. It was then the age of the epic film, often with a strong musical content, like *The Sound of*

Music and *Doctor Zhivago*, or even *Camelot, Lawrence of Arabia* and others of the same ilk. These films were a very risky proposition, not only because of their high cost but also because they did not always attract large audiences. At the same time, we witnessed the birth of the 'film d'auteur', which was less costly and addressed a restricted audience consisting of young intellectuals. There were numerous experimental films, and the best known and the most appreciated of these were not necessarily box-office hits (*Nashville*). Over the years, however, the cost of making these 'films d'auteur' has gradually risen, reaching unprecedented heights with *Gates of Heaven* in 1978. Starting with a provisional budget of US$7.5 million, the costs rose to US$21 million and finally to US$30 million! After much alteration, rewriting and other changes, the final budget came to US$43 million, while the domestic receipts were barely US$1.5 million! The experimental film did not satisfy the demands of the large corporations that had taken over the film industry and we witnessed the return of the 'event film'.

This is how the 'blockbuster' came into vogue. From then on, the cost of the negative increased[6] but the capitalization of expenditure became increasingly restrictive. It became necessary to ensure that the returns were comparable to those in some highly profitable financial market, especially when the investments were large in terms of their absolute value. It was wiser to make fewer films (which inevitably put filmmakers at a disadvantage) and earn more money per film. As a result, the number of films reduced considerably.[7] In addition, the film was expected to have spin-offs such as a best-selling book, lucrative video and television contracts after the film completed its run in the cinema halls, recordings of the sound-track and, of course, extensive merchandising. From the very beginning, the change of scale regarding the cost of production has been quite dramatic: *The Godfather* cost almost US$85 million, *The Towering Inferno* US$52 million, *Jaws* US$129.5 million! This new economic situation brought about a significant change in the film industry. In order to exhibit the product through different media, it was necessary to have a product that did not suffer from any ambiguity, a product that conveyed the same clear picture whatever the medium of communication or the audience. It had to satisfy two conditions: the film should be based on such a concept and style that set it apart from other films, and its

impact must be the same whether it was presented as a film or a book or a piece of merchandise. Consequently, the film's theme was selected after a careful study of the aspirations and reactions of the audience, keeping in mind that pre-production surveys tend to be too prescriptive (care was taken to avoid concepts that had not met with public approval before) and that post-production surveys are too generalized as they use random sampling and extrapolation methods. The only way to overcome these limitations was to communicate a precise message through the film's content with the help of an immediate and concise reference. If needed, the film has to be defined by a strong formula or theme, despite its numerous and complicated ingredients, each of which appealed to a different section of the audience. This came to be known as a 'high concept' film. Thus the unique selling point of *Jaws*, considered to be the first 'blockbuster' and 'high concept' film, was the picture of a shark ready to sink its teeth into an unsuspecting bathing beauty, while that of *Jurassic Park* was the rediscovery of dinosaurs.

Sunk costs and risk multipliers

The production of a work of art entails some costs that cannot be recovered if it is not acceptable to the public. These costs are considered to be 'sunk' (or 'irrecoverable') and they have to be borne, come what may, unless they are turned into a permanent loss when the product proves to be a total disaster. In some fields, these sunk costs are so large that they are the only possible reference to the original budget. The concept of the 'cost of the negative' used in the film industry provides the best illustration. It is the actual production cost of the film and does not include the cost of copies, advertising, distribution, etc.[8] This cost has to be incurred whether the film is successful or not, but distribution and exhibition costs are related to the film's success and are therefore automatically covered.

The cost of the negative goes up all the time. Actors, when first approached, may ask for a certain amount of money as a guarantee (*the pay-or-play clause*). If a producer wishes to engage an actor, the latter must give an undertaking that he will set aside a certain amount of time for his project irrespective of other films that he may sign. The actor may not want to commit himself before seeing the final script of the film, which may not

be ready at the time the producer makes the first contact with him, which he does after negotiations with distributors, television companies, etc. It is, therefore, necessary for the actor to sign a preliminary contract containing suspensive clauses and that is a costly matter. Its cost is doubly irrecoverable because there are two additional risks – it is not known if the film will actually be made and, if made, whether it will be successful. The amount stipulated in this clause may be so large that, at times, the producer prefers to make a bad film with well-known actors rather than honour the cancellation clause.[9]

The purchase of adaptation rights on a novel is also an important irrecoverable cost. The difficulty arises because it is necessary to acquire adaptation rights without knowing for certain if the film will actually be made. Acquiring the option on a literary work is the first cost and it is proportionate to the period for which this right is reserved. From that point onwards, the producer starts preparing the script, which may involve a number of successive drafts and contracts. Once it is decided to implement the project, a final contract is signed, the amount already paid is deducted, and if the project is abandoned, the producer is obliged to forfeit the advance. To this must be added a large number of details, each of which may imply further costs, e.g. will the title of the book be mentioned in the publicity posters? What happens if the film is shown on television? Will the author have the right to sell a theme or a hero to another producer? Dashiell Hammett, author of *Maltese Falcon* made by Warner Bros., wrote a sequel to the story which he sold to Columbia Broadcasting, for which he was sued by Warner Bros.[10] Does the author have the right to talk about the work during the publicity campaign and the launching of the film?

Acquiring space and technical services in advance before the actual shooting of a film is a third example of irrecoverable costs. Producers have to approach studios for this purpose and various arrangements are possible. First, the producer may deal exclusively with one studio, letting it handle all his projects. Secondly, one studio is given preference when the producer comes up with a new project, and if the studio refuses it, the producer is free to approach other studios. Finally, the producer may take upon himself, from the very beginning, many of the expenses incurred by the studio. The last two arrangements are more advantageous for the producer than the first, which binds

him completely to one studio. Unlike the first arrangement, the last two are costly and the producer is obliged to meet a large number of expenses almost immediately.

Can productivity gains solve this problem?

Why is it that the increase in the number of such clauses leads to an increase in the irrecoverable costs, so much so that it has often been said of the film industry that it is more involved in drawing up contracts than in making films? It seems that this is largely because the expected productivity gains hardly ever materialize. When the studio system prevailed, film-making was an industrial activity. Actors got a fixed salary from the studio and were given roles that suited their particular talent in film after film, and the same sets were used simultaneously in several films produced by the studio. At a pinch, even if one film did not succeed, a part of the costs incurred were recovered from the profits made by another film, since the same inputs were used indiscriminately for various films under production. With the end of the studio system and the advent of the blockbuster, this relative control over the irrecoverable costs disappeared.

What holds true for the film industry also applies to other sectors of artistic activity, especially the performing arts. The famous Baumol Law, which we shall take up in detail later,[11] brings out the structural absence of productivity gains in this field. To stage a tragedy by Racine you need the same number of actors today as in the seventeenth century, and a Schubert quintet needs the same number of instrumentalists as it needed two centuries ago. Contrary to what is happening in other economic sectors, it is not possible to take advantage of productivity gains obtained by the substitution of labour by capital. Also, other sources of productivity (sale of tickets, purchase of equipment, etc.) remain the same. At this juncture, irrecoverable costs cannot be amortized against productivity gains and the new avenues opened up by the audio-visual media have not brought about any significant change. If a project is successful and it is possible to sell it through different media, there are substantial productivity gains and it is also possible to recover the irrecoverable costs. But if the project fails, the problem of recovering them persists.[12]

Should risks be transferred to artists?

One way of recovering sunk or irrecoverable costs is to transfer some of them to the artists. This strategy is twofold. In the first place, it is possible to pressurize artists to accept lower fees by playing on their attachment to their profession. This is a classic ploy and a source of much misunderstanding and frustration. The other way is to associate the artists with the project's fate by promising them a fee higher than the original fee in the case of success and a lower fee in the case of failure. In the beginning, artists insisted on this arrangement, as they wanted a share in the profits to which they had contributed. When Universal Studios decided to make *Winchester 73* in 1950, they wanted James Stewart in the lead role, no matter what his price. Stewart's agent, Sam Wasserman, grasped the financial advantage of the situation and used as a benchmark the highest fee paid by Hollywood to an actor, US$300,000 per film received by Clark Gable. But instead of asking a fixed amount, he sought a profit-sharing arrangement for his client, which in this particular case amounted to US$600,000. However, producers soon used this kind of profit-sharing arrangement to their own advantage, by making artists bear a part of the irrecoverable costs. To do this, the artist's share was based on the net profits and not on the gross profits made by the film. When calculating the net profit, a number of costs were taken into account, including the producer's dues in the form of interest on the capital invested by him. This led to a paradoxical situation where the producer became something akin to a salaried employee entitled to a basic fee while the artist bore the risks!

The trick is to know how to define profit, and producers used all their ingenuity either to inflate it or make it disappear all together to suit their own interests, which gave rise to the expression 'creative accounting'. Consequently, artists who were promised a share of the net profit had to seek the assistance of the court, as they had no confidence in the producer's system of accounting. Where the dispute was the result of an accounting mistake, it was easy to resolve it, but in most cases it was due to the definition of deductions by the producer. The most contested deductions were those due to communication expenses (some of which were not related to the particular film but to the

studio's general operations), writing off of certain dubious expenses or even fictitious expenses such as the interest paid on the capital invested by the producer. The arguments were complicated further when unforeseen earnings appeared, e.g. following the adaptation of the product to other media or the sale of a series of works to a television channel. Finally, how should the amount paid to the artist as his share of the net profit be treated? Should it be considered as a loss to the producer and taken into account when calculating the net profit? This again would bring down the artist's profit.

An example of this creative accounting is seen in the suit filed by the American essayist Art Buchwald against Paramount Pictures.[13] Buchwald found that the theme of the film *Coming to America* made by Paramount with Eddy Murphy was almost identical to his short story 'King for a Day'. In both cases, a prince comes to New York, becomes poor and is saved by the love of a young lady whom he makes his queen when he regains his fortune. In Buchwald's story, the hero is the emperor of an oil-producing country ousted from power by a coup d'état, whereas in the Paramount film, the prince comes incognito to New York to find a suitable bride for himself. It so happened that there was a contract between Buchwald and Paramount at the end of which the latter promised to pay the former a fixed amount plus a certain percentage of the net profit, if it made a film based on one of his stories. Obviously, Paramount refused to admit that the film was based on Buchwald's story, especially since the actor claimed that it was his idea and that he had written the script with the help of associates. Paramount refused to give in to Buchwald's demands by declaring that there was no net profit. At the first hearing, the case went against Buchwald, as the judge did not recognize his rights and decreed, on the basis of information provided by Paramount, that the net profit was zero. Buchwald succeeded in proving during a subsequent hearing that those who had written the script were aware of his story. The court conceded Buchwald's claims and this launched a debate on the calculation of net profit. The judge decreed that the net profit had been dishonestly brought down to zero through creative accounting. He pointed out that a particular sum had been paid without any valid reason to Eddy Murphy's associates, the film's by-products had not been taken into account, the deduction

of 15 per cent of the overall costs towards overheads was excess-
ive and, finally, the interest charged on the capital invested by
Paramount was inordinately high.

Should the consumers' surplus be tapped?

The problem of irrecoverable costs is related to the success of
a work of art and the price users are willing to pay for it.
Although some users may be unwilling to pay the price that is
demanded, there will be others who are prepared to pay
more. The price represents only a part of their maximum will-
ingness to pay and the latter are generally prepared to acquire
these artistic goods and services as long as their marginal
utility is higher than their price. The producer seeking higher
earnings may try to tap a part of this surplus in order to
recover a portion of his irrecoverable costs. But how does one
go about tapping the consumer's surplus? It is difficult to
charge different prices unless there is an objective difference
in the goods or services offered on sale. There is certainly no
difficulty in charging theatre-lovers different prices if their
seats are objectively different, but they cannot be asked to pay
different prices for the same type of seats, because this will
turn away those who are charged more. However, we can ask
them to pay a membership fee and in addition an entrance fee
every time they visit the theatre, concert hall or museum. This
pricing mechanism is widely practised in cases where the
fixed costs are high. But is it possible to go beyond this? This
is exactly what a number of cultural institutions do when they
set up an association and charge a membership fee. In return,
the members of these associations are entitled to certain bene-
fits (free subscription to the association's journal, compli-
mentary passes, etc.), which induce potential consumers to
give up a part of the surplus that they ascribe to the cultural
good in question. It is thus possible for the institution to bear
the costs of production without knowing beforehand how the
consumers will respond. This is not a form of patronage
because this type of action falls within the scope of maximiz-
ing individual usefulness. However, there must be a relation-
ship of trust between the person who pays and the institution,
since the former should not at any point doubt the latter's
honesty.[14,15]

Non-profit as the principle underlying artistic institutions

It therefore follows that producers cannot accept the challenge posed by irrecoverable costs unless they enjoy the trust of consumers, artists and patrons. But the latter are prepared to pay production costs or share them only if they have no doubt whatsoever about the way the producer is going to use their contribution. So, any management strategy seeking to maximize profits will raise doubts in the consumers about the producer's motives, as they are bound to think that what they have given the producer will be used to maximize his profits rather than make the product artistically viable. They would not like the producer to pocket the surplus without effecting any improvement in the product's quality or attracting a larger audience. An opportunistic producer would use a part of this money to raise his profits without a change in the level of activity or quality, while his partners expect him to use it for everyone's benefit after taking his normal fee. That is why consumers, artists and patrons prefer to deal with non-profit institutions, which are, by definition, above suspicion. Consumers expect that their subscriptions or membership fees will be used to increase production and improve its quality. Artists will be ready to share risks only if this increases the viability of the artistic product. Similarly, patrons will agree to subsidize productions only if they increase artistic consumption. The difficulty experienced by private enterprises in offering viable products, except when they are willing to forego profits, has already been discussed by Throsby.[16,17] He believes that it is due to the fact that the amortization of irrecoverable costs is slow and it depends on the relationship of trust between producers and consumers.

The growing importance of non-profit institutions

It therefore follows that the presence of non-profit institutions in the artistic domain is not a matter of chance. Their presence is stronger at the production end compared to either the distribution end or the industrialization of products. This means that irrecoverable costs will be greater in the case of production and almost nil in the case of distribution and industrialization of products. The history of artistic activities reveals that theatre

groups, music societies and museums have been able to stabilize their activities only by adopting a style of management that is similar to the one described above. There are, of course, other motives that can explain the importance of this type of management,[18] namely the democratization of culture by charging affordable prices, provision of a wider range of service to satisfy diverse public tastes and involving people by encouraging voluntary service, which are difficult to imagine in a profit-making organization.[19]

The history of institutions set up to promote music provides an apt illustration of non-profit institutions. In the middle of the nineteenth century, the number of concerts went up rapidly in many American and European cities, the most important being London, Paris and Vienna. Two-thirds of these concerts, which often attracted a large number of music-lovers, were meant to promote the career of musicians as music teachers. But there were many such concerts organized by rival associations. The same musicians performed in one concert after another, without having enough time to practise, with the sole idea of appearing on the stage before the public. This unhealthy competition led to the elimination of some groups of musicians and a general stagnation of the quality of music. To stabilize this system and provide suitable places for performances, it was necessary to build concert halls and find a more stable and long-term source of funding, instead of depending entirely on money through tickets. The Americans and Europeans found different solutions to this problem. The Europeans preferred to set up public non-profit institutions to promote music.[20] Thanks to these institutions, musicians were able to lead a more stable life, devote enough time to practise and perform in halls that were more suitable for music concerts. At times, this public support resulted in the creation of valuable public institutions, e.g. the great European orchestras of those days, and at other times to the allocation of strictly controlled subsidies to private bodies, e.g. the London Philharmonic Society.[21] In the United States, the problem was solved by donations from wealthy patrons and this evolved into the non-profit management system.[22] When it found itself on the verge of bankruptcy at the beginning of the twentieth century, the New York Philharmonic Orchestra decided to appeal systematically to wealthy patrons for funds and obtained the support of a group of guarantors.

This enabled it to improve its quality, the greatest testimony to this improvement being the three-year contract with the conductor Gustav Mahler. In 1912, its patron, Joseph Pulitzer, wanted the adoption of a non-profit management system. There was a stiff competition between several non-profit orchestras that led to the choice of different goals. Some preferred to perform for large audiences, while others sought to improve the quality of their music. Two of the non-profit orchestras survived this competition – the Philharmonic and the National – but they were obliged to co-operate and finally merge together following the economic crisis in 1930. Meanwhile, they cut down their expenditures and musicians' salaries, something that only non-profit bodies can do.

This demand for an 'alternative system' is often expressed in more conventional legal forms, an excellent example of which is the institution of the *café-théâtre* or the *café-concert*, where plays and concerts are staged in cafés. In the Lorraine region of France, a *café-concert* called *Le gueulard* went through a lot of difficulties, because it was engaged in two types of activities: profit-making commercial activities such as the sale of food and drinks, and artistic activities such as the staging of plays and other shows, which involved irrecoverable costs. Since this *café-concert* had started off as a commercial enterprise, its activities gave rise to a certain ambiguity: any assistance given for organizing the artistic activities will contribute to increasing the profits obtained by the bar through the sale of drinks. So the owners decided to split their activities by creating two separate bodies – a private enterprise to manage the bar and a cultural association in charge of artistic activities.

Activities of non-profit institutions

Just saying that an institution is a non-profit organization provides very little information about its style of management. The articles of association give some indication, but there is no guarantee that they are sufficiently well defined to serve as a reference for the working of the institution. Malaro cites the example of non-profit museums that stop bothering after some time about the quality of services they provide in their effort to turn to account the fallout from tourism.[23] They may also be prevented from pursuing the objectives defined in their statutes

by other factors such as limited capacity or disagreement between members of the governing body on policy matters. The statutes also include the rules of conduct that should guide members of the governing body when taking decisions. Normally, these rules require the members to inform themselves as best they can before taking any action, to be attentive to all factors that can affect either positively or negatively the working of the institution, and to be honest and faithful while performing their duties. But it is possible to follow these rules of conduct without ensuring a transparent management system, as for example when in good faith the means is considered an end. So, the problem of managing non-profit institutions persists.

When we look at the working of cultural institutions, we are tempted to believe that the 'maximization of the quantity of goods and services' is a simple and workable criterion. Non-maximization of profits means that it is possible to fix the admission charges at the lowest level and admit more spectators or visitors. It will thus be possible to achieve the objects of both democratization and diversification. However, this does not really happen, and one alternative is to make use of the margin that is available to lower the price of tickets in order to finance quality improvement. This type of action is known as the 'search for a higher quality'. It may be maintained that a higher quality is not a bad thing in a field that depends on quality. However, it should be kept in mind that any improvement in quality beyond the admissible level will lead to a rise in prices and costs and, consequently, a decline in the audience or even a fall in subsidies for other institutions. This underscores the existence of a conflict of objectives.[24] Another type of management involves an increase in costs in order to offer better terms to the staff rather than to raise the quality to the highest degree. In the case of museums, observers have remarked that due to shorter opening hours the number of working hours is considerably reduced and it is possible to create additional jobs to handle the workload. This type of conduct, often censured in the public sector, is not commonly found in the artistic field, because artists and even technical personnel are usually more interested in gaining appreciation for the services they render.

Many years ago, X. Dupuis pointed out the existence of a similar dilemma in the production department of the Paris Opera,

which had to decide between producing run-of-the-mill operas
as a part of its traditional repertoire and producing more spec-
tacular shows.[25,26] In the first case, the operas figuring in the
repertoire are repeated without any innovations and it is pos-
sible to ensure an almost continuous stream of performances at
affordable prices. In the second case, it is necessary to create
more innovative shows, with a prestigious cast and involving
very high production costs, because of which the number of
shows is generally limited. It is easy to understand the reasons
behind the first choice, but it is also possible to question the
motives behind the second. It is believed that the high quality of
the shows fetches rewards for the management in the form of
recognition and promotions. It is certainly possible to resort to a
mix of the two systems, where profits can be reduced by lowering
the price of tickets and raising the cost of production.[27,28]

The working of museums also reveals the different types of
practices followed by non-profit institutions. A good example is
seen in the United States, where there are two types of non-
profit museums.[29] The first type of museum professes to be a
'school': it strives to make the visitors understand art and gives
greater importance to school and college students, who are
more suited to its purpose.[30] As opposed to this, the second type
of museum behaves like a 'church' and treats some of its excep-
tional exhibits like sacred relics. These exhibits are classified
and arranged in such a way that visitors can fully admire them.
It is easier for big museums than small ones to make suitable
arrangements for the 'worship' of exhibits. One way of doing
this is to organize prestigious exhibitions, but only the big
museums can take part in these, because their collections
include celebrated works that allow them to join the exhibition
network. These prestigious works constitute the capital needed
to become a co-organizer. This opposition between goals and
management methods is also seen in the structure of their
costs. While the average cost per visitor goes down with the in-
crease of visitors in the case of small museums, it goes up in pro-
portion to the number of visitors in the case of the big museums.
This is not only due to the impressive presentation of both per-
manent collections and exhibitions, but also due to the higher
salaries of their employees compared to the small museums.[31]
Nevertheless, the two types of management mentioned above are
similar on one count. Rather than seek large donations from a

few well-known patrons of art, they prefer to obtain more modest contributions from a larger number of patrons. This obliges them to lay greater stress on the value of the services they offer, irrespective of their declared policy.[32]

The flexible limits of artistic institutions

Like all productive organizations, artistic institutions have a choice between managing their activities by themselves and sub-contracting them, either entirely or partially, to a specialized agency. What are the artistic activities that an institution would like to keep under its direct control and which activities would it like to hand over to another body? Would a theatrical company like to look after its collection of costumes by itself or would it like to engage a professional organization to take care of them? Would a museum like to run its restaurant or even its ticket counters? Would a film studio like to keep under its control all the activities related to film-making or would it prefer to entrust the special effects department to a specialized company?

Limitations imposed by artists' contracts on artistic institutions

The changes in artists' contracts over the years give an indication of the changes in the scope of artistic institutions. There are several types of contracts.[33] First, there is the standard 'labour contract', usually of a limited duration. Then there is the 'ad hoc or activity contract', whereby a skilled person is engaged for a precisely defined activity. And finally there is the 'contingent contract' that lies somewhere between the two preceding categories, in which all contingencies relating to the maintenance, modification and breach of contract are clearly defined keeping in mind the uncertainties of artistic production. There are two lines of reasoning underlying these contracts: relational reasoning where the contracts have a bearing on the behaviour or attitudes to be followed and a transactional logic where the contracts are concerned only with the tasks to be completed. Normally work contracts should deal with non-specialized qualifications associated with routine activities of the company,

whereas activity contracts should deal with the artistic skills associated with a particular project. But in actual practice, the contracts tend to be more flexible: work contracts govern skills that are associated with the institution's regular activities, while non-specialized qualifications are managed through activity contracts.

The traditional interpretation of contract is based on two criteria, namely the frequency of transactions and the specialized nature of assets. It should be further refined to include two more criteria, namely the value of a particular skill for the institution for enhancing not only its quality but also its reputation, and the proximity of this skill to the institution's normal activities. Thus a renowned juggler may be needed in a particular opera, but it is not a skill that is normally required. On the other hand, it may be difficult to manage a tenor, but he can enhance the opera's international reputation.

Depending on the extent to which these criteria are fulfilled, four types of situations are possible. When an artistic institution requires a particular skill that is important not only for ensuring the high quality of its service but is also perfectly suited to its activities, it ought to secure the services of people possessing this skill (e.g. the singers suited to the type of musical shows presented by an artistic institution or the type of actors needed for a particular type of theatre) by giving them work contracts of as long a duration as possible. Even though it may not be easy to use such artists in all the plays or musical shows staged by the company and there is likely to be a difference of opinion about casting them in particular roles, it is better for the institution to engage them on a long-term basis because of their artistic capabilities. In most cases, the artist is initially given a work contract for a specific period. This principle is followed by most dance or theatre troupes, which engage artists for at least one season provided that they are suited to the shows or plays to be staged during that period. If there is any doubt about the reception of the performance by the public, the company may want to revoke the work contract and offer in its place an activity or co-production contract, which will require the artists to share the risk with the producer.

In the second situation, the skill demanded is very valuable from the company's viewpoint, although it does not correspond to its specific need. It would prefer in such a case to sign a

contract covering a specific activity. Such a situation may result from a change in the preceding situation. Thus when an artist attains a level of stardom where his/her very presence can guarantee the success of a show, it is in his/her interest to change the nature of his/her relations with his/her employer, and even switch employers, instead of remaining permanently attached to one employer. This is something an experienced employer will understand. The artist expects to benefit from the gains brought by his/her fame and the company cannot hold on to him/her permanently. An extreme situation would be one where the artist ends up controlling the institution as a result of his/her success and tries to build the company around his/her own name.

In the third situation, the artist does not play a major role, but is a part of the institution's permanent activities (as an extra or a market pitch agent). The company has a choice between giving him/her a standard contract or sub-contracting the work to other agencies instead of bearing the management and administrative costs. There are various types of temporary workers, recruited either on a daily basis or for an entire season and either as full-time salaried employees or as sub-contracted workers. In view of the transaction and administration costs, companies generally try to get skilled persons through specialized agencies, except for companies moving from place to place (circuses and groups of travelling actors), who have to make long-term arrangements irrespective of local conditions.

In the last situation, skill does not play an important part nor does it correspond to the company's basic activities. Services such as cleaning are obtained through specialized agencies that either put their personnel at the disposal of the artistic company or are contracted directly to provide the services. In both cases, but particularly in the latter, the artistic company does not have to manage either the staff or the contracts and can concentrate on its own activities. The only exception would be a travelling company, which would have to take along all the personnel needed for its proper functioning.

Is the distinction between artistic and other skills quite clear?

The above analysis is based on the opposition between artistic skills, specialized skills and others that are replaceable. Jobs

requiring artistic skills claim to play a crucial role in the quality of the service rendered, due to their creative nature and the high salaries involved, which are generally proportionate to the company's turnover. On the other hand, it is believed that non-artistic jobs do not have any role in determining the quality of the artistic product and have no claim on the profits. Normally, there should be no difficulty, but there arises a problem because the dividing line between these skills keeps changing; the non-artistic skills claim that they contribute equally to the quality of the final product and should, therefore, be treated as artistic and get a share in the company's artistic earnings.

This distinction somewhat corresponds to that made by the film industry between the jobs situated 'above the line' and those 'below the line'.[34] Producers, directors, scriptwriters and actors stand above the dividing line and all the others below it. Today, the number of those standing above the line has increased considerably. Apart from producers, there are co-producers, executive producers (all they do is control one particular resource or skill, e.g. the option on a book), associate producers, assistant producers and so on – in fact, anybody who can manage to squeeze in.[35] Other posts are at the centre of a raging debate over extending the notion of artistic skills to include the director of photography, music editor, casting director, wardrobe master, make-up artist, persons in charge of dubbing and special effects, animal-tamers, animal-tamers for children, etc.

This distinction is also found in other artistic fields though in a different form, beginning with the most traditional of them all, the theatre. It is an activity that is more fragmented than film-making and gets less exposure in the mass media, with many well-known plays making their debut in small obscure theatres with casts that change over a period of time. Above the dividing line, we find the producer, art director, director and actors whereas below the line, there are the casting director, the wardrobe master, lighting engineer, sound engineer, etc. – all those professions that want to be recognized for their artistic contribution and want their salaries to be pegged at a more realistic level. The music and recording industry presents a different scene. Although it now closely resembles the cinema, it was not always so. For a long time artists were underpaid, and even today young artists cannot claim a high remuneration

at the very beginning of their careers. But the development of new technologies has increased the scope of this market and has led to an explosion of new musical styles. Traditionally, only artists, the composer and the producer stand above the dividing line, whereas the sound engineers, musicians and the conductor are below the line, but the latter have started to protest vociferously against this state of affairs.

The example of the film industry

Voluntary workers, casual employees, extras and the workers on the company's payroll are categories that dot the history of artistic enterprises. Even when Fordism in its most advanced form was at its peak in Hollywood's studio system, there were rapid changes, which altered the size of the major film-making companies and the weightage given to various categories at the time of signing contracts.

The evolution of the studio system made this debate more intelligible. Film-making was more of a craft when studios started producing pictures and these closely resembled the shows seen in village fairs, which the studios tried to compete with. Film-making was then an integrated activity because the same agency, such as the Lumière Brothers or Charles Pathé, supplied the equipment for projecting the film. It lost this 'fairground' character due to several factors: the agreement between producers to standardize their equipment, the replacement of short sequences – often shot directly – by fiction and feature films, the appearance of film stars. Because of these changes, the studio could introduce different types of films and safeguard itself, at least partially, against the uncertainties of film-making, and it was able to capture markets by selling films and not film-making machinery. But to capture the ever-growing market through exports, once again the producers began to bring together all the resources needed for making a film, including actors, under a stable and permanent organization. The latter were engaged by signing a work contract for a minimum period of seven years, which included a clause allowing them an option on the studio's profits. All other artistic personnel, including scriptwriters, were put on the studio's payroll, as the producers realized that it was better to control the production of scripts than to search for them in a highly fickle market

where scriptwriters were in touch with rival producers. This method was also applied to composers and musicians. All these people were grouped together in one place where they stayed put. This saved the trouble of travelling and it was possible to shoot similar scenes one after another, sometimes scenes even for different films. The facilities of the studio were used continuously and the same sets could be used for the several films being shot. Artists worked full-time, passing from one film to another that were shot depending on the availability of sets, and the scenes of a film were not shot in a logical sequence. Everything was organized in a hierarchical manner, including the separation of various functions, with the producer in charge of the economic aspects having a higher position than the director performing artistic functions. This system proved to be quite efficient, especially for films that were not very original than for films needing more attention and resources, and this gave rise to the distinction between A-grade or high-quality films and B-grade or ordinary films.

This system again underwent a change during the Second World War.[36] Some stars wanted to select their roles and claim a part of the earnings brought by their success. The major studios accepted their demands and agreed to give them contracts for shorter periods, which included clauses regarding the sharing of profits. The judgement against Paramount Pictures was another factor responsible for this change in the structure of the major film-producing companies.[37,38] Deprived of their own network of exhibitors and having to face direct competition from the latter, film companies were forced to improve the quality of their products and increase the proportion of A-grade films as compared to B-grade films. Since they no longer had their own exhibition network, they could not get away with mediocre films. And since they made quality films, they could not make as many films as before. Finally, the advent of television obliged them to produce films that were of a superior quality to what was seen on television and this also contributed to the fall in the total number of films and rise in the percentage of A-grade films. In 1956, the number of films produced was only 70 per cent of that produced in 1940 and the cost of the negative had gone up by 30 per cent in absolute value.

The present period is described as one of flexibility in production. The major studios, which at one time had combined

the three basic functions related to film-making, namely production, distribution and exhibition, have partly given up production activities to concentrate on distribution, having already been prevented from engaging in exhibition by the Paramount judgement. Some companies then sold or sub-let their huge properties and started making films one at a time, engaging artists and other personnel on contracts covering individual films and not a particular length of time. Outsourcing of personnel, to perform a large number of tasks that did not constitute the core of film-making, was prevalent and thus a large number of enterprises specializing in sound effects, special effects, etc. sprang up. Since artists demanded a share in the profits, the film companies were constantly trying to produce commercially successful films so that they could build up their liquid assets. This gave rise to the blockbusters described earlier. There is ample evidence for this flexibility in production: in fifteen years (1966–1981), the number of producers went up from 563 to 1473, the number of sound engineering companies rose from twenty to 187, the number of market-research organizations from three to twenty-four and so on.[39]

Marketing of artistic activities

Marketing aims at establishing a link between the consumer and the products or services on offer.[40,41] Earlier, the aim of marketing activities was to find out how to sell a well-defined product to various sections of the public who were known to a large extent. Today, marketing activities must first define a product according to its prospective consumers. This is a meaningful activity in areas where it is not quite clear if a particular product is suited to a particular group of consumers. Some cultural institutions are very keen to find out if this is so. Thus the management of Chicago's Field Museum wondered how it could win over the public and ensure a brighter future for the museum. This shows that it understood the need to make flexible programmes that were adapted to a wide variety of interests to satisfy university students, schoolchildren, families, collectors, enthusiasts, etc. So the management decided to organize 'three public spaces',[42] the first for holding interactive and virtual exhibitions that would be open to all types of

visitors, the second for thematic exhibitions and the third for more specialized presentations for visitors interested in a specific subject.

When artistic institutions undertake a marketing exercise, they usually do it in three stages: identifying users, analysing their decisions and grouping them into segments or homogeneous categories. In the artistic field, the term 'user' may refer to patrons and prescribers as well as direct and indirect users. The 'customer' is a person who gives orders, the 'prescriber' recommends the use of a product, the 'financier' covers the cost, the 'direct user' consumes it and the 'indirect user' derives satisfaction from its consumption. In the case of a museum, schoolchildren are its direct users, its patrons are both schools and families, the prescribers are educationists and professional artists, the financiers are the public authorities and the indirect users are the local population. These complex distinctions make the standard approaches to marketing appear quite misleading, since each of these players has specific demands and expectations.[43,44]

The analysis of individual decisions is based on three types of variables: the functional dimension or a good's ability to satisfy a person's needs, the economic dimension or the cost of consuming a good, and the psychological or social dimension or the effect of the consumption on the consumer's standing in the community. Faced with these variables, it is possible to identify three processes, at the end of which a person can make up his mind: the cognitive process where the person looks for information and analyses it, the subordinate process where the person's decision is the result of imitation, recommendation or deference, and the emotional process where the decision is based on the feelings or emotions that a cultural consumption is expected to satisfy.

Permutation and combination of these variables and processes produces a large variety of situations. It is absolutely necessary to group the consumers into relatively homogeneous segments in order to decide on the data support and pricing policies. Thus segment is a particular sub-set of users that can be defined homogeneously and is likely to respond to a particular marketing strategy; a segment can be defined according to its expected behaviour either *ex ante* (segmentation by disintegration) or *ex post* (segmentation by integration). The solution

depends on the market's maturity: *ex ante* segmentation is required when there is lack of experience, whereas *ex post* segmentation becomes necessary with the passage of time. Let us look at the market for museums where the possibility of *ex post* segmentation is difficult and it is necessary to constitute segments on the basis of initial hypotheses. Apart from the relatively narrow segment of educated and middle-income or well-to-do consumers, the remaining public is usually divided into four segments. The first is made up of families with children for whom a visit to the museum is a cognitive and educational activity as well as a recreation. This segment looks for means of obtaining information and understanding that it can 'appropriate', and experience has shown that it is willing to pay if the products on offer correspond to its needs and are of the required quality. The second segment is composed mainly of elderly persons having enough time and money at their disposal, for whom a visit to the museum is both a cultural and a recreational activity. For such people, the museum should organize visits that provide comfort, relaxation as well as knowledge about the arts, but this, all said and done, is a costly proposition. The third segment is made up of underprivileged and marginalized social groups having limited resources. The museum management can use their visits as a lever to obtain larger public subsidies. The last segment consists of potential partners. They are not necessarily well-versed in the arts at first; however, as a result of the practice, experience and knowledge they gained from regular visits, they decide to support artistic activities by giving donations, lobbying, etc. It is important for museum managements to attract these potential donors through means that are quite different from those used to attract other segments of visitors.

The marketing of artistic activities gives rise to four problems. The first relates to the possibility of analysing the art-consumer's behaviour. Surveys of the cultural habits of the French revealed that those interested in museums are fairly well educated (69 per cent of visitors have university degrees), however this does not mean that all well-educated people spend their time visiting museums and monuments.[45] On the other hand, marketing can play a significant role in the case of specific activities such as the purchase of books on art when leaving the museum or membership of a museum support group.[46]

The second problem arises from the fact that the consumption of cultural goods requires the user's active participation. Some museums of contemporary art seek the visitors' suggestions on the display of particular objects, lighting, etc. The writing of novels on the Internet, where readers are asked to add a new chapter, suggest the end, etc., also raises the same problem since it implies a different kind of relationship between the users and suppliers that goes beyond their traditional role of buyers and sellers. The third problem is related to the purpose of artistic marketing. Artistic marketing is believed to involve individual consumption alone, whereas it is possible to promote one more objective, namely creation of social links. Apart from standard marketing procedures, there is also what is called 'tribal' marketing, which aims at promoting social relationships rather than satisfying aesthetic needs. It is interested only in encouraging the consumption of objects that create such relationships and not in facilitating access to these objects.[47]

The main problem is that marketing procedures expose the very existence of artistic goods to risk. Marketing analyses the value of artistic products in the light of consumers' willingness to pay for them. This is dangerous in an area where payment is but one of the many factors that affect the decision to consume. Further, marketing tries to promote a particular product instead of another because the former is more likely to elicit a better response, and to attain this objective it is prepared to magnify its effects or even start a new trend among people who do not have the requisite information. A good example of this type of marketing is seen in the field of so-called cultural tourism.[48] Tour operators promote certain destinations in preference to others, not because they are more interesting or culturally richer but because they are in fashion due to various reasons such as an article in the *National Geographic* magazine, a major political event, etc. This means that marketing may produce chronic instability in the case of artistic products.

As a matter of fact, all recent marketing theories have laid stress on the life of a product and have not hesitated, whenever necessary, to 'kill' it in order to promote more promising products. The first of these theories, dealing with the 'product life cycle', distinguishes four phases in the life of a product, namely introduction (launching a high-priced product having little competition), growth (the price comes down as the market

develops), maturity (the appearance of competitors and the need to share the market with them) and decline (only a few niche markets are available and they too are about to disappear).[49] Initially, this theory seems neutral and the analogy between economic and biological life seems to be relevant. But it becomes dangerous when it incites producers to discontinue their products as soon as they come of age, or even make provisions for obsolescence, and show interest only in products in the growing stage. It is easy to imagine the risks of such a strategy for artistic goods and their management if there is a constant urge to create new things, organize events one after another so that attention remains focused on a festival or a monument, and give more importance to outward appearances than to local needs.

The famous matrix devised by the Boston Consulting Group has the same disastrous effects.[50] It grades products on the basis of two criteria: their relative position in the market and their growth rate. By combining these criteria, we can differentiate between four types of products: 'stars' (products commanding an important share of the market and having a high growth rate), 'cows' (those commanding an important share of the market, but having a low growth rate), 'question marks' or problematic products (those having a small share of the market, but a high growth rate) and 'beaten dogs' (those having a small share of the market and also a low growth rate). Its recommendations are quite clear: allot more resources to the 'stars' and phase out the 'beaten dogs', and perhaps even the 'cows', as quickly as possible. But what would happen to artistic movements commanding only a small share of the market and having an uncertain growth rate? Artistic innovations often seem like 'beaten dogs' in the early stages, to become 'stars' only as the years go by, whereas the Boston Consulting Group recommends that 'beaten dogs' should be weeded out immediately.[51,52]

What is known as the analysis of 'diffusion of innovations' strengthens this aspect of artistic marketing. It is based on the idea that by adopting the 'product life cycle' approach, it is possible to predict what type of persons will be interested in a particular product and accordingly organize the various phases for diffusing the product among the public.[53] It so happens that among the consumers there are innovators and adapters, those who constitute the majority and those who are slow. It is

more advantageous to take into account the responses of the first two categories and this means giving preference to the consumption of those who keep up with the times or those who want to be different from others and use them as a reference base. On the other hand, this will depreciate the value of the so-called popular goods. We find here a rift between high culture and popular culture that has been the subject of much controversy. We can also see what such an approach will do to patrons who will then concentrate only on the stars and neglect other sources of creativity.

Fixing artistic prices

Fixing the price is the most important decision in the management of artistic activities and it is the basis of a large number of contradictory factors. Prices bring the earnings needed to cover production costs. Although, in the artistic field, this source of financing is only one of several, it has the advantage of protecting institutions from the arbitrary decisions of government departments and private patrons. Prices give an idea of the minimum value of a particular good or service for its users. This information is of strategic importance when it is necessary to know if the consumers will accept a change in the prices. Prices make the management aware of its responsibilities, since it is in its interest to ensure that its services are the best possible services provided at the most appropriate price. Prices also serve to ration the demand; this is necessary when a limited number of seats are available during a festival or when there is excessive pressure from users on certain sites.

From free services to paid services

In the artistic field, several reasons are given for the provision of free services, e.g. the desire to democratize access to artistic goods, the need to invest in the formation of cultural capital, the possibility of improving the life of the common people, etc. The cost of providing free services is always borne by taxpayers who do not use the artistic good or service even though they have financed it. A better solution would be to provide free access to the service and ask those using it to make a voluntary

contribution. There are a few such cases, but it is more realistic to admit that this system is possible only if the voluntary contributions are supplemented by public subsidies (National Gallery, London) or by private donations (Smithsonian Institute, Washington), as the voluntary contributions alone are not enough to cover the entire costs.[54]

However, the policy of allowing free entry has changed over the years as evidenced by managements of museums. There is a well-established tradition, particularly in the United Kingdom, of allowing free entry to museums. Right from Victorian times, it was proclaimed 'that museums provided a satisfaction that was considered to be legitimate by the entire community and which could not be provided by any other institution'.[55] In the nineteenth century, a similar opinion was expressed in the United States where it was claimed that museums in New York's Central Park should constitute 'an appreciable support for educating the people and a source of intellectual pleasure and confidence for our poor harassed workers'.[56] Despite these pleas for free admission, visitors were charged a small fee, but the fee was meant to keep away people seeking shelter from the rain rather than to discourage interested visitors: 'a small payment will prevent museums from being filled with persons who are idle or of ill-repute'.[57] In France, the practice of granting free admission to museums was not very common as it was believed that a contribution by the visitor would help to preserve the objects and discourage excessive crowding and non-motivated visitors. This policy underwent several changes.[58] Between 1921 and 1970, admission charges to museums were raised regularly in francs, even though they were quite low to start with, in order to avoid a sudden break with the past when admission was free. Since 1980, admission charges have tended to go up more regularly and at a faster pace than before in order to catch up with the general price rise. Between 1990 and 1996, the increase in admission charges to museums was three times higher than the rise in the general price index, namely 32 per cent as compared to 11 per cent.[59]

But no matter what country it is, free admission to museums is always a subject of much controversy.[60] On the one hand, it is criticized because it is considered logical that users, rather than taxpayers, should provide the funds for running artistic institutions. On the other hand, it is admitted that it is difficult to charge admission fees that will cover the total costs. There are

several possibilities. By adopting a system of mixed pricing, it is possible to recover a part of the cost without unduly taxing the user, but this means accepting a deficit. It has been observed that when a museum has to compete with other attractions, the duration of the visit is likely to be limited,[61] price elasticity is normally negative[62] and charging an admission fee leads to a fall in the earnings of museum shops (National Gallery of Canada, Ottawa). A mixed-pricing policy appears to be more logical in such cases. A second solution is to charge an admission fee that is close to the cost price, but to have free days at fixed intervals, either once a week or once a month. When entry fees for museums were introduced in France in 1922, it was decided to allow free entry once a month or once a week. However, this practice had almost disappeared until 1996 when the French Ministry of Culture decided to reintroduce it in the Louvre Museum. The effect of allowing free entry to the museum one Sunday in a month is far from negligible, since the number of visitors is 70 per cent more compared to other Sundays. Further, there is a change in the nature of visitors. The number of visitors from the Ile-de-France region is three times more when entry is free, whereas the number of foreign tourists remains the same. The social origin of the visitors is also different because the number of visitors accompanied by children is three times more and the number of office employees and factory workers is twice as high.

Deciding the price

The logical method of calculating a reference price is to anticipate the number of visitors and the total expenditure in order to arrive at what is known as the 'full cost'. This is based on the assumption that users will accept without any resistance any price that is demanded of them. It is also necessary at this point to take into account the visitors' willingness to pay, which is not an easy task.[63] In some cases, it is possible to calculate the admission charge according to price elasticity, as seen in a study of the admission charges to museums in Paris based on the data pertaining to the period 1947–1997.[64] This study revealed two types of reactions. In some museums there was the usual negative elasticity, but it was amortized (between −0.2 and −0.7 per cent), whereas in some other museums there was a significant

positive elasticity (+0.5 per cent). This information indicates that
the first lot of museums are mainly neighbourhood museums
frequented mainly by local residents (e.g. Musée de la mode
[fashion museum], Musée de la chasse [hunting museum], etc.),
while the second lot are the more 'prestigious' museums', having
a large percentage of foreigners among the visitors (Louvre,
Orsay, etc.). But it is not always easy to obtain data related to
price elasticity. Further, the elasticity may be affected by unex-
pected variables (e.g. the elasticity of admission charges to the
Louvre Museum increases positively every time a new gallery is
opened) and it may change completely depending on whether an
event is of a permanent or a temporary nature.

However, it is possible to take a different approach without
ignoring these data. A visitor may treat the price of a cultural
service as an element of a contract.[65] The management must
therefore take into account the following factors related to the
consumption of the goods offered to the visitors: research (the
user prepares for his visit by studying ratings), confidence
(the visitor relies on the judgement of certain persons) and
experience (the decision to consume depends on past experi-
ence). Therefore it is difficult to fix the price in advance with-
out knowing what the visitor will appreciate.

The nature of the visitors, conditions of their visit and the
type of practices in vogue also provide the basis for fixing dif-
ferent tariffs, i.e. the reference price applies only to a small
minority of users. The first type of discrimination is described
as subjective. Prices vary according to the nature of the users
and age is the most frequently applied criterion. Initially, tariff
differentiation favoured the young (e.g. admission was free up
to age 18 and there was a reduced tariff for those between 18
and 25) for reasons that are easy to understand, namely insuffi-
cient or no purchasing power, the desire to encourage con-
sumption of artistic goods and services, the need to train young
people to appreciate art, etc. Currently, however, tariff differen-
tiation favours the elderly, and all the more so because present-
day trends (lower retirement age, better facilities for travelling,
larger pensions, etc.) have contributed to the development of
tourism for senior citizens. This has led to a substantial fall in
earnings and in some cases to their disappearance, e.g. Centre
Georges Pompidou in 1993, the Louvre Museum in 1994 and
the Centre des Monuments Nationaux (National Fund for

Historical Monuments and Sites) in 1995. As a matter of fact, the criterion of age no longer corresponds to the criterion of income and one wonders whether there are other methods of tariff differentiation that would be more effective. A system of vouchers for participating in cultural activities would reduce the admission cost for persons interested in such activities without reducing the level of earnings.[66]

Quite akin to this subjective discrimination is a system of differentiation based on the users' geographical origin. Residents of the geographical area in which there is a festival, a museum or a library usually have to pay less than those coming from outside, especially tourists. It is for the agency operating the cultural service to decide how far the zone will extend, but it could be quite extensive. For example, museums managed by the Junta de Andalucia are free for nationals of all countries in the European Union. There is a logic behind this argument: the residents already pay taxes that finance the cultural activities and, therefore, the existence value of the cultural good, hence they should not be asked to pay the reference price.

The most common type of differentiation practised today is based on the objective conditions related to the use of cultural goods, especially the timing of the visit. Thus the Louvre Museum has different admission charges for different times of the day (the admission fee is reduced by half after 3 p.m.) or for different days of the week (admission is free one Sunday in a month).[67] Grounds for this differentiation are indisputable. Spacing out visits, to avoid overcrowding and to enable those who cannot visit the museum during that particular time to come later, appears to be a suitable arrangement.[68] In the artistic domain, it is not possible to manage a demand that exceeds the handling capacity of the service by employing measures suggested elsewhere, because restricting the number of users through the price mechanism undermines the principle of democratization of culture. It is also impossible to store users in this case. Deterioration of quality goes against the very concept of culture. The only solution is to divide an artistic service into two categories: first, a service which can be consumed at a time of your choice provided you are willing to pay the price, and secondly, a service available at a lower price but only at a given time. This differentiation does not affect the intrinsic quality of the product, and the objective of democratization is

respected. This result is guaranteed by what is known as 'yield management'.[69]

All these constraints have led to new methods of price management. For example, regular visitors can be given an annual membership card or season ticket at a reduced price, which is obviously lower than the total cost of all the visits they are likely to make.[70,71] More recently, we have witnessed the advent of membership cards, inspired partly by the practice prevalent in the world of theatre. Thus the permanent pass for the Centre Georges Pompidou and the Carte Louvre Jeunes issued by the Louvre Museum to young people were introduced in 1995. Nearly 100,000 visitors from the Ile-de-France region benefit by this arrangement. This system has numerous advantages, namely financial gains and the possibility of breaking even much faster, the likelihood of increasing sales in the museum shops because such visitors are more inclined to buy these products than others, development of communication, better knowledge of the public and a greater ability to develop management tools. This system of season tickets or passes is nevertheless criticized by those who suspect that it results in losses. But it is quite unlikely that the beneficiaries of this system will visit the museum so often that the price of their total visits will exceed the amount paid as subscription. Further, the marginal cost of an extra user is nil when the institution's absorption capacity is not reached. The 'cultural passport' system goes beyond the subscription system, as it covers several types of activities.[72] It is more difficult to implement than the subscription system, since it is necessary to enter into a partnership agreement with several types of institutions, decide on a mode of payment that includes both fixed and variable factors[73] and set up a mechanism for promoting sales.

Associated products and museum shops

The sale of related products is an important source of income for most artistic institutions. Visitors to a museum and theatregoers have a special budget for these activities and, apart from tickets, they are willing to spend on souvenirs and other sundry items. These expenses are interchangeable to a certain extent, and fairly accurate information is now available about these subsidiary earnings. Income from museum shops can easily

attain 30 per cent of the museum's total earnings and even more in some cases.[74] But the margin of profit on these sales is often quite low, because of the expenses incurred in fitting out and running the shop and in having adequate stocks of a wide variety of products to attract buyers, and the corresponding financial outlay.[75] One solution is to join a network or a central purchasing service to take advantage of the economies of scale when negotiating the bulk purchase of products and to obtain quick delivery.[76]

The sale of products by mail order is another source of subsidiary earnings. In France, the association of national museums (Réunion des Musées Nationaux) introduced this system in 1990 and its turnover tripled between 1992 and 1996. The products marketed include reproductions, indirect products (e.g. key rings) that are more effective than reproductions in popularizing museum collections, products based on exhibits (e.g. only a necklace around the neck of a statue is reproduced) and purely creative products.[77] But any mail order network involves a large expenditure on advertising and marketing as well as special management expenses that amount to an average of 10 per cent of the price of the products sold. This mail order network has to maintain files of customers, prepare and mail catalogues, receive orders and arrange for the delivery of parcels, apart from looking after the financial management. Its initial costs are very high and the income derived from every extra buyer is relatively low. The result therefore is far from satisfactory, especially since one out of five buyers drops out spontaneously every year.[78]

Merchandising is a growing source of income and the best example is that of Disney Studios whose empire is based on merchandising. In 1984, marketing and publicity were minimal in Disney Studios. While other studios spent US$6.5 million on publicity and marketing, Disney spent less than US$3 million.[79] Currently, Disney has 550 Disney Stores all over the world and also its own chain of retail outlets,[80] which means that it does not have to pay heavy commissions to retailers that would reduce its profit margin.

Chapter 4

THE ARTIST AS AN ENTREPRENEUR
OF HIS TALENTS

Is it possible to consider the artist's behaviour from an economic point of view? It would be daring, to say the least, to describe in economic terms the activity of a complex, protean and ubiquitous person with the defining traits of a showman, with whom an artist would readily identify himself, or a skilled craftsman, to which status he is often reduced by historians.

Economists should not forget the artist's complex nature, as defined by artists themselves. Whereas the artist is portrayed as a Bohemian in Romantic literature, there is a complete transformation in the case of a court painter overawed by royal patronage. Cast out by society, which he despises, he is now exposed to material cares and the great perils of his art, much like Musset's Fantasio. But this very picturesqueness makes the artist reflect on himself. In the personas of Baudelaire and Mallarmé, the old showman becomes an ironic figure. In Apollinaire and Picasso, we witness the reconstruction of the showman's harmonious image. The artist leaves the circus ring and moves into a lunar landscape. He, who once served as a tool to illustrate allegories, now dares to dream and invites the viewer to witness the miracle of his art and to interpret it as he feels. The artist does not wish to prove anything but only wants to show and be seen. In a splendid book, Sandrine Bazile shows how Rouault's successive portraits of the clown depict the artist's view of himself.[1] In *Pierrot de profil* (Pierrot in profile, 1925), Rouault sees the artist as a clown

who distances himself from his own personality. His sequinned costume should not mislead us, for 'The artist ought to free the world from pain even if he cannot free himself from his own suffering. ... '[2,3] The same clown, who admits quite candidly that his face is made-up, is willing to be humiliated in *Le Clown Tragique* (The Tragic Clown, 1932), but his Christ-like appearance delivers a lasting message. In *Au clair de la lune* (In the Moonlight, 1948), the artist's face appears calm and serene, for he has delivered his message and it is up to those who receive it to interpret it as they feel.

But the showman also has something in common with the craftsman and, in his book on the artists of the quattrocento, Banxdall points out that the contracts of the great Florentine painters were actually intended for craftsmen. The transformation of the craftsman into an artist was not easily accepted and, after the death of Leonardo da Vinci, some writers did not hesitate to say,

> However praiseworthy painting may be It must nevertheless be considered as very inferior to poetry from the point of view of dignity and authority. ... Painting is ... closer to manual labour than to intellectual effort and it is generally practised by ignorant people.[4]

From then on, the painter gradually gave up his workman's garb and donned the mantle of grace and talent though he continued to suffer economic hardships. What are now prized as works of art were originally considered to be the products of craftsmen, the idea being that since the subject was more or less imposed on the craftsman-artist, it was the quality of his work that gave it its real value. Although copies and imitations were not frowned upon, skill was a determining factor. This explains why the artist generally signed his works, although in the beginning they bore the stamp of the person who had commissioned them. Initially, the signature was meant to set the work apart from subsequent copies, and later, to endorse the craftsman's genius. However, the crafts were always associated with physical labour. Also, unlike craftsmen, artists did not have guilds. After the Industrial Revolution, things changed once and for all, and the artist's creation became the very antithesis of the industrial product, even of the craftsman's product. The artist became a part of the artistic community described by Sartre as a 'community of saints'. The artist did not know if there would be a demand for his products and, if ever there was a demand for

them, he was certain that it would come from the middle class. The market was overshadowed by the Academy, and artists did not take long to realize its importance. Their reactions were quite varied – some took refuge in the doctrine of 'art for art's sake', whereas others played industrialism against economics. The situation was quite disheartening, as pointed out by Vasarely: 'You see the paradox ... I can impose my ideas only to the extent that I can make a name as a traditional painter ... in an environment that does not interest me. ... '5

Unlike the worker, especially in the way he is shown in economic analyses, the artist has certain specific traits. His day cannot be divided into 'working hours' and 'free time', as it is extremely difficult to say when the artist is in the process of creating. Because of this, the concepts of training period, preparation and presentation have no meaning, so much so that one can say of these 'creative intellectuals' that they are both working and not working at the same time. There is no division between a 'working area' and a 'non-working area', since areas such as the stage, the workshop and the studio only serve to crystallize the transition from inspiration to implementation and presentation. Finally, we may ask what is the essence of artistic activity? Is it the work of art? Or, does it mean mastering a technique or taking part in a process? It is becoming more and more difficult to analyse an artist as a worker since, as Negri says, he is more of an 'entrepreneur dealing in himself'.6 Another trait that is common to all artists, with the exception of some rare celebrities, is their irregular and relatively paltry income. Their earnings are low because they are unpredictable and unprotected. These small and irregular earnings are generally supplemented by income from auxiliary activities or from royalties, which is a mixture of moral and economic rights. These rights are not at all clear, as virtual reality has changed these works of art into algorithms that can be altered at will. Therefore it would not be paradoxical to repeat our first question: what is a work of art? And hence, what is artistic activity? Finally, who is an artist?

Two paradigms of artistic activity

How does one define the work of an artist? Is it the creation of a product or participation in an activity? The first answer

seems obvious, but the second is not without significance because aesthetic and artistic criteria are unstable and do not suffice to define the areas of artistic activity. Besides, artists are now identifying themselves in terms of the environment or the network to which they belong rather than in terms of artistic reference: 'communication within the sphere of activity and co-operation in specific situations try to compensate for the decline in the membership of artistic groups'.[7] In the absence of other obvious benchmarks, the artist's identity is determined on the basis of his activities within the network, as some of his products will become works of art even if they do not gain recognition. This does not mean that the artist does not strive to create works of art; it only means that he needs time to establish himself as an artist. Being recognized depends as much on his role as a producer as on his function as a creator, as much on his activity as on his work. This change of attitude has grave consequences – instead of basing ourselves on the idealization of the artist's creative function, we base ourselves on activities and practices. We thus contribute to the much-touted disenchantment of art, but at the same time we gain in terms of pertinence.

Artistic activity covers a variety of disciplines, opinions, sensibilities and social positions. It sustains itself by denying that it belongs to a single group and by denying that it indulges in diverting techniques or in overstepping references. The main principle underlying the understanding of artistic activity has less to do with its result than with the heterogeneous association of its components. The method of co-ordinating the activities and persons involved is more important than the work that they produce.[8] By approaching the artist in this manner, we can no longer think of him in terms of his gifts, his precociousness, his Bohemianism, his talents or as an unchangeable and invincible person. These concepts are deeply rooted in the artistic environment and they make it easier to understand his psychodynamics than the functioning of the art market. Too often, the notion of vocation has been used to justify, rather than explain, the years of suffering and underpay and to sidestep the role of talent and socio-political factors. As a matter of fact, this view of the artist as a creator is gradually disappearing and people are beginning to realize that it is no longer necessary to depend on natural aptitudes and talents. According to Menger, the artist

is a hybrid who lives by the logic of income (talent, creation and reputation) and by the logic of insurance (acquisition of skills, use of spouse's resources, etc.). So the artist has now become socialized, whereas earlier he was idealized.[9]

Since artistic activity involves groups of actors, practices and references, it is bound to be compared to a network. Since the artist's knowledge is mobilized within the network of knowledge, he is in a better position to innovate by the linking of knowledge than by living in isolation or by being different from other members of the network. The production of a work of art is not so much the accomplishment of an individual as that of a professional group. When artists form a group, they do not necessarily work together, but each of them works independently within the group. This brings to the fore a plethora of creative impulses and references that do not merge into a standard pattern, which would be quite unproductive.

This multiplicity of practices and procedures, leading to the creation of a work of art, is responsible for a variety of cultural professions, also called 'applied intellectuality'. There is a continuum of activities with numerous poles, so that a creation is not independent and also it cannot be assimilated with another. As H.S. Becker writes, 'In the world of art, every function can be considered artistic, anything that an artist does, even his most undisputed action, can be an encouragement for someone else.'[10] Artistic activity thus progresses through successive accumulation. 'New concepts are being constantly added to earlier ones: design to the plastic arts, industrial design to design, industrial packaging to industrial design...'.[11] Artists move from one activity to another, from collective activities like staging shows to more individual activities like teaching art. Actually, these networks may be in the form of an association or they may have a hierarchical structure. They could be specialized bodies, e.g. artistic, technical, management, etc., having corresponding positions. A cultural institution brings these poles and positions together in a single structure and gives them a definite form. The only danger is that these diverse elements, which are supposed to work together, may start working only for themselves. Subsequently, conflicts become inevitable and this underscores the formalism of these institutions. The ultimate imbalance is reached when works of art become products of the institution.

If we admit that artistic activity has precedence over the artist as a creative force that shapes the material world, we must envisage the possibility of an artist who does not produce any work of art. Several interpretations are possible. Some artists think that by crystallizing their creativity in a work of art they come into conflict with themselves since it arrests their artistic activity, which, by definition, is an open and unending process. It is true that the work freezes their creativity at a particular point of time, but this makes it easier for the user to understand the work. Some artists opt quite openly for non-creation, as they do not want to be compelled to give proof of their artistic status and prefer to live for themselves and the people around them. Still others claim to defend an open and evolving art and are not interested in the promotion and diffusion of their works. But if you cannot associate a work with an artist, how can you assess his contribution, his creativity or even his productivity? As Nicolas-Le Strat says, 'How can one break away from the overpowering and structured view of the artistic product? How can one avoid the excessively conclusive role of creative work?'.[12] One solution is to allow artistic activity complete freedom without trying to arrest its development and to let other artists give it a meaning and a value. The unity of the work no longer lies in the artist's intention or in the object's unitary nature but in the conclusion of a work of art. The viewer's active participation is needed, since it helps to make news, to complete the process and to inspire a work of art. Artistic activity thus leads to a situation where the viewer's intrusion can give shape to what was only a glimmer in the mind.

These two paradigms of art – art as a creation and art as an activity – should be considered permanent features. These two dimensions are to be found in different measures in every artist and this explains the difference between his profession and status. In literature and the plastic arts, it is difficult to disregard the role of the notion of creation in the artist's production, recognition, remuneration, etc. As for the performing arts, we know that the activity of actors and performing musicians is based on co-operation. Artistic institutions are fully aware of the connection between these two paradigms. A painter's studio cannot do away with the notion of the network even though the notion of creation remains the determining factor. A troupe of

actors will give priority to their activity, although the notion of performance is essential from the viewers' point of view.

From artistic activity as a project to the artist as an entrepreneur of his talents

Irregularity is the basic characteristic of all artistic activity. It is also responsible for the low average earnings of the majority of artists. But it must be considered in the light of changes that have occurred in contemporary artistic markets. The nature of artistic activity is such that it is involved in a variety of projects, each of which is executed according to the terms of a contract or by different specialized organizations. In the 1990s, when intervention by the French government stabilized the number of artistic jobs in the public sector, undoubtedly more than in other areas, the part-time jobs constituted, on average, 64 per cent of the total number of jobs. An analysis of the relation between the number of employers and the number of working days supports the earlier observation. Among those who worked only one day in the year, 98 per cent had only one employer and 2 per cent had two employers. Among those who worked 260 days or more during the year, only 23 per cent had a single employer, 31 per cent had two employers, 22 per cent had three or four employers and so on. Irrespective of the number of working days, there are usually several employers, and the probability of having fewer employers goes down with the increase in the number of working days. In view of this irregularity, it becomes difficult to talk of a career. Artistic activity thus becomes a process where the concept of enterprise replaces the concept of employment, with the artist becoming more of a business organization rather than an isolated worker.

How does one interpret this irregularity and its consequences? In a traditional work market, the worker signs a contract for a given period, irrespective of the nature of the specific activity he is required to perform or the project for which he has been engaged. On the other hand, the entrepreneur or producer looks for certain general qualifications, which if the need arises will be supplemented by specialized training or orientation, before assigning his employees to different activities. In such a situation, it is not difficult to find the required skills in the labour market,

although their price may differ depending on the circumstances. But in the artistic field, there is a direct link between the artist's skill and the nature of the activity or project, so that one artist cannot easily replace another within the same project. The relationship between an artist and a producer is valid only for a particular project and it will not be the same for a different project. It is therefore necessary to define a project and look for a particular skill at the same time in the market and this is not concerned with the period of activity but with the type of talent required for a particular activity. If the specific skill needed for a project is not available, it will be impossible to execute it. There is no linear sequence between the definition of the project and its execution as in other fields, because it is necessary to maintain the synergy between the progressive definition of the project content and getting together the corresponding skills needed for its execution. This can have three consequences: the project cannot be implemented unless the requisite artistic skills are found; artistic skills will remain unutilized due to the lack of projects needing these special skills; the working period will be linked exclusively with the given project. This ad hoc element is an integral part of all activities that are intrinsically artistic, because the implementation of such projects depends on existence of these skills and talents that cannot be substituted by others, and now this is also true of many technical jobs.

The artist therefore tends to look after his business himself. Since he possesses a specialized talent that cannot be substituted by any other, it is advantageous for him to remain in control of it, because it is the basis of an activity that would collapse in its absence.[13] The artist becomes something of an entrepreneur, as he exploits a special asset and participates actively in defining the conditions under which this asset will be used. He has to make sure that the particular project is 'just in task' and 'just in time', and this enables him to manage to his own advantage the investment he has made to earn a reputation. In some cases, when his specialized skills are recognized, he can take direct responsibility for the execution of the project in which he is the centre. In other cases, it is difficult for him to adopt this kind of strategy as he does not have the minimum reputation needed as an author, scriptwriter, director, actor, editor, etc.

The existence of small enterprises, or even enterprises consisting of a single person, in the artistic field acquires a new

meaning. This, it is commonly said, is due to the tendency of large enterprises to outsource some of their requirements for greater flexibility and for transferring adjustment costs to others. This happens frequently in the film industry where many independent producers perform those tasks that were earlier managed by the big film companies, and also in the book publishing industry which entrusts a large number of jobs such as iconographic and documentary research, correction and revision of manuscripts, etc. to other agencies. But very small artistic enterprises also owe their existence to the artist's need to exploit his/her assets more gainfully, use an appropriate organization for every new project and protect his/her intellectual property rights more effectively. This protection is a complex matter in the case of a salaried person and it seems easier to protect one's rights with the help of structures under one's control. The emergence of very small enterprises appears quite logical in Europe where the number of freelancers is increasing day by day in numerous sub-sectors. This development has not affected the museum sector but it is very evident in the audio-visual sector, especially in the United Kingdom.[14] This has given rise to three new types of enterprises in the cultural and audio-visual sectors: large enterprises (television companies, publishing houses and national theatres), small enterprises run by a small group or an individual (performing arts and editing of multimedia products), and more recently, small virtual enterprises that do not need physical space and often form a part of a network.

This shift from dependent production organizations to more independent production organizations has compelled us to revise our understanding of the skills required for artistic production.[15] They extend from artistic skills to technical and management skills, in the field of plastic arts as well as in the fields of heritage conservation and audio-visual communication. A person must have the skills of a legal expert, a financier and a manager to make the most of his own artistic talent.

The field of music has been revolutionized by the introduction of new technologies, which have transformed the creative processes regardless of the type of music or the setting. It is now possible to set up a proper production studio in one's own home. Thanks to the computer and the availability of appropriate software, music can be produced without the presence of singers or instrumentalists. These new technologies have also

transformed the distribution process following the invention and the spread of the DVD (digital versatile disk), which improves the sound quality, and the mini disk, which offers almost limitless possibilities for the storage of music. Although talent continues to be the core of the system, the musician must be capable of performing other functions within his team comprising of artists, agents, managers, publishers, distributors and legal experts. Even if this team becomes virtual, each of its members must understand the functions performed by other members and assume them as and when the need arises, with different implications that depend on the starting position.

In the audio-visual field, digital recording has brought about a radical change in the nature of jobs and the skills needed for performing them. The three fundamental skills are audio-visual design, technical expertise and understanding of organizational problems, as evidenced by the creation of new jobs such as the audio-visual media designer and the film and video editor. Let us look at the audio-visual media designer, who has to define and produce audio-visual programmes using electronic equipment. He/she must be capable of consulting the persons in charge of programmes about the purpose and the risks involved. He/she must also be able to select the required equipment and maintain it, analyse and verify recordings, look for material in the visual and sound archives and master the changes in format and standard. Then, he/she must analyse, process and edit the audio and video recordings. And finally, he/she must be able to handle the editing equipment and know how to mix pictures under the supervision of the director and the cameraman.

In the book publishing industry, polyvalence has become necessary following the cutbacks in production and design departments, the advent of computer-aided production, which has brought about improvements in the editorial function, and the development of the marketing system. Consequently, a person working in the publishing industry must understand the public, diversify diffusion channels, take responsibility for the developing rights and manage relations with multimedia agencies. According to many observers,[16] the most striking feature is the appearance of the 'information professional' in all artistic sectors. Artists now serve as an interface between production and the supply and use of information. They act as mediators

between systems and users and they must possess artistic, creative and communication skills.

A final important factor in the transformation of artistic activity is its location. It is a popular belief that artistic activity can function equally well from anywhere. With the advent of new information technologies, it is possible for artists to work in far-away places. However, reality does not conform to this commonly accepted idea. We find that artistic activities are concentrated in towns and cities, especially in certain favoured areas within metropolitan cities. Once an artist is actively involved in projects that need constant revision, he/she must be in a position to move quickly from one project to another, even as he/she is engaged in related activities during the interval in order to have an alternate source of income. This is possible only in areas having a high population density and a wide variety of activities. On the other hand, producers or executors of cultural projects must be located in places where they can easily find people with specialized skills and thus cut down their respective transaction costs. This search for contiguity explains the existence of cultural districts analysed earlier.[17]

Limitations on earnings and options

Underpayment of artists

It is widely accepted that artists' earnings are below average.[18] In the United States, the difference is about 6.9 per cent[19] and it is about the same in England and Germany.[20] In France, the difference is between 10 and 30 per cent depending on the area of activity.[21] And even in the Federative Republic of Russia, where for a long time artists enjoyed a privileged position as compared to the average citizen, their earnings were about 30 per cent lower than the average income in the early 1980s and this figure increased to 40 per cent during the 1990s.[22] However, surveys generally err towards optimism since they study only established artists and not all those who want to be artists or are already artists. The survey conducted by Wassal and Arper on contemporary artists in New England shows that their earnings from art constitute just 46 per cent of their total earnings. Their average earnings are 1.6 per cent lower than those of other

workers, whereas the level of their qualifications is 16.6 per cent higher than that of the rest of the population, and the average level of transfers in their favour is slightly higher than the average for the rest of the population.[23] The artists' position is further aggravated because the cost of artistic activities tends to be quite high and may even exceed their earnings. In a survey of artists in the field of plastic arts conducted in New York in 1989, it was found that their average earnings amounted to US$3,000, while the average cost of their activity amounted to US$9,625, entailing a deficit of more than US$6,000. This deficit is generally covered by earnings from other non-artistic sources, with about a quarter of the artists engaged in more than one non-artistic occupation to make up this loss.[24]

The lower the artist's qualifications, the lower the difference in earnings and vice versa. We tried, together with J. Maurel, to verify this hypothesis of underpay in the case of dancers in France by comparing the results of a field survey of casual dancers attached to several companies (about a hundred artists located in Caen and Paris) with the results of sample groups.[25] The purpose of the study was to compare the level of dancers' earnings with those of other professionals having a similar level of training and qualifications. We found that these dancers generally start working at a very young age (often when they are just 10 years old), do not engage in any other meaningful activity and they change their careers very quickly and radically once they have crossed the age of 30.[26] The results bring out an interesting phenomenon. We found that at present dancers earn 17 per cent less than what they would have earned had they been engaged in non-artistic occupations. But in the case of classical dancers, the difference is only 13 per cent. The difference between the two types of dancers is largely due to the fact that generally the qualifications of classical dancers are significantly lower than those of contemporary dancers, since the former start their career at a very early age and do not continue their scholastic studies. It is therefore necessary to compare them to segments of the population having lower academic qualifications, unlike contemporary dancers who should be compared to segments having a higher level of professional training or academic qualifications.[27]

Having noted these differences, we must also take into account the changes that have occurred over the years. Several

explanations have been offered for the relative decrease in artists' earnings since the early 1980s, such as the stopping of subsidies, allocation of more funds by cultural enterprises for marketing than for payment of artists and the presence of a larger number of artists.[28]

In addition to the low earnings of artists compared to other professionals, there is also a difference between the various sectors of artistic activity. In France, earnings are much higher in the audio-visual sector than in the sector of performing arts.[29] Surveys conducted by ENPALS in Italy several years ago indicate that the circumstances of radio and television artists are satisfactory, but those of stage actors and musicians are pitiful.[30] The same sources showed that the earnings of women artists were lower, the average difference being about 44 per cent.[31,32]

The illusion created by superstars

The existence of a few superstars may lead us to believe that the low earnings of artists are not such a widespread phenomenon. As a matter of fact, the very notion of superstars implies that their number is small. It is not a new phenomenon, and it is created by producers who look at it as a means of increasing their earnings before the artists get a chance to take advantage of their superstar status. It is generally associated with Carl Laemmle, the founder of Universal Pictures (formerly IMP). In the early 1920s, film actors were almost non-entities, as they were known by the name of the studio that employed them. And this was the case with an actress known to the public at large as the 'Biograph Girl' where 'Biograph' was the name of the company she worked for, although her real name was Florence Lawrence.[33] However, she was unhappy with the Biograph Company and the manager Griffith and accepted Laemmle's offer. Laemmle planned to use her image as the 'Biograph Girl' to his own advantage. He signed a secret contract with her even as he announced her disappearance, hinting at an automobile accident. The public blindly accepted this news as it did not know her real name. Three months later, Laemmle announced the release of a film featuring this actress under her real name. The public rushed to see her and the film was a roaring success. The Biograph Company could not do anything to counter this subterfuge, since it had not employed

the actress under her real name. This kind of fame, artificially created by producers and amplified by the media, has given rise to the so-called economics of superstars.

Once technology makes it possible to duplicate services and consumers begin to value a service because the artists involved are famous, then managers are forced to pay high remuneration to the best-known artists. This is a cumulative phenomenon since a well-known artist attracts more viewers, which brings him/her more fame, and this process goes on as the stars become superstars. This phenomenon is even more powerful when the product can be reproduced. Some artists do not enjoy the same degree of success because their work cannot be reproduced endlessly at practically no cost. As Mankew[34] points out, eighteenth-century cabinet-makers such as Riesner, who were great artists in their own right, did not earn as much as the film stars of today. Their products were unique and though they were in great demand they did not fetch the amount of money earned by artists today. The audio-visual media have given birth to a large number of stars and their development has created superstars.

Rosen was the first to go into the details of this phenomenon in his famous article on the economics of superstars.[35] The existence of superstars explains the increase in both demand and supply. There is an increase in the supply because recent developments in the media permit economies of scale. There is an increase in demand because the element of uncertainty is reduced due to the artist's fame. Differences among artists in terms of talent and fame are translated into differences in earnings, and sometimes even a minute difference in talent can be responsible for a substantial difference in earnings. The artist's activity does not effect a change as much as the size of the audience. Adler has contributed to this initial thesis by disputing the claim that the recognition of talent by the public is a quasi-evident phenomenon.[36] Potential viewers select talent at random, since all artists are supposed to have the same skills and, therefore, the same possibility of attaining fame. This selection enables them to exchange opinions with other viewers, and it is only then that some artists find themselves credited with more talent than others. This increases their following among the viewers who have not expressed their opinion. The rise to stardom is a matter of chance. McDonald has dealt with this

question from the supply side. According to him, this distortion regarding earnings is due to the presence of a large number of poorly paid artists. In the race to increase one's earnings, some of them get left behind. Only those who can get higher remunerations survive in the profession because they contribute to the fame of artistic productions.[37]

Are artists forced to put up with the situation or do they accept it willingly?

But if we return to the general situation, how do we explain the chronic paucity of earnings in this field? We will take up later Baumol's famous explanation that the absence of productivity gains in artistic activities can force those working in this field to accept smaller remunerations, but at this stage we will restrict ourselves to pointing out that this is only a partial explanation. Throsby explains these low earnings by claiming that it is the artistic activity itself that is important to those who practise it and they are not overly concerned with monetary returns. The artist is therefore doubly remunerated – by the psychological pleasure and satisfaction that he gets from his activity and by the monetary return. But even if artists get a psychological return, they must also get a monetary return to cover their expenses. It, therefore, follows that their monetary returns cannot decline below a certain limit regardless of their psychological returns. If their artistic activity does not get them a sufficient monetary return, they are obliged to supplement their earnings by engaging in another activity (e.g. a musician gives music lessons, a designer gets a job in an architect's office, etc.). This explains why artists are keen on getting additional income from activities other than artistic creation, activities that are sometimes quite remote from the latter. This has an interesting consequence which helps us to understand their attitude: if monetary earnings from their non-artistic activities increase, they are able to devote more time to their artistic activity despite the low earnings.[38]

This model has given rise to two methods of verification. The first method involves finding out whether artists earn more or less compared to what they would have earned, with the same qualifications, had they opted for a non-artistic career. If a non-artistic career brings them a higher income, the fact that they devote all or a part of their spare time to artistic activities

suggests that they find them useful in themselves, which compensates for the small income. Similar verifications have been performed earlier in the case of musicians, singers, dancers, etc. Generally speaking, performing artists, except for stars and superstars, belong to this category. But it is not possible to deduce from these findings that artists willingly accept this underpayment. The second method consists of finding out if each artist has an income from non-artistic activities that is higher than his/her income from artistic activities. If it is so, the person who does not devote all the time at his disposal to non-artistic activities is supposed to be compensated for this difference in earnings by the psychological return he gets from his artistic activity. On the whole, this hypothesis has been found to be true.[39]

Choice depends on the level of earnings and the type of artistic activity

This analysis of artists' earnings has been reviewed in the most interesting manner in the writings of Cowen and Tabarrok.[40] In addition to choosing between artistic and non-artistic activities, the artist may also have to choose between different artistic styles within the same activity. An artist may thus decide to express himself in a novel idiom that may not be fully understood by his contemporaries. He would certainly gain a greater satisfaction by doing so than by using his time to produce less innovative artistic work, but he may also earn less. If it is true that the majority of users follow the middle path when it comes to appreciating a work of art and the number of those who appreciate avant-garde art is much smaller, then the artist will earn considerably less if he fails to satisfy the average viewer. In other words, the artist will have to incur opportunity costs on choosing an avant-garde style. What are the factors that prompt an artist to choose between an avant-garde style of expression and styles that are more familiar to the general public? There are four possible elements: an improvement in the artist's economic circumstances, the nature of his production function, whether his work is reproducible and the size of the market.

First, an improvement in the artist's economic circumstances will prompt him to increase his artistic activities and concentrate more on work in the avant-garde style. He can then satisfy

his basic needs, in spite of devoting less time to commercial work of a non-artistic nature and more time to artistic activities that are less profitable but personally more satisfying from the artistic point of view. The artist's circumstances may improve as the society in which he lives becomes more prosperous, since an increase in productivity makes it possible to obtain more goods and services for maintaining the same standard of living. It may also be because, for social or family reasons, some artists live in an environment that is more supportive of their activities. This means that artists who are better off are able to devote themselves to avant-garde art, whereas those who are less well-to-do are obliged to give top priority to the requirements of the public. In his book on the choice of activity of young artists in the Netherlands during the seventeenth century, Grampp observes that artists from well-to-do families specialized in painting, whereas those from poor families specialized in less sophisticated decorative work.[41] There can also be an improvement in the artist's living conditions if he receives a subsidy from the state, in which case we find ourselves in a paradoxical situation. An artist who receives subsidies will be able to devote himself to avant-garde art forms, but this will make his work less saleable and he will ask for more subsidies in order to survive. He will thus find himself caught in a vicious circle whereby he cannot survive without subsidies.

Secondly, the nature of the artist's production function and his field of activity will influence his choice of style. In some fields, in addition to talent the artist also needs a lot of capital and his work is influenced by his need to recover the costs. This is what happens in the film industry where the substantial cost of the negative forces the producer to adapt his work to the lowest public taste. In other fields such as painting, the capital required represents a small fraction of the product as compared to artistic talent, and the artist is subjected to fewer material constraints. Consequently, there is bound to be a greater proportion of avant-garde works in the field of painting than in cinema because the nature of the constraints is different. The theatre is somewhere between the two, because it needs more capital than painting (a minimum space for staging the show, sets, costumes, etc.) but less than cinema.

When a work is reproducible, the artist can earn a large profit if his product is suited to the market, provided of course that

the cost of reproduction is negligible or zero. When a work cannot be reproduced, the problem of economic and artistic choices changes everything. The artist does not lose anything by ceasing to produce for the average consumer and it is more advantageous for him to do what pleases him, provided he can find consumers who find his work attractive. This is not impossible, except that the job of surveying the market has to be entrusted to a specialized agency. This explains why there are more avant-garde artists in the plastic arts than in other fields.

The larger the market, the greater are the gains obtained by adapting the work to popular taste. Conversely, profits will be lower if the work does not conform to popular taste. At the same time, the larger the market, the easier it is to overcome the limitations imposed by the costs and consumption. Thus we observe two totally opposite effects. If you look at an artist whose aim is to satisfy the demands of the average consumer, you find that he can afford a slightly more unorthodox style because the size of the market allows him to recover his costs. Similarly, an avant-garde artist too can adopt a style that is slightly more conservative so that he can earn more to cover his costs. In other words, the larger the market, the less dramatic the difference in styles, since the artists will then favour styles that are midway between popular and avant-garde art, which explains the coexistence of several artistic styles.

The search for more flexible earnings

It is quite true that the creation of a work of art is satisfying in itself, but it cannot be said that artists are satisfied with their monetary gains, which are widely known to be insufficient. There are three ways of compensating these insufficient earnings: reformulating contracts related to artistic activities, engaging in non-artistic activities to increase one's earnings and defining the modalities of income over a period of time, which is the purpose of royalties payable to authors and performers.

The first method, which has been described in the previous chapter, consists in sharing risks. From the artist's point of view, this sharing is meaningful only if he can hope to earn more than the amount stipulated in the contract. For that, he must insist on three conditions: first, the amount should be decided according

to the actual results of the work or the 'back end'; secondly, the amount should be based on the gross profit and not the net profit; and finally, it should be based on the anticipated gross profit to take advantage of any income accruing from the adaptation of the product to other mediums of expression or from rights of reproduction. Thus three types of earnings are possible in the film industry: a percentage of the gross earnings or receipts, a percentage of the 'circulating gross earnings' (the gross earnings minus the costs of distribution and reproduction) and a percentage of the 'adjusted gross earnings' (the circulating gross earnings minus publicity and marketing expenses). If the artistic product is successful, the last formula is closer to the first, but in case of failure there is not much left for the artists.

No matter what country they live in, artists are forced to look for alternative or supplementary sources of income through non-artistic activities, as their principal income is inadequate to satisfy their basic needs. The most important source of such supplementary income is teaching. In France, musicians who, considering their qualifications, earn less than the average are able to equal the average or even earn a little more by giving music lessons. A study conducted in Australia shows that the share of income from non-artistic sources is substantial and earnings from purely artistic activities account for barely two-thirds of the total earnings, except for authors who receive royalties on the sale of their published works. This income from non-artistic sources is a determining factor for those actors who cannot depend on the earnings from their theatrical performances.[42] This underlines the importance of social security systems. When these systems were first introduced, the idea was to create a monetary link between periods of activity and inactivity and to balance them, since the amount of the contribution was calculated on the basis of the amount paid as unemployment benefit. But over the years, some of these systems have become a permanent support mechanism for artists and they have a tendency to run short of funds. Consequently, they have to be subsidized through other sources and this gives rise to endless disputes. Resorting to supplementary earnings also results in multiple employers in both artistic and non-artistic fields. Surveys conducted in France show that only 12 per cent of artists have the same employer in the artistic field year after

year, whereas 61 per cent change employers but remain in the artistic field and 27 per cent have contracts in the non-artistic field after having completed a contract in the artistic field.[43]

Copyright and royalties

The search for additional earnings apart from the income from artistic activities has given rise to a debate on artistic and intellectual property rights between the proponents of two diametrically opposite approaches.[44] The first approach refers to copyright, which is based on patent rights. To prevent the copying of certain books and to discourage such publishers, an author's writings are protected for a certain number of years, which is deemed necessary for recovering his investments. In 1709, Queen Anne decided to protect certain works like editions of the Bible and treatises on law for a period of 14 years. Without this protection, no publisher would have brought out new editions of these books for fear of seeing his own publications being driven out of the market by cheaper copies. The producer thus became entitled to an income from the sale of his works. Some believe that the principle of copyright is not justified because the consumer has to pay a higher price than what he would have paid otherwise. Others believe that this income is necessary to guarantee the creation of new products and to maximize the long-term welfare of the consumers. The second approach refers in particular to royalties payable to authors. The purpose of these royalties is to protect the creator of the work, which is considered as an extension of his personality, and the underlying principle is essentially moral. These moral rights are of four types: attribution rights or the right to be identified as the author of the work in question; publishing rights or the right to decide if and when a work should be staged or published; withdrawal rights or the right to withdraw a work from circulation; and the right to integrity or the right to ensure that the work is preserved as a whole. The last right is justified by many, who claim that the violation of a work's integrity reduces the present and future value of all the works by the author and acts as a disincentive for new creations. This reasoning further crowns the edifice of moral rights with the right to repent, which allows the artist to question his own work in order to rectify it or withdraw it.

But this claim to moral rights is not always recognized. There are some who maintain that it is based on a Romantic approach to the role of the artist, which is contrary to the functionalistic concept expressed by Foucault. This view has been reiterated by Rushton who says,

> We are used to looking at the artist as the ingenious creator of a work in which he generously and willingly conveys the most profound meanings. ... It is really just the opposite ... the author does not precede his work ... he performs a function through which he chooses, rejects, selects ... he influences the free circulation, the free manipulation, the free composition or disintegration of conventions... .[45]

If it is so, one fails to understand why this manipulation of ideas should benefit from moral rights. But according to Diderot, the artist remains a creator and he deserves this protection, which Diderot refuses to give to scientists who, he believes, are simple manipulators.[46] To this moral angle is added an economic angle having the same legitimacy as patents. If the production of artistic works is not protected, it will find itself placed at a level lower than the optimum. This idea, which rapidly gained currency in Germany and France, though it is less prevalent in Anglo-Saxon countries, gave rise to three types of economic rights benefiting authors: the right to reproduce, the right to perform and the right to write sequels.

The recognition of these rights protecting authors or intellectual production has given rise to many controversies. In the first place, is the economic argument on which they are based valid? Should they be strictly limited or can they be applied to all those who are engaged in creative activities? Can moral rights be converted into earnings? How should these intellectual property rights be managed? What happens when we enter a virtual world where it is possible to manipulate the contents of a work to such an extent that one wonders where the original work has gone and who is its author?[47]

Economic relevance

Since these rights raise the price of artistic goods, they transfer the consumer's surplus to the producer, which can have a negative effect as the consumer may reject the artistic good in question. But this short-term loss of surplus has the long-term advantage of maintaining the production of works of art and of

preserving both the consumers' and the producers' surplus. The principle of rights by itself is not objectionable, as the problem refers more to the level of rights and their duration. This has given rise to several lines of reasoning.

The first argument is that these rights have sanctioned the creation of a monopoly in order to encourage creativity. Right from Locke's time, it has been believed that every person has the right to own what he produces and this principle underlies all the laws on intellectual property rights. According to others, the recognition of these rights gives the creator a monopoly, which is, in effect, a source of scarcity as well as income. Extending their validity means depriving consumers of a price reduction even after the artist's death, which stresses their role as 'protectors of income'. It is therefore necessary to ask if these rights really contribute to the creation of more works by the author? Some dispute this contention by claiming that these rights lead to an *ex post* income, of which we are not quite certain. Others point out that there were significant literary and musical works even before these rights came into existence and they were extremely successful even then. The underlying argument, which we shall take up later, is that of cultural optimism: once the artist gets approval from the market, it is in his interest to produce more works to fulfil its demands, and this is what produces a large number of successful artists. There could, however, be some agreement on the duration of copyright: insofar as it is intended to encourage the author, there is no need to continue it after his death.[48]

The second refers to the conversion of moral rights into economic rights. For example, the right to integrity is not usually disputed, but is it ethical to terminate it by paying economic compensation? This argument seems valid if a statue created for a particular spot is moved to another. In some countries like France, these moral rights are observed so strictly that they cannot be changed even slightly and they are indefeasible unlike economic rights, which have a limited duration. These rights do not have the same sacrosanct character in the United States. So, when director John Huston's heirs sued Turner Entertainment for transforming Huston's black and white film, *The Asphalt Jungle*, into a technicolour film, the American courts dismissed the case on the grounds that Huston was only an employee of the company that made the film and that his

economic rights had been respected. On the contrary, the tech-
nicolour version of the film could not be distributed in France,
because the director's moral right to maintain the integrity of
his work was accepted without question. After the law on the
rights of visual artists was passed in 1990, the United States has
accepted the principle of voluntary renunciation of certain
moral rights, but not their complete renunciation.

The third argument refers to the application of copyright
laws to copies. The notion of copyright would lose its meaning
if it were agreed that it did not apply to copies. However, there
are some who believe that they should be exempted as they
create consumption externalities. Once products give rise to
network externalities, the appearance of new documents – even
those not protected by copyright laws – can increase the num-
ber of consumers beyond those who are in a position to pay for
the copyright and this contributes to collective welfare.[49] This
argument is somewhat tendentious because it ignores the fact
that the artistic good may not exist in the first place in the
absence of rights. Further, it helps to legitimize a practice that
has little to do with the argument relating to the non-protection
of rights when the copy is said to be private. The difficulty is
that the private reproduction does not remain private and
entails a substantial loss for the holder of the copyright, espe-
cially if the quality of the reproductions is very good. One solu-
tion would be to tax the material used for making private
copies, e.g. blank video cassettes, and the money so obtained
could go to copyright management associations.

These debates on the economic benefits of copyright laws are
all the more significant because we have seen them being
applied in some countries to persons who could not, by any
standard, be qualified as authors or composers. Initially, the
term author was defined very strictly and the only dispute was
whether his heirs had any claim to these rights. But with the
passage of time the concept has become wider. In the field of
books, the term author has now been extended to include trans-
lators and illustrators. Similarly, in the film industry, script
and dialogue writers are also deemed to be authors, while in
the record industry lyricists and those who write the blurbs on
jackets are included in the category of composers. Performing
artists have not lagged behind in claiming protection under the
copyright law for their contribution to the actual staging of a

performance. In France, the law of 3 July 1985 has given them intellectual property rights, called 'incidental rights', related to the use of works in which they have participated. This has had important economic consequences in the fields of cinema and audio-visual productions where actors, stand-ins and musicians have also claimed intellectual property rights along with singers and musicians in the record industry.

The collective management of artistic property rights

It did not take authors long to realize that it would be more advantageous for them to manage their rights collectively, as it would be difficult for each of them to negotiate the observance of their rights in all manner of situations. There are, therefore, two economic justifications for their collective management: inequality of negotiating powers and the high transaction costs. The inequality of negotiating powers arises from the fact that authors are generally solitary persons but are often obliged to deal with powerful collective bodies. In addition, many producers believe that one author can easily replace another and this makes publishers and distributors encourage rivalry among them. Finally, the economic value of a work of art cannot be determined until it is confirmed by the market. As a result, organizations situated downstream take advantage of this lack of information and fix artists' payments according to their own expectations instead of taking into account the intrinsic value of the work. In view of these circumstances, it is advisable for writers to form a writers' union. In addition to inequality of negotiating powers, there is also the matter of the different types of media that are used for diffusing a work. If they are numerous, the author will have to deal with a large number of persons, each of them related either directly or indirectly to a particular media. If the author finds it difficult to define and control the exercise of his rights when confronted with a complicated set of procedures, he will find it even more so when there are several of them. It is possible to lay down certain principles such as the principle of proportionate payment, but the author must be capable of identifying, enforcing and monitoring them, each of which increases the transaction costs necessary for protecting his rights.

Thus collective management of rights seems to be a rational meeting-point for supply and demand. It is a means of pooling

together mechanisms for monitoring, evaluating and defining contractual rules, which can benefit persons working singly. While justifying the collective management of intellectual property rights, we may also ask why collective management agencies do not merge together with the encouragement of the artists themselves. What we have here is a natural monopoly, where the operational cost of the copyright system is bound to go down as the system becomes more widespread. But there are two arguments against this: firstly, the operational costs will be very high and, secondly, since the creation of new products is sector-based, the same process cannot be used for all products. Consequently, collective management can also have negative results. Management agencies may exercise monopolistic powers *vis-à-vis* their members, and they will not manage the rights of both artists who have already gained recognition and those who are not so well known in the same way, since the expected earnings of the former will be considerably higher than those of the latter. What is worse is that an agency managing authors' rights may encourage rivalry between various producers and publishers and strengthen the monopoly of one at the cost of others.[50,51]

The second drawback of the collective management of authors' rights is that the expenses incurred in this can be so high that authors, publishers or broadcasting organizations prefer to negotiate directly among themselves and share the savings thus effected. Finally, since they do not face any competition, these agencies can be quite inefficient and we find that some of them have gone bankrupt even though their work does not involve any risks.[52] Also, many initiatives have been taken in recent years to improve the functioning of these collective management agencies without censuring them. The music industry has set a good example in this respect by adapting itself to the nature of users (discotheques) and uses (payment for each private copy is collected at the time of selling blank tapes, cassettes and CDs for recording purposes).

The challenge of virtual reality

Regardless of the debates on this subject, the protection of artistic property rights presupposes three conditions: the existence of a support system for organizing this protection, the precise

identification of the author, and the spatial identification of rights and their monitoring. The advent of digitization has brought about a fundamental change in these conditions. Digitization has led to the dematerialization of artistic works to a large extent. These works are reduced to algorithms, can appear in different forms and thus become independent of the original form. This constituted the basis of the system devised for monitoring the observance of artistic property rights. Digitization has created such high storage capacities that users can order customized products to suit their needs and add new elements to them as and when they please. Artistic products are now the result of modification of an original work by multiple additions through the dialogue between the user and the computer through the computer screen. Finally, thanks to international communication networks, it is possible to have any number of copies and it has become almost impossible to exercise any control on the violation of rights within the national framework.

This upheaval was already predicted by innovations appearing in the 1960s. Following the advent of cable networks in the United States, some copyright holders and distributing agents claimed that these undermined the traditional production and distribution mechanisms and that eventually the existence of artistic products would be compromised. Cable operators offered to pay a compensation, but that was not enough to remedy the situation, especially since the law courts maintained for some time that broadcasting through cable networks amounted to organizing a private show and that it was not a public broadcasting service. With the coming of electronic art, another new feature was observed, namely the active role played by the viewer or visitor. For instance, many works of electronic art allow the visitor to manipulate the lighting and even change shapes to a certain extent (Tinguely's *Rotaza*, Spinoven's *The Eye*, etc.).

Digitization can strengthen the collective management of intellectual property rights in two ways. As the number of outlets multiply and get diversified, it will become difficult for actors to negotiate individually each contract. They will have to keep a constant watch on how their works are being used and find the most relevant interlocutor in the multimedia chain. As for producers, they have to spend very high transaction costs to

obtain the overall rights from the rightful owners involved in the production of texts, photographs, animated pictures and music, and it is better for them to entrust the job of fixing the appropriate remunerations to institutions. In France, SESAM was set up jointly in 1996 by a group of agencies who were involved in the collective management of music (SACEM), the rights of authors and drama composers (SACD), the rights of multimedia producers (SCAM), the rights of artists working in the plastic arts and graphics (ADAGP) and the copyright for pictures (SDI) in order to work out the respective protocols for the validation of rights. The idea was to have a single organization to calculate the amount of royalty and to handle the orders for payments and transfers. In 1996, the European Union Commission had envisaged a single-window system for the entire European region, which would have made this task simpler and brought down transaction costs related to the knowledge and implementation of rights. But in April 1998, the European Conference in Birmingham adopted a stand that was totally opposed to its earlier stand, probably because those involved in digitization have nothing to gain from the confirmation or consolidation of artistic property rights.

It therefore follows that from an artist's point of view three economic mechanisms are possible: giving permission for exhibition of the work or for the use of various media for diffusing the work, entering into partnerships in order to share profits, and marketing one's products independently. Let us take the example of a content company looking for outlets for its products, which is obliged to adopt a strategy to enhance the value of its rights. The first solution would be to grant a licence for the productive use of its work. If it is a publishing company, it will turn a literary work into a film or it will make a serial based on it. The licence should mention the different ways in which its products will be commercialized in the future and the specific conditions for exploiting each one of them. Once this is defined, the publishing company will be able to keep the entire profit without having to take any operational risks. Unfortunately, it is difficult to know in advance in what ways its products will be commercialized. The history of video-discs illustrates this point: many contracts had reserved their rights only for an optical base, whereas the same rights were later used to produce CD-ROMs without making any additional payment. If a software

company continues in this manner, it will be able to play only a limited role as the value-added products emanating from its copyright will lie outside its traditional sphere of activity.

The second solution would be to stop giving licences and enter into a partnership agreement by offering one's assets for the creation of new products. The company entering into a partnership will have to possess three types of skills or assets: creativity, technical know-how and marketing skills. Such partnerships may be useful in the long run, but they expose the holders of creative assets to two difficulties, namely recovery of assets and sharing of profits. As we have seen earlier, sharing of profits generally gives rise to conflict.

The last solution consists of investing directly in the production of electronic works. The investment is fraught with risk, but the results can be substantial. At all events, the experience of the new giants of the digital age shows that, sooner or later, it is necessary to work in partnership with other companies because this activity involves a number of highly sophisticated and specialized skills.

If none of the above three solutions is practicable, there is still one last alternative: opt for an immediate and total payment in full discharge of all rights. Some well-known authors do not hesitate to take this option, but the person must be sufficiently renowned to obtain cash payment from producers for full rights of his/her work. This sale of copyright to the highest bidder is profitable only for a few authors. An interesting example is the situation that prevailed in the United States in the nineteenth century where, until 1891, foreign authors were not entitled to the same copyright protection as American writers.[53] Because of this, American publishers did not hesitate to print pirate editions of manuscripts that had already been published in the United Kingdom because it was financially profitable. However, they faced one big obstacle, namely the competition between various pirate publishers. Also, American publishers got into the habit of paying handsome remunerations to British novelists after they had given the manuscripts to an English publisher.[54] Besides, they decided among themselves to adhere to the following code of conduct: when one of them announces that he is publishing a particular British novel, the others should not publish the same novel. The system worked quite well and was rarely violated except in the case of Thackeray.

Although pirate editions of all his novels had been published – with his consent and for a consideration – by Harper, 'The Virginians' was also published by another American publishing house, which refused to follow the common code of conduct. American writers clearly supported their British colleagues and demanded that American copyright laws should also protect the latter, because the absence of such protection encouraged competition, which harmed their interests. And when the new law was enforced, the price of British novels went up and there was a relative fall in their number.[55]

CHAPTER 5

CREATION AND HERITAGE

Works of art are made to last, so we tend to look at them differently depending on the period to which they belong. At the time of their creation, we dwell on the risks involved in their production, the challenge posed by sunk costs and the strategic role played by distributors. With the passage of time these concerns make way for others, e.g. how do we define a stock of works of art with reference to the past? And this raises another question of why some works are included in heritage at a given point of time while others are excluded. Are recognized earnings always legitimate? How can they be mobilized to give rise to new activities and do we have the right to change their purpose? Should works of art be allowed to circulate? How do we determine their price long after the death of their creators? Do we have the right to change their objective? How do we deal with the duplication of works of art, whether they are copies or reproductions, fakes or pirated versions?

But instead of starting off by opposing living works of art to those that are dead, it would be better to treat them as a kind of memory, subjected to a continuous process of inclusion and exclusion. We will find among them works that are likely to last a long time, monuments with a long history behind them, objects that have been rediscovered, such as old paintings and sculptures, and new objects hoping to make a direct entry as works of contemporary art.

How is heritage created?

The purpose of all works of art is to become a part of our cultural heritage. But whether they are designed to last, such as musical compositions, literary works and monuments, or whether they get immediate recognition like contemporary works in the field of plastic arts is a million dollar question. The problem of defining heritage gives rise to two questions. First, which among the existing works of art can be recognized at a given point of time as an element of heritage? And secondly, what are the mechanisms that can be used to give contemporary creations a direct entry into the domain of heritage?

Heritage as a convention

The French law of 1913 defines heritage as an 'assortment of ancient monuments or buildings of artistic, historical or cultural interest'. To this we may add

> movable objects (or even furniture which may have been originally designed to be immovable, i.e. permanently fixed to the ground), whose conservation is in the public interest from a historical, artistic, scientific or technical viewpoint.[1]

But even this definition is too narrow and it is necessary to add

> things that are useful to understand our society … whose preservation is in the public interest for artistic, scientific, technical, historical reasons or those related to town-planning.[2]

It must be pointed out that

> human beings need approval from their fellow beings and every period borrows from earlier periods the emotions that enable it to create and produce… .[3]

Consequently, a garden is as important as a chapel and an old postcard is as valuable as a cooking utensil. The concept of heritage can be extended to cover all types of objects and a recent example is the effort to conserve industrial heritage, which covers objects of daily use, as well as natural and cultural heritage. When we look at objects of daily use, we find that their nature changes from day to day with changes in lifestyles and they are affected by our decision to invest in new objects and declare others redundant. As for natural heritage, it is initially a large expanse of land with a collection of buildings and

factories with access roads, which has been redesigned to create houses (Lowell), offices and even museums (e.g. the comic-strip museum – Centre National de la Bande dessinée – set up in the old Champigneulle breweries in Angoulême). As part of cultural heritage, it bears testimony to the growth of knowledge and technical know-how.

Since everything can be considered as heritage, can anything be left out? In his well-known book *Le culte moderne des monuments* (1902), Riegl points out that the heritage cult will lose its intensity as more and more objects are included in heritage and the antiquity of an object will become more important than its historical value. So all that does not belong to the present can be claimed to be heritage, which amounts to saying the same thing in different words. As Poulot says, 'Heritage is a convenient reflection of the present cut off from memory and history....'[4] Antiquity is greatly prized because it promotes the consumption of heritage by the public at large and encourages tourism, which turns heritage into an objective and an attractive product.[5]

How is it that certain things that are considered to be a part of heritage at a given point of time were not so earlier and will also not always remain so in the future? Why is it that objects, which have outlived their utilitarian function and should therefore be without interest, manage to attract a great deal of attention and acquire a new meaning? Some things attract attention right from the time they appear and continue to do so because of tradition. But it must be noted that the majority of what constitutes heritage is selected. An object does not become a part of heritage because of its nature, but because some knowledgeable people agree that it should be so. Since the relationship between a community and objects of heritage does not follow a natural sequence, we must know how to build a new relationship so that a community can create a heritage of its own. We may claim that objects become a part of heritage because of their historical value. The past being a subject of knowledge, archives provide us with an archival heritage, excavations yield an archaeological heritage, art collections give us a museological heritage and so on. Apart from the fact that this heritage mainly interests specialists and does not have much to do with popular culture, things that endure become heritage only if they are recognized as a valuable legacy. There is a difference between a historical

object and a piece of heritage as seen in the example of furniture given by Heidegger. He says,

> Antiquities preserved in a museum, such as a piece of furniture for example, belong to the past; however these things endure even in the present time. ... In the course of time, the piece of furniture gets broken or worm-eaten. ... It is not its age that gives it its special character....[6]

Attaining the status of a heritage object is thus the result of a process of appropriation and reappropriation, which may be either repetitive or intermittent, through which a community recognizes a heritage object or an asset.[7] A new relationship of appropriation is thus formed between these things and the community. Once they are taken out of their original context, movable as well as immovable objects become the subject of a promotion campaign; they are appropriated and reinterpreted. As Barthes puts it,

> Whatever a society may think or decree, the work of art surpasses it, it traverses it like a form which in its turn is filled with more or less incidental and historical meanings. A work of art is eternal, not because it imposes a single meaning on different persons, but because it suggests different meanings to a single person.[8]

What are the reasons for this appropriation? Identity may be one of them. A work of art or an object is preserved and highlighted because it is more representative of itself as compared to other works or objects. This approach to heritage prevailed in the nineteenth century, but it is perhaps less valid than it appears at first sight. When the major national museums such as the British Museum (1753) and the Louvre (1793) were set up, the collections under their roofs had nothing national about them; on the contrary, they gave the public the opportunity to see objects from the great civilizations of the past. Displaying the splendours of Greek and Roman antiquity seemed more important than expressing the national spirit. As a matter of fact, the first national antiquities museum was set up in France only in 1867. At the same time, there was no attempt to classify the wide variety of natural or artificial objects on display into different categories like pictures, works of art, Greco-Roman antiquities, specimens, curiosities, etc. The approach was interesting and all-encompassing, the spirit philosophical and universal. If there are doubts about the relationship between heritage and identity in the case of immovable objects, there are likely to be many

more in the case of movable objects. But heritage is much more than an expression of identity. One of the reasons for including an object in our heritage is its exemplary character. Another reason is our quest for perfection. The establishment of the Louvre Museum was largely justified by the need to provide references to both students and teachers of art and several days in the week were set apart for them. The exhibits have a bearing on both art and history and it must be admitted that the state has demonstrated great wisdom in offering this splendid spectacle to its citizens. If we take this position, we are likely to be accused of conformism or academicism because exemplariness and non-conformity do not go together. We may also ask ourselves if this traditional role of heritage is not outmoded. In what way can ancient aesthetics serve as a reference to our times? Is it not true that modern reproduction techniques can give us the necessary examples of the right quality and thus enable us to save the money spent on the conservation of these ancient objects? We could thus dematerialize our heritage, have remote appropriation and perhaps even modify aesthetic references.

The state can play a crucial role in defining heritage, as seen in France. Right from the days of the *Ancien Régime*, the rulers strove to perpetuate a unitary memory by building monumental structures, commissioning works of art or setting up collections of art objects. Under Louis XIV, almost 10 per cent of the state budget was set aside for arts and since then the nexus between heritage and politics has played a significant role in France. Revolutionary fervour brought about another change, if we were to believe Camille Desmoulins's claim that 'the forty thousand palaces, mansions and castles of France offered the winners a wonderful opportunity to plunder'. But after the initial phase of vandalism aimed at destroying the symbols of the *Ancien Régime*, the National Assembly set up a special committee to look into the future of monuments, arts and sciences dedicated to the nation by the decree of 2 November 1789. As a result of Abbé Grégoire's stand on the preservation of works of art as a symbol of national unity ('Barbarians and slaves detested the sciences and destroyed monuments to the arts. ... Free men love them and preserve them ...'), the state assumed the responsibility for the conservation of heritage following in the footsteps of the earlier monarchical regime. However, giving a concrete shape to this concept of heritage proved to be a

complex problem and the first definitions are seen in the speech made by the deputy, Jean-Baptiste Mathieu, on 19 September 1793. He said,

> Monuments and antiquities, these interesting vestiges of the past ... that history consults, the arts study and philosophy observes, that our eyes take pleasure in contemplating with the interest inspired by the very antiquity of these things and all that gives a kind of reality to the past, are the numerous objects that figure in the inventories and investigations of the Arts Commission. ... It is worthy of the wisdom of the National Convention, of its taste for the arts, to bring to life all these riches, and revive them for the benefit of the ignorant people who despise them

A number of laws were passed to devise systems to protect this heritage and to place under them a growing number of monuments and objects. With the arrival of new mediators, foremost among whom were associations and enterprises, the state tried to preserve its own role by extending its protection to new buildings and setting up memorials, still unable to decide whether it should recognize an official culture or support 'tribal' cultures.

The situation in India is extremely interesting, as there is a very wide range of heritage subject to a multiplicity of public and private decisions and pressures ranging from its use for tourism to its maintenance for religious purposes as well as lobbying by real estate speculators in town centres.[9] The concept of preserving heritage was introduced in India by the colonial government. Lord Curzon, Governor-General of India, declared in 1905,

> I cannot conceive of an obligation more strictly appertaining to a Supreme Government than the conservation of the most beautiful and perfect collection of monuments in the world or one more likely to be ignored by a delegation of all authority to provincial administration Thus it has come about that, owing to the absence of any central and duly qualified advising authority, not merely are beautiful and famous buildings crumbling to decay, but there is neither principle nor unity in conservation or repair[10]

The Archaeological Survey of India, set up in the early twentieth century, was for a long time the only body responsible for India's heritage policy and it had to function in an extremely hostile environment. Some of the monuments were still being used for religious worship and those who managed them were totally opposed to the idea of including them in a colonial list while others were coveted by real-estate speculators. Today,

some 5,000 monuments figure on the list of the central government and about 4,000 on the lists of various state governments. These monuments come under the Department of Archaeology supported by a network of organizations and statutes such as the Indian National Trust for Art and Cultural Heritage (INTACH), the Mumbai Heritage Regulation, the Hyderabad Heritage Regulation, the Maharashtra Regional Planning Act, etc. Faced with the possibility of a decline in the so-called cultural tourism, it has become a practice to distinguish between two types of monuments – those that are interesting from a purely touristic point of view or 'dead' monuments and those that are still being used for religious worship or 'living' monuments. Although this distinction is quite clear in many countries (e.g. the ancient monuments in Egypt), it is not so in India where there are very few monuments that fall exclusively into the first category. This dual nature applies as much to major sites like Jaisalmer as to private residences like the *Havelis* of Ahmedabad, and this has resulted in politicizing the debate on the preservation of historical monuments.

> Under the circumstances, we can understand why the exploitation of tourist destinations like Goa and Jaisalmer does not succeed in spite of the fact that they desperately need to be developed to improve the quality of life of their inhabitants. Such exercises result in tragic consequences: they get caught between the squalor of poverty and the squalor of pretence. Such tragedy cannot be mitigated by emphasizing the gains in terms of foreign exchange – however important that gain may be to the national exchequer....[11]

Similarly, the history of Quebec shows inconsistencies in the concept of heritage. First, it was necessary to draw up an inventory of the flora and fauna of this land of continental proportions. Then, it was necessary to catalogue the heritage of the early settlers, who felt cut off from their original culture, but which had to be preserved by keeping alive their traditions. Thus the preservation of objects, costumes, rites and rituals of the mother country took precedence. With the coming of the English, the heritage of the early French settlers was relegated to the background in favour of the heritage of the new colonial power. So, on the one hand, there was a proliferation of monuments imitating British monuments while, on the other hand, exotic and picturesque objects were also given a lot of importance. Things changed a little after the country became industrialized. It was a time when

people were proud of belonging to the modern world, but at the same time they were nostalgic for the past. Then came the quiet revolution followed by separatist or independence movements which brought about a change in attitude – instead of brooding about the past, it was felt that it should be interpreted. The process of selecting heritage became highly politicized – not so much the purpose, but the criteria to be applied and the display of its elements.

At the same time, there are cases where the state is nowhere near the forefront. Thus the UNESCO World Heritage List, drawn up after the 1972 Convention, serves as an inventory in many countries that do not have a heritage policy of their own.[12] There was nothing new about the idea. As far back as 1937, during its meeting in Athens, the League of Nations had proposed measures to preserve the world's cultural heritage. Soon after the Second World War, special conventions (1956) had envisaged measures for protecting cultural property in case of conflict and later (1970), the need to combat the illegal transfer of artefacts. But the world really became aware of the necessity to protect heritage, and the possibility of doing it, when the temples of Abu Simbel and Philae were moved to safer locations during the construction of the Aswan Dam in Egypt. The principle of the 1972 Convention was not to exclude individual states, but to involve in its conservation efforts states that already had an inventory and a conservation mechanism and encourage those that did not to go in for them. The idea behind the establishment of the World Heritage List is to attract the attention of those who live in the vicinity of monuments to the wealth and diversity of our cultural heritage. It is supplemented by another principle, adopted on the insistence of the United States, namely extending the concept of heritage to natural sites. To qualify for the status of World Heritage, several criteria were proposed, e.g. the object had to be a masterpiece of human creative genius, a proof of the exchange of influences, a proof of a living civilization or one that has disappeared, an illustration of human history, an example of the occupation of traditional territory, or it had to be associated with traditional beliefs, ideas, etc. As opposed to the traditional principles of classification, the strategy proposed by UNESCO lays stress on the notion that heritage sites or complexes can include particular districts of towns (e.g. Cartagena in Columbia) or parts of

the countryside representative of a particular culture (e.g. the banks of the Loire). Despite its shortcomings and all the under-lying political intrigues and populist manoeuvres, this Convention and its list have tried to draw attention to the sites and monuments of some countries in the hope that it would set in motion efforts to protect them and curb the activities of speculators. These efforts do not always succeed. In some cases, they have caused a lot of pillage (e.g. Angkor) and in others they have contributed to the degradation of the site due to the influx of tourists (e.g. Fez). Other choices have given rise to controversy either because they reflect the desire to fulfil geographical and political quotas (mainly in favour of the countries of the South) or because the principle of authenticity stressed in the list is applied very differently in the case of dif-ferent cultures and civilizations.

The efforts undertaken by members of the Organization of the Caribbean Islands for protecting monuments and sites (CARI-MOS) are equally noteworthy. Conservators from the different member countries got together to draw up a list of all their her-itage monuments with assistance from the European Union. In view of the differences in history and culture, they adopted very flexible criteria ranging from historical importance to tourism potential as well as architectural value, originality of materials used, etc. The concept of authenticity cannot be easily adopted in this case because many of the monuments have been modified frequently and used for different purposes.[13]

We should perhaps conclude by taking into account some stable references. An element or object becomes a part of her-itage after the adoption of a convention. As J. F. Léniaud points out,[14] an object becomes a part of our heritage once it loses its functional value after a process of adoption that some prefer to call 'appropriation' and others 'assumption of monuments' (J. P. Sartre). The process of identification as heritage is man-aged by mediators, the chief among them being the state, on the basis of several criteria that are added to the ones men-tioned earlier such as exemplariness, identity and remunera-tive value, and others that serve to elucidate them further. The first criterion is communication. An object becomes a part of the heritage because it is meaningful for a community and because its existence symbolizes its history and the sharing of common values.[15] The second criterion is scientific: an object

becomes part of heritage if it stands out among other objects due to its historical or artistic value and also if it cannot be replaced.[16] The last criterion is economic: an object becomes a piece of heritage because it has an economic value and its disappearance would be a loss for the community. This criterion is reversible because a monument may be destroyed in order to gain economic benefits which, although incorporated in it, cannot be exploited effectively for monetary gains.[17]

Heritage as a destination

The situation is quite different when it comes to contemporary works wanting to make a direct entry into heritage and it can have important consequences. For example, the selection of a church built in a particular style or belonging to a particular period is likely to increase the value of churches belonging to the same style or period, but the stock of such churches cannot increase. On the contrary, the recognition given to a living artist produces a positive change in his creative activities and increases his stock of works. Further, in the absence of objective criteria, this recognition is often the effort of an agent, who is not an artist but a gallery owner or an art dealer, who brings the artist to the notice of the public.

In most countries, the market for plastic arts has a particular structure called an oligopoly with a fringe in which we can also include the market for lithographs and other artefacts.[18] When the producer is part of the core group, he/she is recognized as an artist and can dictate his/her price. He/she can also get a better price for his/her works in the secondary market, which is a positive factor if he/she lives in a country that recognizes the right to follow property. The artist is thus able to control the income from his/her works, but only after paying a commission to the dealer or gallery owner who has helped him/her gain recognition. Even if an artist is on the fringe of the art world, he/she has a chance of gaining recognition. He/she can enter the market without any difficulty as long as the sunk costs are low, but he/she must produce a lot and be prepared for a low price as long as he/she is not associated with the recognized standards.[19] Contacts between the fringe and core groups and between the different sub-groups within the core group are maintained through art dealers and galleries. It is believed that

the art dealer, as we know him today, first appeared on the scene at the end of the nineteenth century when institutions ruling the world of art found themselves overtaken by the advent of new artistic norms. Gallery owners and collectors like Durand-Ruel, Vollard and Kahnweiler, tried to elucidate the norms of modern painting. As a matter of fact, there soon developed a specialization with two types of gallery owners[20] – the gallery owner who was a mere trader buying and stocking works of the more established artists and the more enterprising gallery owner who exhibited works of little-known artists and was willing to take risks. The latter even agreed to finance the work of some artists provided they entered into a long-term agreement giving him the first choice, buyer's monopoly, etc.

There is no unanimously approved convention to qualify contemporary works as works of art. So the process of recognition or the passage from the fringe to the core group occurs only when the work receives a seal of recognition and the artist conforms to an existing model or creates a new model. The adoption of this model makes it possible to identify the creator, gives a brand image to his/her works and reduces the cost of information. This model can be imposed or manipulated by intermediaries such as art critics, conservators, collectors, art dealers and gallery owners,[21] who help in changing a studio product into a work that can be bought and sold in the market. A producer, who adopts such a model, can earn a monetary income because of the differentiation of his/her products and a part of this income goes to the intermediaries as remuneration for services rendered to the creator and his/her clients. In order to succeed, this supply strategy must elicit a suitable response on the demand side and it can elicit it because consumers are prone to imitative behaviour. The purchase of a model by a consumer brings about an increase in the number of consumers who find in it the information they are looking for. As the demand for the model goes up, more information and products related to it become available. Models will thus become the objects of higher adoption yields.

Once a standard or model has been adopted, it is in the interest of both artists and intermediaries to maintain their position and extract as much money as they can from the market as their respective positions can be compromised by the emergence of other standards or models. A group will defend its

celebrity status by holding exhibitions or retrospectives and by associating public museums with these shows. It will take part in international fairs, bring out catalogues and try for orders from public institutions. By giving prominence to a standard or model, its distinctive character gets highlighted and it becomes possible to consolidate the group's income.[22] The group may also try to maintain the rarity of its products by limiting production, by using different mediums or by segmenting artistic references. While they are trying to gain recognition, artists produce a large quantity of work in order to slip into the group promoting the model and by setting in motion a process of greater adoption yields. Once they have established themselves, they reduce their supply considerably, preferring to sell less, but at a higher price. They may also use other mediums as their standard or model, which allows them to fix different prices for different mediums. Often well-known painters try their hand at sculpture[23] or just start 'painting plates'. By adopting a wide variety of mediums, the income from a number of newly created sources is added to the earnings from a reference matrix.[24,25] Finally, they can segment their supply by dividing their work into several periods, following in the footsteps of Picasso (in whose case the periods marked a genuine evolution of his style of painting) for economic gains. The beginning of a new period enables the artist to increase the volume and price of his/her new works without however bringing down the price of works belonging to the earlier period. The only condition is that the artist must not abandon the characteristics of the work that brought him/her fame initially. Picasso's work displays three aspects of this strategy – the division of his work into periods, use of different mediums such as ceramics and sculpture and a reduction of output once he had established himself as an artist.

The difficulty of ceasing to be heritage

Once works of art are qualified as heritage, is it possible for them to get themselves disqualified? The problem arises mainly in the case of works that have been specifically classified. This classification affects a large number of works and the only thing that puts a brake on the growing volume of heritage is the financial difficulties experienced by the state in looking after

them.[26] The recognition and preservation of new works thus becomes impossible and as the queues in front of the classification commission become longer, the absence of protection is felt more acutely. Of course, there are procedures for disqualification and it is surprising that they are never used or used only in very exceptional cases.

This state of affairs can often be explained by the conservative attitude of professional bodies entrusted with the job of classification, which do not like the idea of reversing their earlier decisions or even those of their predecessors. They are even less willing to do this because of frequent reversals of trends, aspirations and fashions in the past, and they prefer to avoid the risk of going against the current. Things become even more complicated when it is not known what direction the current will take! This is only a part of the explanation, because these persons generally act only as advisers or experts and are not empowered to make the final decision.

Another argument seems more relevant. Classification enhances the value of an object while disqualification destroys it. This phenomenon is very noticeable in the case of the most recent and therefore the most striking art form. For example, the classification of twentieth-century houses not only increases their value as real estate but also the value of neighbouring houses. Disqualifying these houses will lead to a fall in their value. This is so true that we are tempted to ask ourselves whether the principal aim of classifying twentieth-century buildings as heritage is to encourage their owners to look after them better and improve their surroundings, and not to give prominence to a particular aesthetic criterion. As long as economic interests are involved, one can expect more severe lobbying for the classification and maintenance of a property rather than for its disqualification.

Consequently, the economic effect of classification can be dramatic. Firstly, owners use a variety of means to pressurize the state to protect their properties and it would not be wrong to assume that this unproductive investment will be equal to the difference between the present and the anticipated income. The income thus obtained is unproductive and resources are badly allocated because these investments do not lead to the creation of new services.[27] Secondly, the owners will not do anything on their own for the upkeep of these properties. They will do just

what the state asks them to do and expect the latter to provide the necessary funds. Finally, this recognition may lead to the privatization of public property and a further increase in earnings. Let us take a look at the 'right to an image' in the case of buildings. For a long time, this right was not questioned, undoubtedly because the chances of getting any financial gains from their commercial exploitation, particularly through the sale of postcards, seemed remote. But recently there have been more and more conflicts between the owners of classified buildings, who hoped to make some money by exploiting their image, and producers or publishers of picture postcards showing these buildings who have no intention of paying their owners. As it frequently happens, law courts have tried to find a compromise solution, but in most cases the solution satisfies neither of the two parties. In a judgement delivered in 1999, the French Supreme Court said that there are no restrictions on using such pictures for private purposes, but if they are used for commercial purposes, the publisher is obliged to remunerate the owner of the classified building or object. This judgement has in a large measure upset the working of the market as regards the use of a non-exclusive attribute of ownership. The court could have simply said that since there is no restriction on taking pictures of the building, the producer can exploit such pictures commercially, and leave the rest to competition. But it felt that the owner should be able to turn to account the source of income artificially created by the government. Classification of urban properties has created confusion about ownership rights by strengthening individual rights, but without making adequate provisions for their resale to the government.

Economists may want to present the cost of classification in a different manner. The satisfactory working of the market implies that the one who finds a new use for a resource becomes its owner and can profit by it (the principle of 'finders–keepers').[28] In this case, the finder does not get the potential benefit of his innovation because he is obliged to accept conditions artificially created by the authorities in favour of the owner which have no connection irrespective of the latter's efforts. It is even very likely that this income may prevent the production of the goods as planned.

It is more difficult to disqualify than to classify. To make the procedures of classification and disqualification more flexible, it

is necessary to ensure that owners of heritage buildings will not be able to exploit them commercially by introducing suitable rules and regulations and ensuring their enforcement by law courts. A more flexible system of classification, which would be valid for different periods and subject to different conditions according to the type of heritage, can reduce the size of these earnings and allow a more equitable allocation of resources in the course of time.

Competition between different types of heritage

Unless there is an unlimited demand for heritage, the increasing attention paid to some types of heritage may lead to the neglect of other types. If the public admires a particular school of painting, museums and collectors will follow public opinion when they evaluate the works in their possession or when they make new purchases. If it is a contemporary school of painting, the artists of this school will increase their supply and make additional profits. From the economic point of view, these changes will occur smoothly if the increase in the price of a particular form of art makes investors turn their attention to other forms. But this does not happen. A study conducted by Geraldine Keen shows that between 1951 and 1969, the value of classical painting increased 37 times, that of modern painting 27 times, of Chinese ceramics 24 times, English silverware 8 times, etc.[29] This shows that collectors do not switch from one form of art to another as easily as one would expect them to.

Further, a growing interest in a particular form of art does not necessarily damage other forms if the stock of heritage is increased artificially. Auction houses do not stop adding to their catalogues, so much so that even the biscuit tins of a famous artist are elevated to the status of works of art.[30] Museums do not hesitate to catalyse these tendencies by including more and more manufactured objects in their collections. They take the risk of destroying whatever consensus there may be on the value of the museum and its management, and the museum which ought to restrict itself to interpreting the value of works of art ends up deciding what is art and what is not. The choice of objects in a collection will depend on the curators, some of them more daring when it comes to accepting new forms of art and marginalizing older forms.

This tendency is more noticeable in the field of music where musicians constantly play new works to please audiences although the time invested in their production is much higher. A striking example is the concerts of ancient music in London, which gradually decided to play only works that were less than twenty-five years old, and that too over a period of almost one century.[31] In the United States, there was a rapid development of symphonic music that gave every newcomer a chance, while American composers were selected by region. Today, musicians have fallen on bad times and contemporary musicians earn very little from original compositions. This is due to the increase in cost of presenting works for the first time as such concerts are often performed before small audiences from the neighbourhood.

Enhancing the value of heritage

There are many ways of enhancing the value of heritage, some of which consist of reviving it without adding any new services, e.g. the reissue of a record, the rerun of a film or printing a new edition of a book. Other methods are based on the introduction of new services, e.g. holding an exhibition of a painter's works, colouring a black-and-white film, reinterpreting a play or a musical composition, etc. However, in the last case the performance may bring a lower return because the public is already familiar with the play or the composition. Some of these methods may be used by private institutions hoping to maximize their earnings from works to which they hold a copyright, others by public institutions wanting to achieve certain social objectives through exhibitions, rehabilitation, etc.

Diffusion, redistribution and inventories

The first objective of the owners of heritage objects is to ensure that they remain popular over a long period of time and that their popularity is revived at regular intervals with the intention of maximizing their earnings. They are prepared to spend to gain access to portals in order to increase their earnings. They are also prepared to give up a portion of the difference between the price paid by the user and the costs borne by them, including the cost of the portal, and put it at the disposal of users. But

when a portal introduces in its programme works that are less in demand than others, it runs the risk of losing its audience as well as its income from advertising or business income. The portal must therefore strike a balance between the profits accruing from the sharing of earnings and the eventual loss of earnings due to the loss of audience.

To understand the pros and cons, let us take a look at the profession of the disk jockey described by Richard Caves.[32] Some record companies give 'payolas' to disk jockeys (DJs) for playing certain pieces of music that are not very popular with the listeners. They earn a twofold profit in the form of broadcasting rights and a greater exposure on the network as compared to other records by the same artists or from the same company. But since the radio station employing the disk jockey is likely to lose listeners by playing this music, it is usually not interested in sharing the payola. This is an old practice which started in the United States where men[33] went from one bar or night-club to another, buying a round of drinks for musicians and singers so that they would play the songs they were promoting. The early record companies found this system too costly and decided to form a cartel in the form of the Music Publishers Protective Association to eliminate competition among themselves.[34] With the growing use of recorded music, methods used to control these payments became less effective and record companies decided that it was better to have their music broadcast in radio programmes of a cultural nature irrespective of the cost, rather than be left behind by their rivals. This movement reached a feverish pitch with 'hit parades' and 'top of the charts' that decided the popularity of a song among the listeners.

Another example can be seen in the book publishing industry. The distributors of a book, mainly bookstores, agree to put in special efforts to give it more prominence in their display. The price they demand for this is often paid indirectly by allowing them higher profit margins, thereby reducing the publisher's earnings. In 1998, Barnes & Noble demanded about US$10,000 to display a book for one month on tables placed at the entrance of its stores and about US$2,000 for a mention of the book in their monthly review.[35] This puts independent publishers in a difficult situation as they are unable to bear this burden and favours vertical concentration which could be a way of reducing kickbacks.

There is nevertheless another method of reviving a work without putting pressure on a portal. It calls for a slight modification of the work to provide an excuse for resurrecting it. This method is often used in the film industry where a longer version of an old film or a new coloured version of a black-and-white film is presented to the public. But this gives rise to two questions regarding the author's rights and obsolescence of the original. Copyright laws may not allow such manipulation when a product's moral rights to integrity are affirmed and indefeasible. The modified version spells the doom of the original work and may even create the impression that this new version will be replaced some day by a still newer version, which will reduce its commercial prospects. Producers therefore prefer to make a sequel rather than go in for a slight modification of the original.

When confronted with the possibility of slow or deferred sales, those who hold stocks of books, cassettes, videos, etc. find it advantageous to hold on to their stocks and offer a larger inventory at a given point of time. This is particularly true because these works are put on display for a very short period and potential consumers do not have enough time to notice them, so they make their purchases from the stocks available with booksellers. Film distributors are aware of this and they periodically rerun old films on the commercial circuit in the hope of earning more through box-office receipts than through the sale of cassettes, VCDs or other by-products (Disney). By building up large inventories, it is possible to realize economies of scale and size even at the risk of selling works at a price that does not always cover the storage and distribution costs.

At this stage, some producers have to make a second choice. Is it better to send works to retailers as and when there is a demand for them or to stock them permanently in retail outlets? The operation costs can be controlled in the first case but not in the second. Without taking the potential demand into account, it is advisable to negotiate contracts for permanent stocking with retailers, and producers have to be prepared to withdraw books and records without claiming a penalty from the retailers even if they come back in a damaged condition. This strategy can also be advantageous because it allows them to display their works for a longer period and thus give rise to more varied demands. To get the best returns from an inventory, a choice has to be made between two methods of marketing: mail order sales with

the risk of mobilizing a public that is already aware or through displays in stores with the risk of having to bear heavy storage costs. In the case of books, studies show that the second method is advisable only if there is a more than 50 per cent chance of selling them through the bookstore.[36] A compromise solution would be for the publisher to send all the demands to a retailer who would be willing to bear a part of the storage costs.

The management of inventories can prompt copyright holders to change their behaviour. Writers and artists may try to calculate the various possible consequences for the publisher and propose a system of sharing profits accordingly. Instead of getting a percentage of the sales, the authors may get a lump-sum payment against their rights. Another problem arises if there is a conflict between the composer and the players at the time of republishing a musical composition. This is a classic situation in the field of music where initially the composer and the player are often one and the same. But when this music is sold in the market, the composer-player has to compete with other players and he only gets a royalty for his musical composition, but not for his playing.[37]

Private and public art collections

All art collections must be properly classified. The classification system is a legacy of the Swedish botanist Linnaeus who devised it for classifying plants and animals. The aim is to classify different series of objects not only according to their peculiarities, but mainly because their juxtaposition gives a comprehensive view of an activity, of the treatment of a substance, a style, etc. Unlike traditional economic activities, setting up a collection increases the marginal utility of the collected objects due to the introduction of an additional element and brings in higher yields.

A study of the behaviour of major private collectors shows that most of them are businessmen and are probably prompted by financial motives. Other studies have shown that, today, returns on investments in works of art are comparable to returns on other investments. What is different is the dispersal of returns and this means that for a collector not affected by the risks involved, the financial gains from his investments in art are comparable to the returns on his other investments. The

strategy adopted by private collectors is now explained as an interest in art for art's sake, an image-building exercise, the desire to use the financial means at their disposal, their ability to manage risks and their knowledge of networks that brings to their notice numerous interesting opportunities.[38] The large American collections often owe their origin to useful information communicated indirectly by friends and acquaintances. Thus Albert Barnes's collection was started on the basis of advice given by William Glackens and Katherine Dreir on the basis of advice from Marcel Duchamp.[39]

Acquisition of art collections by business houses is a recent phenomenon.[40] There are many reasons behind them, such as image-building and the management's desire to find means of satisfaction that its shareholders would certainly not be in a position to provide. Also, in the majority of cases, corporate collections correspond to the management's avowed tastes. The angle of financial returns is generally absent, but it is noticed that collections are started when the treasury is full and they are liquidated when the company finds itself in financial straits. The works of art are displayed in the company's premises, except for those on loan, and they are generally works of recognized artists.[41]

The management of public collections is characterized today by the proliferation of a wide variety of museums and the demands they are forced to satisfy. This has given rise to different kinds of institutions and development strategies.

As regards the different types of institutions, fine arts museums no longer constitute a benchmark following the appearance of ecomuseums, economuseums and interpretation centres. Ecomuseums are meant to draw attention to crafts and industrial heritage housed in buildings symbolic of past activities. They are essentially collections of movable objects that were once the tools or the products of these activities. In European countries, popular arts and traditions occupied a minor place in the world of arts dominated by the fine arts. The reasons for this marginalization go far back in time, probably to the Renaissance, when cultural attitudes imposed

> the rules and principles of a scholarly culture on the higher classes in society while the rules and principles of an oral culture prevailed for other classes.[42]

However, it was not always so. The French Encyclopaedists pointed out in the eighteenth century that craftsmen were capable

of recording and studying technical knowledge. But following the French Revolution, there was a dichotomy between the conservation of these two streams of art. On the one hand, it was decided to set up a fine arts museum in each administrative division while, on the other, there was a general tendency to neglect museums of popular arts and crafts, industrial arts, natural history, manufacturing, construction and design, which grew spasmodically. This cleavage between the artist and the craftsman is a reflection of the false division between intellectual and manual activity. Things are changing today due to three factors. First, decentralization which has prompted various areas and communities to highlight their ethnological heritage as an image-building exercise and use it as a lever for starting new activities. Secondly, the development of archaeology which unearths vestiges of the past and enables us to study cultures and societies that constitute a benchmark. Thirdly, the emergence of an organized market for popular arts and crafts having its own intermediaries, rates and speculators.

An institution that is very well known in North America is the interpretation centre built around a theme rather than a collection. Unlike traditional museums, the interpretation centre tries to devise communication processes by using all kinds of imaginable mediums and makes them available to different types of people so that they can understand the meaning of a theme or a region and its corresponding values. The interpretation function being closely linked with the principle of group dynamics, these centres lay stress on direct contact between people and the acquisition of personalized information by adapting the content and rhythm of messages to each visitor. Unlike ecomuseums, interpretation centres do not always seek to make their visitors aware of the importance or the identity of their region. They have a wider perspective and they address everybody in order to make them understand a technique, a production system, a group, an activity, a region, etc.

The term economuseum, which is very popular in Canada, is both new and elliptic. It expresses the desire to conserve the legacy of small enterprises, often cottage industries, by employing management methods based on the principle of profitability. A small enterprise or cottage industry engaged in the manufacture of traditional or contemporary objects having a cultural connotation is selected for setting up a centre to

explain the production process to visitors and make them aware of their heritage. This symbiosis between an enterprise and an interpretation centre is also intended to draw attention to the environmental qualities of the building or site and its importance as a piece of heritage. Following the globalization of references and techniques, regional and local architecture is no longer synonymous with archaism. On the contrary, there is a conscious effort to restore local heritage to its previous glory through the restoration and maintenance of old buildings.

Together with this diversification of institutions there has also been a diversification of strategies for the management of collections. Should museums continue to be conservation centres or should they also become diffusion centres? Should we target an informed public or many different types of public? Should we confine ourselves to displaying works of art or should we also include artefacts, virtual products, etc.?

We may point out that recent changes in thinking have led to the inclusion of artefacts, virtual objects and even audio-visual programmes in the classical collections of art objects that are normally found in museums. We may also point out the conflict between conservation strategies based on highlighting a collection and those based on highlighting a theme, a region or a technique, thus reducing museums to the status of another popular medium. At one end, we have the classical art museum, whose main purpose is to preserve a collection of works of art without any intention of interpreting them or treating them as a resource for enlightening diverse groups of visitors. At the other end, there is the interpretation centre whose purpose is to communicate information and strengthen the feeling of identity, often with the help of artefacts, virtual objects and audio-visual programmes. The ecomuseum lies somewhere between the two because it tries first and foremost to go back to the community's roots by using works of art and artefacts. The same applies to some science museums whose exhibits include historical objects as well as artefacts and audio-visual programmes.

Together with these different management methods there are also different types of public and methods of funding. Thus museums target a specialized or restricted public except for some 'superstar' museums to which we shall come back later. They find it difficult to cover their running costs with their earnings from

admission charges and they claim subsidies on the grounds that they preserve existence values. Public authorities, who find it difficult to satisfy these demands, would like them to broaden their objectives and aim at a better balance between existence, utilization and communication values. Many museum curators refuse to do this on the pretext that this would change a cultural institution into a centre for leisure activities. They also believe that some of these activities may not be conducive to the preservation of works of art and they do not want their cultural centre to become an area for social communication. This is a serious controversy and it would be wrong on our part to take a simplistic view by giving too much importance to the training of curators and their psychological make-up. The management of public collections and museums has given rise to similar debates everywhere and they highlight the fact that our expectations from museums, which were once simple, have now grown considerably. Two solutions have been suggested to resolve this problem.

The first solution is to change the management strategy by changing the museum's centre of gravity and welcome a larger number of visitors from different backgrounds. This would also solve financial problems. This is true today of the Jacquemard André Museum in Paris owned by the Institut de France, which has entrusted its running to a private organization called Culture espace. The museum is now open every single day in the year and organizes a wide variety of activities ranging from small business lunches and evening receptions to workshops for children and marriage receptions. The collections are well looked after and they have even been diversified and enriched, the employees are better paid and the budget is balanced. The admission charges are about 20 per cent more than in other museums in Paris, but the increase is compensated by providing additional services (e.g. availability of free audio-guides for visitors). Perhaps things would not have gone so well if the museum had not been located in the heart of Paris and if it had not minimized its role in terms of producing existence values.

Another solution to this conflict between objectives has been offered by North American museums, especially those in Canada. They have divided the museum into two separate areas. One of them is open to all free of charge and is a kind of agora where short-term exhibitions are held to attract as many visitors

as possible. The second area houses special and thematic collections and has an entry fee, and it performs the role of a traditional museum. This hybrid form is very relevant as it allows the museum to balance its budget. Furthermore, it solves the very delicate problem of striking a balance between tourists who are keen on seeing prestigious collections and local residents who look at their museum as a place for meeting and communication.

The evolution of heritage from exhibitions to stardom

The practice of holding exhibitions goes back a long way, but for a long time these exhibitions were meant for a limited public. It was also not so widespread as museums were hesitant to allow their works of art to travel to distant lands (except when these works belonged to an individual, e.g. the Hermitage Museum before the Russian Revolution whose art collections were the only ones that travelled in Europe at the Tsar's pleasure). But things are changing fast and now there is a plethora of blockbuster exhibitions. They were organized at the outset for political reasons and the first major exhibition of Italian works of art held in London had Mussolini's support. It was the first time that Botticelli's *Birth of Venus* travelled abroad. But today most of these exhibitions are the result of the museum network's desire to revive interest in their collections. Museums are not in a position to sell their works or to add new ones to their collections and this is a good opportunity for them to attract more viewers and come into the limelight. It is said that these exhibitions contribute to the democratization of cultural practices and one wonders what kind of people they appeal to.

 According to Haskell, the negative effects of these exhibitions are becoming more and more evident and they will probably end up by outnumbering their positive effects. These adverse effects are related to the material damages[43] that are more serious than one would like to believe, the manipulation of artistic criteria and the publication of catalogues that trivialize artistic works instead of conveying more information about them. But what is even more serious and has a more lasting effect is, according to him, the growing segmentation of works of art according to the demand for them. Works that figure in these exhibitions are put into a special category while others that have not been included get marginalized. What is even worse is that museums that are

not a part of this network also suffer the same fate. So Haskell believes that this classification depends more on current trends and political considerations than on artistic merit.

Today's 'supermuseums' have become the equivalent of these grand exhibitions and are the true 'superstars' of the heritage sector. Frey attributes five characteristics to these *superstar museums*.[44] They are a must on every tourist's itinerary and they open their doors to millions of visitors every year (e.g. the Louvre in Paris gets 6 million visitors, New York's Metropolitan Museum gets 4 million and the Uffizi in Florence gets 2 million). Their collections are famous all over the world. Their architecture appears more and more spectacular, whether it is their outward appearance (the Pyramid outside the Louvre Museum and the Guggenheim in Bilbao) or their internal layout (the Metropolitan in New York and the Orsay Museum in Paris). Finally, their supplementary earnings are substantial and often more than the earnings from admission charges.

These museums are subject to certain factors that are similar to those affecting superstars. As far as demand is concerned, the price elasticity is quite low and they cannot be substituted by other museums. As regards information, the media is responsible for their celebrity status that prompts visitors to rush to see them without obtaining additional information. In terms of supply, they take advantage of the economies of scale, which are fairly substantial. They are also affected by the less pleasing factors that affect superstars. Visitors are increasingly torn between the need to visit a museum and the desire to spend their time on other amusements and this has prompted museum managements to concentrate their efforts on the promotion of entertainment and other auxiliary activities. But more than anything else, museum managements tend to give priority to tour operators thus neglecting the functions that they are meant to perform *vis-à-vis* the local population. Consequently, the museum has ceased to be a place of meeting and communication for the inhabitants of that area and has lost its social value.

Conservation of industrial heritage

The conservation of industrial heritage is becoming more and more important because our fast changing industrial society

has left us a legacy of numerous industrial estates. They were certainly not built for artistic reasons, but when they fell into disuse following technological advances, they were either abandoned or handed down to various local governments without assigning any specific purpose. For a long time, this heritage was ignored or even sold off as scrap, an excellent example being the Pavillions Balthard in Paris. The areas that inherited these buildings found them burdensome and did not know what to do with them. But gradually, the authorities saw the light and devised various strategies for their use.[45] The first strategy was virtual salvage: when a highway is being constructed or a museum is being renovated, a picture or a model of a Gallo-Roman villa or a blast furnace is created (Saint Dizier Museum). The second was light salvage: the future is preserved without making any immediate commitment regarding its restoration, a strategy that does not lead to any development. The third strategy consists in rehabilitating a place by introducing activities that have no connection with its previous use. For example, the Saint Etienne factory now houses an engineering college, the spinning mills of Elbeuf have been turned into a public housing estate, the Meunier chocolate factory in Noisiel has become the headquarters of Nestlé, silos have been converted into houses in Brussels, hotels in Ohio and museums in France and so on. The last strategy is to convert old forges into museums, e.g. ecomuseums. Sometimes it is possible to use these old buildings for the same activity, e.g. at Vannes le Chatel in the Vosges region, the old glass factory was converted into a complex consisting of a research laboratory, a training centre for glass workers, exhibition halls, an amphitheatre, a multimedia simulation centre, etc.

The circulation of movable heritage objects

This circulation now goes beyond organizing exhibitions where museums forming a network loan their exhibits to one another, although this practice is on the increase. For economists, there is a simple criterion to find out if works of art should circulate or not. If an object provides more satisfaction in a new place than in the place where it was kept earlier, it is better to transfer it. However, there is a tendency

to interpret this criterion as an opposition between private use (with fewer users and less satisfaction) and collective use (more users and greater satisfaction). So when a work of art changes its place and becomes an object of public use instead of an object of private use, it ought to circulate, but this would be less justifiable in the opposite case.

This argument can be fortified by another criterion: whether an object should be allowed to leave its original place or, in other words, whether it is better to respect its authenticity value or to increase its contemporaneity value. The authenticity value is stressed by those who believe that a work of art has meaning only in its original setting like W. Benjamin's *Hic et Nunc* (Here and Now) and that it loses its aura as soon as it is removed. The contemporaneity value is emphasized by those who believe that it is better for a work of art to be admired by as many people as possible. It can then fulfil its role as a point of reference, a source of creativity and an emotional factor even if it has to lose a part of its aura to do so. Spurred by international organiza-
tions, the Conventions of Athens (1931) and The Hague (1954), the Charter of Venice (1964) and the Nara Declaration (1994) insisted that works of art should be kept in their original loca-tions to preserve their authenticity value. It must be admitted that these conventions and charters have not had much effect except in some rare cases (like the preservation of the temples of Abu Simbel and Philae), nor have the concerned countries implemented them directly.

In more concrete terms, it is better to consider the problem of circulation from the viewpoint of the country of origin than from the viewpoint of the country receiving the works of art.

Legislation to prevent works of art from leaving the country

In France, a law has been in force since 1920 to prevent the export of works of art without prior permission and the absence of such permission means that the work gets registered with the state. As regards internal circulation, the state has enacted another law that allows the administration to exercise its right to acquire a work at a price fixed by the state. The first law restricts the circulation of works of art and gives teeth to the second law by putting a ceiling on the sale price, thus reducing the cost of acquisition of works by the state. Strategic manoeuvres may take

place between the representatives of the administration and the sellers, as the latter can get the necessary permission to sell only by offering a concession on other works of art in their possession. Recently, there have been more debates on the regulation of the sole market. In 1992, a European law made a distinction between national treasures and cultural goods, each country having the right to define its national treasures. These treasures are to be governed by laws, but other artistic goods can be exported freely, temporarily in a few cases but permanently in most cases. The list of goods governed by preventive regulations is not definitive and the only criterion envisaged at the time was a minimum price of approximately €50,000 so that goods whose market value was lower than the stipulated price could circulate freely.

Law courts to regulate the entry of works of art

Courts usually have to intervene when works of art are smuggled into a country to determine their rightful owner and decide if the disputed transfer should be cancelled. In the United States, many objects including terra cotta figurines, pottery, wall paintings and pearls were brought into the country illegally. In their country of origin these objects were rarely identified which left their true origin in doubt. However, in 1977, in a famous judgement, a Texas court decided to convict dealers who had imported these works, and obliged the buyers to return the objects to the countries which had filed a suit. It took a great deal of time to enforce this legislation because the ownership rights of the country of origin had to be clearly established and this gave rise to a series of conventions between the United States and Latin American countries. But the movement spread and even the United States Congress asked institutions like the Smithsonian to return objects that could be classified as relics and should be returned to their natural surroundings. These practices were followed even within various States and Canada decided to follow them in the case of objects belonging to Indians and Eskimos living within its territory. Gradually, countries started implementing the UNESCO convention adopted in 1970 asking all members to protect their heritage from illicit traffic within the country and also from international smugglers.

In 1983, this law proved to be very effective in the case of the Mycenaean treasure of Aedonia. While excavations were being carried out officially at the archaeological site in Aedonis, New York's Michel Ward Gallery put up for sale a large collection of artefacts together with a catalogue. The Greek Government immediately filed an appeal, following which the gallery cancelled the sale and returned the artefacts. But before these artefacts left American shores, two exhibitions were held in the United States and special arrangements were made for their display in the Athens Museum. However, the argument generally used in support of the refusal to return such objects, namely the lack of protective measures in the country of origin, could not be used in this case to turn down the request as in the past.

The main difficulty in enforcing the law is the absence of a bilateral agreement between the country of origin and the country to which the work of art is taken. The Unidroit Convention of 1995 was adopted for the express purpose of putting an end to the illicit traffic of works of art. This presupposes the existence of bilateral co-operation accords between the countries concerned, which would enable them to ban all illegal traffic of works of art between them. However, the implementation of this convention, which would strengthen the law for the protection of national treasures, is very slow. An agreement was signed between Italy and the United States on 19 January 2001, but other countries like France have not yet ratified this agreement and, as a result of this, it has not been implemented so far.

The plundering of national treasures: contemporaneity value or authenticity value?

In his book *La voie royale*, André Malraux defends his abortive attempt to remove bas-reliefs from the abandoned Cambodian temple of Banta-Srei. He was found guilty and forced to return the bas-reliefs to Cambodia. According to him, by exhibiting these abandoned masterpieces in France he would have restored their cultural function. As a matter of fact, Malraux hinted that a work of art has two values: an ethnological or historical value which is meaningful only in the context of the life and thought of movable or immovable objects, and a contemporaneity value which gives them a new social role such as creating aesthetic emotions and contributing to further creation.[46,47]

Two examples supporting this argument are the Parthenon friezes and the horses of Saint Mark.

In 1982, Melina Mercouri, who was then Minister for Culture of the Hellenic Republic, demanded that the marble friezes from the Parthenon be returned to Greece to restore the symbol of an ancient civilization in its birthplace. Lord Elgin, the perpetrator of this vandalism that took place in 1801 with the connivance of the Turkish Government, was criticized even in his time, but despite that the British Government bought the friezes from him and displayed them in the British Museum. It is a never-ending controversy and the British Government's most positive response to Greece's claim was to offer to send copies of the originals. The staple argument against their return was that the friezes were better protected from atmospheric pollution in their London home than in the open-air site in Attica. This prompted the Greek Government to declare recently that it would construct a special museum in front of the Acropolis to house the friezes. The Greeks hope to demonstrate that it is possible to resolve the conflict between the conservation of architecture and sculpture and that there is no conflict between the identity and contemporaneity values so dear to Malraux.

In 1815, after signing a peace treaty, France returned the four horses from Saint Mark's Cathedral in Venice brought to Paris by Napoleon and displayed atop the Carrousel triumphal arch of the Louvre. These sculptures, whose Byzantine origin is quite evident, were plundered from Constantinople by the Crusaders with the help of the Republic of Venice. However, the Turkish Government has never asked for their return and, consequently, there has been no conflict between their authenticity and contemporaneity values. There is no doubt that this is so because these sculptures were displayed in Saint Mark's Cathedral for so many centuries that they became an indisputable part of its identity.

The price of movable heritage: painting

Analysing the prices of movable heritage satisfies two major concerns. First, is it possible to explain how the price of a work of art is fixed at a given point of time, particularly at the

time it makes its appearance? And secondly, how do prices change with the passage of time and can works of art be treated as good investments? The first question applies mainly to the price of contemporary works of art about which there is no information available in the market, and an attempt has to be made to fix a reasonable price. In the second case, we are dealing with works that have existed for some time and we must ask ourselves what price we would be prepared to pay for them in view of other purchases that can be made and the possibility of an increase in their price. It is advisable to remember how the price of works of art reveals a complete reversal of the standard analysis used for fixing prices.

The reversal of the price-fixation model

From the economist's viewpoint, the price of an object is fixed under the joint influence of supply and demand. Thus it will be higher when the demand is higher than the supply and vice versa. But the situation changes depending on whether we are looking at it from a short- or a medium-term view. In the short term, the supply is fixed and the price varies under the influence of demand and the needs that it can satisfy. In the medium or long term, the supply may change and the price level will depend on the cost incurred for producing a good to satisfy the demand for it. So the price will be determined by the cost of production whereas in the short run, it was determined by its availability.

But the price of works of art follows the reverse pattern. Historical works show that many works of art began their lives as services intended to fulfil recognized economic functions such as decoration, construction, etc. and their price was fixed according to the cost incurred for their production.[48] Painters were paid according to the size of the painting and dramatists, during the Renaissance and various golden ages, were paid according to the length of the play, the number of characters, etc. To illustrate this idea, let us look at fifteenth-century Italian paintings. In his book *L'œil du Quattrocento*, Michael Banxdall analyses the terms of the contracts whereby 'patrons of art' fixed the remuneration of artists engaged to paint pictures or frescos for them.[49] According to one such contract, Borgo d'Este, the

Duke of Ferrare, agreed to pay £10 per square foot for the frescos to decorate the walls of the Palazzo Schifanoia. According to another contract, the Florentine merchant, Giovanni di Bardi, paid for paintings according to the materials used and the time taken by the artist. The contract between Giovanni di Cosimo di Medici and Filippo Lippi for painting a triptych is even more informative. It specified that Saint Michael should figure in the picture, but it did not mention the colour of his clothing. Since the patron wanted the painting to be gilded, Lippi wrote to him asking for an amendment of the contract as gold would be very costly and the cost had not been included. He wrote, 'If you agree to give me sixty florins to cover the cost of the material, the gold, the gilding and painting, Bartolomeo acting as I have proposed, I undertake for my part, in order to cause you less worry, to complete the picture by August 20... .' These contracts clearly indicate that the artist was paid according to the cost of production. Although he could demand more payment once his reputation was established (but this would happen much later), he still had to respect scrupulously the patron's wishes and a preliminary sketch was included in the contract. This method of fixing prices did not however mean that patrons did not have motives other than the decoration of their homes. They also derived aesthetic pleasure from these works. The glorification of God and defending the city's honour were among the subjects of these paintings and they could, if the need arose, justify an increase in price.

In the long run, these considerations lose their significance. The price then depends on the intensity of the demand for exceptional works or on the unavailability of a work whose cost of production has been recovered a long time ago. Is it not said today that if there were no Japanese buyers, the price of the Impressionists would fall by at least 30–40 per cent in the market? The model for determining the price is thus inverted. Usefulness, which is one of the factors that explains how prices are fixed in the short term, is valid in this case only in the long run. On the other hand, the cost of production, which explains the long-term value, is valid here only in the short run or, to be more precise, at the time when such works make their appearance. These explanatory models have to be further specified according to whether we are dealing with the market for contemporary or old works of art.

Aesthetic value and market trends: the price of contemporary painting

The price of a contemporary painting by Tinguely may be higher than that of a painting by Pistoletto and lower than that of a painting by Rauschenberg. Does this mean, as Frey and Pommerehne claim, that Rauschenberg has been painting longer than Tinguely and Tinguely longer than Pistoletto because they were born in that order? Or does it mean that the price is linked to the number of exhibitions held by the artist in the past, because here again we find that the first artist has held more exhibitions than the second and the second more than the third? Or does it mean that the price is influenced by the artist's nationality since the first is American, the second Swiss and the third Italian? Or, finally, does it mean that the gallery with which the artist is associated determines the price because all the three artists work for different galleries? It appears that several factors must be identified before deciding if statistical data allow us to determine the relative importance of various artists. There is no doubt that the cost of production can serve as a basis for determining the price. The price of a new work in the market reflects the costs related to the medium of expression, the style and the materials used by the artist. It follows automatically that the cost of a drawing will be lower than that of a painting which itself will be lower than the cost of a sculpture and so on. But the price will ultimately depend on aesthetic satisfaction that is not necessarily linked to the conditions of production.

What are the factors that determine the value of a painting? The first factor responsible for the price difference is the style.[50] If we make a distinction between various styles of abstract or non-figurative art (abstract expressionism in the United States, tachisme in France, etc.), pop art, op art, etc., we have a basis for determining the value that confirms the latest trends arising out of the relative scarcity of these works. The second basis for price differentiation would be the importance of the artist's earlier work. This refers to the number of exhibitions in which he/she has participated and the number of awards he/she has received. Similarly, the time that has elapsed since his/her first exhibition is also a factor that adds to the value, as information about the artist and his/her works

is available for a longer period. Another likely factor is linked to the number of different mediums in which the artist expresses himself/herself. If he/she works in three mediums of the visual arts, e.g. painting, sculpture and graphics, he/she has a greater artistic value than other artists who work only in one medium. A final criterion is the price fetched by the artist's works during the latest sale of his/her works, which would mean that the price is determined through recurrence or regression.

An econometric analysis of these variables involving a hundred artists studied during the period 1971–1981 confirms some of these hypotheses.[51] It was found that artists expressing themselves in several mediums such as drawing, painting and sculpture were rated higher than those who confined themselves to only one of these mediums. Being the recipient of an award was the second determining factor followed by the holding of a one-man show. On the other hand, two factors seem to pay a limited role: participation in group shows and the date of the first show in which the artist took part. As for the role of different styles, it corresponds to the hypothesis presented above according to which old styles have less value than new ones, though it was not possible to determine if this was the result of fashion or the existence of a large stock.

The market also plays an important role in determining the price, especially due to the strategies employed by galleries holding exhibitions of certain artists to promote the sale of their works, and also the amount spent on publicity. Some galleries do not hesitate to buy works in order to sell them later. This helps to raise the price as the artist gets more recognition in the market than he/she would have got in normal circumstances considering the processes involved in establishing his/her artistic worth.[52] This factor has the opposite effect if for some reason it is difficult to sell his/her works or if the gallery's expectations are not fulfilled. Artists themselves adopt certain strategies for enhancing the value of their works. In the expectation of higher prices, some artists prefer to increase their supply in order to give a boost to their immediate earnings while others reduce their supply in order to capitalize on the paucity of their works. Another factor that can upset the market is the death of an artist. This freezes the stock of his/her works and usually triggers off a speculative rise in prices.

On the demand side, there are the foreseeable classical factors such as the amount a buyer is prepared to spend on the purchase of works of art, tax benefits and anticipation of inflation since works of art are considered to be an investment.

Owing to the multiplicity of factors, we may finally ask ourselves if the artistic value as determined by experts really plays a determining role. In a study carried out in the United States, Frey and Pommerehne observed that the difference between the artistic value determined by experts and the value that can be anticipated on the basis of the variables described above is hardly more than 10 per cent, irrespective of the fact that the painter was studied during the period 1971–1983. If we compare these values to prices obtained in auctions, the relation between them is satisfactory. Buyers seem to be guided by the artistic judgement of critics or experts. As for experts, they have a fairly wide understanding of the value of various artists based as much on their 'recognition' as on the intrinsic quality of their work.

Is it advisable to invest in works of art?

After the Second World War there was a spurt in the international sales of works of art and records were broken one after another as though nothing could hold the market back. In 1984, the record was held by a Turner landscape entitled *Folkstone* which was sold for almost US$9.4 million. A year later, Van Gogh's *Landscape in the Rising Sun* almost touched US$10 million (9.6 million to be exact) while Mantegna's *Adoration of the Magi* exceeded that figure (US$10.4 million). But in 1987, Van Gogh's *Sunflowers*, bought by the Japanese Insurance Company Yasuda for US$39.9 million, created a new benchmark. This record was broken before the year ended by Van Gogh's *Irises* sold for US$53.9 million. It is interesting to note that the seller's mother had bought the picture thirty years earlier for US$0.5 million at current prices which means an actual return of 12 per cent per annum. Does this mean that works of art are a good investment even if prices are high? It is tempting to say so in view of the above figures. However, it is necessary to proceed cautiously. The variables involved are many and partly unexpected. But results based on practical experience indicate that works of art are not a popular form of investment.

Information regarding prices in auction halls can be taken as a starting point. Price movements in less organized markets such as flea-markets and barter deals do not have the same value because these markets do not guarantee the sale of works at prices that can be considered credible. The authenticity of a work is the second important factor considering that the history of the art market is replete with the sales of fake Dürers and Rembrandts. Consequently, the price of these artists went down (although the price of a Dürer shot up when it was identified as a Van Eyck). Certification of works of art poses a serious problem as forgers have kept pace with art experts by improving their techniques. One of the best examples we have is that of Corot. The artist is supposed to have painted about 3,000 canvases during his lifetime, but there are about 8,000 Corots circulating in the United States alone! Of course, we must not forget that the painter was rather liberal with his signature. The transaction costs of works of art (auctioneers' fees, taxes, insurance, transport and storage charges) are the third factor to be taken into consideration as they keep on increasing. Just the auctioneer's fee can amount to 10–20 per cent of the sale price. Protecting the works from theft is another important element of transaction costs. During the last decade, the number of works stolen has trebled while the percentage of stolen works that were recovered has gone up from 22 to 25. This can be attributed to the fact that in a growing market for works of art, there are thieves using more and more sophisticated methods and there is no agency to keep track of the total number of works that are stolen.

Several studies now available tell us whether the purchase of a work of art is a good investment. They all proceed in a similar manner. They look at the general price index over a long period, generally ranging from the seventeenth to the twentieth century. Then, if the required data are available, they take into account the price index of works of art whenever relatively regular transactions can be identified during this period, which is sufficient to eliminate certain works.

Several conclusions can be drawn from these studies. In the first place, it is possible to see the changes in the price of a particular work. When you take inflation levels into account, the rate of returns over such a long period seems quite low. Thus the price of Velasquez's *King Philip IV*, which increased from an

equivalent of US$600 in 1645 to an equivalent of US$40,000 in 1910, represents a return of just 2.7 per cent in real terms. On the other hand, there are losses in some cases. Alma Tadema's *Discovery of Moses* bought for £5,250 in 1904 should have been sold for £23,700 in 1960 to maintain its value in the face of inflation, but it was sold for only £252!

Secondly, it is possible to assess the average return on a painting and many such studies have been undertaken since Anderson's study on this subject in 1994, which is treated as a primary reference work.[53] If we take another look at the studies conducted by Frey and Pommerehne, we find that the rate of returns on painting as a whole during the period under consideration amounts to only 1.5 per cent. This figure is extremely low as compared to the estimated returns on other investments, be they financial or real estate, which are at least 3 per cent. Investment on painting thus represents a loss of about 1.5 per cent per annum. This is the average and an investor can only hope that he/she does not fall within this average. But Anderson claims that the return is substantially higher – about 6 per cent – which allows us to invert these conclusions. Some paintings bring in very high returns, e.g. 26.3 per cent for Franz Hals' *Man in Black*. Since they were put on the market, the best known Impressionists have brought a return of about 10 per cent which is an excellent performance. On the contrary, painters like Alma Tadema, Rosa Bonheur, Joseph Israel, Sir Joshua Reynolds, etc. are not doing well at all. But the real problem lies elsewhere. There is no point in calculating today the returns for a period stretching over several centuries, which exceeds the lifetime of an investor and also that of his descendants. So it is necessary to revise the conclusions according to the period of ownership of the painting. According to the studies mentioned above, the rates of returns change according to the periods under consideration so that in addition to the dispersal of painters there is also a dispersal in time. Between 1635 and 1949, the average rate of returns was 1.4 per cent as compared to a pre-inflation rate of 3.7 per cent and a post-inflation rate of 3.3 per cent on financial investments, which shows that the purchase of works of art is 'on average' not a good investment. The opportunity cost of holding a work of art is about 1.9 per cent per annum. It seems that these poor results can be explained as an effect of trends that make some artists lose their value before they start going up once again

(e.g. El Greco, Jan Vermeer and Joseph Turner). Since 1949, the rate of returns on the purchase of works of art has gone up to 1.7 per cent. During the same period, the rate of returns on financial investments has come down to 2.4 per cent per annum due to a rise in the level of inflation, and the opportunity cost has consequently come down from 1.9 to 0.7 per cent. The relative attraction has increased not so much due to changes in the value of paintings as such but due to changes in returns on long-term financial investments. During this period, the standard deviation has lessened leading to a more uniform rate of returns on various paintings. This may be the result of a more organized market where the opinion of specialists has become a determining factor.

A more recent study conducted by Gérard-Varet and others supports this argument.[54] The period under consideration is not so long (1855–1970) and the prices refer to the public sales of works of artists born after 1830, which eliminates violent fluctuations in the prices of certain artists. The average rate of return during this period amounts to 5.6 per cent, which is much higher than that indicated by earlier studies. Further, the rate varies according to the periods under consideration. Thus it is 6.6 per cent for the period between 1855 and 1914, but it goes down to 0.5 per cent during the period 1915–1949 and rises to 12 per cent during the period 1950–1970. So investment in works of art appears to be profitable during the contemporary period while it was not at all profitable in the period between the two World Wars.

Another conclusion that can be drawn from these studies is that the return on a painting varies inversely with the period of ownership. The optimal period seems to be between twenty and forty years, always with the same internal dispersal. When the ownership period is longer, the return has a tendency to go down, but the dispersal of returns between different works also goes down, and this implies a reduced risk. After studying these analyses, it is difficult to claim that the purchase of works of art is a profitable financial investment. It does not seem to be very much more profitable than investment in securities and it is even less profitable when inflation is under control. This observation, that some people will find surprising in view of the present trends in the art market, can be explained in two ways. In the first place, the high transaction cost of a work of art brings down its value as compared to the expected value. Further, there are other reasons for owning a work of art such as the pleasure of being the owner

of a prestigious work of art and income obtained by exhibiting it, motives which are more or less included in its sale price.

Proliferation of heritage: copies and fakes

When a work of art is meant to last, copies and fakes are bound to appear. We may point out in passing that some arts such as lithography and etching are based on the principle of reproduction and a series of etchings is considered as a series of works of art, their number indicating only a difference of degree. The difference between a copy and a fake lies in the fact that a copy is admitted to be a copy while a fake is passed off as the original with the intention of cheating. This distinction must be kept in mind because the problems it raises are quite different from one another. Artists are not always opposed to copies and some even make a living out of them whereas fakes are a violation of their art and their resources.

Before examining various arguments, it is advisable to find out if it is possible to make a clear distinction between originals, copies, reproductions, fakes and pirated versions. In their valuable contribution on this subject, Benhamou and Ginsburgh point out that courts in New York declared that a picture, 90 per cent of which had been repainted, could no longer be considered as an original and could even be considered a fake.[55] In the case of sculptures, copies are admittedly works that require a high degree of skill and many hours of work.[56] These two examples show that the dividing line between the original and the fake is extremely subjective, while that between the original and the copy is relatively easier to decide because there is no intention to cheat. Another criterion that adds strength to the previous one is the cost. A copy is generally less costly than the original whereas a fake may cost just as much. In the case of copies, there is another distinction: copies made by using the same technique of production and copies made by using other means. The former will be described as copies and the latter as reproductions. Fakes should be easier to describe provided they are discovered. But difficulties may arise because these fakes may be reproductions of works that were themselves not genuine. Finally, piracy refers to the large-scale production of fakes and affects cultural industries rather than painting and sculpture.

Copies: from being the lesser evil to stimulating the art market

Copies may have a positive effect. They provide artists with a means to hone their skills and build up their artistic capital. During the Renaissance, making copies and imitations was widely accepted as a means of acquiring skill and renown, and even great artists like Michelangelo, Breughel and Vermeer personally supervised the production of copies of their own works, which they managed to sell at the same price as the original. Some collectors were quite happy to collect copies and commissioned well-known artists to make these copies. It has been pointed out that in the seventeenth century the price offered for originals in the Amsterdam market was not much higher than that of copies.[57] More recently, the Rodin Museum was supposed to make up to seven copies of the works that the sculptor had left behind in his studio. But the interest in copies declined gradually as the opening of public museums brought about a change in references in favour of the original.[58]

Secondly, copies served to stimulate a potential demand for certain types or styles of paintings. This was observed in the case of coloured engravings and it set a trend. This trend is also seen in auctions organized by large auction houses, including Christie's in Amsterdam, where the number of copies, especially the more expensive copies, seems to go up year by year. It is not so commonly seen in the sale of copies in museum shops even though it does exist to a certain extent.[59] Generally speaking, this propagation effect is considered to be positive.[60]

Finally, copies can have a network effect by prompting a large number of consumers to go in for the same product and by increasing the usefulness of this consumption for each one of them.

Fakes: condemned by almost everyone

There are hardly any arguments in favour of fakes. Perhaps the only one is that they provide the average artist the means to attain fame and increase his earnings. While copies have received recognition, fakes are considered to be harmful, not only for the artist but also for the consumer and the working of the market.

The first argument against them is that they give rise to heavy costs for certifying the authenticity of works of art. The

information available is no longer sufficient and enormous transaction costs have to be incurred to ascertain that the work is genuine, especially because technological innovations make it more and more difficult to recognize fakes. One would expect that dealers would check the works that pass through their hands to protect their own reputation, but experience shows that they can be tempted by short-term gains in the hope that the fake will not be discovered. The second argument against fakes is the financial loss suffered by artists and producers. Not only are they not entitled to any royalty on fakes, but the presence of fakes which can be passed off as originals will bring down their price. This is very evident in the case of video-cassettes where the proliferation of good-quality fakes sold at a lower price drives legal videocassettes out of the market. The extreme case is when, thanks to digital recording, the fake is of the same quality as the original and is available at a significantly lower price.

Is it necessary to add, as some would like us to, that the presence of fakes can act as a disincentive for the supply of artistic goods? An artist-producer will be discouraged by the presence of fakes and forgeries and he/she must always be prepared for such an eventuality. The only way out for him/her is to hope to amortize his/her costs through the sale and diffusion of original works before they are exposed to competition from fakes. This will inevitably prompt him/her to make products that can be sold quickly and lose interest in others. Fakes therefore serve to encourage the production of artistic goods that are the most sought after and discourage the production of those goods that are not much in demand.

On the contrary, as Frey points out,[61] the debate on fakes assumes a completely different dimension when one considers that art depends more on recognition than on money. The proliferation of fakes will make an artist more famous, but he/she must ensure that the originals can be clearly identified. Together with this recognition, if the artist was certain that he/she would get what was due to him/her, the debate would have a different ending since digital art and digital recording techniques have revolutionized its very basis.

CHAPTER 6

WORKS OF ART AND CULTURAL INDUSTRIES

Artistic activity usually begins with the creation of an original work of art and leads to the manufacture of artistic goods on an industrial scale. The major artistic products are books, records and films. However, there is hardly any relationship between each of these industries and the original creation. The reproduction of works of art is an age-old phenomenon and the novelty lies in the advancement of the tools for reproduction. Whereas at one time there were only a few simple processes like casting or stamping, they have developed over the years and it is now possible to combine various processes of modification and reproduction.

One way of approaching this transition from works of art to industrial products is to examine the nature of the original goods and the final products and verify whether they provide the same amount of satisfaction. Let us take the case of music. The listening conditions are bound to be different according to the nature of the goods, namely a live performance in a collective space versus recorded music in one's home. Some people believe that there is a shortfall in quality. Reproductions do not have the 'halo' of authenticity that distinguishes an original work of art, nor do they have any exhibition value. When a CD-ROM brings to life the splendour of Gothic sculpture in a drawing room, the cathedral becomes virtual and the work of art loses its aura and retains only its exhibition value.[1,2]

Walter Benjamin cites the example of rock carvings to show the difference between the authenticity value and the exhibition value. He says that the images on the walls of a cave dating back to the Stone Age had a magical significance, while a photograph only has an exhibition value.[3] Artists' roles have also changed. While earlier they performed before a live audience, they now perform before a camera and acquire an aura similar to film stars. Similarly, the nature of the audience has changed. Once its cultural value gets diluted, art becomes a form of entertainment and it is judged by its entertainment value.

Another way of understanding the difference between works of art and cultural products is to question the changes in economic reasoning and the structures that accompany this transition, and it is only here that economists can intervene, as they cannot go into the earlier debate on aesthetics. While the production of a unique work of art is an intrinsic part of artistic activity, the production of cultural products has to obey the dictates of the market. This may give rise to a tension between creators and industrial producers, since the artist who sees his work taken over by cultural industries is forced to accept their monetary assessment of his work, which is usually according to commercial rather than artistic criteria. Cultural industries thus appear as oligopolies consisting of a core of major corporations, which are not prepared to give up their role as distributors, with a number of smaller production and management companies at the fringe. In other words, they could be described as 'oligopolies with a fringe'.

The change in the economic scene is not, however, confined to the replacement of small-scale production by an industrial chain, with the growing domination of upstream activities by downstream activities or even the domination of production by the market. The advent of digitization and the Internet has changed the situation by bringing about a symbiosis in the markets for cultural products. A product created for a particular market can also be sold in other markets, thus encouraging the integration of enterprises whose fields of activity were earlier considered to be different from each other. Multimedia groups prefer to convert this excessively vertical integration into horizontal integration. Instead of having two independent stages – the creation of a work of art and the conversion of a work of art into an industrial product – there is now only one

stage, where the work of art is created in such a way that it can be easily adapted to different media that users can appropriate. The labels of communication and leisure now cover artistic activities whose uniqueness gets dissipated in hybrid products like amusement parks and video games. This is the new model favoured by cultural industries.

The creation of oligopolies and the triumph of marketing

The development of cultural products has been associated with their efficient marketing, since it is necessary to recover their sunk costs, which are usually very high, by covering as wide a market as possible through a diverse network of outlets and portals. Although their production may be handled by several enterprises, the marketing of cultural products is in the hands of a few groups. Some of these groups may also be engaged in production, but they are all in a position to organize the distribution chain and promote the cultural products because of their strategic position. Let us take the example of the book industry in France.[4] Two distribution groups – Matra-Hachette and Vivendi-Havas – have divided the market between themselves, whereas the number of publishers has more than trebled during the last twenty years (from 800 in 1971 to 3,000 in 1998),[5] about one thousand of whom bring out barely two titles per year.[6–8] Music and cinema too provide very apt illustrations.

The oligopoly of music

There are many links in the chain that constitutes the music industry. Its creation brings together the lyricist and the composer, while performance requires the participation of authors, singers and technicians. The production transforms a creative work into a product.[9] The recording is either marketed directly by the production company or sold to another company that distributes it under a licence. Through the distributor, the product reaches retail outlets that sell them directly. In some cases, a re-release is necessary if the number of sales is too large. Sales are generally done through music stores, but there is also a marked increase in on-line sales. The different links in the chain are held together by contracts, three of which are essential to

understand its working. The 'artist's contract' is between the artist whose music is recorded and the person who finances this recording. By signing such a contract, the producer invests his money in a specific production, thereby adding one more item of recorded music to his catalogue which enhances his prestige. This contract stipulates that the royalty will be proportionate to the sales,[10] and it may also include clauses about the artist's willingness to give first preference to the producer, clauses concerning the renegotiation of the contract, etc. By signing a 'publishing contract', the owner of the record agrees to surrender the inheritance rights of the recorded music to a recording company. The 'distribution contract' is signed between the recording company and the distributor for the sale of the finished product and it defines the duration of the distribution rights, distribution zones, etc. All these elements add to the final price of the record.[11,12]

This model is modified by two factors. In the first place, the same agents often assume several roles, thus the artist becomes his own producer and the producer his own publisher. Secondly, digitization gives more power to some links in the chain such as the broadcasters. As a result, there are many more obstacles at the point of entry. The first obstacle is the signing of the contract, because there are many demands for records, although the number of records released is relatively small. The second obstacle is exposure through the media, since the sale of a record goes up if it is heard frequently on the radio and television. The proper display of records by retailers is the third obstacle, since their visibility to the users depends on how they are distributed and displayed. Nevertheless, with the concentration of production and distribution in the hands of a few companies, it has become possible to eliminate the last two obstacles. The five major recording companies (Polygram/Universal, EMI, Sony, Time Warner and BMG), which control more than 80 per cent of the world market are associated with a multitude of labels and production units, publishing branches, manufacturing units and distribution networks.[13] Sony has carried this integration even further because it also manufactures music systems.

Around this core, there are several independent and small enterprises. There are very few among them having their own independent distribution networks, and they still have to specify their artistic policies to find profitable slots and attract

established artists such as Harmonica Mundi.[14] There are a few small companies that can hope to become majors. One company that was able to nurse such an ambition in the 1980s was Virgin, since it had a position of advantage in the field of rock music, a contract with the Rolling Stones and a chain of Virgin Megastores. But it could not join the ranks of the major ones, as it controlled just a small segment of the market (5 per cent) and was finally absorbed by EMI. These independent companies do not expect very high profits from their first albums, unlike the majors, and they are further handicapped by the meagre publicity of their products on radio and television channels. The major companies usually dominate the playlists, because to figure in them it is necessary to invest a considerable amount on publicity when releasing a new album. In France, 90 per cent of the spending on advertising comes from the major recording companies.[15]

Another type of fringe player is the virtual distributor or virtual stores, such as CDNow, Music Now,[16] etc. whose turnover in the year 2000 was almost equal to that of specialized companies. Traditional distributors waiting to extend their markets, mail-order clubs or virtual agents create these virtual stores. If it is absolutely necessary, some of these sites are willing to broadcast the music without any payment as the major portion of their earnings are derived from advertisements, e.g. Napster 1. This site has shown how the Internet can revolutionize broadcasting, with each music lover becoming a broadcaster for other consumers. The Napster 1 server was able to centralize the list of music files installed on the hard disks of netizens, because by simply downloading a small software programme, each netizen could have free access to the hard disks of fellow netizens. This downloading of records, however, created a serious problem for the more traditional recording companies, especially after the advent of the MP3 format, which enabled anybody and everybody to receive and send music through the Net.[17] Various software programs for recording this music were also developed along the same lines as the best known among them, namely Liquid Music Player. To counteract the risk posed by MP3 to their sales, the major recording companies adopted two strategies. Some of them got together with software companies to develop the Secure Digital Music Initiative (SDMI), but the interests of the individual companies

prevailed over long-term co-operation strategies. Other com-
panies like Bertelsman signed agreements with certain sites like
Napster. The major company then put its catalogue at the dis-
posal of netizens, earlier treated as pirates, for a nominal sum
(US$5 per month) and acquired a major share of the site's cap-
ital (around 58 per cent). The problem of piracy and rights has
not been solved in spite of this strategy. But a simple calculation
shows that it is better than nothing, since the profits earned
from the giving up of piracy by music lovers are higher than the
amount spent on scrambling and production of albums.[18] As a
matter of fact, the number of Napsters is increasing worldwide
due to the availability of sophisticated technologies. So, this
agreement may not be able to persuade more netizens to keep
to the straight and narrow, provided of course that this path is
still considered worth following.[19]

The judgement pronounced by the Court of Appeal in San
Francisco on 12 February 2001 against the practices followed
by Napster 1 has changed the scenario by recognizing the viola-
tion of copyrights. Napster 1 and its partner Bertelsman are
therefore planning to set up Napster 2 where users will have to
pay for downloading. Here again, two formulas are possible: a
basic subscription fee for a fixed number of downloading opera-
tions every month or a higher fee for unlimited downloading.
Each leading brand will then receive a sum of US$150 million
per year and independent brands will be paid smaller amounts
proportionate to the number of files that are downloaded. The
big recording companies have some reservations about this
system, and some companies, like Vivendi and Sony, have
announced the conclusion of a common management agree-
ment covering their files on the Internet, but with a partner 'less
dishonest' than Napster.[20]

Oligopoly in the Film Industry

In the early days of the cinema, film producers also looked after
the distribution and exhibition of their films. But soon there
emerged a new system where the major film companies took
over the activities of management, production, distribution and
exhibition.

The story of Charles Pathé illustrates the growth of the
cinema in its early stages. 'I was wonderstruck like the rest of

the world', he said when he heard Edison's phonograph – an instrument that could reproduce songs transcribed on a wax cylinder connected to a pair of earphones – at the Vincennes Fair. Charles Pathé was determined to buy it together with the ten odd cylinders, each of which played a different song to the crowds that gathered at various fairs. The idea was not bad. But for Charles Pathé, who was an industrialist at heart, its main drawback was that only one person could enjoy it at a time, and this cut down its profitability. But the success of the show held on 28 December 1895 in the basement of the Grand Café on the Boulevard des Capucines in Paris opened new vistas before him. If Edison had succeeded in bringing photographic images to life, the Lumière Brothers made animated pictures accessible to a large number of people at the same time. Charles Pathé immediately started looking for capital, and after many failures, he got help from his brother who gave up trading in wine to enter the manufacture of cinema equipment. The Pathé Brothers threw themselves wholeheartedly into their new venture and began developing and manufacturing new types of cinema equipment, taking up at the same time the production of uninterrupted film sequences. The Pathé Company was successful in its new venture and started raking in substantial profits. The time was ripe for taking industrial risks.

The main obstacle they encountered in their efforts to develop the market was that these films were sold to the owners of cinema halls, who were hesitant to buy them as they were not sure if they would appeal to the public and whether they would recover their investment. So Charles Pathé got the brilliant idea of renting out films instead of selling them outright to cinema owners. It would then be possible to make longer films and open more cinema halls. It was also necessary to explore the market in other countries. There was an enormous demand for films in the American market, which was sluggish because of the influence of the Edison Trust. Shortly after that, the Pathé Company signed important contracts with American cinema owners and started exporting its films on a regular basis. This brought in enormous profits, as the investments had already been recovered by showing these films in the French market.[21,22]

After the First World War, the Americans made up for lost time in terms of machinery. The relative size of the market was the main reason for the Americans' success. Soon there was a

reverse flow of films from the United States to France, and from then on it became increasingly difficult to recover the cost of making French films in a market flooded by American productions. 'A good 1,500 to 1,800 m film, depending on whether it is made in America or in France, produced a gross profit that was 30–40 times higher in America than in France.'[23] Only the introduction of talkies gave some breathing space to French film-makers, as English language films were handicapped first by the absence of dubbing facilities and, later, by the difficulty of dubbing their products in French.

The story of Charles Pathé gives a brief summary of the early years of this cultural industry, but the cinema soon underwent a drastic change,[24] and many factors contributed to the growth and stabilization of film production. First, the increase in the number of cinema halls, beginning with the nickelodeons where admission was only 5 cents, and secondly, the development of the narrative film at the cost of films involving scenes or news items. The latter lagged behind because it was difficult to transport heavy cameras to the place where the event was taking place. The transition from the short film to the narrative film led to a specialization of roles. In addition to the cameraman, there had to be a director in charge of the technical aspects of the product ranging from selecting the story and the shooting locations to direction and scriptwriting. Similarly, the actor's role became more clearly defined, more and more specialization being a logical offshoot of the system.

But the most important factor was distribution. As long as the exhibitor's access to a film was linked to the projection equipment, the market was bound to develop slowly. But things changed when exhibitors found themselves in a position where they could change their programmes. It then became necessary to standardize the equipment so that film distribution is independent of the projection equipment. The agreement that separated, once and for all, the markets for equipment and films led to the creation of the Motion Picture Patents Company.[25] Following this agreement, producers who were members of the MPPC were able to join hands and set up studios. The number of production units increased and they functioned simultaneously, with each unit having its own director.[26] Some producers decided to move to the West Coast, to Southern California, for a variety of reasons. They wanted to get away from the

restrictive practices of the new cartel, take advantage of the lower price of real estate and the moderate climate that, unlike New York, would allow them to work throughout the year. Further, they could set up studios without any outside interference. The strict division of work and space allowed them to go in for mass production of films, since by now the problem of distributing this incessant flow of films, which was a real bottle-neck, was solved.

Independent film-makers, who depended on this distribution market, did not hesitate to buy large film companies to ensure a continuous supply of films to the exhibitors,[27] or to organize distribution networks like Universal Pictures. The main point now was to supply entire reels that would cover a full show instead of having to show a number of short films, which was a more costly affair. They targeted cinema halls having higher earnings than the nickelodeons, and they used two methods. The distribution rights were split into geographical zones and cinema theatres were rented directly by the producer or distributor who pocketed the ticket money and gave a fixed amount to the exhibitor. A distribution network of this type was organized and it expanded to become Paramount Pictures, a distribution company that assured a continuous supply of films. Paramount signed a distribution agreement with the exhibitors, assuring them a supply of two new films every week. This was known as block booking. Realizing the strategic role played by the distributors, some actors joined hands to start their own distribution company. Thus Mary Pickford, Charlie Chaplin and Douglas Fairbanks set up United Artists and the famous director D.W. Griffith joined them later.

However, the mass-production system tended to produce nondescript films that were likely to bore the audience. So producers created the star system to give greater individuality to films, which at that time had a similar story line, similar sets and the same actors, in fact nothing that could rouse the viewers' interest. The introduction of the star system was to have a profound effect on all sectors of film-making. Where production was concerned, the engagement of stars raised the costs, but it also acted as a buffer against risks. As for distribution, publicity and marketing, they were organized around the stars, and in the case of exhibition, the extra expenditure led to an increase in the price of cinema tickets.

The time was ripe for the emergence of a few distribution companies that could dominate the industry because they enjoyed economies of scale and the benefits of large-scale production, which enabled them to dominate production and exhibition. But this came to an end just after the Second World War, following the judgement against Paramount Pictures. In 1948, the big companies were censured for discriminating between cinema halls belonging to them and others, for allowing their successful films to be exhibited only in their own cinema halls (giving rise to the notion of general release) and for forcing independent exhibitors to accept unfair deals in order to get a continuous supply of films for exhibition. Consequently, the court's judgement obliged Paramount Pictures who were involved in the litigation, and by extension other big companies, to open up their exhibition networks to other producers and treat all exhibitors on an equal footing. This put an end to the vertical integration of exhibition by distribution companies. Shortly afterwards, the big companies used the Paramount judgement very astutely to their own advantage. When television networks started showing their own fiction films, they were compelled by the courts to adhere to the equality of treatment clause in the matter of distribution and exhibition, and this forced television companies to stop producing fiction films.

Integration is no longer as vertical as it was thirty years ago. Nevertheless, distributors continue to be as powerful as ever. They have more than made up the losses incurred by giving up production and exhibition, and raking in higher profits in the field of distribution,[28] in addition to greater participation in communication conglomerates, which were interested in the film libraries of the big companies. The establishment of conglomerates went through several phases, the earliest going back to the 1960s. Universal was the first company to join a television conglomerate, namely MCA/Revue Productions, which had already bought the Universal City studios in the hope of creating a profitable synergy between its music recording and film production activities. Way back in 1966, Paramount merged with Gulf & Western, a conglomerate having interests in communication, agriculture, services, etc.[29] At about the same time, United Artists was taken over by Transamerica Inc., which was mainly involved in the insurance business. On the other hand, MGM, Twentieth-Century Fox and Columbia remained independent.

But the companies that had joined conglomerates did much better and commanded a larger share of the market.[30]

Contrary to the assembly-line production system followed in Hollywood studios, there emerged a new system where a film was treated as a separate entity and not one of a series. This marked the transition from the 'studio system' to the 'package unit system'. Each film was treated as an independent economic project. Consequently, the film had to be more spectacular than the films normally seen on television. This led to the birth of the 'blockbuster' and the 'high concept' film. It brought about a change of scale and the cost of the negative shot up. Enormous investments were required and returns had to be comparable to those of others in the financial market, the only thing that mattered for these conglomerates. It was better to make fewer films (which went against the producers' interests) and earn more money on each film. As a result, the number of films went down substantially. Between 1970 and 1980, the number of films made by Columbia went down by 50 per cent, MGM–United Artists by 75 per cent and Fox by 50 per cent. On the contrary, the films made by Paramount, Universal and Warner Bros. remained constant or even showed a slight increase.

However, the blockbuster–high concept system continued to pose severe problems for both producers and distributors. By reducing a film to a single theme or image, it was possible to sell it in many different forms and use the publicity budget more effectively. There is, however, the danger of alienating some sections of the public. As a result, the high concept film was considered to be a success only from the economic point of view. In a study covering almost 500 films released in the 1980s, Justin Wyatt has shown that high concept films earned the highest box-office returns.

The advent of Japanese companies in the 1980s brought about a change of scene in Hollywood.[31] Columbia Pictures was acquired by Coca-Cola in 1982 and then by Sony in 1989 and became Sony Pictures Entertainment. Universal was taken over by the Japanese giant Matsushita and became the Music Corporation of America, Inc. These changes brought in their wake further changes in the equation between the traditional Hollywood majors.

While the major companies formed international alliances to control the market more effectively, small independent

production companies also grew in importance. In 1992, 87 per cent of American films were made by independent producers against 60 per cent in 1980 and 32 per cent in 1970, with each of the major companies producing only ten to fifteen films per year.[32] This fall in the production of major companies is not a matter of chance. Due to the incessant increase in the average cost of making a film,[33] the major companies opted for formulas that were more flexible than the studio system and concentrated only on the production of blockbusters, which required detailed planning. Even for their own films, they did not hesitate to engage independent producers for making trailers, for special effects, etc.[34] Disney is the only company not to follow this trend because, as its chairman said, 'We want to control the oil flowing in the pipelines'.[35] It continues to make its films one at a time as Hollywood used to in its early days.[36] As a result of these new production strategies, Hollywood majors do not hesitate to pool their means of production when they make blockbusters. For example, Paramount and Fox joined hands to make *Titanic* at a cost of US$200 million.[37] Although the major companies have gradually disassociated themselves from production activities (they produced less than 25 per cent of the films in 1997), they still control 90 per cent of the distribution.[38]

However, despite the Paramount judgement, the major companies continue to control the exhibition of films in cinema halls. Although they control fewer cinema halls (20 per cent), all these halls are located at prime locations in New York, Los Angeles and Chicago, hence their films are released to an audience whose opinion counts. They exert a concerted influence on European markets with the result that European exhibitors are obliged to accept their films. Finally, the advent of multiplexes has given the distributors a new opportunity to reinvest in the exhibition market.[39]

The permanent strategy adopted by distributors is to find new markets, in addition to the ones already available, with the help of the media. Here again, the cinema provides an apt illustration of this strategy and, paradoxically, it is the advent of coded pay-per-view channels that has brought about a change. This system is beneficial for viewers, who need to pay only for the films they actually watch, but it is even more profitable for distributors who are able to win over viewers who are not frequent visitors to the cinema.[40] But not satisfied with utilizing

cable television or even creating special channels for exhibiting their collection of films, e.g. TCM (Turner Classic Movies) or FXM (Movies From Fox),[41] the majors have taken over television companies, the extreme case being that of Disney.[42]

The video market too has attracted large investments. The 'First-Sale Doctrine', which decided the selling price according to the first use and without prejudice to other uses, prevented producers from receiving their potential royalties on video cassettes, because of the wide circulation of cassettes and the possibility of recording other films on them. In 1982, the courts softened the blow by pronouncing a judgement in favour of Disney and Universal and compelling JVC to pay them a percentage of the price of every video recorder sold, thus compensating the majors for the loss entailed by piracy.[43] But this did not solve the problem completely. Another problem opposing the interests of the majors is in deciding to opt between paying cable networks and potential earnings from the sale of cassettes. A studio like Disney, having heavy investments in paying cable channels, has to strike a balance carefully between these investments and its earnings from the sale of cassettes.[44] Once again, Disney provides the best example. In 1984, it did not often show its gold-mine of cartoon films either on video or on television.[45] But in 1985, the new management changed its strategy by publishing a large number of classics in the form of videos.[46] In 1987, when the latest Disney films were released on video cassettes (and not just the oldest films), its earnings quadrupled.[47]

Digitization and the Internet: literary production

To understand the changes that have recently taken place in the cultural industries, we must see to what extent the digital revolution has influenced production, reproduction and diffusion of works of art. We will first look at literary works.

Digitization has turned works of art into algorithms that can be changed at will and can be easily adapted to different media. A product of the digital revolution, the Internet, is not satisfied with developing e-commerce. It eliminates the bottle-necks that once acted as gatekeepers and allows users to modify works as per their desire. This gives rise to a situation where one wonders

which is the real work and who its author is. Cultural works can be simultaneously produced in many different forms and they can be made to assimilate creative elements contributed by the users. The circulation of such works is so high that the old distinction between the original and the copy no longer has any meaning. Keeping a check on copyright and the royalties due to authors, which requires a clear identification of the contents, the medium and the author, is almost impossible, because the contents keep changing, the medium has disappeared and the work is becoming more and more of a collective product. Optimists will find new sources of creativity and well-being in such works, while pessimists will look at it as a system that allows the multimedia groups having a vast collection of cultural products to survive at the cost of a growing confusion between culture, entertainment and sports. To show how a work of art can change at every stage of its traditional development process, let us look at the restructuring of literary production in both content and form during the course of its development: writing, publishing and distribution.

On-line writing

Digitization and the Internet have brought with them on-line literary creation, which is essentially a new way of writing. Delphine Beringuer[48] makes a distinction between collective novels, interactive novels and hypertext novels. Using the original text written by the 'master of the site' as a starting-point, netizens write a collective novel by imagining the rest of the story and suggesting alternatives, each one contributing a paragraph or, in some cases, even a chapter. The principle behind this collaboration is old and it reminds us of the practice followed in schools at the beginning of the twentieth century, where one class added what it felt was relevant to a text written by another class before sending it on to yet another class. The Internet acts as a catalyst by solving logistic problems 'by eliminating delays and distances and by providing the initiator of a novel an inexhaustible supply of potential participants'.[49] The potential authors should make sure that the text remains coherent; they should keep in mind the mental make-up of the various characters, respect the configuration of locales, etc. Once it is completed, the novel is treated as a collective property. The sites that host such collective efforts

are increasing in number, but they do not always produce very significant results. The site 'France-Loisirs' gives an interesting example, citing as reference the experiment undertaken by Amazon.com jointly with John Updike. The main character of this collective novel, entitled *Thirty Days to Kill*, is Carla Tucker who is sentenced to death in the State of Texas. At every stage, a jury selects the best chapter, and one of the contributors, Yann Queffélec, has made a positive assessment of this experiment. He says,

> ... the novel, as it exists today, shows ... that it is possible through the Internet to write a novel collectively by involving budding as well as experienced writers, and also French-speaking writers in France, Belgium and Canada. All this demonstrates the power of the Internet. As a matter of fact, it is very impressive, when the theme of a chapter is announced, to see all these texts coming from different directions and all revealing a high quality of writing.[50]

Another way of writing is the interactive hypertext novel. The hypertext brings together fragments of writings that appear and disappear on the screen following a simple click. This hypertext is non-linear, similar to some traditional books that allow the reader to flit from one scene to another, e.g. the ancient *Book of Changes* in China, a collection of sixty–four short texts meant to be read by following the reference points indicated by a throw of the dice. It is not a continuous narrative.[51,52] The hypertext makes the reader an active partner and confers a new status on him. Two readers of the same 'hyperbook' will never read the same text. Some authors present novels where a number of divergent stories sprout like branches from a common trunk. Other authors imagine a complete fusion of different genres and it results in 'encyclopaedic novels', which have links that refer readers to other websites dealing with the subjects mentioned in the novel.

Finally, there are novels that are simultaneously hypertext and collective novels, which make it difficult to strike a balance between the central power and the original initiatives. Thanks to the special software, a poem by Pierre de La Coste entitled 'La Ville' turns every screen into a crossroad, proposing several itineraries through an utopian town composed of districts of Venice, Prague, Athens or the suburbs of Paris. The reader strolls through this town by choosing lines and going back to the same place several times, thus there are as many poems as there are readers.[53]

On-line publishing

Digitization has opened numerous possibilities in terms of composition, storage and printing. Thanks to the changes it has brought about in printing, it is now possible to print the exact number of copies required. As regards storage, books can be stored in the form of electronic files. And finally, it has facilitated distribution by permitting transfers in real time. Electronic publishing is a welcome solution for authors who have little hope of getting their works published through the classical circuit. They no longer need to go through publishers whose margins often amount to 50 per cent of the selling price, which means printing a large number of copies to break even.[54] As for readers, they have a choice between various formats. The number of on-line publishers is going up rapidly, e.g. OOHOO Publishers was set up in 1998 and Librissimo in 1997. The former allows readers to download digital books or take printouts. The latter provides on request facsimiles of books in the public domain, which have been preserved and digitized by associate libraries.

These publishing houses offer several advantages such as providing common services for different virtual bookstores, establishing a direct link between readers, storage of select information, developing interactions related to books and organization of book fairs. They have also given rise to criticism because they are a threat to the traditional network of bookstores, which look on them as a source of competition. Two observations may be made regarding the dangers of competition. First, on-line publishing and traditional publishing can complement each other. Secondly, they can serve different purposes, but traditional publishing need not feel threatened because the prices charged by on-line publishers are higher.

On-line bookstores

Books are among the most popular products sold on the Internet. According to Jeff Bezos, founder of Amazon.com, the world's first virtual bookstore, books are very suitable for e-commerce for a number of reasons. They make it easy to look for a particular book (according to words in the title, the author's name, etc.). Books are generally bought on an impulse,

and it is easy to send them by this method. Two contradictory trends are visible today in the on-line sale of books: the major traditional bookstores have taken advantage of the Internet to expand their existing business, while new service providers have launched an exclusively virtual business on the Net. There is a tussle between traditional bookstores distributing their products through physical sales channels and virtual bookstores that have created new models of intermediary financing.

In the United States, electronic bookstores have proved to be very successful because their prices are very competitive (due to a discount of 10–40 per cent). Established in 1995, Amazon.com continued to be the biggest virtual bookstore on the Internet even in 2000. It depends on a network of 50,000 publishers offering 2.5 million books in English, of which 40 per cent cannot be found in traditional bookstores. Their prices are 30–40 per cent lower than the prices of books available in ordinary bookstores. Amazon has built up a network of 200,000 associate sites (search motors, specialized sites, etc.), which offer visitors a vast selection of books as well as a link with Amazon if they wish to place an order. In exchange, the associate sites receive a commission on the sales. Amazon has cornered about 2 per cent of the market for books in the United States and it has expanded its activities to include other cultural products like records, CD-ROMs and video cassettes. Amazon's success prompted Barnes & Noble (the largest bookseller in the United States, with a chain of more than one thousand stores) to open an on-line site to compete with Amazon.com. In France, the sale of books through the Internet represents 4 per cent of the total sales. It is strictly controlled by the Lang Law passed on 10 August 1981, which decrees that there should be a single selling price to be fixed by the publisher and a maximum discount of 5 per cent. This law prevents virtual bookstores from making the most of their generic advantage. But French virtual bookstores are growing in number, with a new one making its appearance every month. Amazon set one up in 2000, and FNAC, which opened a website in March 1997, is ranked first in the sale of cultural products through the Internet.[55] A growing number of independent bookstores are setting up sites for the on-line sale of books.[56]

The success of virtual bookstores is largely due to the wide range of services they offer to netizens. They have a rich editorial content, press reviews, choice articles and extracts as well as

other information about a book and its author, all provided free of cost. In addition to giving advice and bringing new works to the notice of netizens, all virtual bookstores pride themselves on providing a personalized service. Three virtual bookstores, Amazon, Barnes & Noble and BOL, bend over backwards when it comes to providing personalized services to their visitors by asking them to give them their profile. Finally, virtual bookstores create a community space where everyone can express his/her opinions, and they try to impart the feeling of belonging to a community in order to keep their clientele.

The advent of digitization in the book industry has brought about a change in people's reading habits. A survey conducted by the 'Société des gens de lettres' in March 1999 at the time of the Paris Book Fair (Salon du livre), however, showed that access to the Internet has not made people give up printed books. Of all the persons questioned, 64 per cent declared that they spent as much time reading printed books as they did before, while 83 per cent said that the Internet helped them to discover new books and authors (55 per cent). But downloading texts has not become a common habit, as 83 per cent admitted that they had never downloaded a book. On the contrary, 82 per cent of those questioned opined that writers should get a royalty for the diffusion of their works on the Internet.

Multimedia groups: have the arts got submerged in entertainment?

Under the influence of the digital revolution, oligopoly (with its attendant fringe) has made way for another type of organization where cultural industries are concerned, and multimedia groups are taking the place of groups that used to deal in specialized fields. The shift from the old pattern to the new one has taken place because of the convergence between software industries (cinema), programme distributors (television), manufacturers of audio-visual equipment and network managers. Thus Sony, through the acquisition of CBS Records and later Columbia, tried to combine hardware (sale of audio and video equipment, television sets, etc.) and software (sale of programmes) and became the symbol of an integrated multimedia group controlling the entire entertainment business.

Digitization and the Internet have brought about a tremendous change. Digitization has transformed cultural works into algorithms that can be produced in many different forms and the Internet opens the door for the dissemination of these products. A group's traditional profession is no longer adequate, because it must know how to use other skills and control different media. New players from the field of telecommunications or computer programming play a major role because of their specialized skills and knowledge, and the more traditional players from the audio-visual domain have no option but to join them. They are compelled to adapt their development strategies, which were based on the economics of prototypes, to a new model based on the economics of networks, and they have to collaborate with enterprises familiar with this market and having specialized knowledge about the management of networks. The old chain of artistic creation, consisting of translating ideas into a particular medium followed by distribution, marketing and consumption, have been replaced by a new model where the group acts as an arbiter between artists and different user groups.

Going from strength to strength

On 10 January 2000, the first Internet service provider American On Line (AOL) joined hands with Time-Warner, the giant of media and entertainment industries. They announced a merger involving a total capital of about US$300 billion. Although it was touted as an alliance between the two companies, it was really a takeover of Time-Warner by AOL, with the latter's shareholders controlling 55 per cent of the new company's stocks. Time-Warner's vast empire covered the press, television and cinema and it was considered the world's number one media group.[57,58] It is the first time that one of the oldest and the most powerful of the traditional media groups has allowed itself to be absorbed by a leading group of the new economy.

Six months later, the formation of Vivendi–Seagram, another worldwide group, was announced. Since 1998, Vivendi Canal+ had become the top French group in the field of communications, having taken over Havas and expanded its activities in the field of mobile telephony, which prompted it to launch the portal Vizzavi on the Internet. In 1994, Seagram, which had made its

fortune in the liquor trade during prohibition, turned its attention to the entertainment sector and took over MCA, which had earlier been reorganized under the name of Universal Studio and later Polygram. The company produced and distributed films, television programmes, videos and music, and also managed entertainment parks. It is still involved in the liquor trade, because even though this market does not offer much scope for development, it assures a regular cash flow that is needed for financing its other activities having a vast growth potential. After this takeover, Vivendi-Canal+ took over two majors of the entertainment industry, namely the film company Universal Studio and the recording company Universal Music (formerly Polygram) to become the No. 1 group in Europe. The new group also became the world's No. 1 group in the music industry (this honour is also contested by AOL–Time-Warner) and the fourth largest in the film industry.

Both the groups had to prepare themselves for the Internet, which would allow them to show films, video on demand and television programmes. For Time-Warner, the advantages of such a merger were obvious, as it was now able to access a new platform for the distribution and sale of its product, the Web. The Vivendi-Canal+–Seagram merger was based on the same strategy.

What about the others?

Industrial groups belonging to the earlier generation had allowed a large number of independent producers to function on the fringe. Will the same thing continue? Some people believe that the Internet will allow small enterprises to function in the production field (e.g. production of special effects or use of databases for production of audio-visual programmes) or even in the field of distribution, because access to the distribution market is essentially free on the Internet. Because of its wide reach and its ability to influence a public that is as diverse as it is vast, the Internet is one of the most effective means of direct communication. It has already contributed to the popularity of films like *The Blair Witch Project* made on a low budget, which has succeeded in gaining a wide audience by a judicious use of the web. An independent film-maker, who can master the techniques of virtual imagery and the art of writing screenplays

will have more freedom in writing and suffer fewer constraints in terms of distribution. On account of their format, short films and animation films are particularly suitable for digital compression, while feature films still face difficulties (poor picture quality and limited availability of pass-band).[59]

The best option for independent producers is interaction. Digitized receiving sets enable viewers to interfere with the running of the programme, and instead of passive consumption there is active consumption. The user enjoys greater freedom of choice in the consumption of the programme that has been selected. He/she can access information and other material on the subject, navigate within an audio-visual flow, return to a particular sequence, while continuing to record and resume the direct run at any time. Between private or one-to-one communication and public or one-to-many communication, there are many mixed formats that fall under both the audio-visual medium and telecommunications. There is a direct supplier–client relationship and the net-spectator can regulate his/her consumption as he/she goes along. Thus the net-spectator becomes an editor. Consequently, it is possible to turn to profit audio-visual programmes intended for niche audiences that cannot be distributed on traditional circuits.

Initial investments may be substantial, but the costs of running an on-line distribution network are low, especially because it is not necessary to make numerous prints of a film. Once it is set up, the network can also be used to exhibit the less commercial films. Far from being a risk for a distributor looking for the largest possible audience, they enable him to show value-added products.

From audio-visual products to subsidiary and derived products: the Disney symbol

If this optimistic dream has really come true, it signifies a dramatic change in the functioning of cultural industries because their very base has been turned upside down. The net-spectator has become not only the editor but also the author, while consumption has become exclusive and even intangible. In addition, there is an overlapping between entertainment and culture. What strikes us most about the emergence of these new groups and their inevitable portals is the importance of

commercial activities – merchandising, theme parks and video games. Disney is the best example of this new pattern. What in the early 1980s was an amusement park company going through a lot of difficulties, with a history of cartoon films that were considered as a part of heritage, has within a span of ten years become an economic giant in the fields of leisure and entertainment, a benchmark in terms of innovation and an example of cross-fertilization between various elements of the leisure sector.

After several attempts, first in Kansas City and later in Hollywood, Walt Disney finally succeeded in drawing a mouse named Mortimer, later renamed Mickey on his wife's suggestion. This mouse was soon joined by Minnie, followed by Pluto (1930), Goofy (1932) and Donald Duck (1934). The first real cartoon film, *Snow White and the Seven Dwarfs*, was made in 1937. Things remained unchanged for a while, but there was a burst of activity after the Second World War. The fact that Walt Disney's cartoon characters had been used as emblems on the badges worn by American soldiers during the War contributed to his success. In partnership with ABC, Walt Disney decided to build an amusement park in Anaheim, a suburb to the south-east of Los Angeles. In the late 1960s, two new projects were taken up – another amusement park, this time in Florida, and a township of the future, the Experimental Prototype Community of Tomorrow (EPCOT). This was the last great dream of Walt Disney who died in 1966. The company was in dire straits; it had to survive on the earnings from its stock of cartoon films, and its share of the market came down to 4 per cent. Public taste had changed over the years and the company did not want to put any more money into film-making, as it was not in a position to bear more sunk costs. At the same time, the cost of running its amusement parks was shooting up, its relations with television companies had deteriorated and the value of its shares in 1984 was reduced by one-third as compared to the previous year. Disney was then taken over by a real estate group.

The new management headed by Michael Eisner and Frank Wells set off by building on its reputation. They bought studios and distribution agencies and plunged again into film production going beyond the traditional Disney culture. They also revived animation films and started selling cartoon films in the

form of video cassettes. They returned to spectacular television shows, modernized their parks and raised the admission charges. They ventured into the hospitality sector, developed new merchandise, mobilized their land resources and changed their system of paying their staff by modifying the system of stock options. They tried all these ploys and succeeded remarkably. In the early 1990s, Disney became a money-making machine in addition to transporting people to a dream world. Its shares doubled in value during these years. Three things were responsible for its phenomenal success in merchandises, theme parks[60] and cartoon films on video.

Disney had always sold the rights for using its cartoon characters for commercial purposes, and in the early 1980s some 8,000 products sported the Disney characters. The main products, i.e. clothes and toys, targeted children. During the 1980s, the new management, who felt that this avenue was under-exploited, began to develop the existing market by inviting other types of firms (starting with watch-makers) and manufacturing its own merchandise (jewellery, records, etc.) in order to remain in total control of its brands. This attempt to control its own brands soon became an integration policy, as Disney set up its own network of retail outlets consisting of 550 Disney Stores. These stores were doubly successful, both financially and in terms of popularity, in addition to providing publicity without any extra cost.[61,62]

The Walt Disney Company owns four theme parks: Disneyland in Anaheim, California; Disneyworld, Epcot Center and the Disney/MGM Studio in Florida; Tokyo Disneyland; EuroDisney near Paris. These parks attract crowds of visitors, since Disney has the advantage of being the 'first mover' in this segment of the leisure and entertainment market. When it wanted to open its own amusement park in 1989, MGM/UA preferred to enter into a partnership with Disney to take advantage of the crowds of visitors visiting Disneyworld in Florida. Only Universal seems to be able to hold its own against Disney.

As for video games, Disney Imagineers is developing new virtual games. Walt Disney Computer Software is a subsidiary that has joined hands with Nintendo to make video games based on the Disney characters in addition to selling its own products.[63] Thus the cinema provides the basis for numerous other uses and is no longer an end in itself.

Disney too faced difficulties, e.g. when it had to invest funds outside the United States, especially for setting up EuroDisney.[64] But these difficulties were a result of the shift from cultural industry to the leisure and entertainment industry, which has its own peculiar problems. Disney is an excellent example of the evolution of culture as the new symbol of entertainment for three reasons. First, each sector of activity carefully considers the possible consequences of its policy for the group's other activities. Secondly, its investment policy is guided by prudence, as it avoids drastically raising the prices of its products. And finally, it is more interested in maintaining its liquidity than in profit.

What is an artistic product, who is an artist/consumer?

The combination of digitization and the Internet permits numerous changes in the nature of works of art. To a certain extent, artists, users and producers can all influence the form in which the product is presented or interpreted. Traditionally, the creators in software industries produce a generic product that is supplied in the same manner to all potential users. But this has changed in the digital world. Due to interaction, each user can enjoy an experience that is quite different from that of another user depending on how he interacts with the contents and the additions that he makes to the original product. Ultimately, it is the user who defines the contents rather than the supplier, and there is a significant redistribution of roles. At a pinch, we may say that the work of art, when reduced to an algorithm in this manner, acquires as many faces as the number of manipulations it is subjected to.

This gives rise to a large number of problems. The first problem is the multiplication of the derivatives of a work of art. The derivatives should actually be a faithful replica of the original and not be truncated in shape or altered in spirit in order to correspond to the author's moral rights. Any inaccuracy in the reproduction of a pre-existing work can be considered as detrimental to its career and can be assailed as an infringement of its integrity. The second problem arises from the reprocessing of works of art, i.e. works of art transformed into software, since this too affects the author's moral rights. The assimilation

of multimedia products into software serves the sellers' interests by limiting the possibility of protest from their authors, as the protection of their moral right is liable to paralyse the economic importance of works of a utilitarian nature. The last problem arises either from the private or collective use of the work. The same rules do not apply to both because it is permissible to copy a video cassette as long as it is meant only for private use. But there is not much difference between public and private use today, as it is possible to download these works without specifying whether they will be seen only by one person or by many.

What are the new challenges before producers?

Players in the cultural products market are now witnessing the emergence of a 'surprise visitor' who is difficult to control. It is the amateur having semi-professional means of designing and producing works who is gradually appropriating entire segments of products and services with the intention of diverting them.

This questions the traditional view of copyright based on two factors: the existence of a concrete or tangible product and the belief that a copy can never be a perfect substitute for the original product.[65] With the advent of digitization and the Internet, the number of persons who can access high-quality copies is practically unlimited. An individual consumer can make a copy through his/her personal computer, store it in the hard disk and produce more copies. The cost of duplication is going down day by day and the quality of the duplicate is comparable to that of the original. Laws in this regard are very difficult to enforce, since there are too many digitized works of art in circulation on the Net. Even if the country of origin has protective laws, the work circulates so fast on the Net that it can be downloaded by millions of netizens before any legal action can be taken.

Is it possible to take steps to prevent the free distribution of these digitized products? Violation of intellectual property rights must be controlled at the level of intermediate users or portals and not at the level of end users or consumers.[66,67] This means investing in very costly tracing mechanisms. It is symptomatic that public organizations have given up the fight and

called for self-regulatory measures, while private organizations have announced rewards to those who can help them detect frauds.[68,69] There are two main techniques of controlling the contents, namely encryption, which prevents duplication and modification, and the digital signature, which introduces a sign identifying the product's origin. IBM has developed an electronic signature called cryptolope. This technique slows down access and the distribution costs partially wipe out the advantages of digitization. All said and done, digital marking helps not so much to prove the violation of copyright or authors' rights as to urge users to obey the law. It is a kind of digital tattoo or a technique that is effective insofar at it questions the protection of privacy.

Further, technological innovations constantly overtake existing control mechanisms. During the last two years, the MP3 format of digital compression has become widespread on the Web and music files can circulate freely, a situation that is very likely to occur shortly in the field of videos. Microsoft has been working on Mpeg4 to make the contents of videos more secure. In fact, there are already several versions of unsecured Mpeg4 available on the Web, the best known among them being Div X. The only solution seems to be to set up a common mechanism of control by means of on-line contracts of the 'click to accept' type. There will then be less uncertainty regarding the acceptability of the product than about the number of consumers who will actually pay for it. The only solution is to recover the costs as quickly as possible by taking full advantage of the consumer's urge to be the first to use the product.

Another possible solution is to finance the payment of rights through the returns from sales of the equipment in use. This is the principle underlying the French tax on blank video cassettes, which is ploughed back into the film industry. But whereas it was easy in the case of video cassettes, which are essentially tangible products, it does not appear to be so easy in the case of the Internet, unless there is a move to tax computers and consoles. This would call for a perfect integration of legal procedures with the audio-visual domain, which is still beyond the scope of the World Trade Organization. There is no common front against piracy, and this is the least that is needed to protect copyrights.

What are the new challenges before artists?

While producers find it difficult to ensure that their copyrights are recognized, artists find it more and more difficult to protect their rights, especially because, in addition to controlling distribution, they have to monitor manipulation of their works. Piracy of digital works on the Internet is encouraged by four factors. There is no deterioration of quality when digitized works are copied, the cost of reproducing on-line works is negligible, there are techniques that allow the copiers to proceed anonymously and a large number of Internet users are not aware of laws concerning copyright and authors' rights.

How do you go about protecting a text that will circulate on the Net in a truncated or modified form after others have made changes in it?[70] It is better to allow societies for management of authors' rights to do this job, because they are in a better position to handle bureaucratic procedures.[71] Thus we find new organizations for managing authors' rights coming up. Centres for protection of authors' rights like the Media Photographers Copyright Agency, set up by the American Society of Media Photographers, ensure that their members' interests are protected when leasing electronic rights. Single-window facilities like the Clearingstelle Multimedia der Verwertungsgesellschaften fur Urherber und Leistungsschurtzrichte (CMMV) indicate to potential users the names of persons holding the rights of various works.

But it is difficult to persuade people to respect moral rights. It does not seem to go well with digitization techniques, the conditions for putting a work on the Web and people's expectations in the matter of consuming audio-visual products. The transnational character of the Web further accentuates the difficulties experienced in enforcing moral rights. The EEC is considering the possibility of simply doing away with moral rights or allowing their relinquishment through a contract. This solution will not be easily accepted in France where the inalienability of moral rights is the basic principle behind all artistic works.

Whether it is risks related to copyrights or intellectual property rights, the real problem lies in the Napster generation. This generation has got used to getting products free of cost, because their suppliers had hoped that they could start billing the users for the products once the latter had got used to consuming

them. They have also got used to commercial television, where advertisers pay the bill or maintain a regular clientele through attractive sales-promotion campaigns. Wherever multimedia groups explore the possibility of developing new modes of consumption that they will be in a position to control, they witness the emergence of a host of netizens circulating copies of their creations without any risk or difficulty. This is nothing but an underground economy and it is the new rule of the game.[72]

CHAPTER 7

CULTURAL PESSIMISM OR CULTURAL OPTIMISM?

In view of the risks and the sunk costs of artistic activities, some economists are of the opinion that state intervention is necessary to ensure an adequate production of artistic goods and services. Further, the desire to democratize cultural practices prompts them to equate the management of art with state intervention.[1] The supporters of this approach generally rely on opinion polls, which are often more complex than one would expect them to be. Although they may support the idea of the state's participation in the protection of national heritage, they are usually less certain when it comes to state intervention in the development of creativity. On the other hand, other economists feel that this approach does not take into account the risks and negative effects of state intervention such as imposing restraints on creativity and the bureaucratization of artists and that it does not necessarily produce the expected democratic results. They also believe that the market has been able to stimulate greater waves of creativity compared to the patronization of art by official agencies. There is a growing debate between the cultural pessimists on the one hand, who believe that only the state can rectify the structural weaknesses of the market, and the cultural optimists on the other, who are convinced that the market can stimulate creativity and the large-scale diffusion of artistic goods.[2] This debate is further intensified by the existence of different types

of governance and the inexorable spread of regionalization and even globalization.

The cultural pessimism theory

According to the adherents of cultural pessimism, the market for artistic goods and services is trapped in a contradiction that it cannot overcome: prices can never be low enough for the widespread consumption of these goods and services nor can they be high enough to cover the costs of production.[3] The argument must, therefore, be considered from the point of view of both demand and supply. No matter from what angle you look at it, you end up with the idea that as far as the development of art is concerned, the market is guided only by the prospect of short-term profits, whereas it should respond to society's long-term aspirations. The market will willingly create illusions of modernity when it is a matter of preserving and enriching a priceless heritage. Hence a writer like Cowen has grouped these viewpoints under the heading of 'cultural pessimism'. In fact, there is every reason to be pessimistic about the role played by the market in the artistic field and corrective measures should be taken as soon as possible.

On the demand side

One of the major arguments is that some artistic goods are advantageous to the community without individual consumers being aware of it. One example would be the role of the arts in enhancing a region's image, bringing about social awareness, promoting the values of citizenship, etc. It is therefore necessary to control artistic consumption. This argument has also been presented in another form: the lack of consumption of artistic goods diminishes the welfare of other players, whereas the consumption of artistic goods would increase their welfare. This is the classic argument of external effects and it is up to the community to facilitate the type of consumption that it considers desirable. It may adopt various measures for this purpose such as the protection of heritage by the government, subsidizing the cost of consumption, assisting the initiatives of art lovers, etc.

Another argument holds that individuals may not have at their disposal the information that would encourage them to indulge in artistic practices. There is evidently a gap between the preferences indicated by individuals and their 'higher' preferences, or between the consumer's practical sovereignty, which he exercises in a concrete manner in the market, and his critical sovereignty, which is evident when his preferences are understood clearly, classified logically and monitored coherently. The factors responsible for this gap between practical sovereignty and critical sovereignty may be the result of external manipulation of the preferences as, for example, when the market creates on its own values that need fulfilment, or when these values cannot be correctly understood due to lack of information or judgement.

The third argument, which acts as a lever for the two previous arguments, deals with differences in income. Very few would dispute the influence of inequality of income on artistic consumption. A basic study conducted by Baumol and Bowen showed that the poorest people in America, comprising 34 per cent of the total population, account for merely 8.5 per cent of the theatre-going public. The real problem lies not so much in this observation, which is widely accepted, as in its nuances. Since low income is usually associated with a low level of education and a poor cultural background, it is advisable to know which of the two factors contributes more to the difference in artistic consumption. This opposition between the monetary and cultural dimensions of consumption was seen in the late 1970s when economists noted the decline in the efficiency of the Welfare State.[4-7] Very few studies have been undertaken from this angle, so the analysis needs careful handling. Netzer claims that cultural practices are strengthened when access to culture becomes less costly and this seems to indicate that income plays a determining role.[8] According to other studies, even when access to culture is free, there is very little or no change in cultural disparities, which means that education plays a determining role. Further, these analyses may vary according to the cultural practices under consideration, and the study of visits to museums may not lead to the same observations as the study of the popularity of the theatre or street arts.

On the supply side: the Baumol Law and the resultant arguments

Several arguments focus on the difficulties faced by artistic enterprises wanting to offer their services in the market in a dependable manner. Economists have shown that even if this was possible, it would be at the cost of a substantial fall in their quality. These arguments are generally advanced in the name of the Baumol Law, but other arguments can also be added in their support.

By showing that the arts face a serious dilemma and by insisting that state intervention is the only way of recovery, Baumol and Bowen proposed an approach that serves, even today, as an unavoidable reference for many economists while some others consider it as the only legitimate reference.[9] The central argument is very simple. The arts are affected by the cost disease, which makes them more and more expensive, and leads them to a dead end where you can either raise the price at the cost of bringing down the demand or put a ceiling on the prices, which will drive away the artists! This thesis, which was first put forward in relation to the musicals staged on Broadway, has now been extended to other fields such as the cinema and heritage, and it is considered a justification of state intervention.

The root cause of this dilemma lies in the change in the level of productivity, which has put artistic activities at a disadvantage *vis-à-vis* the rest of the economy. Actually, productivity can increase under the influence of several factors such as the substitution of work by capital or economies of scale, but artistic activities do not admit such factors. The manner of staging a play or playing a musical composition does not change with time except in terms of actors, musicians and other artists. The rendition of Schubert's Quintet needs as many musicians today as were needed in Schubert's time, and a tragedy by Lope de Vega needs as many actors today as four centuries ago. But there are other sources of productivity such as improvement of management and economies of scale and scope. But according to Baumol, these factors seem to have a very marginal role in the artistic field, and this includes the most important sources of productivity, namely the substitution of work by capital. The time spent by an artist in producing a

work of art can never be reduced by using a gadget, because the artist's time is an end in itself and not a means of producing another good. Because of this, a live performance cannot claim to reach the level of productivity characteristic of the economy taken as a whole. The productivity of the artistic sector does not grow as fast as the rest of the economy and it is impossible for the artist's earnings to increase at the same rate as the earnings of others except by reducing the production costs. An increase in the relative price of artistic activities would discourage consumption, and the only way to keep the demand steady would be to put a ceiling on the earnings of artists, thus reducing their relative real income and induce them to gradually give up their artistic activities. As a victim of this cost disease, the performing arts are faced with a difficult choice: they can opt to lose either their audience or their actors. The only way out of this dilemma is to increase their earnings through public subsidies, which would enable them to narrow down the growing gap between rising costs and the stable admission charges.[10]

The dilemma underlying the Baumol Law can be illustrated by a simple example. Let us assume that the productivity of the Italian economy has gone up by 20 per cent and that all of it is translated into a rise in salaries. During this period, there is no increase in the productivity of the Scala Theatre in Milan, but the salaries paid to its artists go up by 20 per cent in keeping with the general economic trend. If the Scala Theatre can accommodate 1,200 persons and there are six shows per week, the weekly audience consists of 7,200 spectators. If there are 72 artists working 25 hours per week, one artist-hour produces four spectators per week (7,200/1,800). If an artist is paid €61 per hour in the beginning of his career, it means that the cost of production per spectator is €15.25. If he/she is paid €73 per hour after 10 years, the cost of production per spectator will be €18.30. The management can refuse to increase the artists' salaries, but then the latter may want to leave. The management can, however, bring down other artistic expenditure (on sets, costumes, etc.), which amounts to replacing the economic deficit by an artistic deficit. Only subsidies can release the performing arts from this triangular trap of 'economic deficit – artistic deficit – flight of artists in which they are permanently ensnared'.[11]

Is it possible to avoid this cost disease? Apart from artistic deficit, a remedy that is often suggested consists of taking advantage of the economies of scale. The earlier argument was based on a specific seating capacity, but if the capacity is increased during the opera season, then everything changes. It is also possible to explore other avenues and add new audiences to the original audience, e.g. through television, cinema or multimedia products. In the preceding example, it would be sufficient to have five spectators per artist instead of four in order to make up the increase in costs and even bring down the theatre's relative costs. But it is not always easy to do so from the technical point of view, because it may be difficult to prolong a season or increase the size of the hall if the contracts with artists and hall-owners have been signed for a limited period. For this reason, permanent troupes having their own premises are in a more advantageous position. But this does not mean that there are no additional costs in this case as retransmission usually entails new expenses (for sound recording, additional cameras, changes in lighting, special rehearsals, etc.) as well as a substantial loss of earnings (due to the reduction of seats).[12,13] It is necessary to make the show more attractive for the audio-visual media and this means a further increase in costs. Finally, the economic compensation given by distributors is usually quite low, since they claim that the show has to compete with other popular programmes. This generally means that the show cannot be telecast during prime-time, hence it is difficult to attract major advertisers, which implies lower earnings. By telecasting the show on pay channels, it is possible to avoid the obstacle related to prime-time, but such channels are usually of a specialized nature and have a more restricted audience. Further, getting involved in commercial or pay-per-view television channels means exposing the show to the risk of copying.

Since there seems to be no remedy for the cost disease, can we at least question the methods of verifying it and its actual reach? As the Baumol Law is demonstrated in stages, there are three successive ways of verifying the seriousness of this disease. Is there a productivity and cost differential? And if so, is there an artistic deficit? Is the share of subsidies becoming larger as compared to the earnings of performing arts?

It can be ascertained whether there is a productivity differential by comparing the cost index of artistic activities with the

general price index (or the general cost index based on partic-
ular analyses). An analysis of productivity gains based only on
the audience is more ambiguous. Increasing the number of
spectators through broadcasting a show through the audio-
visual media can also be treated as a remedy for the cost dis-
ease. The cost differential has been the subject of many studies.
Since 1966, Baumol and Bowen have been interested in the
long-term cost of running theatres (during the period
1750–1950) in Great Britain, and they have shown that the cost
per performance increased 13.6 times, whereas the general
price index went up only 6.2 times.[14] In the above study, they
have also reported that in the field of music the average price
of tickets for concerts by the New York Philharmonic
Orchestra increased by 2.5 per cent per year during the period
1843–1943, as compared to a price rise of 1 per cent in real
terms.[15] In 1984, Baumol showed that in the case of the
American Symphony Orchestra, the annual difference between
the increase in the average cost of putting on a concert and the
increase in the cost of living was 1.5 per cent during a shorter
period, 1974–1983. In Australia, Throsby and Withers observed
the same difference for the entire range of performances staged
between 1964 and 1978.[16] In England, Peacock, Shoesmith and
Millner have shown that for all the performances staged in
London between 1975 and 1981, the cost differential was
+15.25 per cent in the case of dance, +15.1 per cent in the case
of the theatre, +13.75 per cent in the case of opera and +13.5
per cent in the case of music concerts.[17] This order probably
changed during the 1980s, especially in the case of the opera,
where the costs showed a tendency to spiral uncontrollably.
There were fewer studies in France, though the ones by Leroy
on the theatres in Paris and by Dupuis on the opera produced
similar results.[18,19]

It has not always been easy to point out artistic deficiencies,
but a method can be suggested for cutting down artistic costs.
The script can be shortened and modified to reduce the number
of characters; sets and costumes can be simplified; stage adapta-
tions of novels can be used; and so on. But it is difficult to qual-
ify them as cost-cutting measures, especially since they are
generally vaunted as creative innovations. Replacing the period
costumes by contemporary costumes can be explained as a
means of giving a new meaning to the play, although it is actually

a way of reducing the costs substantially. There is another difficulty in addition to the difficulty of interpretation; there is a strong competition from the high-quality shows in metropolitan cities. There are alternatives rather than substitutes in these shows and this means that each artistic performance is interpreted according to its context. Di Maggio and Stenberg point out in their conclusion that:

> In most American cities, theatres have a quasi monopoly on programming while in New York, competition makes them diversify their supply and even look for niche audiences.[20]

It is, therefore, better to move on to the third type of verification and see if there is really a diversification of resources in the case of the performing arts. Let us assume that in order to encourage the local population to visit the theatre more frequently, a local theatre voluntarily reduces the price of tickets and makes up the loss through a subsidy. According to Heilbrun and Gray, this diversification of resources should be analysed according to the nature of the institutions involved in order to arrive at a better diagnosis.[21] A study conducted by the Ford Foundation on symphony orchestras estimated the proportion of unearned income at the end of the 1970s to be 53 per cent and it has been going up ever since.[22] Heilbrun and Gray have come to the same conclusion in the case of other institutions like the theatre.[23] The only performing art that has proved to be an exception is dance, and this appears quite paradoxical because we know for sure that it needs subsidies the most. But it seems that it receives fewer subsidies because it attracts very small audiences. As a result, as Schwartz and Peters point out,[24] dance companies are obliged to depend on the sale of tickets for covering their costs. This means that their proportion remains stable or may even go up. The expenses of theatre companies increase to some extent, but the price of tickets should increase at a faster rate than the general level of prices in order to cover the possible rise in costs. There is probably a productivity deficit but not the effects expected in terms of subsidies. In France, it is difficult to prove the growing diversification of resources because it has always been there and public subsidies have played a determining role. In the case of major national institutions in the field of performing arts, the rate of subsidies varies between 50 and 75 per cent on average, over a very long duration.[25]

Improvement of quality

Another argument justifying state intervention has been advanced on the basis of the studies of Di Maggio in the United States and Dupuis and Greffe in France. The search for quality may lead to a conflict between the general interest and the interests of the artistic company, which can be resolved only through public subsidies. Keeping in mind the general interest, it is necessary to strive for two goals, namely maximizing the number of spectators and maintaining the highest standards of quality. But as compared to other activities, artistic activity is characterized by the absence of an objective criterion to determine quality, since creativity signifies the highest possible quality. However, the above two goals may be in opposition in the case of an artistic venture. To attract a large audience, it must control its costs and prices, which means that it must put a ceiling on the expenditure incurred to ensure quality. But for more creativity and better quality, it must incur more sunk costs. Thus there is a conflict between artistic and commercial interests and only a public subsidy or private patronage can provide the funds needed to improve quality without reducing the audience.

This argument can be stressed from a different angle. An analysis of different kinds of management behaviour shows that some managers are capable of mobilizing resources and using them prudently. Although some kinds of management prefer to use the real gains accrued for their own benefit, others prefer to use them for improving the quality even beyond the original norms. Unlike the previous case where maximization of quality took place at the cost of the audience, it is achieved in the present case at the cost of the management's gains, with the size of the audience remaining the same or even increasing in some instances. The case of the management of the Paris Opera presented earlier demonstrates this quite clearly. With a given deficit but with a growing budget and a higher subsidy, the management under Lieberman succeeded in improving the quality of the shows in addition to increasing the number of spectators.[26]

The cultural optimism theory

The supporters of the cultural optimism theory attempt to prove that neither is the state intervention useful nor is it able

to make the market function properly. Far from producing the expected results, it gives rise to the state control of the arts with an assured income for some officially recognized artists based on their resourcefulness instead of their creativity. They also advance historical arguments to show that the periods when the market had an upper hand were more favourable for the development of art than the periods dominated by state intervention.

The mirages of public intervention: pseudo redistribution

Public intervention in the field of culture often occurs in the name of redistribution and equality. Are these objectives really fulfilled? Statistical data do not support this claim. Disparities persist irrespective of the country, and the only visible result is the redefinition of the scope of artistic activities. Surveys of the cultural practices of the French people show how long it has taken to attain some of the goals of redistribution as well as the lack of satisfactory results in this field. Comparing the changes that have occurred in the case of 3,000 persons during the seven–year period between the surveys, we find that the disparities have not changed very much (Table 1). During the 1990s, the audio-visual media enjoyed a greater democracy with the encouragement of amateurs and the street arts. But as far as the traditional recipients of public assistance such as the performing arts, heritage, the plastic arts and the book industry are concerned, there was hardly any change in the users of cultural services. The frequency of visits to artistic institutions or the extent of consumption of artistic goods does not change very much. The variations that do take place are due to stimuli on the supply front, such as the organization of a festival or the opening of new galleries in a museum. This causes a sudden spurt in the number of visitors after which the composition of the users of these cultural services soon comes back to normal (3 per cent in the case of the opera and 30 per cent in the case of monuments).[27] Although the real expenditure on culture has more than doubled during the last twenty years, its output has come down no matter what indicator is used. Public interest is aroused only when there are special events such as the Music Day or Heritage Days.

Table 1 – The proportion of French people aged 15 and above who have visited cultural institutions at least once during the last 12 months

	1973	1981	1988	1992	1999
Theatre	12	10	14	12	16
Amateur theatre	10	12	14	16	20
Dance ballet	6	5	6	5	8
Folk dance	12	11	12	11	13
Opera	3	2	3	3	3
Operetta	4	2	3	2	2
Classical concert	7	7	9	8	9
Rock and jazz	6	10	13	12	8
Music Hall and variety shows	11	10	10	9	10
Circus	11	10	9	14	13
Funfairs	47	43	45	34	
Cinema	52	50	49	48	49
Museums	27	30	30	28	33
Monuments	32	32	28	30	30
The plastic arts exhibition	19	21	21	23	15
Public Balls	25	28	28	27	
Zoo	30	23	22	24	
Sports matches	24	20	25	17	

Source: Series of surveys of the cultural practices of French people, Paris: La documentation française. Surveys of the cultural practices of the French people took place in 1973, 1981, 1988, 1992 and 1999.

This disparity is not apparent in the cultural consumption of the rural population. This result is theoretically interesting, but it is also indicative of the growing mobility of people who come to the city to satisfy their cultural needs rather than the mobility of cultural services.[28]

What is noteworthy is that these surveys intended to measure the artistic practices of the French people have increasingly become surveys of the different ways of spending their leisure and free time and other entertainment practices. It is necessary to tone down their conclusions, because there is a greater deviation from the meaning of arts than the authors would have us believe. Does this mean that the Ministry of Culture is supposed to administer the free time of the French people?

Although these data are quite pessimistic about the role of public expenditure, they remain the same even after an analysis

of household budgets. Actually, one would expect public expenditure to bring down private expenditure, thus minimizing its role. But nothing of the sort happens. During the period 1989–1996, the share of the household budget spent on culture remained remarkably stable (3.5 per cent in 1989, 3.4 per cent in 1996), whereas the software and media sector progressed at the cost of other cultural expenses.[29]

How can these results be explained? The advocates of state intervention in the artistic field opened a debate on the difficulties of democratization, with the idea of making top-quality productions available to the largest number of users possible and convincing them that they were worth seeing. But then it becomes necessary to choose between lowering the quality in order to reach the largest possible number of users and maintaining the quality at a high level even if the number of users is smaller. There are effectively two models of democratization: one known as 'contamination through contiguity' and the other known as an 'elective shock'.[30] In the first case, the cultural policy seeks to create a common interest, based on cultural practices, among persons having different motivations. It is possible to appeal to the pleasure motive to attract this public, which would amount to giving up very high creative standards or those considered too esoteric. In the second case, there is an attempt to mobilize exclusively artistic motivations, thereby gaining in terms of intensity what is lost in terms of reach. In France, the cultural policy was based on the first approach when culture was under the Ministry of Education and Fine Arts. But it adopted the second approach later when it was decided to set up a separate Ministry of Culture, which considered itself essentially as a ministry of professional artists and tended to distance itself from popular associations.[31]

Conversely, we find that cultural practices are no less widespread in countries having apparently less pretentious policies on the arts. Let us look at the results of a survey, similar to the one in France, conducted by the National Endowment for the Arts regarding public participation in artistic activities in the United States.[32] This survey too was carried out periodically (in 1982, 1985, 1992 and 1997). Its latest publication indicates that cultural practices increased between 1992 and 1994, and the rates of using cultural facilities were comparable to those noted in France and were sometimes even higher. Thus the proportion

of Americans who had visited at least one museum during the past twelve months was 35 per cent, which was higher than the rate observed in France.[33] In the case of theatre, the rate is lower than in France, but it is higher in the case of musical comedies and operas. There are a larger number of amateur singers taking part in choirs (more than 20 million Americans take part in public performances and the minorities are over-represented in this field), although this observation could be counterbalanced by the base of the survey.[34] Americans claim that the major obstacles to artistic consumption are lack of time (64 per cent) and, when they do have the time, the unavailability of interesting programmes (59 per cent). Price takes the third place (50 per cent), although it is the factor generally invoked to justify public intervention.[35] One last factor worth mentioning is that during the period between these two surveys we notice a slight but systematic increase in the age of art consumers.[36] This observation should not be disregarded when taking into account the behaviour of the Internet generation.

Contemporary art: an opportunity for creation and squandering of public funds

Contemporary art is probably the field where the gulf between the aims and results of the cultural policy is the widest. Since 1992 and the publication of the results of the survey on the relationship between the French people and art, observers have been remarking on this hiatus. According to Yves Michaud,

> In [this field] ... things are very clear. On the one hand, the practices and tastes of the French people reveal a very conventional relationship with art; on the other hand, the practices of professionals in the art world are totally different.[37]

Interest in contemporary art is practically non-existent, with Van Gogh (43 per cent) placed far ahead of Buren (1 per cent) in the order of preferences by the persons who were questioned. This order of preferences has not changed very much as indicated by the results of a similar survey published in 2001: 41 per cent against 4 per cent.[38] These findings can be moderated by pointing out that when it is a matter of buying works of art, 44 per cent would prefer to buy the works of a young artist, whereas only 21 per cent would go in for a classical work, except that there is no comparison between the prices of the

two. But the finding that everybody would agree with is that while 44 per cent of the persons who were questioned professed interest in ancient art, only 14 per cent said they were interested in works of art created after 1960.[39] The state has done every-thing to promote contemporary art during the last ten years. The changes that have taken place include the following: public institutions are encouraged to commission works of con-temporary art, regional funds have been created to promote contemporary art, mechanisms like the Plastic Arts Com-missions have been used regularly to fund artistic creation, markets for the contemporary arts have been developed and the museums are filled with new works of art. The failure of these efforts to democratize culture has brought severe criticism, and the ambiguity in this case arises from the fact that the debate on aesthetic criteria has been added to the debate on public management. Three interpretations are possible.

The first admits the failure of the classical process of dissem-inating artistic goods. In the field of painting, democratization of culture has bourgeois overtones. Inevitably, new works of art are initially appreciated by an elite group (the educated middle class) and subsequently by a growing number of people. As Millet admits, this model did not succeed. She says,

> I was naive ... there were many of us who looked at the relationship between art and the public as a pattern ... which imitated Impressionism. First the bourgeois made fun of it but later they were won over by its charm. ... And they all ended up admiring it. ... We sin-cerely believed that it would be the same in the case of the avant-garde artists we championed.[40]

According to another interpretation, the democratization of cultural practices occurs not through the spread of elite culture among people but through a competition between various groups or communities to impose the tastes of one group or community. This results in a marked segmentation of cultural practices, e.g. youth culture, trendy culture, culture of housewives under fifty years of age, etc. As Michaud puts it, 'The rise of cultural and aes-thetic democracy consists of something other than the affirma-tion of the taste of the majority as "classical", "conventional" or "conservative".'[41] There is no guarantee that the state can spread the types of culture that are not already in demand.

But according to the third interpretation, it is the promotion of art by the state through the allocation of public assistance

that explains how this system can function without visitors and without buyers. In the late 1980s, the state was involved in almost 75 per cent of the transactions in the plastic arts market either in the form of direct purchases or through orders placed by public institutions. This market is all the more strategic as private demand is stable and exports have come down over the years. The aim of this intervention is to encourage young artists and to build a public collection of contemporary art at a low cost. Its concrete result would be the creation of a source of income for the practitioners of certain artistic styles who have formed their own pressure groups. Apart from its policy of assisting artists to obtain training and establish themselves, the state has four types of instruments at its disposal:[42] regulations (registration of works of art, permission to export a work of art, pre-emptive rights,[43] the system of donating works of art to a museum in lieu of the inheritance taxation);[44] granting tax rebates for patronizing art;[45] commissioning the creation of special works of art and allocating funds for acquiring works of art;[46,47] popularizing contemporary works of art (publishing catalogues or books on art, assisting young artists to hold their first exhibitions, supervising the network of Centres of Contemporary Art, etc.). The state thus controls more than half the art market in terms of price as well as the number of works on sale. According to some people, the state has established a complete monopoly.[48,49] Several studies have thrown light on the purchase of works of art by the state. According to Pflieger et al. (1991), the total number of works acquired by the Regional Funds for Contemporary Art (FRAC) between 1981 and 1989 amounted to 1,320 by 657 artists, which means an average of two works per artist. According to Moulin, the concentration is even higher, with 0.1 per cent artists having got one-fifth and 3 per cent one-third of the total amount. It has further been observed that women are under-represented as they account for only 15 per cent of the works acquired, although they constitute about 25 per cent of the artist population. Also, 50 per cent of the loans are given to artists residing in the Ile-de France region. As Gleizal has pointed out, this leads to confusion between the private and public spheres.[50] He says, 'The state has not been able to provide the necessary incentives. Instead, by becoming a direct player it has interfered with the working of the market.' Due to this intervention, the state has become a

proprietor and it tends to be partial towards the practitioners of certain styles of production, who know how to exploit these tools. Selection committees are composed of well-known artists and art dealers, and this strengthens the position of the artists they support.[51] This intervention increases the earnings of artists, because they are likely to get a classification of their work as heritage and also the right to obtain a percentage of the price paid by subsequent buyers for their works. Finally, and what is perhaps even more serious, it encourages artists and dealers to try for higher earnings from the state, which is an active buyer, instead of trying to attract buyers in the less flourishing private market. Thus Hayek's verdict seems quite apt. He says,

> In such a society, having political influence is much more advantageous than trying to satisfy the needs of one's contemporaries. As everything tends to turn into a political issue … an ever-increasing proportion of human activity is diverted from productive endeavours towards political efforts.[52]

Bureaucratization of artistic activities

Besides the above-mentioned examples from the field of contemporary plastic arts, several authors have tried to give a more general idea of the phenomenon of the bureaucratization of culture. Marc Fumaroli points out that though state intervention may be justified in some cases, it can also contribute to the bureaucratization of culture.[53] Citing the example of the Third Republic in France, he observes that the state restricted itself to protecting heritage and developing artistic education and did not interfere with the contents of artistic works. So it did not indulge in making judgements on the value of works of art and did not set up committees consisting of officials and officially recognized artists where the officials sided with the views of the officially recognized artists to avoid any controversy when they were not likely to succeed. The Third Republic's policy of horizontal action, as opposed to sector-based action, was given up after the Second World War. An elaborate political programme was worked out for the dissemination of culture, following which the state multiplied its subsidies for particular performances or activities. As a result of this new approach, culture drew closer to entertainment and distanced itself from art. In the world of theatre, this movement for the democratization of

culture was led by Jean Vilar and supported by André Malraux, who gave it a concrete form by setting up cultural centres (*Maisons de la culture*) all over the country. And it received its final finishing touches from Jack Lang. According to Fumaroli, by adopting a sector-based approach instead of a horizontal approach, which would allow consumers the freedom of choice, the state created coteries and gave rise to a culture dependent on subsidies without making any perceptible impact on cultural behaviour patterns.

This criticism has been repeated even by officials from the Ministry of Culture such as Michel Schneider, the former French Director of Music.[54] His analysis is based on the low productivity of the government's music policy. In thirteen years, there was no change in musical habits although the budget for music went up 3.2 times (from €0.61 billion in 1981 to €2.13 billion in 1993), which is in sharp contrast to the impression created by some over-hyped events like the Festival of Music. According to Schneider, this has happened because the state is not a good patron of the arts. It tries to control their creation without devising a proper procedure for taking decisions. The committees appointed under Jack Lang's ministry behaved somewhat like the official Salons that failed to recognize the merits of the Impressionists.

Finally, in his famous book titled *The Democratic Muse*, Banfield[55] points out that the argument that cites lack of information as a justification for the official control of culture is not at all valid. Consumers will look for even less information than before if the state claims to provide it to them. In any case, there is more emotion that information involved in the markets, which have never existed by definition.

The market as a source of creativity

After refuting the traditional arguments advanced by the advocates of cultural pessimism, the supporters of cultural optimism present historical arguments to show that the periods when the market played a dominant role were more advantageous to artistic development than the periods dominated by state intervention. According to the advocates of cultural optimism, a market economy plays a greater role in encouraging creativity and in developing the arts than any other system. They

do not hesitate to remind us that Gauguin denounced the effects of the system followed by the Arts Academy when he claimed,

> Happy are the painters who lived when there was no Academy; but for the last fifty years the state has only been supporting mediocrity. ... As opposed to all these pedants, there have been artists who have agreed to paint without being paid. ... The talent of these independent artists suffices to show the futility of a ministry of the arts. ... The words of Courier remain true: 'What the state encourages withers and what it protects dies.' [56]

Why is the market supposed to contribute to the development of the arts? The art market is very sensitive to the diverse tastes of consumers and sees to it that they are satisfied. Since they enable artists to work simultaneously for various backers or clients, art markets can safeguard their independence and maintain their creative abilities. The main criterion for success is the artist's proximity to his public. To this we may add another criterion, namely the market's ability to provide the means to nurture this creativity. By proceeding in this manner, we can bridge the gap between the culture of the elite and the culture of the masses, as the expansion of the market is expected to satisfy the requirements of both these classes and even move smoothly from one to the other. It is the market that decides which is the dominant form of culture and it can change the status of a work of art. Thus the film *Blade Runner* was first made with a happy ending and then made a second time with a sad and more creative ending, what the director had wanted from the very beginning. So, from a film of mass appeal it became a film for the elite. Three examples illustrate the theory of cultural optimism.

The first example is to be found in literature. With the invention of printing, books ceased to be works of graphic art and became true cultural products for mass consumption, so that their authors could finally make a living out of writing. The division of the market between large publishing houses, small publishers, university presses, etc., gave writers greater access to the market. Many critics may not agree with this optimistic interpretation. Did the development of printing not lead to a lowering of quality? Is it not true that newspapers, pocket books and mail order books lower the quality of the product? On the other hand, writers like Rabelais and Perrault thought that the ability to produce numerous copies of a book was a sign of

modernity. But in *Gulliver's Travels*, Swift showed that the Houyhnhnms, who excelled in the art of speech since they did not have books, trounced the Brobdingnagians whose libraries had almost a thousand books each and the Lagados who had a countless store of books. Swift was of the opinion that it would be better to control these books through a public mentor. Another criticism claims that some books do not bring sufficient earnings for their authors so that they can live independently as they desire. However, this does not hold true in the case of writers like Balzac, Defoe, Dumas, Dickens and Tolstoy, who were able to earn enough from their writing careers by diversifying and simplifying the publishing format to suit their readers. We may even go further and point out that it was the market that allowed women writers like Jane Austen and the Brontë Sisters to become successful, at a time when women artists had little say in society. And a final criticism claims that the market forces artists to satisfy the existing needs instead of nurturing their own creativity. However, this criticism assumes that the market is restricted and that one author becomes successful at the cost of another, which is a debatable point. It is always possible to create new slots of a permanent nature that will attract new readers without affecting the existing authors and their readers. Is it not true that, even so, a few prominent works will overshadow others and exercise an irreversible domination over them? Blockbusters always create their own audience instead of satisfying a variety of needs. Cowen has replied to this criticism voiced earlier by Tocqueville in *De la démocratie en Amérique* in the following words: 'The real problem is not whether Grisham sells more copies than Faulkner but whether works of high quality will find a publisher and a market.'[57] So, it is more important to have a large number of publishers and books than to have a blockbuster. The mass consumption of books develops only when they are available in plenty and not when there is a paucity of books.

Cowen's second example pertains to the market for paintings, especially at the time of the Impressionists.[58] At that time, there was an Academy of Fine Arts, which controlled the field of painting and painters. Among the tools at its disposal was the French School of Painting in Rome where it would send artists, who could gain fame by winning prestigious prizes. It also controlled the purchases made by the state and the annual exhibition

(Salon) in which the most successful works were exhibited. Talented artists like Delacroix gained recognition during this exhibition, but its main purpose was to preserve the norms that had prevailed in the past despite all odds. On the other hand, a painter like Chardin had to depend on the market for the success of his still-life pictures. Fragonard too depended on the market for the recognition of his paintings, which were not based on historical themes. Daumier relied on the market created by the press, and by selling two lithographs per week he was able to escape from the official system and become the principal critic of the dominant group of society. Painters of the Barbizon School tried to change the rules governing the lighting of landscapes by refusing to seek recognition from the Academy. Daubigny, Millet and Corot succeeded by selling their landscapes on the market and gaining recognition for a new style of painting, while the champions of Academic painting criticized them thus, 'This is popular painting meant for people who have no taste. This art disgusts me.' Actually, the French Government favoured a change of style and Napoleon III helped the rebel artists to hold the *Salon des refusés* in 1863. However, this did not change the opinion of the dominant groups. As a result, the Impressionists formed their own group; in 1873, Pissarro, Renoir, Sisley, Degas and Morisot joined Monet in holding the *Salon des Indépendants*. It took time for this Salon to gain recognition and success came only after four years. The Impressionists owed their success to the private art dealers who exerted a decisive influence on the market by buying their works and disseminating them, thus providing the artists with an income that allowed them to continue painting. A dealer like Durand Ruel became a multimillionaire by investing in the works of Manet and Monet. Theo Van Gogh and Ambroise Vollard did the same for other artists, and there soon emerged a flourishing market for contemporary art. Artists were able to make a living and some of them like Auguste Renoir even became very wealthy. The reorganization of funding methods enabled the Impressionists to develop their creative abilities. Instead of historical scenes and landscapes, they started painting pictures depicting balls, boat rides, railway stations and picnics. The pleasures enjoyed by their contemporaries became the subject of their painting, whereas earlier they were considered a sign of decadence. There were rapid changes, as manufacturers

brought out new brushes and pigments, but it was the develop-
ment of new styles that made a real difference, with the arrival
of the Post-Impressionists, Pointillists, Nabis, Fauvists and
Cubists in sequence. Paris became the centre of artistic creation
and the main art market, with artists like Picasso openly paying
tribute to art dealers thus, 'What would have become of us if
Kahnweiler did not have a good business sense!'[59]

The field of music provides the third example of cultural opti-
mism.[60] The most recent forms of music are generally margin-
alized by funding agencies, except a few like Boulez who has
received substantial financial aid from the French Ministry of
Culture. We must, therefore, ask ourselves whether the market
can create opportunities for contemporary music. The most com-
monly cited example is that of Mozart. In his early days, Mozart
received public patronage as the Konzertmeister of Salzburg to
maintain the musical tradition. After leaving this town, Mozart
made a living by playing contemporary and popular music. His
compositions, concerts and music lessons brought him enough
money to live comfortably without having to adopt officially
favoured styles. But towards the end of his life, he lost this finan-
cial independence once again and had to accept the post of the
Imperial Kammermusicus, while he continued to finance his
main musical compositions through the market and through pri-
vate commissions.[61] Cowen describes the emergence of African
music in America in more recent times.[62] Forcibly uprooted from
their native land, the African-Americans reinvented musical
instruments like drums, marimbas, guitars, etc., while their trad-
itional music inspired them to invent new styles like the Blues.
They prospered in the Mississippi delta where there was a flour-
ishing market for their music. Based on an oral tradition, this
music spread rapidly and soon occupied a dominant position in
the music-publishing market. From a popular local style, the
Blues became known all over America, thanks to concerts,
records, radio broadcasts, night clubs, etc. This led to the devel-
opment of other styles like Jazz and the Gospels. Their Creole
background inspired other styles like Ragtime and, of course,
Rock and Roll in cities like Memphis and Chicago. It was only
because of the market that these new musical forms developed
rapidly, but it was the record market rather than live concerts
that contributed to their growth. Even major publishers, who
showed little interest in these new styles in the beginning, soon

started giving them more space in their catalogues. But as in any other market, their success brought competition. The representatives of traditional music like ASCAP opposed BMI, an independent company that actively promoted these new styles of music. Other record companies tried to influence disk jockeys and radio and television comperes to play their records (the payola system). However, this did not prevent the success of new styles like Rap, Techno, etc. because musicians could compose and play their music at a nominal cost. Since their music appealed to a wide market, they did not have to face the traditional dilemma between the elite culture and the mass culture. Every time a new musical style emerges, there is a competition between old and new record companies as artists often prefer to start their own companies. And once a new style is established, it gives rise to a further fragmentation, such as Rap giving rise to Soft Rap and Hard Rap.

The advocates of cultural optimism are not content with pointing out the positive effects of the artistic market. They want to show why there are so many bans on state intervention in the cultural field and why cultural pessimism is in vogue.

The first explanation put forth by cultural pessimists is based on their attitude to the past. Many cultural pessimists identify culture with 'what they identified and liked in the past'.[63] Cultural pessimism looks at what existed in the past instead of what can exist in the future, and it does not take into account the fact that artistic creations appear quite suddenly. The second reason in favour of cultural pessimism is that people prefer to consume products that are known to them rather than those that are unfamiliar. In the field of music, for example, the period of listening and one's attention span are important for getting used to a new type of music or a new composition.

> It is only after some time that Haydn and Mozart seem superior to Gluck, Cherubini, Cimarosa or Gretry. ... Most eighteenth-century critics did not understand the difference between Mozart and his contemporaries... .[64]

If we consider a particular period, it is easy to say what is important and what will be important later. Even Chopin's contemporaries described his music as a 'tiresome cacophony' or a 'revolting and murderous sound for the ear... '.[65]

In their desire to bring up and educate their children according to traditional norms, many parents underestimate and even

reject the artistic works that question these norms. It is believed that markets for artistic goods threaten parental authority and there are frequent pleas for their regulation. Posner, however, has proposed another interpretation. He says that knowledge can be acquired either through experience or emotion and older persons give more importance to experience than to emotion.[66] But the market for artistic goods and services also takes these differences into account and makes provisions for memory and melancholy.

Religious attitudes have also contributed to cultural pessimism right from the time of the Byzantine Empire and the Iconoclasts when all images were banned for some time. Religions have always been very circumspect regarding the dissemination of images since they are mainly intended to honour God rather than for any other purpose. In a different context, even thinkers like Plato had banished poets from his ideal state and pleaded for the control of artists.

A final explanation is to be found in the attitude prevalent in artistic circles, which are often hostile to the market, above all to the idea of allowing art dealers to decide the fate of their creations. This is a reflex action that is similar to the behaviour of actors of silent films who revolted against the talkies because they thought that it was a commercial ploy to distort their art. Others believe that artists are hostile to the market because they do not want to compete with one another. Actually, this attitude is not very common because many artists also want recognition from the market, as Jonathan Swift points out when describing the behaviour of authors. There is no doubt that this creates a difference in the behaviour of well-known artists and those who are not known.[67]

Public governance of artistic activities

The expenditure incurred by the state may form the basis of its artistic policies, but it would be wrong to treat it as a yardstick. The expenditure incurred on culture by enterprises and households is usually much higher and within the state there are many divisions. In a country like France, the expenditure incurred by the Ministry of Culture, which generally attracts the most attention, represents only 7 per cent of the total expenditure on

culture. The total state expenditure on culture is not much higher than that of various regional bodies (17 per cent as compared to 15 per cent), while private expenditure is considerably higher than state expenditure (66 per cent as compared to 34 per cent).[68] The state must, therefore, confine itself to indicating the general directions to be followed and ensuring that public funds are used properly.

The arts policy in France: the vicissitudes of state control

The French are very fond of pointing out that at the time of Louis XIV, the state spent 10 per cent of its budget on culture, an amount that has not been equalled by any of his successors or any other government since then. Even though figures may have changed, the temptation to exercise control over culture has always been there. But to clarify the stakes involved and the contents of the cultural policy, it is better to begin with the early years of the Fifth Republic and the efforts of André Malraux in this field, since they continue to define the general principles underlying state intervention in cultural matters, which has been named differently as cultural action, cultural development or cultural vitalism.

Malraux's regime (1959–1969) appears rather ambiguous and the only point on which everybody agrees is the identification of his cultural policy with the birth of the Ministry of Culture. Many activities were already being carried out in the cultural sphere, most of them under the umbrella of the Ministry of National Education, usually under the label of popular educa-tion and directly under the control of associations. The effects of this policy were visible mainly in the theatre, which was sup-posed to reach out to sections of the population that had never had access to it before. This led to the creation of national drama centres[69] at the instigation of Jeanne Laurent. They received very little assistance from the government and had great difficulty in winning over new sections of the public other than those who had become upwardly mobile under the Republic (teachers, research scientists, executives, etc.). Malraux, however, insisted that the purpose of art is to bring people together, something that cannot be achieved by either reason or religion. It enables people to resist the dream machines created by capitalism and other totalitarian

doctrines. So the new cultural policy was aimed at

> making the main creations of humanity, and above all those of France,
> accessible to the largest number of French people: obtain the biggest
> audience for our cultural heritage and encourage the creation of works
> of art and the spirit that enriches it.[70]

To achieve this, it was necessary to create an administrative
machinery, which would go beyond the sympathetic ama-
teurism of popular education, and also a ministry consisting of
professional artists. The aim of this decentralization of cultural
activities initiated by the state was to reach out to the largest
number of people, and that was precisely the role assigned to
the cultural centres (*maisons de la culture*), pompously called
the 'cathedrals of the modern age'.

It is important to delve deeper into two more points. First, it
was believed that culture does not have much to do with edu-
cation and entertainment. State intervention would therefore
sift out the measures promoting popular entertainment, which
had preceded this new cultural policy. Nevertheless, one such
institution, the National Popular Theatre (TNP), was allowed to
continue and even put under a classical institution like the
Comédie Française. As for the rest, education was regarded as
a vehicle for transmitting the culture of the past, while enter-
tainment was treated as a means and not the end of culture.
Instead of education and entertainment, there was a meaning-
less formality and dramatization of works of art and the public.
The second point deals with the purpose of democratization; in
this case, it goes beyond a simple approach aimed at redistribu-
tion to become a shared emotion. At that time, the *maisons de
la culture* were the pivot of this cultural action. From the his-
torical angle, they permitted a logical balance between the old
method of managing cultural activities, namely the mobiliza-
tion of amateurism, and the new method based on a partner-
ship with professional artists.

> The *maison de la culture* is not a village hall, a community cultural
> centre, the office of sundry associations, the much awaited meeting
> hall... the hall that amateur actors dream about. ... It is ... a permanent
> opportunity to draw closer to the truth in areas where well-disposed
> volunteers are just starting out....[71]

There was no effort to break away completely from the
maisons de jeunes (youth centres) that were a part of the leftist

tradition in France, but only to move beyond the simple areas for leisure and entertainment and transform these friendly spots into places where people could establish a rapport with universal culture. The artistic activities practised in these centres were to be universal in spirit, multifaceted, pluralistic and of a high quality. Hence, they were to be conducted under the guidance of professional artists, with amateur associations only helping them to carry out their mission instead of being a basic element.

After the events of May 1968, a new cultural policy of 'cultural development' was formulated. This term was supposed to include the earlier doctrine of 'cultural action'. There was no attempt to dismantle the organization set up by Malraux, but it was to be run differently with greater stress on communication and close links with education. It was necessary to admit not only the existence of an elite culture but also of various references and their right to be disseminated. 'The triad of high culture, public assembly and access to works of art ... [was succeeded by] ... a triad of creation, multiplicity of groups and a dialogue between expression and experimentation'.[72] Consequently, the state could no longer stipulate the cultural practices that would serve as a reference, because the new policy was meant to promote multiple cultural activities in different fields. It was supposed to cover diverse projects, collaborate with other local bodies, beginning with the communes, and take into account the interests of the common people. It would continue to stress creativity, but by starting a dialogue between creators, local leaders, elected representatives and users, so that negotiation and tolerance would be the principles underlying the development of culture. And finally, it had to ensure that the opposition between the artistic and sociocultural aspects did not turn into a permanent rift.

Soon, there were many noticeable changes. The first was the creation of the Fund for Cultural Intervention (*Fonds d'Intervention Culturelle*), directly under the Prime Minister, and its main object was encouragement rather than coordination, and certainly not management. The second change was the relative importance given to the Centres of Cultural Action, which were actually meant to host cultural activities unlike Malraux's *maisons de la culture*, which were meant to host ceremonies. Finally, associations and sociocultural or

socio-educational leaders were even more welcome in the ministry, where they were even given specialized training. But this discourse on cultural development ended by freezing the basic debate, which at that time was aimed at the cultural industries.

This inertia came to an end with the presidential elections in 1981 and the appointment of Jack Lang as the new Minister for Culture. Culture received a great deal of importance, largely because of the initiatives taken in cities by the elected representatives of the majority party, the new Minister's dynamic approach and the strong condemnation of the spread of American cultural imperialism over the cultural industries. The slogan, 'economy and culture: the same fight' brought about a change in the traditional view of the stakes involved in the cultural policy. When economic interests dominate culture, culture can overcome them and produce positive economic effects. Concern about cultural identity and the right to be different have a strong economic basis and can lead to greater inventiveness and production – so much so that it is possible to talk of cultural vitalism. After having considered culture as sacred, there is now an appeal for greater creativity, which is expected to produce economic gains and, when it is not legitimized by democratization, there is another ground for justification, namely economic production.

In this set-up, it was quite normal to decentralize cultural intervention in order to create an environment that was extremely favourable to creators. This decentralization affected not only the traditional cultural institutions run by the government but also the relationship with the regional authorities. This movement was so effective that ten years later, these concerns about identity and social issues were more common at the local level than at the level of the ministry, which was still involved in the management of professional artists. A second significant change was the growing importance given to the economic consequences of culture, not only by the traditional cultural industries but also by the creative industries (e.g. design. fashion, etc.). But the effectiveness of this policy has not yet been established and it is necessary to separate the wheat of long-term actions from the chaff.

The arts policy in the United States: the role of the National Endowment for Arts

From the time the United States of America came into being, there was a strong demand for government support for cultural activities. The first public commissions were given in 1817 to the artist John Trumbull, who submitted to the government a 'Programme for a permanent support to the arts by the government'. But the major support during this period came from private patrons, leading to the establishment of the Smithsonian in 1846 with a grant from John Smithson and the Freer Museum around the Freer collection. During the New Deal, the project management programme for creating employment opportunities led to a large number of initiatives in support of cultural activities, most of which have disappeared in the course of time.[73] The proposal for setting up the National Endowment for the Arts was made during the presidential campaign of 1960. John F. Kennedy, who wanted to win the support of those in the artistic field, declared that supporting culture was one of the functions of government.[74] As soon as he was elected, President Kennedy put culture at the top of his agenda. Not only did he invite artists en masse to the White House but he also tried to create a permanent mechanism to support the development of the arts. There is no doubt that the President's motives were far more complex and went beyond his fondness for the arts, something he was quite candid about. They were actually a part of his political calculations, since one of his rivals, Nelson D. Rockefeller had chalked out a very daring cultural policy for New York. But once the movement had been launched, the projects had to be put into execution without making excessive demands on federal funds. He began with some attractive announcements, but the execution of the projects took very long and his untimely assassination interrupted the process.[75]

Although many artists had expected President Lyndon B. Johnson to show little interest in these projects, he saw to it that they were completed.[76] Two federal funds were set up in 1965, one for the arts and the other for humanities. Other public initiatives were taken up at same time, such as the development of the educational system with a special attention to the teaching of the arts, tax deductions for financing artistic activities, exemption from postage for non-profit artistic organizations

and the principle of allocating 1 per cent of the amount sanc-
tioned for all federal operations to artistic activities. All these
were in addition to the efforts of major private foundations like
the Ford, Rockefeller and Chandler Foundations, which would
soon be called into question.[77] The NEA involved itself in a few
well-targeted operations, notably in the realm of the performing
arts, namely theatre, music and dance. At the same time, it
was accused of being partial to the elite. Almost all its budget
was spent on projects related to the major cultural institutions
of the north-east, reflecting the loyalties of members of the
National Council for the Arts and the staff of the NEA.[78]
However, this trend was curbed and President Johnson, who
did not receive from artistic circles the same kind of warmth as
his predecessor, decided to block a part of the funds (about 10
per cent) for setting up the American Film Institute, on the
grounds that its film industry was the United States' major con-
tribution to the development of the arts and there was no
reason why it should not get special treatment.[79]

Quite unexpectedly, the NEA received a big boost during the
Nixon presidency. There was a fourfold increase in its budget,
which increased to US$40 million and its new Director was a
woman, Nancy Hanks, who had been in charge of most of
the cultural projects of the Rockefeller Foundation. She was of
the opinion that the NEA should ensure that cultural activities
were open to everybody. As the arts were becoming a necessity,
even though some people still considered them as a luxury, they
had to be taken to out-of-the-way places, suburbs and ghettos.[80]
This was followed by a period of activism in the true sense of
the term. All cultural practices were funded by the state, begin-
ning with the museums, which had received almost nothing till
then. The definition of culture was broadened to include pop
music, popular handicrafts, graffiti, zoos, botanical gardens,
etc. Nancy Hanks decided to exercise the greatest possible even-
handedness at the geographical level to ensure that the object-
ives that she had announced were fulfilled. This meant that she
had to provide each member of the Congress with a detailed
account of the funds allotted to his state or county. Trying to
fulfil all these objectives could paralyse the entire operation, as
all activities and all constituencies had to be given the same
treatment, which meant distributing funds mechanically
according to criteria that usually pertained to the form rather

than the content. As a result of the growing number of panels and sectors, which only those in charge of NEA could fully understand, administrative procedures gradually gained an upper hand over creation and organization.[81]

Consequently, the Director became more involved in political and administrative activities and Livingston Biddle, appointed Director by President Carter, was expected to fulfil this role.[82] He started off by trying to 'debureacratize' the NEA, which functioned like a government department, by announcing to all its members that their stay in the organization was temporary and they would have to leave at the end of their five-year term. He believed that this was the only way of putting an end to the populism, which led to the proliferation of aid.[83] But bureaucratic tendencies were deep-rooted, and it became impossible to avoid this proliferation when in a single year more than 20,000 applications for subsidy had to be processed by 300 persons! The NEA was openly criticized for being completely unaccountable for the results of its actions, which appeared to the public only as rising costs, and the uncontrollable increase of programmes, which had shot up from the initial 13 to over 250! Further, every sub-sector of the NEA adopted its own guiding principles, which often went against the overall philosophy that had inspired its creation, especially the idea of increasing audiences. So, the strongest criticism was directed against the NEA's failure to bring about an increase in audiences in the areas in which it had intervened and music was cited as an example.

As soon as it took over, the Reagan Administration announced a drastic reduction of 20 per cent in the NEA's budget, although the government had earlier proposed a 10 per cent annual increase. There was an immediate reaction in cultural and bureaucratic circles and a caucus was formed in the Congress. The actual reduction was only 6 per cent, i.e. four times less than what was announced, but it did take place in spite of all the protests. The new Director, Frank Hodsoll, changed the panel of experts expecting that there would be a different choice of programmes and that institutionalized programmes that no longer merited support from the government would come to an end. He also instituted a national medal for the arts, which was awarded to the most generous among the private financiers. As a matter of fact, the administration wanted to encourage private funding of culture and decided to renew or increase tax concessions for

this purpose.[84] The NEA started languishing because it refused to declare its aims clearly and, what was more serious, it seemed incapable of generating its own resources and was doomed to depend on the state's generosity.[85] The management of state intervention in the realm of plastic arts became a subject of greater controversy, because mistakes were more obvious and debates more vocal than in other sectors. For a growing number of Americans, avant-garde art became synonymous, rightly or wrongly, with political agitation and scandals. When the NEA was attacked by its adversaries, it was supported neither by its champions nor by professional pressure groups, and all appeals for better quality or bigger audiences proved to be useless.[86] The next Director, Frohnmayer, resigned in 1992 after making his dissatisfaction publicly known. Once he had given up his post, he became a champion of artistic creativity and opposed the control exercised by public financing, something that was very surprising coming as it did from a person who had headed the NEA!

When Clinton took over as President, a new management was appointed, first under Madeleine Kunin and later under Jane Alexander. The budget was gradually increased and there was greater support for local actions and training programmes. But when the NEA completed thirty years, the Congress decided to scrutinize the organization from top to bottom and decided to cut down its budget by 39 per cent.[87] The seventeen sectors that shared the funds allotted to the NEA were replaced by five functional divisions in charge of creation, heritage and conservation, education and access, planning and stabilization. The NEA laid stress on partnership in its action and became more active in assisting handicrafts. In its strategic programme for the period 1999–2004, the NEA has asserted that its guiding principles are recognizing the diversity of artistic activities and encouraging projects.[88]

What ails the different sectors? To start with, priority was given to the theatre, undoubtedly because it was the liveliest domain, but also because it had to compete directly with the cinema. Everybody harped on the difficulties of staging a show and the high costs incurred either because of artists, the sets, renting a suitable space, rehearsals, etc. The only ones who profited by all this activity were the lawyers and this was an indication of problems that were likely to arise in other cultural sectors like the cinema. The costs had doubled in less than six years, and

the subscription system did not produce the expected results. There was even talk of a cycle in theatrical activity. In the first phase, one or more brilliant theatre personality managed to stage very successful shows. In the next phase, the local community came to the institution's support and brought in money by attending its performances more frequently. But the costs went up too fast to be able to maintain the expected sources of success, leading to deficits and, in some cases, even to closure. Conflicts between art and economics got exacerbated, television was denounced and everybody turned to the government to get more funding in the name of democratization, which probably never existed nor was even sincerely desired. In the present case, the situation was further aggravated by the negative reaction of private donors.[89] But the situation worsened as the NEA had to make up for the absence of the Ford Foundation. It also had to solve the problems of more and more institutions attracted by the possibility of obtaining federal funding, especially those who lobbied with their representatives in the Congress to get them a share of the funds. This spurt in the number of theatres was the second major problem,[90] and though the public was not aware of it, it gave rise to the creation of several training programmes for actors. Between 1960 and 1970, the number of trained actors increased from 4,800 to more than 18,000. The situation became unmanageable, as the theatre companies believed that they had a right to state funding renewed year after year. So, the NEA adopted two measures. First, it reduced all theatre subsidies by 10 per cent and then it proceeded to classify the companies on an annual basis, withdrawing the subsidies for those who stood at the bottom of the scale.

It was only in the early 1970s that the NEA began to take an active interest in museums following an important report published in 1969, called the Belmont Report.[91] According to this report, which had been prepared with the assistance of several museum directors, museums were not in a position to provide the services expected of them, especially educational services. This was mainly due to their responsibilities in the field of conservation and renovation, which took up the major portion of the meagre resources at their disposal and prevented them from undertaking others. This diagnosis applied not only to the fine arts museums but also to science, history and other museums. Although they were unable to obtain sufficient financial

resources, museums had managed to establish for themselves the Institute of Museum Services, which was asked by the government to lay down the criteria for obtaining funds and public assistance. But the Institute was not able to provide a basic definition, as a result of which any 'body' calling itself a museum could claim such assistance. Thus there were different types of demands for assistance, and they had to be channelled, for want of a better solution, by insisting on certain criteria such as the accessibility, geographical diversity, etc. These criteria were quite logical but they could not become the basis of a policy.

For a long time, the general public neglected the field of dance. Gradually, as a result of innovations, private foundations – including the Ford Foundation – began to provide substantial assistance to dance companies. The NEA followed suit but it stipulated just one condition, namely that the company should organize tours, and the subsidy was given on the principle of accessibility rather than quality. During the 1960s and 1970s, there was a double explosion of the number of both the dance companies and the audience. In New York alone, there were more than a hundred companies, the top four of which offered subscriptions. Boston had ten permanent modern dance companies. In fact, the audience soon began to diminish and the pressure on the resources of the NEA, and also of the Councils for the Arts in various states, grew to such an extent that there were not enough public funds to satisfy the demands. This gave rise to a peculiar, but important, phenomenon. The companies tried hard to achieve at least a small audience to recover the costs and hence presented more and more shows of Tchaikovsky's *Nutcracker*, which was very popular with the general public. This one ballet represented 40 per cent of the shows put on by these companies, and the figure was even more significant because it was applicable everywhere, no matter what criterion was applied – geographical, legal, art school, etc.[92] But that was not enough, and artists, e.g. those of the famous American Ballet Company, willingly accepted a lower pay to tide over the difficulty.

Although American symphony orchestras are widely appreciated, their audience has always been small and concentrated, the proportion of the audience in urban areas being less than 2 per cent of the population. Nevertheless, the price of tickets remained relatively low, musicians were paid according to the

income from admission charges and, at the beginning of the century, these orchestras received substantial public assistance. Five orchestras (New York, Boston, Philadelphia, Chicago and Cleveland) became very famous, but during the early 1960s the number of orchestras as well as of concerts almost trebled in less than ten years. Besides, larger concert halls were built all over the country. Despite endowments from private and public funds, the resources of these orchestras had a tendency to decline, the best example being the Chicago Orchestra whose endowments came down to one-sixth in a few years, whereas its costs continued to go up. The Chicago municipality tried to solve the problem by guaranteeing a fixed number of concerts for 52 weeks, but did not bother to find out if there was an audience for these concerts. At the same time, musicians had a powerful lobby and they managed to get several guarantees: their payment no longer depended on box-office receipts (especially since the municipalities organized an increasing number of free open-air concerts), and they were also entitled to earned leave. What is significant is that the NEA sided with the musicians and pleaded with the federal authorities to increase the subsidies given to orchestras. This was successful, and during the late 1970s assistance to orchestras was the largest, constituting almost 20 per cent of the NEA budget. But as in the case of the theatre, the situation was complicated by the pointless development of training programmes for musicians in universities, which were generally more theoretical than practical. As the audience was comprised of older people, another idea was tried out matching the wishes of the American Symphony Orchestra League, namely the Americanization of programmes that normally tended to concentrate too much on the European classical repertory. Programmes changed gradually, often giving rise to controversies because a section of the audience still demanded classical works. The NEA also started funding the composition of new works. This again was not enough. In the late 1980s, there were 2,000 orchestras in the United States or almost half the total number of orchestras in the world, and the twenty–six top orchestras attracted half the audience. To crown it all, in spite of the small budget the number of players continued to grow.[93]

The opera and its audience did not lag behind other sectors of the arts in asking for public assistance. In the United States, the opera is associated with the elite, whether it is the Met or the

numerous other operas that later sprang up all over the country. Following the Second World War, there was a spurt in the number of operas and also, to a lesser extent, in the size of the audience. There was also a growth in the number of touring companies, which had negative effects on the running costs of the opera. Just like the Met, different operas faced a number of difficulties due to the popularization of the opera on television and the demand for spectacular shows, which had the foreseeable consequences of a rise in the price of tickets and a fall in the audience. The only way of continuing to maintain the opera companies was by changing their repertoire drastically. The NEA made the difficult choice of launching modern operas, whereas the companies opted to go in the opposite direction and presented shows that were closer to musical comedies than operas.

Several factors strike us when we look at the history of the NEA from its birth to the present day. First, it has always shown a tendency to resist bureaucratization. Secondly, there have been cycles in its priorities and it has alternated between the performing arts in general and heritage, music, plastic arts, the creation of new organizations, usually non-profit organizations, etc. The circumstances that allowed the NEA to succeed are easy to identify: the availability of substantial funds, high returns on the capital obtained as low-interest loans, the quality of persons appointed as directors of the NEA and a consensus about its mission, at least until it reached a phase of disarray. However, other factors did not allow it to accomplish its expected mission. By laying stress on creation instead of the expansion of the audience, it found itself under the domination of experts in its early stages and later under the domination of bureaucrats. By giving too much importance to specialists, it created excessive compartmentalization and deprived itself of the benefits of cross-fertilization and mutual enrichment. By giving priority to production over training, it failed to bring about a sustainable development of culture.

The different types of artistic policies

The two policies described above indicate that there are different types of cultural policies, which differ from one another in terms of structure and implementation. Many of the instruments used for implementing these policies have been

mentioned earlier and we will dwell here on the different strategies behind them.

Different types of state intervention

Some countries have built their cultural policies around a public institution while others have preferred to rely on funding from private organizations. This choice is guided by the degree of confidence in the market, the existence of community relationships and the means employed to involve the public. Let us take the subject of training: some countries began with the creation of a public sector in the field of culture and soon introduced a public system of training, whereas other countries chose to rely on private systems. Let us take the laws regarding heritage: the very existence of public museums and national monuments implies that there is an official system for classifying heritage, which will also be applied to private museums and monuments, while their absence makes the problem less urgent. Due to a certain amount of hybridization of the different types of management and funding, one would suppose that these differences would lose their significance and that the difference between the institutions is one of degree rather than of nature. It would mean forgetting that the relative importance of the players depends on the nature of the institutions and that the games being played do not always have the same motives or the same effects. It is also not certain whether the states will have more power if they chose public forms instead of private ones. Let us see how subsidies are decided. In the first case, those who apply for subsidies should have a good rapport with the organizations that enjoy a position of strength within the government, whereas in the second case, the authorities can be more exacting about specifications or the fulfilment of obligations agreed upon in principle.

Another dichotomy is seen when analysing the differences in artistic consumption and the mechanisms used for correcting this imbalance. The selectivity of cultural practices, which is regretted by one and all, is without doubt the strongest argument in favour of artistic policies, and it is therefore logical that it should enable us to distinguish between different artistic policies. The presence of prices is the first factor of selectivity, followed by the availability of information, geographical distance,

availability of free time, etc. But while some people opt for free entry, others prefer systems based on the issue of vouchers. There is a big difference between the two systems: the first one allows the supply to determine the nature, quality and relevance of these services, while the second allows the user to pick the service of his choice and thus express his approval of the supply. Systems dominated by the state prefer not to charge users, but statistical data show that this is not enough. Although there is no admission charge, it is necessary to finance various activities such as information campaigns, the creation of more facilities and also providing for mobile facilities such as mobile libraries. Other systems may not go so far, as they are content to redefine the voucher system to make it more effective. It must, however, be recognized that the first of the two options is the one that is more commonly chosen, especially by traditional public institutions. If we take the example of public museums, we will notice that the proportion of direct public subsidies is very large. In the United States, public subsidies and private donations account for 83 per cent of the budget of federal museums, 64 per cent of the budget of state museums and 61 per cent of the budget of municipal museums. Art museums have to rely mostly on private patronage (80 per cent).[94,95] As for the performing arts, a similar proportion is seen in France, where the subsidies received by the Comédie Française amount to about 75 per cent of the budget of the institution, while the subsidies received by the Paris Opera amount to about 80 per cent of the budget. There is nothing exceptional about this proportion, because if we consider the funding of the major orchestras or the German operas, we will find that public subsidies account for 70–89 per cent of the budget since receipts from admission charges are very low (11 per cent in the case of the Dusseldorf Opera, 13 per cent in the case of the Stuttgart Philharmonic Orchestra, 15 per cent in the case of Munich Philharmonic Orchestra and 28 per cent in the case of the Bavarian State Opera).[96]

A third dichotomy is seen in the organization of artistic professions and, more commonly, in the organization of artistic production. The main cause is the low rate of income. The countries where culture is controlled by the state do not hesitate to create mechanisms to control this source of artistic income (e.g. creation of government jobs, special youth programmes,

payment of an unemployment dole, etc.). Other countries make an effort to ensure that works that are appreciated by the public become a source of earning for their authors. Somewhat paradoxically, the results of these two systems are often not as clear as one would expect them to be, and the difference between the earnings of artists and the average earnings of similarly qualified persons is usually less in the so-called 'liberalí' countries than in state-controlled regimes.[97] But this difference is often due to the indirect effect of public subsidies, which entice people to become artists, and they cling to the profession even when market forces make it difficult to enter the profession and there is no demand for their work.

One more dichotomy is caused by the concentration of public assistance or its distribution among a large number of artistic institutions. In general, artistic policies have concentrated their attention on those activities demanding intensive artistic effort and operating on a bigger scale. Their public intervention involves a considerable amount of money and prevents the granting of assistance to a larger number of small enterprises. This bias is also found at lower levels, when regional authorities and even municipal bodies follow the example set by the central government. This approach has three consequences: it inevitably favours a certain type of taste, it does not encourage innovation in a systematic manner and it does not give equal opportunities to all artistic activities.

The last dichotomy depends on the way the market is allowed to function. Even in the absence of direct public intervention, there may be an attempt to control the market so as to avoid short- or long-term excesses. Given below are two illustrations from totally different fields. The first relates to the market for books. Some European countries (like France, Italy and Belgium) have imposed a fixed price to protect distribution networks and bookstores from the competition from hyper-markets, which can offer substantial rebates because of their large turnover, and to prevent books that are not read widely from being slowly eliminated from the one or two big retail outlets that still exist. Parodying a famous law of economics, we may say that 'books that are easy to read drive out difficult books'. But there is also another version of this argument. Since books cannot be considered as indispensable goods, they are subjected to impulse buying by consumers and they will be purchased

more frequently if there are a large number of distribution out-
lets where books are prominently displayed. It is, therefore,
absolutely necessary to have a dense distribution network,
covering the entire territory and having books catering to all
groups and communities irrespective of their reading habits.
The only way to achieve this is to avoid the elimination of small
neighbourhood bookshops by large departmental stores that
can afford to give discounts because of their large turnover. It is
therefore essential to maintain the single fixed price for books.[98]

The second illustration pertains to the market for monuments.
In many countries, the destruction or drastic conversion of monu-
ments is allowed, provided that the general rules and regulations
relating to the permission to build and modify are obeyed. But
in other countries, these monuments are generally protected
through special rules classifying them as heritage, which prevent
their proprietors, whether public or private, from modifying
them as they please, and the latter are obliged to maintain them
with the help of public funds. This legislation is very important
from the conservation angle. But this change in the market has
a price: apart from prompting proprietors to eliminate monu-
ments or parts of buildings that have not been classified as herit-
age, it encourages rent-seeking actions, i.e. the proprietors enjoy
monopolies that they would like to exploit to make money.

The different public organizations that influence the world of art

What form should public intervention take? Would it not be
better for the state to allow independent agencies to intervene
in the world of art and thus open the way for a joint action by
both public and private funding agencies on the basis contrac-
tual arrangements? When the state does intervene, would it not
be better if it decentralized its functions and transferred them
to local authorities?

Who should decide the allocation of public funds: political
bodies or agencies that are relatively distant? The first hypothesis
is dangerous because there are accusations of populism,
inequitable selection and public control of art. Some countries
have therefore maintained a distance between political bodies
that assume the final responsibility and the agencies entrusted
with routine decisions relating to the management of funds allo-
cated for artistic activities. This does not completely eliminate

the risks mentioned above. In actual fact, the method of appointing the members of these agencies, defining their powers and the duration of their term of office are determining factors. A good example would be that of Great Britain, where non-commercial cultural initiatives originate from a relatively independent body, namely the National Arts Council. This body co-ordinates and channels the funds allotted by various ministries, organizations belonging to the third sector (e.g. foundations, associations, trusts, charities, etc.) and individuals and companies (donations). More often than not, the state prefers to rely on Commissions under its control consisting of government officials, artists and elected members. The working of these Commissions is often criticized, because their actions are not so transparent and the non-artist members often show an indifferent attitude, leading to the selection of artists for public assistance by the artists themselves. The Commission's heterogeneous composition ensures that nobody takes the responsibility, with the bureaucrats bowing down to the artists and the latter claiming that they never have enough freedom.[99]

There is another advantage in seeking the help of agencies, as it is possible to enter into a more active partnership with private institutions, with the third sector or even with local authorities. Currently, partnership arrangements are always made in the funding of artistic activities and those in charge of artistic programmes are obliged to do the rounds of various offices to balance their budget. As a matter of fact, this practice of doing the rounds of various offices is useful in that it provides valuable information and can influence the size of the project. On the other hand, there is a fear that such partnerships may add to the costs of the organizers and some may take advantage of them to shift their responsibilities on to others.[100] Hence, partnerships with government officials often involve these risks or are deemed risky even when there is no real risk. It is also better if the often indispensable funds invested by the state in these partnerships are managed jointly by the partners, with an equal share of both rights and obligations. And this can be accomplished more effectively by a decentralized agency than by a Commission consisting of government officials.

In addition, public authorities stand to gain from this practice because it allows them to mobilize a larger amount than what would otherwise be available to fund artistic activities. Let us

take the example of the National Endowment for the Arts mentioned before. In the face of exigencies, its management decided in 1985 to create the Council for the Arts, which was to be funded equally by the NEA and the state. The initial endowment proposed by the NEA was too small. However, by introducing this new policy, the NEA brought together local players and depended on neighbourhood information networks, which shielded it from the usual accusations by the bureaucracy, especially since its first allocation of aid was given to the north-east. Besides, the states soon exceeded their share, which enabled the NEA to exert pressure on them and they followed totally different directions giving rise to a wide variety of experiments and experiences.[101]

If we assume that the government decides to take charge of the allocation of public funds, which level of the administration would be most suited for this purpose: the central government or the regional bodies? The motivations for public intervention change according to the nature of the decision-making body. Whereas the government is concerned with the conservation of national heritage, the local bodies give more importance to cultural practices and the use of cultural services. This may be a reflection of the relative distribution of powers, but initiatives taken outside the strict field of jurisdiction reflect this distribution of roles. Let us look at the proportion of different kinds of expenditure incurred by the regional bodies in France. The expenditure on music is 22.6 per cent, on books and libraries 14.5 per cent and on organization of different programmes 13.4 per cent, whereas the plastic arts and the crafts are allocated 7.8 per cent and historical monuments only 5.9 per cent.[102] On the other hand, at the national level, monuments and the plastic arts claim a large share, whereas the share of music and books is considerably less. Having admitted this, the size of the municipal bodies is an important explanatory factor. Thus the higher the population covered by the municipal body, the higher the amount allocated to the plastic arts. This relative division of actual powers is based on the reasoning that since the municipal bodies are directly responsible to their electors, they have to prove that they are capable of improving the living conditions and satisfaction level of the population under their jurisdiction, while it is easier for the government to intervene in areas where public opinion is not so vociferous. Further, the decentralization of public intervention seems to be the best

means of bringing about equal access of all the classes to culture, especially when there is a great deal of local differences.

Choice of funding methods

One problem relates to the amount of funds to be allocated to artistic policies. It could be said in general terms that this amount is defined by the market's shortcomings, but it is very difficult to say how far this funding should go and what should be the limit of the external effects. At best, this approach can be based only on the definition of the minimum level, whose fulfilment does not depend on financial factors alone. The second criterion could be found in a comparison between different countries, but that would amount to neglecting the effect of funding traditions and habits and the role played by enterprises. There is nothing to prove that the levels in other countries are either adequate or unbiased. The third criterion is more practical. The budget is revised every year in the light of marginal adjustments, and these, if the need arises, are altered to suit medium-term programmes. Production costs are a determining factor, and if they rise faster than the inflation level, one can expect a slow but compelling growth in the expenditure on culture in real terms. Another practical criterion has been adopted by other countries, namely allocating a certain percentage of the national budget or the GDP for culture. The first reference is particularly shaky if the public expenditure does not represent a significant percentage of the total amount spent on culture. In France, it is considered preposterous to follow a system according to which the proportion of the budget for culture is 1 per cent of the national budget, whereas the expenditure of the Ministry of Culture is only 25 per cent of the public expenditure and 7 per cent of the total expenditure on culture!

An important option would be to decide on how to strike a balance between public subsidies and tax benefits. This choice has been there for a long time in countries depending on private patronage, because they are obliged to offer tax benefits to maintain the flow of aid from patrons. But it also exists today in countries exerting a strong control over art and culture, as they find it difficult to allocate sufficient public funds to fulfil the ever-growing demands of artistic activities. The essential argument here is the presence or absence of governmental

interference: by banking on tax benefits, the government allows citizens to decide what type of activities they would like to support instead. Another argument that is often advanced is that public subsidies are generally given to a certain number of large institutions that are as costly as they are prestigious, depriving small or newly created institutions of such assistance. But some may point out that ordinary citizens are not well informed and that there is no reason why the state should not take interest in the use of funds coming out of its coffers. They cite Netzer, according to whom citizens who have the right to take such decisions do not represent all sections of society but only some of the more affluent social and professional classes. This certainly does not correspond to the objectives of democratization of culture.[103] In other words, for supporting specific aims, both in terms of supply and demand, it is better to give public subsidies than tax benefits. On the other hand, from the standpoint of organization and working costs, the system of tax benefits is obviously preferable to the system of giving public subsidies.[104]

One last point concerns the nature of funds that can be mobilized for supporting artistic activities. There have been frequent pleas that the arts should be funded with the proceeds of state lotteries, football pools, etc., which can raise large sums of money (as in the Republic of Ireland and the United Kingdom). If this source of funding has the disadvantage of fluctuating considerably year on year, it also has the advantage of raising large amounts of money 'under general anaesthesia'. However, on the basis of careful observation, Schuster warns us against this system, as it leads to a substantial increase in the availability of funds during the first phase, but during the second phase prompts many traditional sources of funding to turn away from artistic activities in favour of missions or objectives that are not yet covered by the proceeds of lotteries.[105] On the other hand, he observes that wherever such systems have been set up, they have led to a stabilization of options in the artistic field.[106,107]

Is public governance impervious to globalization? Cultural exception or cultural diversity?

Public policies in support of artistic activities can no longer be considered without considering regional integration or even

globalization. As for cultural industries in the European Union, two factors can be taken as a starting point.

Some cultural industries are already highly integrated at the world level. The record industry – notwithstanding the recent developments mentioned below – can be described as a global industry in which the main players operate across huge areas, occasionally using specific publishers or distributors to take advantage of the local conditions. In contrast, the book industry – logically enough because of the linguistic diversity – is less integrated at the world level and more reflective of national dynamics. However, we are now entering a new age with regard to cultural industries. For a long time, cultural industries were confined to a particular sector and operated according to an oligopolistic model, with a large number of small production and retail companies gravitating around a core of major distribution corporations. Now, in the digital age, the frontiers between different cultural sectors are disappearing. Cultural productions are becoming formulas that can be applied to different media, and corporations from different sectors are integrating with each other, with Internet access portals becoming a crucial prerequisite.

Some countries in the European Union have adopted an original strategy known as cultural exception. Because of the role that works of art and artistic products play in the development of a country's identity and the education of its citizens, these countries wish to protect such goods from market forces, which is likely to cause the disappearance of local original productions in favour of imports, thus diluting the country's image. Although France has only recently invoked this strategy at the level of international regulation, it has followed it implicitly for a long time. This strategy of making an exception of certain artistic goods – also practised in varying degrees by Greece, Italy and Spain – first manifested itself during the Uruguay Round and the negotiations on the inception of the WTO. To avoid the abolition of broadcasting quotas for audio-visual products under the European Union's Television Without Borders Directive, France urged its European Union partners to exclude audio-visual goods and, by extension, cultural goods in general from the negotiations, so that they could continue to enjoy existing European Union or national protection. Arguments in favour of cultural exception can, of course, mask other motivations, such as the interests of

lobbies wanting to protect their market positions and revenue from competition. But it cannot be ignored that many countries advocate the strategy of cultural exception, which poses problems for integration. At the G-8 summit in Okinawa in July 2000, heads of governments stressed the dual nature of artistic goods as both marketable and symbolic goods. It is therefore important to facilitate their circulation without, however, destroying their symbolic significance. Various international regulations recognize the specific nature of cultural goods. The GATT acknowledged in 1947 the need for production quotas for films and reiterated it in 1994. It also excludes national treasures of artistic, historical or archaeological value from its regulations (Article XXf). The General Agreement on Trade in Services (GATS) allows temporary exceptions (the 'positive list' principle), as in the case of film production, for a period of five years. The Agreement on Trade-Related Intellectual Property Rights (TRIPs) renewed existing agreements and proposed new measures to assist their protection. UNESCO added a number of provisions for the protection of heritage and intellectual property. The European Union began to take an official interest in culture with the Maastricht Treaty, the first to include a provision to

> contribute to the flowering of the cultures of the Member States, while respecting their national and regional diversity and at the same time bringing the common cultural heritage to the fore (Article 128).

The European Union has also produced other texts at a lower level, including the Television Without Borders Directive (STE-132), the Culture 2000 programme designed to create a common cultural area, the public broadcasting service proposal, the agreement on co-producers and the agreement on the mobility of artists (1999).[108,109]

The issue is to know whether European integration will remain centred on the principle of cultural exception – in which case there will be no major changes in trade, regulations or structures – or whether European integration will marginalize cultural exception – in which case we can expect larger markets, homogeneous regulations and integrated structures. France supports the former approach, but it has mitigated its position in two respects. With the integration of cultural industries, a process occurring beyond its national borders, France now advocates cultural diversity rather than the narrower principle

of cultural exception that paves the way for more balanced positions and compromises. France agrees to change its national regulations, if similar regulations are adopted at the European Union level, and is willing to support the concept of European culture instead of French culture if cultural specificity is asserted at the European Union level. This is a delicate balance to achieve, given the many issues at stake, the variety of national positions and the conflicting interests of the Commission, which is at once the natural and explosive meeting point of free-market dynamics and technocracy. Perspectives, therefore, vary from sector to sector and the result is more a change in the mode of governance of cultural activities in the European Union rather than a major change in regulations or structures.

Regional integration at work

From the outset, there are two radically different positions. First, there is the position adopted by the Commission inspired by unrestrained free market dynamics, which seeks to impose the principle of a single market across all sectors. Secondly, there is the position adopted by France, which considers that artistic goods should be exempted from homogenization and a solely market-based treatment. Three examples of artistic practices are given below, which show different outcomes and different degrees of pragmatism. Let us first take the example of books, where France has not been able to get its policy accepted by the European Union, but has been allowed to maintain it within its territory and, together with other countries, argue for fixed prices for books across linguistic areas. In the case of heritage and circulation of artistic goods, France has complied with the Commission's single-market policy. And finally, in the case of the cinema, France continues to impose its system on the Commission but agrees to define cultural specificity at the European level.

The book industry is less globalized than the record industry and is characterized by regional issues. Although there are fewer public stakeholders in its book industry than in other cultural sectors, France has a highly symbolic regulation in the context of regional integration and transition to a single market, namely the 1983 law on fixed prices for books. By having fixed prices for books with severe restrictions on discounts (a maximum of

5 per cent), the government has protected not only the livelihood of independent bookshops, but also the future of numerous books destined to disappear from distribution channels and, over the years, from production. Although the issue owes more to conventional economic debate than to cultural exception (small bookshops and product lines threatened by mass retailing), the government's reaction was different in this case because cultural goods were involved. Many countries have followed the example of France in different ways. Some countries have enshrined the principle of fixed prices in law (Belgium, Greece, Italy and Portugal). Others prefer to achieve the same result through agreements with the industry (Austria and Germany). Still others have abandoned this approach after exploring it in some measure (Sweden and the United Kingdom).

The debate was gradually brought before the Commission, at the instigation of private operators – divided in their opinions – and the European Parliament, which sought to protect the specificity of books. Opponents of fixed prices for books (Sweden and the United Kingdom) argued that unrestricted prices encouraged competition between publishers. To counter the fears expressed by France, Sweden cited its own history. In the early 1970s, it had to put an end to a similar system which had led to the fall of book prices without reducing the number of bookshops (but the Swedish Government continued to grant subsidies to bookshops). The advocates of fixed prices reiterated their argument about distribution. Since books are not a necessity, they are considered impulse purchases on the part of consumers, and such purchases will be more frequent if there are a large number of places where books are distributed and sold. The Netherlands believed that fixed prices encourage diversity in the supply; if prices are unrestricted, there will be a tendency on the part of publishers to concentrate on the supply of mass-market books. The advocates of fixed prices also pointed out that in countries where the principle of fixed prices is applied, average prices are lower and add to the consumer surplus.[110]

However, advocates of fixed prices, including France, have modulated their requests in two respects. First, they recognize that such a legislation is challenged by electronic distribution, the effects of which are still difficult to assess in the case of European countries which, unlike other parts of the world, have maintained a network of local bookshops. Italy, for example, plans

to re-examine its legislation regularly and make necessary amendments in the light of its experience. Secondly, and most importantly, countries that support fixed prices for books want these prices to be fixed across linguistic areas and not just in individual countries, which would require re-deploying this legislation at the European level. Austria, for example, argues that it needs to have a fixed price for books written in German, because its own book industry cannot otherwise compete with the German industry. The difficulty, however, is that the Commission wants to abolish all cross-border obstacles to the circulation of goods.

The Commission, which is already opposed to the principle of fixed prices and France's intention of generalizing it in the entire European Union, was equally hostile to the proposal of many countries to fix prices across given linguistic areas (or, failing that, in individual countries), because this would hinder cross-border trade. However, since the Commission is unable to impose its views on the coalition, it continues to allow each country the freedom to pursue its own policy and insists only that member states must consult the Commission before effecting any changes in their legislation (Article 81 of the Treaty). The Commission also has to take into account that in 2000 two countries, namely Belgium and Italy, brought their legislation closer to the fixed-price principle, thus moving away from the Commission's position. It is gradually becoming evident that the Commission will have to respond positively to the three linguistic areas that support fixed prices, namely the German-, French- and Dutch-speaking areas. The countries concerned want the Commission to implement the principle of fixed prices across each of these linguistic areas, if only to avoid unfair competition or eviction that could lead in the long run to the pricing of supply. In 2000, the Council of Ministers under France's chairmanship adopted a position in favour of this principle, but the Commission is reluctant to translate it into an official directive.[111] As often happens, there is co-ordination between countries that agree to apply a given principle; but they do not succeed in transforming it into a legislation at the level of the Union in the absence of unanimity.

As mentioned earlier, the protection of immovable and movable heritage is one of the oldest cultural policies in France. Its most visible manifestation is the system of listing monuments, paintings, sculptures, etc., the main aim of which is to ensure

their conservation and, secondarily, to avoid their alteration and restrict their circulation. In France, a law was passed in 1920 subjecting exports of works of art to prior permission. If permission was not granted, the items were usually listed as heritage. For domestic circulation, another instrument of control was introduced. The state was given a pre-emptive right on the sale price. The former procedure limits the circulation of works of art, while the latter reduces the purchase price and therefore the cost incurred by the state for acquiring works of art. This created opportunities for strategic manoeuvres between the state and the vendors with the latter receiving the required permission only in exchange for concessions on other works of art. This system was reinforced by another provision, albeit less spectacular. Any public sale or auction must be organized only by agents having a public monopoly. Auctioneers thus acquired the status of state officials, with Drouot in Paris being the main auction house. This had two consequences: it made auctioneers particularly receptive to the wishes of public institutions and the Ministry of Culture and it prevented foreign operators such as Sotheby's or Christie's from entering the market, except as buyers, which they did frequently. This monopoly has in fact existed since the sixteenth century, although the number of beneficiaries has increased.

The implementation of the single market is changing this system radically. In 1992, Sotheby's asked for the implementation of single-market legislation which would enable the United Kingdom auction house to conduct public auctions in France and thus end the French auctioneers' monopoly. It would in fact allow all operators, European as well as others, to organize public sales freely and to sell directly to private buyers and institutions. France finally agreed in principle to abolish the national auctioneers' monopoly by passing a law on 10 July 2000. However, it has not yet passed the enabling decrees, which means that the previous legislation is still applicable. France has also implemented the principle of free circulation of goods. The single-market principle was applied to works of art, but with a major exception at the request of France and other countries, who have an extensive national heritage. European legislation makes a distinction between national treasures and artistic goods, with the definition of national treasures left to each country. Countries can retain national treasures, but they

must henceforth allow the free export of other artistic goods, at least temporarily. However, this raised the problem of some countries divesting the new legislation of all meaning through their definition of national treasures. The system, though substantially different from previous practices, is still not clear. Artistic goods can circulate freely, while unanimously recognized works of art can be retained. Between these two extremes, there is a whole category of intermediate goods that cannot be retained. European case law recognizes a financial threshold: only works whose value currently exceeds 75,000 euros can be subjected to preventive measures or permanent retention. In the art market, this threshold is not considered particularly high.

To conclude, an art-market regulation developed in France regarding resale rights is currently being debated at the European level as some other countries have adopted it (Belgium, Denmark and Germany) and want the legislation to be uniformly applied. Introduced at the beginning of the twentieth century on the plea that artists are often forced to sell their work due to financial need and are unaware of the long-term price and value of their work, resale rights are particularly difficult to apply when works can circulate freely between countries. Arguments in favour of resale rights are based on the weak bargaining power of artists and the dynamic value of their works of art over a period of time. The Commission does not contest a resale right, which can also be interpreted as an intellectual property right that recurs within the 75-year period recognized for royalties within the European Union. Therefore, there is agreement between the European Union and the countries that have adapted resale rights on their duration and extension. Where a debate could occur is on the percentage, which ranges from 2 per cent in Belgium to 5 per cent in Denmark and Germany. The real difficulty stems from the fact that a number of countries, such as the United Kingdom, have not adopted resale rights and have no intention of implementing them.

Cinema and audio-visual production is the area that most clearly reflects conflict in the cultural field between the position of individual countries, the forces of regional integration and the WTO. France intends to protect its large film industry (in the 1990s, France produced on average around 40 per cent of the European films) and to prevent its market from being completely and permanently dominated by the United States

majors. The dispute is not new, with the first screening quotas dating back to the period between the two World Wars. Among the variety of instruments currently deployed, two play a key role: advances on revenues and quotas.[112] Although similar instruments exist in other countries, including the broadcasting quotas adopted in the European Television without Borders Directive, they are particularly widespread in France. And unlike other countries, which have these instruments but do not always apply them, these mechanisms are rigorously enforced in France where they have become national institutions.

These mechanisms frequently provoke the ire of the American film industry and 'cultural exception' is usually invoked to defend them. As a result, France continues to use these instruments, but it has extended the benefit of advances on revenues to those co-productions with European and other countries, including the United States, that involve a French producer and France now includes European films in its broadcasting quotas. These instruments have met with passive acceptance from the Commission and some European countries but more active support from some others, such as Greece and Italy. In terms of regulations, however, the Commission has not gone further than issuing directives, whose application is largely left to the member states. At the instigation of countries that support an interventionist policy, the Commission launched the MEDIA programme, which offers various grants for training and for the production, translation and retailing of audio-visual works. Some limited assistance is also provided for retailing films in other European countries.

The member states' difficulty in reaching an agreement was particularly apparent at the European Audio-Visual Conference held under the chairmanship of the United Kingdom in Birmingham in 1998. For countries like Sweden and the United Kingdom, the audio-visual industry is one of several creative industries and their main concern is to enhance the circulation of products and obtain proper remuneration for authors. For countries like France, the main priority is to support production and retailing so that local film industries are not excluded from the audio-visual market, given the implications in terms of loss of culture and identity. The Commission considers the cinema as a unique artistic product, but it prefers incentive to regulation although it does not prevent other countries from implementing their own legislation. France's position is likely to evolve, not as

a result of European integration, but due to technological innovation, i.e. the availability of films over the Internet. At the debate held three years ago, under the chairmanship of the United Kingdom, the French Government did not take into account this possibility having far-reaching consequences for distribution. France now admits that distribution through the Internet will seriously challenge systems such as quotas and it is now considering the possibility of re-deploying its intervention in the realm of production since it can no longer control distribution. This is in line with the spirit of the MEDIA programme, which aims to encourage a continuous flow of audio-visual production rather than change market processes for the circulation of goods.

Regional integration has led to the restructuring of cultural policies, as illustrated by the three examples cited above. In the area of heritage, the legislation has changed. In the case of cinema, the legislation has been adapted to take the European dimension into account. As for books, the legislation has remained the same, although the Commission and some member states are opposed to its contents. A new phenomenon is emerging in European countries, where cultural activities rarely escape from the tutelage of the state. Cultural stakeholders are no longer obliged to seek dialogue exclusively with their own government; they are free to appeal to the European Union (either the Council, the Commission or the Court of Justice) to defend their positions, which their government refuses to validate or even entertain. Retail chains have petitioned European organizations for the right to offer discounts and thus circumvent the principle of fixed prices. Foreign producers have contested the application of advances on revenues on the grounds that a co-production with a French producer is simulated and should not benefit from this system. The criteria used to define national treasures have not yet been called into question, but it is only a matter of time. Although their powers are still limited because of the absence of clear regulatory systems, regional bodies have entered the game. This is a direct, albeit limited, effect of regional integration on the cultural sector.

From cultural exception to cultural diversity

In contrast to the total liberalization of trade – which would put an end to advances on revenues, give a free rein to competition

and eliminate quotas so that the circulation of cultural goods is not hindered – cultural diversity may be seen as a way of guaranteeing the fundamental right to information and freedom of expression and even enhancing the meaning of competition and integration through the criterion of excellence, in addition to numerous economic benefits. Diversity is a source of creativity and quality, and it encompasses goods that are not cultural by definition. Diversity is a form of capital that enriches the development process. This observation is supported by new theories of geographical economy and international trade, which argue that the initial endowment of resources is less important than the capacity to obtain growing yields from them. But it is true that cultural diversity is a very slippery concept. It means many things and it can be easily manipulated. It can be used here to distinguish among the diversity of contents, which is the most traditional understanding of the term, structural diversity, which is related to the consideration of minorities, and access diversity which is related to the possibility of using various spaces or channels of access.

The time seems to be ripe to stop justifying the necessity of state intervention in the arts because elite culture is unable to pay for itself or protect specific economic players such as artists or art dealers. It is in fact the economic, social and territorial implications of artistic goods and industries that are prompting governments to engage in responsible competition because there is no progress without the development and cross-fertilization of cultures. But the starting positions and the control of portals are too unequal for many countries and territories to rely on mechanisms that are not aimed at giving different cultures the right to express themselves. As often happens in the artistic field, distribution, rather than production and retailing, is the key issue since cultural diversity can only be maintained if products are known, i.e. if they can enter the market. Faced with this issue, we need to adopt modern criteria of competition.

The United States Strategic Trade Policy bears testimony to this concept. The President's report to Congress for the year 2000 states clearly that the purpose of the administration's efforts to enforce intellectual property rights, extend the protection of royalties from 75 to 95 years for companies, adopt the Digital Millennium Copyright Act to prevent the circumvention of anti-piracy measures, implement the 1998 agreement on

telecommunications, develop electronic commerce, and negoti-
ate with Japan on access to satellite and cable television mar-
kets, is to achieve the economy of the twenty-first century, or,
more simply, to control distribution. There is no shortage of
declarations in Europe, where the management of containers is
traditionally divorced from the management of their contents,
whereas in the United States the two are combined. This sep-
aration is responsible for maintaining areas of intervention spe-
cific to each country. It is likely that different national positions
will converge over the years, because the different countries
realize that cultural diversity is more important than cultural
exception. However, this convergence of positions within the
European Union will depend on developments in the market for
'containers' over the next few years.

NOTES

Introduction

1. In a study undertaken for the European Union Commission, we have assessed the number of artistic jobs in Europe in absolute and relative terms (see Tables below). They represent approximately 1.2 per cent of the active population, which is very significant. We find that the larger the population, the higher the number of artistic jobs. However, if we extend the definition of artistic jobs to include jobs in the crafts sector and creative industries like design, fashion, etc., this proportion raises to approximately 2.5 per cent of the active population [Greffe X. (1999), *L'emploi culturel à l'âge du numérique*, Paris: Anthropos-Economica].

Artistic jobs in European Union Countries (in absolute terms)

Country	Total	The live arts	Heritage	Audio-visual	Other cultural industries
Germany	615 000	100 000	80 000	75 000	170 000
Austria				3 681 000	
Belgium	37 445	12 400	10 970	7 590	6 485
Denmark	26 000		2 900	5 303	
Spain	177 000	42 400	20 000	38 600	72 000
Finland	26 050	9 060	8 560	7 025	1 971
France	284 500	160 000	59 000	27 000	38 500
Greece				8 847	

Continued

Continued

Country	Total	The live arts	Heritage	Audio-visual	Other cultural industries
Ireland	12 950	6 150	1 500	3 500	1 800
Italy	262 000	104 000	36 413	87 000	34 000
Luxemberg				747 000	
The Netherlands	92 672	35 000	15 961	16 111	22 500
Portugal	25 044	12 000	4 000	6 544	2 500
U.K.	396 720	90 100	71 000	91 000	20 200
Sweden	53 657	33 000	3 500	10 907	3 500

Artistic jobs in European Union Countries (%)

Country	Total	The live arts	Heritage	Audio-visual	Other cultural industries
Germany	1.56	0.25	0.20	0.19	0.43
Belgium	0.91	0.30	0.26	0.18	0.15
Denmark	1.10		0.12	0.22	
Spain	1.10	0.26	0.12	0.23	0.44
Finland	1.09	0.37	0.35	0.29	0.08
France	1.13	0.63	0.23	0.11	0.17
Greece					
Ireland	0.90	0.41	0.10	0.27	0.12
Italy	1.16	0.46	0.16	0.38	0.15
Luxemberg					
The Netherlands	1.29	0.49	0.22	0.23	0.30
Portugal	0.52	0.24	0.08	0.13	0.05
U.K.	1.44	0.32	0.25	0.32	0.08
Sweden	1.36	0.83	0.08	0.27	0.08%

Source: Greffe X. (1997), *L'emploi culturel en Europe*, Rapport à la Commission européenne, Bruxelles, Direction générale de l'emploi et des affaires sociales.
Greffe X. (1999), *L'emploi culturel*, Paris: Economica.

2. Breton A. (1950), *Introduction au discours sur le peu de réalité*, Paris: Fayard, p. 102.
3. Benjamin W. (2000), *L'oeuvre d'art* (dernière version de 1939), in *Oeuvres*, Paris: Gallimard, Folio Essais, p. 306.
4. Gauguin P. (1978), in *The Writings of a Savage*, D. Guérin ed., New York: Viking Press, pp. 29–32.

Chapter 1

1. Cournot (1872), *Œuvres complètes*, Paris: Bibliothèque Nationale, pp. 36–7.
2. Mossetto (1994), *Aesthetics and Economics*, Dordrecht: Kluwer Academic Publishers, p. 42.
3. Marshall (1920), *Principles of Economics*, London: Macmillan, p. 94.
4. Mossetto, *Aesthetics and Economics*, p. 47.
5. Marshall, *Aesthetics and Economics*, p. 213.
6. Over the years, the entrance to the castle of Chenonceaux has been moved far away from the main castle so that visitors could not see it without buying a ticket.
7. Frey B.S. (2000), *Arts & Economics: Analysis and Cultural Policy*, Berlin: Springer-Verlag, pp. 100–3.
8. Waquet D. & Laporte M. (1999), *La Mode*, Paris: PUF, Collection Que sais-je?, No. 3426, p. 1.
9. Rousseau J.J. (1959–1995), *Oeuvres complètes*, Paris: Gallimard, Collection la Pléiade, Vol. 4, p. 457.
10. Bourdieu P. (1975), 'Pour une économie des biens symboliques', *L'Année Sociologique*, No. 22, pp. 49–126.
11. Barthes R. (1967), *Système de la mode*, Paris: Le Seuil, p. 10.
12. Barrère C.H. & Santagata W. (1999), 'Defining Art: From the Brancusi Trial to the Economics of Artistic Semiotic Goods', *International Journal of Arts Management*, Vol. 1, No. 2, pp. 28–8.
13. Idem, p. 29.
14. Baumol W.J. & Bowen W. (1966), *Performing Arts – The Economic Dilemma: A Study of Problems Common to Theater, Opera, Music and Dance*, Cambridge, MA: The MIT Press.
15. Reinach S. (1924), *Apollo: Histoire générale des arts plastiques*, Paris: Hachette, pp. 1–2.
16. Idem, p. 2.
17. Graham G. (1998), *Philosophy of the Arts: An Introduction to Aesthetics*, New York: Routledge.
18. Hume David, 'Of the Standard of Tastes', quoted in Graham (1998), p. 14.
19. Mill J.S. (1985), *Utilitarianism*, London: Fontana, p. 12.
20. Tolstoy L. (1995), *What is Art?* transl. A. Maude, Oxford: Oxford University Press, p. 511.
21. Graham G. (1998), *Philosophy of the Arts: An Introduction to Aesthetics*, pp. 56–63.
22. Mosseto, *Aesthetics and Economics*, p. 19.
23. Baudelaire Ch. (1972), in *Selected Writings on Art and Artists*, J. Charvet ed., Harmondsworth: Penguin, p. 399.
24. Tester K., Ed. (1998), *The Flâneur*, London: Routledge, p. 7.
25. Sartre J.P. (1965), *Nausea*, transl. R. Badlick, Harmondsworth: Penguin, p. 64.

26. Benjamin W. (1972), *Der Widerkehr des Flâneurs*, Gesammette Shriften III, Frankfurt: Suhrkamp.
27. Idem, p. 147.
28. Sennett R. (1977), *The Fall of Public Man*, Cambridge: Cambridge University Press, pp. 12–5.
29. Weber E. (1976), *The Protestant Ethic and the Spirit of Capitalism*, Parson's translation, London: George Allen and Unwin, p. 181.
30. Tester K., ed. (1998), *The Flâneur*, p. 153.
31. An example of this attitude can be seen in the Association des amis de l'Ecole d'Epineuil le Fleuriel in the southern part of the Cher department. It is the school where Alain Fournier studied and which inspired him to write his emblematic novel, *Le grand Meaulne*.
32. Benjamin W. (2000), *L'oeuvre d'art*, p. 273, Paris: Flammacion.
33. Idem, p. 282
34. Idem, p. 283.
35. Idem, p. 289.
36. Bernié-Boissard C., Dreyfuss L. & Nicolas-Le Strat P. (1999), *Ville et emploi culturel; Le travail créatif-intellectuel dans les agglomérations de Nimes et Montpellier*, Montpellier: Université Paul Valéry, ARPES, p. 96.
37. Waquet D. & Laporte M. (1999), *La Mode*, Paris: PUF, Que Sais-je?, No. 3426, p. 37.
38. Idem, p. 40.
39. Ministère de la Culture (1998), *Les designers textile et surface*, Paris: Département des Études et de la Prospective, p. 17.
40. The French term *dessin* for design refers to an artistic activity. Hence design is considered to be an art rather than a technical skill. If the term designer (borrowed from English) seems restrictive in French, we find professionals giving preference to more French-sounding words like styliste, dessinateur, coloriste and créateur. However, it is necessary to agree on a common usage: thus the designer is involved in the initial stages followed by the dessinateur who provides the artistic vision and the styliste who harmonizes creative and marketing activities.
41. Ministère de la Culture (1998), *Les designers textile et surface*, op. cit., p. 25.
42. Generally, designers are present wherever any kind of pattern or adornment is involved in the making of a product. Designers are far from being isolated or marginalized within an enterprise. On the contrary, they are often at the very centre of the network that brings together managers, marketing services, design studios, heads of various products and others. Sometimes, they are not a part of the enterprise and are called in when new and creative ideas are needed.
43. Ministère de la Culture (1998), *Les designers textile et surface*, op. cit., p. 27.
44. In terms of employment, textile or surface designers held almost a thousand jobs in France in 1998 and their number is going up fast. Most of these designers are women, especially free-lance designers, and we observe some typical traits of cultural employment: very few full-time

jobs or jobs with indefinite contracts; an average seniority of 13 years for those who have been assimilated in the enterprise; free-lance designers who are much younger; remuneration given partly as honorarium and partly as royalty and sometimes as salary in the case of external designers; training partly in art schools or industrial design centres and partly on the job; and a predominant feeling of having fulfilled a vocation by becoming a designer. The average earnings of designers are much higher than those of artists but they have some problems in common such as the need felt by free-lancers to have another occupation, lack of proper recognition of their talents, the fact that they are not paid what they deserve and non-payment of royalties.

45. Almost all the porcelain factories and their retail outlets had left the town centre so that there is no living proof of the activity which had made the town world-famous.

46. For a long time, Thiers was the French cutlery capital and even today it boasts of the largest concentration of cutlery manufacturers in France. Like many other towns specialized in the manufacture of a single product, it faced enormous difficulties in maintaining its market. During the 1980s, the Thiers municipality set up a cutlery museum with the purpose of highlighting its local products. But not everybody considered it useful, especially the cutlery manufacturers who felt it was more of a symbolic revival of the past rather than an opening to the future. So the municipality, in association with the Conseil Général of Puy-de-Dôme, the Chamber of Commerce and Industry and the labour unions, decided to give another dimension to the museum by adding the 'House of Cutlery-Makers', an enterprise which manufactures goods that stand out because of their originality and creativity. The idea is not to compete with other local manufacturers, but to serve as a laboratory devising new designs and techniques that can be copied by all. The museum has thus widened, enriched and prolonged the life of a tradition instead of just highlighting it. The most significant result of this idea of attaching a laboratory to the museum is the use of new materials in the place of old ones which have become too costly and the regular participation of cutlery manufacturers from the Auvergne in all international exhibitions.

47. Today there is 60 per cent unemployment in this sector.

48. Greffe X. & MacDonnell V. (1996), *Local Development and Cultural Industries in Europe*, Research Report, Brussels: European Union, DGV, pp. 22–24.

49. Caves R. (2000), *Creative Industries: Contracts between Art and Commerce*, Cambridge, MA: Harvard University Press.

50. This attribute is often compared to the relative importance of fixed costs, except that fixed costs can be recovered to a large extent.

51. Greffe X. (1996), *L'évaluation du programme des écoles-ateliers en Espagne*, Paris: OECD.

52. Idem, pp. 50–2.

53. Idem, p. 60.

54. Venot C. (1999), *L'entreprise se met en scène: le théâtre d'entreprise*, Research Report, Université de Paris 1, Panthéon-Sorbonne.
55. Faujas A. (1999), 'Acte 1, scène 1 : il y a de l'euro dans l'air, il va falloir s'y faire', *Le Monde*, 4 May, 4, p. V.
56. Venot C. *Actualité de la formation permanente*, 1997, No. 120, p. 53.
57. Venot C. (1999), *L'entreprise se met en scène: le théâtre d'entreprise*, pp. 25–6.
58. Ritzer G. (1999) *Enchanting a Disenchanted World: Revolutionizing the Means of Consumption*, London: Sage Publications, p. 8.
59. Campbell C. (1989), *The Romantic Ethic and the Spirit of Modern Consumption*, Oxford: Basil Blackwell, p. 153.
60. Williams R. (1982), *Dream Worlds: Mass Consumption in Late Nineteenth-Century France*, Berkeley: University of California Press, pp. 70–1.
61. Benjamin W. (2000), *L'oeuvre d'art*, p. 314.
62. Clair R. (2001), *La fin de l'art contemporain*, Paris: Gallimard.
63. Greffe X. & MacDonnell V. (1996), *Local Development and Cultural Industries in Europe*, pp. 27–8
64. At Blyth, in Britain, reintegration programmes have been organized to encourage the long-term unemployed to put up theatrical performances in order to develop their self-confidence, motivation and initiative.
65. Greffe X. & MacDonnell V. (1996), *Local Development and Cultural Industries in Europe*, pp. 29–30
66. Roulleau-Berger L. (1999), *Le travail en friche: les modes de la petite production urbaine*, La Tour d'Aigues: Editions de l'Aube.
67. The 40 odd associations grouped around the original structure provide about 300 full-time jobs and organize about 500 events every year. But what is important is that they attract approximately 150,000 particip-ants, every one of whom is simultaneously a spectator and an actor in his own little way.
68. Lyotard J.F. (1979), *La condition postmoderne*, Paris: Les Éditions de minuit, Collections Critiques, p. 82.
69. Maffesoli M. (1988), *Le temps des tribus: le déclin de l'individualisme dans les sociétés de masse*, Paris: Le livre de poche, Méridiens, p. 88.
70. Eco U. (1998), *Entretiens sur la fin des temps*, Paris: Fayard.
71. Dechartre G. (1998), *Evénements culturels et développement local*, Paris: Conseil Economique et Social, Imprimerie Nationale.
72. A play is staged to enable people to discover the Ferme du buisson at Mesniels (Meunier), where a public housing unit is recreated to make them look at it from a different angle.
73. Mayakovsky (1912), *Une gifle au goût du public*, Paris: Gallimard.
74. This idea goes back to Rousseau's time in his *Lettre à d'Alembert sur les spectacles*, as also in Romain Rolland's appeal for a people's theatre and in the strategy of the *Théâtre du soleil*, where the spectators had to be active participants if not actors (in 1789, they were asked to play the crowd of revolutionaries).

75. Alan Kaprow: '18 Happenings in 6 parts', Reuben Gallery, 1959.
76. Strehler and Grassi in 1947.
77. Greffe X. (1992), *Social vs. 'Cultural Integration in the Cities'*, *Conference on Urban Development*, Paris: OECD, Territorial Development Service.
78. Munnelly A. (1997), 'The Temple Bar Experience: Innovative Ways of Creating Employment in the Cultural Sector', in C. Bodo ed., *New Frontiers for Employment in Europe*, Roma: Circle Publications, No. 9, pp. 73–4.
79. From 1990 onwards, a programme of investment on urban environment was launched and successfully concluded. It was helped by the opening of new enterprises and the revitalization of the district due to the rehabilitation of 30 industries, the resurfacing of roads, improved street-lighting, provision of new public facilities, health services and safety measures. To the original €120 million provided by public and community funding were added another €70 million contributed by the private sector. Twelve projects were completed, among them the Irish Film Centre, the Temple Bar Gallery and Studios, the Multimedia Centre for Arts, the Children's Cultural Centre, the National Photographic Archive, the School of Photography and the Viking Exhibition Centre, covering a wide variety of themes and public interests. This represents a total of about 400 enterprises, a quarter of which are non-profit organizations. As for job opportunities, it is estimated that about 500 full-time jobs in the cultural sector plus another 1,500 jobs in the non-cultural sector were created as a result of various activities. Further, it is expected that in the future about a thousand new jobs will be created every year of which the FAS has set aside a certain number to rehabilitate the residents who were forced to leave the district when renovation work was in progress. Finally, the presence of Temple Bar has improved Dublin's cultural image and it has now become an emblem of its national and international environment.
80. As a result, the employment growth rate was 9 per cent higher than that for the whole of Scotland which, by the way, was exceptionally high (+8.4 per cent) during this period.
81. The *Pactarim programme* has been in force since 1998. For a long time, it was not properly understood as its references applied only to European countries where considerable public funds are set aside for culture and renovation. But in Santo Domingo there was no budgetary allocation for this purpose. At the same time, the local officials preferred to join other departments like the one in charge of the mobilization of community networks and their own bankers. They restored networks, made an inventory of dangerous sites, devised the most appropriate schemes to tap savings. Programmes for renovation of buildings were accompanied by plans to modernize the crafts base, the only means of guaranteeing the availability of resources till the very end. It was only after three years that the operations for renovating and restoring the historical centre of Santo Domingo (centro colonial) actually began.
82. Liviantoni Carlo (1997), 'The Case of Spoleto in the Employment Policy of the Umbria region', in C. Bodo ed., *New Frontiers for Employment in Europe*, Rome: Circle Publications, No. 9, pp. 77–80.

83. Santagata W. (2000), 'Cultural Districts', *International Conference on Arts and Cultural Economics*, Working Paper, Minneapolis, University of San Tomas.

84. A very old complex that was recreated recently, Babelsberg near Berlin, is an example of what a cultural district largely based on private initiative should be. The object was to create a centre of artistic skills and activities on a site which had in the past played a key role in film-making, but which found itself abandoned after the reunification of Germany. This site was initially renovated with the help of French investments, which were used to rebuild the infrastructure, access roads to studios, dressing-rooms for artists and a computer network. At the same time, High Tech Babelsberg, a high technology centre, was set up in view of the growing importance of new technologies in the audio-visual domain, particularly for the production of special effects, dubbing and editing of films, etc. As the activities increased, often in small independent structures, it was decided to offer them a logical platform linked by broad-band networks making it possible to connect any number of computers and companies. Three hundred jobs have already been created and it is expected that another thousand or so will soon be available. The centre does not exclude large enterprises because they have the means to make available to smaller enterprises the resources that they do not need or cannot use themselves. Finally, this centre is developing training facilities and creating an atmosphere conducive to the spread of new skills that have not yet been identified by regular training institutes or certification agencies.

85. Santagata W. (2000), 'Cultural districts', p. 4.

86. Greffe X. (2002), *La dimension économique du patrimoine monumental*, Paris: Ministère de la Culture, Direction de l'architecture et du patrimoine, Rapport final, Chapter 3.

87. Greffe X. (2001), *Managing our Cultural Heritage*, New Delhi: Aryan Books International, pp. 154–8.

88. The European Commission (1995), *Local initiatives in the fields of development and creation of employment opportunities: Survey Conducted in the European Union*, Working Document of the SEC Commission (95) 564, p. 17.

89. Veblen's theory, according to which leisure performs the function of stimulation and demonstration, conforms to this viewpoint.

90. Chris R. (1997), *Decentring Leisure: Rethinking Leisure Theory*, London: Sage Publications, p. 77.

91. Idem, p. 91.

92. Origet du Cluzeau Cl. (1998), *Le tourisme culturel*, Paris: PUF, Que sais-je? No. 3389, pp. 14–5.

93. Amirou R. (1995), *Imaginaire touristique et sociabilité du voyage*, Paris: Presses Universitaires de France.

94. Observatoire National du Tourisme (1998), *La fréquentation des lieux culturels et non culturels en France métropolitaine en 1991 et 1996*, Paris, Analyses et perspectives du tourisme, No. 51.

95. Origet du Cluzeau Cl. (1998), *Le tourisme culturel*, pp. 79–80.

96. This was a major problem in Lascaux, which was solved by closing the original cave and creating an identical copy for visitors. Depending on the nature of the site, it is possible to find other solutions.

Chapter 2

1. When the quality of a service, the satisfaction it is expected to give and the price to be paid for it are not known, the prevalent price is taken as an indicator of quality, a higher price being an indication of a better quality. If Q_{ua} stands for the quality of an artistic service and P for its price, it would normally be written as
$$P = P(Q_{ua})$$
but in the present case, we have
$$Q_{ua} = Q(P)$$
with
$$\delta Q_{ua}/\delta P > 0.$$
Hence, the higher the price the greater the demand for the service from consumers.

2. Mossetto G. (1993), *Aesthetics and Economics*, Milano: Etas, p. 101.

3. Idem, pp. 101–3.

4. It is a common phenomenon as far as Payolas are concerned. We will deal with them in Chapter 7 when we study cultural industries.

5. Radway J. (1990), 'The Scandal of the Middlebrow: The Book of the Month Club, Class Fracture and Cultural Authority', *South Atlantic Quarterly*, Vol. 89, pp. 703–36.

6. Levy E. (1987), *And the Winner is ... The History and Politics of the Oscar Awards*, New York: Ungar, pp. 5–8.

7. Todd R. (1996), *Consuming Fictions: The Booker Prize and Fiction in Britain Today*, London: Bloomsbury Press, pp. 87–9.

8. Idem, p. 193.

9. Mossetto G. (1993), *Aesthetics and Economics*, p. 157.

10. Caves R.E. (2000), *Creative Industries*, p. 192.

11. Simpson C. (1987), *The Partnership: The Secret Association between Bernard Berenson and Joseph Duveen*, London: Bodley Head.

12. White C.H. & White C.A. (1993), *Canvases and Careers: Institutional Change in the French Painting World*, Chicago: University of Chicago Press, pp. 95–96.

13. Goldfarb Marquis A. (1991), *The Art Biz: The Covert World of Collectors, Dealers, Auction Houses, Museums and Critics*, Chicago: Contemporary Books.

14. Pacheco F. (1990), *Arte de la pintura*, Edicion Bassegoda I Huelgas, Madrid: Catedra.

15. Langholm O. (1998), *The Legacy of Scholasticism*, Oxford: Clarendon Press.

16. Negron Z. (1999), 'Francisco Pacheco: Economist for the Art World', in *Economic Engagements with Arts*, De Marchi & Goodwin, eds, Durham: Duke University Press, pp. 37–8.

17. There are two opposing types of conventions. The first type is known as monocentric and uses strictly methodical criteria so that the price of an artistic item can be fixed on their basis without any difficulty. The second type of convention is called polycentric and is based on multiple criteria, which can be combined suitably in each individual case so that the buyer's power of interpretation plays a major role in the price he will fix for a given good.

18. Moureau N. (1997), 'Essai sur la détermination endogène de la qualité: le prix de l'art contemporain', Ph.D. Dissertation, University of Paris XIII.

19. Stigler G. & Becker G.S. (1977), 'De gustibus non est disputandum', *American Economic Review*, Vol. 67, No. 2, pp. 76–90.

20. 'On the conventional view of inscrutable, often capricious tastes, one drops the discussion as soon as the behaviour of tastes becomes important – and turns his energies on other problems. In our view, one searches often long and frustratingly for the subtle forms that prices and incomes take in explaining differences among men and periods. If the latter approach yields more useful results, it is the proper choice.' Stigler & Becker, 'De gustibus non est disputandum', p. 77.

21. Becker G.S. (1997), *Accounting for Tastes*, Harvard University Press, p. 25.

22. Marshall A. (1962), *Principles of Economics*, 8th edn, London: Macmillan, p. 94.

23. 'There is however an implicit condition in this law of diminishing marginal utility which should be made clear. It is that we do not suppose time to be allowed for any alteration in the character or tastes of the man himself. It is therefore no exception to the law that the more good music a man hears, the stronger is his taste for it likely to become ...' (idem).

24. As in the case of Becker and Stigler.

25. Bourdieu P. (1969), *La Distinction*, Paris: Le Seuil.

26. Idem, p. 18.

27. Idem, p. 18.

28. Idem, p. 43.

29. Puhl M. (1999), 'Consommations culturelles et recherches d'interaction sociale: proposition d'une nouvelle grille de lecture de l'expérience culturelle sociale', *Association Française de Marketing*, Vol. XV, pp. 73–91.

30. Moureau N. (1997), *Essai d'analyse endogène de la qualité: le cas des œuvres d'art contemporain*, p. 121.

31. Idem, p. 154.

32. Navrud S., Pederson P.E. & Strand J. (1992), 'Valuing Our Cultural Heritage: A Contingent Valuation Survey', Center for Research in Economics and Business Administration, Oslo: University of Norway.

33. Willis K.G. (1994), 'Paying for Heritage: What Price for Durham Cathedral?', *Journal of Environmental Planning and Management*, Vol. 3, pp. 267–78.

34. Martin F. (1994), 'Determining the Size of Museum Subsidies', *Journal of Cultural Economics*, Vol. 18, pp. 255–70.

35. Bille Hansen T. (1997), 'The Willingness to pay for the Royal Theater in Copenhagen', *Journal of Cultural Economics*, Vol. 21, pp. 1–28.

36. Hanemann M. (1991), 'Willingness to Pay and Willingness to Accept: How Much Can They Differ?', *American Economic Review*, Vol. 81, pp. 635–47.

37. Kahneman D. & Tversky A. (1979), 'Prospect Theory: An Analysis of Decision Under Risk', *Econometrica*, Vol. 47, pp. 263–9.

38. Peterson G. & Brown T. (1998), 'Economic Valuation by the Method of Paired Comparison with Emphasis on Evaluation of the Transitivity Axiom', *Land Economics*, Vol. 74, No. 2, pp. 240–61.

39. Desaigues B. & Bonnieux F. (1998), *Economie et politiques de l'environnement*, Paris, Dalloz, Précis, pp. 235–55.

40. Idem, p. 254.

41. Bishop R.C. & Heberlein T.A. (1979), 'Measuring Values of Extra-market Goods: Are Indirect Measures Biased?', *American Journal of Agricultural Economics*, Vol. 61, pp. 926–39.

42. Desaigues B. & Point P. (1993), *Economie du patrimoine naturel: la valorisation des bénéfices de protection de l'environnement*, Paris, Economica.

43. Roche Rivera H. (1998), 'The Willingness to Pay for a Public Mixed Good: the Colon Theater in Argentina', *Tenth Conference on Cultural Economics*, Barcelona, 14–17 June, Vol. C, pp. 197–202.

44. Kling R., Revier Ch. & Sable K. (2000), 'Estimating the Public Good Value of Preserving Local Historic Landmarks: The Role of Nonsubstituability and Information in Contingent Valuation', *11th Conference of Cultural Economics*, Minneapolis, Minn.: University of Saint Thomas, 29 May.

45. The choices were explained at length to 500 households selected at random, and a rate of 50.5 per cent in favour of returning the money was considered satisfactory. The pollsters then tried to pinpoint the factors that had prompted positive and negative answers, the factors singled out in this case being the amount of tax borne by each household, the age, level of education, income before payment of tax and an indication of preferences regarding the monument.

46. The effect on income is eliminated in the case of pair comparison.

47. Santagata W. & Signorello G. (1998), 'Contingent Valuation of a Cultural Public Good and Policy Design: The Case of "Napoli Musei Aperti"', *Working Paper*, University of Turin (Department of Economics) and University of Catania (Dipartimento di Scienze Economiche Agraria).

48. Idem, p. 20.

49. Fiorentino S. (1999), 'The Economic Analysis in Cultural Heritage Investment Projects: An Overview', Symposium on *The Urban and Regional Planning Requirements for a Cultural Heritage Conservation Policy*, Programma Rafael, European Commission and Consiglio Nazionale delle Richerche, Roma, 22 January, pp. 6–7.

50. Ashworth J. & Johnson P. (1996), 'Sources of "Value for Money" for Museum Visitors: Some Survey Evidence', *Journal of Cultural Economics*, Vol. 20, pp. 67–83.

51. Greffe X. (2000), *Gestion Publique*, Paris: Dalloz, p. 212.

52. Greffe X. (2001), *Managing our Cultural Heritage*, Chapter 3, New Delhi: Aryan Books International.

53. Barros C. (1998), 'Willingness to Pay for Public Museums: Hypothetical and Related Commitments', *Tenth Conference on Cultural Economics*, Barcelona, 14–17 June, Vol. C, pp. 165–70.

54. Fiorentino S. (1999), 'The Economic Analysis in Cultural Heritage Investment Projects: An Overview', Symposium on *The Urban and Regional Planning Requirements for a Cultural Conservation Policy*, Programma Rafael, European Commission and Consiglio Nazionale delle Richerche, Roma, 22 January, p. 4.

55. Idem, p. 8.

56. Clawson M. & Knetsch J.L. (1966), *Economics of Outdoor Recreations*, Baltimore: The Johns Hopkins Press.

57. At the most, this reservation may be rejected by claiming that this behaviour can be explained by the exceptional nature of the visit and that the hypothesis of uniform elasticity remains valid.

58. Leibenstein H. (1950), 'Bandwagon, Snob and Veblen Effects in the Theory of Demand', *Quarterly Journal of Economics*, Vol. 64, pp. 183–207.

59. Becker G.S. (1997), *Accounting for Tastes*, Cambridge, MA: Harvard University Press, p. 167.

60. Becker G.S. (1997), 'A Theory of Social Interactions', *The Journal of Political Economy*, Vol. 82, No. 6, 1974, pp. 1063–94.

61. Mazza I. (1994), 'A Microeconomic Analysis of Patronage and Sponsorship', in A. Peacock & I. Rizzo, eds, *Cultural Economics and Cultural Policies*.

62. The starting point of this analysis is quite similar to the previous one. A person may buy a private good X or a public good that is expected to benefit the whole community. By giving this sum of money, the patron also wins the community's approval which depends on the amount of the donation and also on how much the community appreciates such donations, i.e. ϕ. When the individual giving the donation values this social approval, we have to take into account the degree of appreciation of social approval μ with $0 < \mu < 1$. Normally the donation will be high if ϕ and μ are high and vice versa. This gives rise to two observations:
 1 Even if ϕ is high, it need not remain so. On the contrary, we may assume that with the development of patronage, this coefficient will have a tendency to go down, either because the community's need declines progressively or because there is competition between patrons. This means that measures in favour of patronage should be revived regularly if we wish to maintain it at the same level because this will compensate for the loss of social esteem with an increase in corresponding financial benefits.

1 μ will be more or less high depending on the nature of players involved, but in the case of collective players such as companies or organizations, it is likely to be much lower. In that case, it will be difficult to generalize the attitudes in favour of patronage, unless we make sure that these donations enjoy higher tax benefits, or even if they are made free.

63. Andreoni J. (1998), 'Towards a Theory of Charitable Fund-Raising', *Journal of Political Economy*, Vol. 106, pp. 1186–213.

64. Di Maggio P. (1982), 'Cultural Entrepreneurship in Nineteenth-Century Boston: The Creation of an Organizational Base for High Culture in America', *Media, Culture and Society*, Vol. 4, pp. 33–50.

65. Mossetto G. (1992), *L'economia delle citta d'arte*, Milano: Etas Erl, p. 35.

66. Fiorentino S. (1999), 'The Economic Analysis in Cultural Heritage Investment Projects: An Overview', Symposium on *The Urban and Regional Planning Requirements for a Cultural Heritage Conservation Policy*, Programma Rafael, European Commission and Consiglio Nazionale delle Richerche, Rome, 22 January, pp. 9–10.

67. This expenditure, which is the residents' income, becomes in its turn a new source of expenditure, and continues in this manner.

68. Greffe X. (2001), *op. cit.*, *Managing Our Cultural Heritage*, Chapter 2.

69. Greffe X. (1997), *L'évaluation des projets publics*, Chapter 3, Paris, Economica.

Chapter 3

1. See Chapter 7, p. 239.

2. Watson P. (1992), *From Manet to Manhattan: The Rise of the Modern Art Market*, New York: Random House.

3. Chapple S. & Garofalo R. (1977), *Rock'n Roll is Here to Pay: The History and Politics of the Music Industry*, Chicago: Nelson Hall.

4. Caves R. (2000), *Creative Industries*, p. 206.

5. Grover R. (1997), *The Disney Touch*, Chicago: Irwin.

6. Between 1975 and 1985, the average cost of making a film rose from US$3.1 million to US$14.5 million with the rate of increase rising further during the following decade.

7. Number of films

Company	1970	1972	1974	1978
Columbia	28	27	21	14
MGM + UA	61	42	21	19
T.C. Fox	14	25	18	7
Paramount	16	22	23	14
Universal	17	16	11	21
Warner Bros.	15	18	15	18

Source: Joël Augros (1996), *L'argent d'Hollywood*, Paris: L'Harmattan, p. 125.

8. Litwak M. (1994), *Dealmaking in the Film Television Industry: From Negotiations to Final Contracts*, Los Angeles: Silman-James Press, p. 228.

9. Idem, p.14.

10. U.S. Justice Department, 216 F. 2D 945 (1954).

11. See Chapter 7, pp. 210–214.

12. In some countries, like France, because of the system of quotas, it is possible to recover a part of the irretrievable costs even if the film fails at the box-office. However, over the years television companies have become very selective when it comes to buying films to fulfil quotas.

13. Squire J.E. (1992), *The Movie Business Book*, 2nd edn, New York: Simon & Schuster.

14. Hansmann H. (1981), 'Non Profit Enterprises in the Performing Arts', *Bell Journal of Economics*, Vol. 12, No. 2., pp. 84–98.

15. O'Hagan P. (1998), *The State and the Arts*, Cheltenham: Edward Elgar.

16. Throsby examined the situation of a private producer who, in the most favourable circumstances, can hope to recover his irrecoverable costs only by accumulating a large number of users over a period of time. Right from the beginning, he finds himself in a dilemma. He can either function as a profit-making body and try to recover his investment as soon as possible, or else he can decide to give up all ideas of making a profit, or even of recovering his costs, and hope to survive with the help of subsidies and donations.

17. Throsby put forward this idea differently by taking the example of a private enterprise. He demonstrated that in order to ensure the full development of cultural activities, it is necessary to balance the average cost with the price instead of balancing the price with the marginal cost, which would mean putting an end to profit.

18. Greffe X. (1999), *Le rôle du troisième système dans le développement des activités culturelles*, Brussels: European Union Commission, DGV.

19. Malaro M.C. (1994), *Museum Governance: Missions, Ethics, Policy*, Washington, DC: Smithsonian Institution Press, p. 6.

20. Caves R. (2000), *Creative Industries*, p. 243.

21. Weber W. (1975), *Music and the Middle Class: The Social Structure of Concert Life in London*, New York: Holmes & Meier.

22. Hart Ph. (1973), *Orpheus in the New World: the Symphony Orchestra as an American Cultural Institution*, New York: W. W. Norton.

23. Malaro M.C. (1994), *Museum Governance: Missions, Ethics, Policy*, Washington: The Smithsonian Institution Press, p. 7.

24. An interesting illustration of this phenomenon was seen in France in 1999. A public sector theatre (the Gerard Philippe Théatre in Saint Denis) fixed the price of its tickets so that it could continue till the end of the season only if it received an additional subsidy from the government while the subsidy granted to other theatres of the same type in the rest of the country was proportionately reduced. For the first time, there was disunity among the directors of various theatres who had earlier referred all problems of financing to the Ministry of Culture. They vehemently

reproached the management of the Gerard Philippe Theatre for achieving its objectives at the cost of other theatres.

25. Dupuis X. (1982), 'Essai sur l'économie du spectacle vivant: le cas de la production lyrique', Ph.D. Thesis, Villetaneuse: University of Paris XIII.
26. Dupuis X. & Greffe X. (1980), 'L'économie du spectacle lyrique: répertoire ou festival permanent', *Le Monde*, 14 July, p. 12.
27. Greffe X. (1989), *Analyse économique de la bureaucratie*, 2nd edn, Paris: Economica, Chapter 3.
28. Greffe X. (1999), *Gestion Publique*, Paris: Dalloz, Chapter 2.
29. Burt N. (1977), *Palaces for the People: A Social History of the American Art Museum*, Boston: Little Brown.
30. This is not a new type of behaviour. When museums were first set up, they were meant essentially for artists and fine arts students who had their exclusive use on some days.
31. Jackson R. (1988), 'A Museum Cost Function', *Journal of Cultural Economics*, Vol. 12, pp. 41–50.
32. There is no profit involved in these types of management and the average entry fee or receipts are exactly equal to the average cost. But since their aim is to get as many visitors as possible, small museums are obliged to lower their entry fee so that their receipts are equal to the average cost where as the big museums, desirous of improving their quality to the highest degree, are obliged to raise their entry fees to cover their average costs. In both cases, private managements feel the need to raise their entry fee as seen in the case of private and state theatres. When faced with failure, both state and private theatres behave similarly, but while the state theatre is obliged to respect its programme schedule, the private theatre can, if need be, suspend its shows. In the face of success, they may either raise the price of tickets or increase the number of shows. A private theatre may opt for both modes of action, but in the second case, it may find itself in a compromising position if it has no control over its premises or if its contracts with its artists do not cover this possibility. Things are different in the case of a state theatre whose programme schedule and ticket prices depend to a large extent on the amount of the subsidy. The price is fixed so that it is affordable for a wider public and the choice of programmes is determined by the objectives of creating and conserving heritage.
33. Claire R.W. (2000), *Entertainment 101: An Industry Primer*, Beverly Hills, CA: Pomegranate Press Ltd, p. 8.
34. Idem, Chapter 2.
35. Idem, p. 37.
36. Stanley R.H. (1998), *The Celluloid Empire: A History of the American Movie Industry*, New York: Hasting House.
37. *United States Vs. Paramount Pictures*, 334 U.S. 131 (1948).
38. Conant M. (1960), *Antitrust in the Motion Picture Industry: Economic and Legal Analysis*, Berkeley: University of California Press.
39. Storper M. & Christoferson S. (1987), 'Flexible Specialization and Regional Industrial Agglomeration: The Case of the U.S. Motion Picture

Industry', *Annals of the Association of American Geographers*, Vol. 77, pp. 104–17.

40. Bartoli A. (1997), *Le management dans les organisations publiques*, Paris: Dunod.

41. Greffe X. (1986), *Gestion Publique*, Paris: Dalloz, Chapter 5.

42. Field Museum (1986), *Field Museum of Natural History Bulletin*, Chicago, pp. 16–7.

43. It rarely happens that the same people are simultaneously taxpayers (financiers), citizens (decision-makers) and users (consumers).

44. De Quatrebarbes B. (1996), *Usagers ou clients? Marketing et qualité dans les services publics*, Paris: Les éditions d'organisation, p. 75.

45. Donna O. (1999), *Enquêtes sur les pratiques culturelles des Français*, Paris: La Documentation Française.

46. Colbert F. (1993), *Le marketing des arts et de la culture*, Montréal: Gaëtan Morin.

47. Cova B. & Roncaglio M. (1998), 'Le marketing tribal en pratique: pour une précision des concepts', *Congrès de l'Association Française du Marketing*, Vol. 14, pp. 391–408.

48. Walle Alf H. (1998), *Cultural Tourism: A Strategic Focus*, Boulder: Westview.

49. Wasson Ch. (1974), *Dynamic Competitive Strategy and Product Life Cycle*, St. Charles, Ill.: Challenge Books.

50. Kotler P.H. (1965), 'Phasing Out Weak Products', *Harvard Business Review*, Vol. 43, pp. 107–19.

51. It is obvious how such an approach will affect patrons, encouraging them to take interest only in stars thus endangering the existence of other sources of creativity.

52. Greffe X. (1999), 'Economics of Heritage and Cultural Tourism', *Working Paper of The Institute of Tourism*, University of Bethlehem.

53. Rogers E. (1983), *The Diffusion of Innovations*, New York: Macmillan.

54. Greffe X. (1999), *La gestion du patrimoine culturel*, pp. 123–6.

55. Dickeson V. (1994), 'The Economics of Admission Charges', in Kavanagh, *op. cit.*

56. Stebbins H.G. (1874) *AMNH Annual Report*, Vol. 1874, p. 41.

57. Ruskin (1880), 'Letters to Leicester Museum Subscribers', *Art Journal*, New Series, Vol. XIX.

58. Amiguet P. (1997), 'Les prix dans les musées', *Working Paper*, IREST, Paris: University of Paris I.

59. The admission charges to the Louvre and Versailles museums, considered to be the most prestigious in France, were increased the most.

60. Grampp W.D. (1989), *Pricing the Priceless: Arts, Artists and Economics*, New York: Basic Books.

61. Spending 2 h in a museum should not be worth more than 2 h in the cinema.

62. Especially for local visitors, when tourists are charged different admission fees. With the increase in admission fees, there has been a greater

decline in the number of local visitors and young people than in other categories of visitors (Victoria and Albert Museum, London).

63. Amiguet & Greffe (1997), *Recherche sur les prix des musées à Paris: tendances et élasticités*, Research Paper, Paris: Directorate of Museums, French Ministry of Culture.

64. Idem, pp. 22–50.

65. There is nevertheless the problem of uncertainty regarding the quality of service. In their study of museums in southern France conducted in 1994, Teboul and Champarnaud (1994) pointed out a variety of factors expected by museum visitors ranging from the originality of themes and the educational value of the exhibits to comfort. In their study of admission charges to museums in southern France, Teboul and Champarnaud were not only able to define – with the help of surveys – the themes that interested visitors but also grade them according to their importance. The points mentioned are:

 1 unity, originality and clarity in the theme of the exhibition,
 1 a comparative lack of beauty in the exhibition (a criterion that is particularly difficult to analyse),
 1 a comparative lack of educational value,
 1 a comparative lack of selection,
 1 a comparative lack of comfort.

66. As a matter of fact, this system of vouchers is difficult to organize because it needs prior co-ordination between a large number of social agencies.

67. Since 1994, the Louvre Museum has a fixed admission fee that varies according to the time of the day. The rates are different if you visit the museum before 3 p.m. or after (€6.86 before and €3.81 after). The principle is to have fewer visitors in the earlier part of the day by encouraging single visitors or groups to visit the museum after 3 p.m. when the admission fee is lower. After 2 years, it was found that this arrangement had improved the quality of visits and the differentiation of tariffs was fully justified. Other institutions have followed in the Louvre's footsteps, especially Versailles and the Grand Gallery of the Natural History Museum (where the rate is lower in the mornings) and the Military Museum. In some cases, it must be noted that the lowering of tariffs is justified because the time that remains for the visit is quite short.

68. Daudet S. & Vialle G. (1994), *Yield Management*, Paris: Les Presses de l'Institut du Transport Aérien.

69. See Greffe X. (2001), *Managing Our Cultural Heritage*, Appendix V.

70. In France, the law of 1921, which introduced admission charges for museums, also provided for season tickets for visiting museums, art collections and monuments. The price of a monthly ticket was equal to the price of 10 visits, the price of a season ticket valid for 2 months was equal to the price of 20 visits and the cost of an annual pass was equal to the price of 50 visits.

71. For a long time this practice was only partly successful. Another measure, introduced at about the same time, became more popular since it allowed free entry to members of museum associations provided they

paid in advance, as a donation, an amount that equalled at least half the price of the annual pass.

72. Patry S. (1998), 'Les passeports culturels ou comment inciter le public à fréquenter les musées?', *Working Paper*, IREST, University of Paris I.

73. Usually three types of formulas are used: a paid pass which allows the passport-holder free entry, a free pass which allows him a certain number of entries and a paid pass which allows him entry at reduced rates. The choice between these different formulas depends on the objectives and the target group. For example, the second formula is more likely to attract young people rather than the first or the third. Apart from financial benefits, other associated benefits must be taken into account such as the opening of exhibitions in the same conditions, the possibility of taking guided tours and attending lectures (usually at reduced rates).

74. In the Villeneuve d'Ascq Museum, the average amount spent by each visitor is 10.67 euros or twice the average price of the ticket.

75. Taking the Villeneuve d'Ascq Museum as an example, we find that the profit margin is 30–40 per cent excluding taxes for books, 60 per cent for prints and 50 per cent for gifts and other objects. The profit margin on books is more or less fixed as the prices are regulated, while the profit margin for prints is higher; in other cases, museum shops have to compete with hypermarkets.

76. Even in the case of ordinary products like customized picture postcards, each print order has to be for at least 3,000 copies for it to be economically viable. Generally, it is not possible for an outlet to sell so many copies of the same postcard during a given period.

77. Gouyon Ch. & Greffe X. (1998), *Rapport sur le groupe de travail Musées-Economie*, Paris: Directorate of Museums, French Ministry of Culture.

78. In the case of the Réunion des Musées Nationaux, the total cost of management for one order is 8.69 euros, the cost of the catalogue, 50,000 copies of which are printed, is 1.06 euros per copy and the average cost of market exploration varies between 30.49 and 60.98 euros per user. A look at the projected turnover of the RMN in 1996 discloses the following facts: average number of orders per customer amounts to 65.55 euros excluding taxes, the average yield from customers who buy the most varies from 6 to 32 per cent while the average yield from normal customers is about 3.5 per cent.

79. Grover R., *The Disney Touch*, p. 91.

80. Idem., p. 144.

Chapter 4

1. Bazile S. (2000), 'Le saltimbanque dans l'art et la littérature de 1850 à nos jours', Ph.D. Dissertation, Bordeaux: University of Bordeaux III.

2. Rouault G. (1912), *Planche XIII du Miserere*, Annex 50, Paris: Dubois.

3. Starobinski (1956), *Portrait de l'artiste en saltimbanque*, Paris: Gallimard, pp. 105–7.

4. Blunt A. (1966), *La théorie des arts en Italie de 1450 à 1600*, Paris: Gallimard, pp. 94–5.
5. Vasarely (1967), *Déclarations*, *Robho*, No.1, quoted by Raymonde Moulin, p. 49.
6. Negri *et al.* (1993), *Des entreprises pas comme les autres*, Paris: Publisud.
7. Bernié-Boissard C., Dreyfus L. & Nicolas-Le Strat P. (1999), *Ville et emploi culturel, le travail 'créatif-intellectuel' dans les agglomérations de Nîmes et Montpellier*, Montpellier: Université Paul Valéry, ARPES, p. 103.
8. Idem, p. 104.
9. Menger P.M. & Vari S. (1993), *Le marché du travail et l'emploi intermittent dans les arts du spectacle*, Paris, Centre de sociologie des arts, Ecole des Hautes Etudes en Sciences Sociales, p. 118.
10. Becker H.S. (1988), *Les mondes de l'art*, Paris: Flammarion, p. 110.
11. Bernié-Boissard C., Dreyfuss L. & Nicolas-Le Strat P., *Ville et emploi culturel, le travail 'créatif-intellectuel' dans les agglomérations de Nîmes et Montpellier*, p. 97.
12. Idem, p. 115.
13. Artists generally resort to this type of action to avoid sharing the financial gains obtained from an artistic activity, but at the same time, this action underlines the strong link between artistic skills and the existence of a project.
14. Greffe X. (1999), *L'emploi culturel à l'âge du numérique*, Paris: Anthropos-Economica, Chapter 3.
15. KOTA (1997), *Database and Academy of Fine Arts*, Finland.
16. Schmidt B.E. (1998), 'Approche socio-politique de l'économie des filières de la production culturelle et ses effets sur la dynamique sociale et sur la cohésion sociale', Paper presented at the Seminar on Publishing, CEFRAC, Paris, p. 3.
17. See Chapter 1, pp. 35–37.
18. Greffe X., *L'emploi culturel à l'âge du numérique*, Chapter 3.
19. Filer R.K. (1986), 'The Starving Artist: Myth or Reality: Earnings of Artists in the United States', *Journal of Political Economy*, Vol. 96, pp. 56–75.
20. Towse R. & Khakee A., eds (1992), *Cultural Economics*, Berlin: Springer-Verlag.
21. Greffe X., *L'emploi culturel à l'âge du numérique*, Chapter 3.
22. Idem, p. 80.
23. Wassal G.H. & Arper N.O. (1992), 'Towards a Unified Theory of the Determinants of Earnings of Artists', in R. Towse & A. Khakee, eds, *Cultural Economics*, Berlin: Springer-Verlag, pp. 187–200.
24. Montgomery S.S. & Robinson D.M. (1978), 'Visual Artists in New York: What's Special about Person and Place?', *Journal of Cultural Economics*, Vol. 2, pp. 63–76.
25. Maurel J. (1999), 'Et pourtant ils dansent ... La carrière du danseur et les conditions de sa rémunération', *Working Paper*, University of Paris I, Paris, MATISSE, pp. 15–7.

26. Idem, p. 37.

27. Another argument that merits consideration is that the demand for classical dance performances is higher than the demand for contemporary dance, a fact which is also responsible for the distortion in their earnings.

28. Throsby D. (1998), 'Economic Circumstances of the Performing Artist: Baumol and Bowen Thirty Years After', *Journal of Cultural Economics*, Vol. 20, pp. 225–240.

29. Observatoire de l'emploi culturel, *L'emploi dans le spectacle vivant et l'audiovisuel d'après les données du GRISS*, Note No. 3, October 1994, p. 9.

30. Bodo C. & Fisher R. (1997), *New Frontiers for Employment in Europe: The Heritage, the Arts and Communication as a Laboratory for New Ideas*, Roma: Circle Publications, No. 9, p. 169.

31. Idem, p. 170.

32. Idem, p. 172.

33. Dick B.F. (1997), *City of Dreams: The Making and Remaking of Universal Pictures*, Lexington, Kentucky: The University Press of Kentucky, p. 27.

34. Mankew, G.M. (1997), *Principes de l'économie*, Paris: Economica.

35. Rosen S. (1981), 'The Economics of Superstars', *American Economic Review*, Vol. 71, No. 3, pp. 845–56.

36. Adler M. (1985), 'Stardom and Talent', *American Economic Review*, Vol. 75, No. 3, pp. 750–62.

37. McDonald (1988), 'The Rise of Superstars', *American Economic Review*, Vol. 78, No. 3, pp. 732–55.

38. Throsby D. & Withers, G. (1979), *The Economics of Performing Arts*, Edward Arnold.

39. Greffe X., *L'emploi culturel à l'âge du numérique*, Chapter 3, pp. 120–3.

40. Cowen T. & Tabarrok A. (2001), 'An Economic Theory of Avant-Garde and Popular Art, or High and Low Culture', *Southern Economic Journal*, Vol. 67, No. 2, pp. 232–53.

41. Grampp P. (1989), *Pricing the Priceless*, New York: Basic Books, p. 89.

42. Throsby D. (1998), 'Economic Circumstances of the Performing Artist: Baumol and Bowen Thirty Years After', *Journal of Cultural Economics*, Vol. 20, p. 227.

43. Menger P.M. & Vari S. (1993), *Le marché du travail et l'emploi intermittent dans les arts du spectacle*, p. 120.

44. Greffe X. (1998), 'On Intellectual Property Rights in a Virtual Age', *International Conference on Property Rights*, ICARE, Venice: University Ca Foscari, 12 December.

45. Foucault M. (1992), 'What is an author?', in C. Harrison & P. Wood, eds, *Art in Theory: 1900–1990*, Oxford: Basil Blackwell, p. 927.

46. Lhilaire-Perez L. (2001), 'Diderot's Views on Artists' and Inventors' Rights: Invention, Imitation and Reputation', *Les Cahiers de l'innovation*, Paris, CNRS, No. 22, pp. 12–25.

47. This last point will be dealt with in the chapter on cultural industries because it cannot be dissociated from the digitization of works of art.

48. Landes W. & Posner R.A. (1989), 'An Economic Analysis of Copyright Law', *Journal of Legal Studies*, Vol. 18, No. 2, pp. 325–63.

49. Takeyama L.N. (1994), 'The Welfare Implications of Unauthorized Reproduction of Intellectual Property in the Presence of Demand Network Externalities', *The Journal of Industrial Economics*, Vol. 42, pp. 54–68.

50. Kaufmann G. (1959), 'Les auteurs et l'industrie phonographique: une application du contrat-type dans les relations internationales', Ph.D. Dissertation, Faculty of Law, University of Paris.

51. Besen S.M. & Kirby S.N. (1989), 'Private Copying, Appropriability and Optimal Copying Royalties', *Journal of Law and Economics*, Vol. 32, No. 2, pp. 255–280.

52. For example, SPADEM (*Société de la Propriété Artistique des Dessins et Modèles*) went bankrupt in 1996.

53. Caves R. (2000), *Creative Industries*, Chapter 11.

54. Shillinsburgh P.L. (1992), *Pegasus in Harness: Victorian Publishing and W. M. Thackeray*, Charlottesville: University of Virginia Press.

55. Griswold W. (1981), 'American Character and the American Novel: An Expansion of the Reflection Theory in the Sociology of Literature', *American Journal of Sociology*, Vol. 86, pp. 740–765.

Chapter 5

1. Bady P. (1984), *Les monuments français*, Paris: Presses Universitaires de France, Que sais-je? pp. 6–7.

2. Siaudeau (1987), *Rapport sur le patrimoine en Allemagne*, Paris: Ministry of Culture, DEP.

3. Dupuis X. & Greffe X. (1986), 'La valorisation économique du patrimoine', Seminar on the *Economics of Culture*, Avignon, published in *Economie et Culture*, La Documentation française, Tome 1, pp. 24–36.

4. Poulot D. (1987), 'Les nouvelles aventures du patrimoine', *Libération*, 15 October, p. 11.

5. Riegl A. (1984), *Le culte moderne des monuments*, Paris: Le Seuil.

6. Heidegger M. (1980), *L'être et le temps*, Paris: Gallimard, pp. 180–2.

7. Montpetit F. (1994), *Essai sur la détermination du patrimoine*, Montreal: Presses de l'UQUAM, p. 11.

8. Barthes R. (1966), *Critique et Vérité*, Paris: Gallimard, p. 51.

9. Greffe X. (2001), *Managing Our Cultural Heritage*, New Delhi: Aryan Books International, pp. 30–2.

10. Joshi I. & Pande K. (1998), 'The Heritage Policy in India', *Indo-French Seminar*, jointly organized by the Indian Institute of Management, Ahmedabad and INTACH, 8 October.

11. Menon A.K.G. (1998), 'On Heritage Policy', *Indo-French Seminar*, jointly organized by the Indian Institute of Management, Ahmedabad and INTACH, 8 October.

12. Audrerie D., Souchier R. & Vilar D. (1998), *Le patrimoine mondial*, Paris: Presses Universitaires de France, Collection Que sais-je?

13. Centro de Inventario de Bienes Culturales, Oficina de Patrimonio Cultural de Santo Domingo, Dominican Republic.

14. Léniaud J.F. (1994), *L'utopie du patrimoine*, Paris: Eres.

15. It would however be wrong, while defining heritage, to marginalize the role of cultural ideology as seen in the different incarnations of the Vendôme column in Paris. It was erected by Napoleon I in the place of a statue representing a royal personage; it was later modified by Napoleon III who added to its summit a statue of the emperor. The Commune destroyed this symbol of military tyranny on Courbet's initiative and it was planned to rebuild it elsewhere. The Third Republic accused Courbet of megalomania and anti-artistic reactionary behaviour and ordered him to pay for the reconstruction of the column. An example, which cannot however be compared with the one above, is the role of Nazi ideology in the elimination of works of art and the persecution of their creators. Seeing signs of degeneration in modern art, the Nazis took cultural ideology to extremes, but not without engaging in lucrative commercial deals. From the exhibition of horrors in 1933 to the exhibition of degenerate art in 1937, the Nazis devised a system of destruction, plunder and resale which affected a growing number of schools and styles, modern art being just the first one to suffer at their hands.

16. This criterion is often used, unlike the preceding one, to maintain the character of an object or a monument as a piece of heritage even when its communicative value is not recognized.

17. These criteria are applicable to specific cases depending on the nature of the heritage concerned. Let us take the example of a piece of industrial heritage. Among the numerous forges inherited from the past, which are the ones worthy of preservation? You must know exactly at what point a forge stops being just a forge and reveals some specific characteristics. At Cousance aux Forges, forges were selected for preservation because they were the first forges used to make decorative cast iron objects and also the first chimney plates for the aristocratic Guise family. Does heritage represent a stage in economic or technological history? The first blast furnace made by Darby was considered to be fit to be turned into an industrial museum, the Ironbridge George Museum Trust. Does this industrial heritage represent an important period for heritage? By preserving the catalogues of La Redoute and Maufrance, local communities have tried to highlight them as the symbol of their region. Can this heritage trigger future development? The revival of the cutlery industry in Laguiole is not so much a tribute to an activity of the past as a belief in its future.

18. François A. (1999), 'La recherche de rentes et le marché des arts contemporains', *Working Paper*, LAEP, University of Paris I.

19. According to François and the data available in INSEE (National Institute of Statistics and Information about the Economy), in France

the number of artists belonging to the core group is very small consisting of barely 100–200 artists, while there are around 20,000 contemporary artists in all.

20. Pflieger S. et al. (1098), *Le marché des arts contemporains*, Paris: La Documentation Française, 1991.

21. Idem, p. 92.

22. Idem, p. 91.

23. The most successful case is that of Fernando Botero, who is today as well known for his sculptures as for his paintings, both of which sell equally well. He sold his first paintings in the late 1940s and started selling his sculptures in 1973.

24. The supplier who has used this strategy to the utmost is Ben. In fact, he has used an extremely large variety of mediums, e.g. canvas, installations, buildings, sculpture, clothing, etc. thereby running the risk of seeing his prices stagnate in the original market. The result is a wide range of products bearing his signature, 'Ben', marketed through a large number of distribution circuits.

25. By using this strategy producers can stabilize their earnings, and if there is a decline, they can fall back on several segments of demand.

26. Statistics in this regard must be approached with caution. A study by Benhamou reveals that France has added considerably to its stock of heritage during the 1980s. However, statistics indicate that this is not at all true. Strictly speaking, classification has not increased from year to year and even today it is considerably lower than what it was 20 years ago (70 versus 100 per year). On the contrary, the registration of new additional works (inscription supplémentaire), which costs the public exchequer much less, has gone up considerably to reach the earlier level. This increase in the registration of new works is the result of a radical change in the procedure, which is now decentralized in 22 zones, and this has naturally resulted in an upward movement, which has got amortized over the years. We must add to this the official extension of heritage status to twentieth-century buildings.

27. Buchanan J., Tollisson R.D. & Tullock G. (1980), *Toward a Theory of Rent-Seeking Society*, College Station: Texas University Press.

28. Kirzner I. (1978), *Perception, Opportunity and Profit: Studies on the Theory of Entrepreneurship*, Chicago: University of Chicago Press.

29. Keen G. (1971), *Money and Art: A Study Based on the Times-Sotheby Index*, New York: G.P. Putnam's Sons, p. 48.

30. Aslop J. (1982), *The Rare Art Traditions: The History of Art Collecting and its Linked Phenomena Wherever these have Appeared*, London: Thames and Hudson.

31. Weber W. (1992), *The Rise of Musical Classics in Eighteenth-Century England: A Study in Canon, Ritual and Ideology*, Oxford: Clarendon Press.

32. Caves, R. (2000), *Creative Industries*, pp. 286–96.

33. Called *laboureurs de musique* in French.

34. Coase R.H. (1979), 'Payola in Radio and Television Broadcasting', *Journal of Law and Economics*, Vol. 22, pp. 269–328.

35. Tabor M. (1998), 'In Bookstore Chains, Display Place is for Sale', *The New York Times*, 15 January, A1, D8.

36. Auletta K. (1997), 'The Impossible Business', *New Yorker*, 6 October, pp. 50–63.

37. This situation may change over a period of time. The birth of rock and roll in the United States gave rise to a similar situation because the music composed by black musicians was increasingly played by white players (see Caves, R. (2000)), pp. 286–96.

38. Gee M. (1981), *Dealers, Critics and Collectors of Modern Painting: Aspects of the Parisian Art Market between 1910 and 1930*, New York: Garland.

39. Saarinen A.B. (1958), *The Proud Possessors: The Lives, Times and Tastes of Some Adventurous American Collectors*, New York: Random House.

40. Marorella R. (1990), *Corporate Arts*, New Brunswick, NJ: Rutgers University Press.

41. Idem, pp. 36–9.

42. Cuisenier J. (1991), *La maison populaire*, Paris: PUF, p. 151.

43. Haskell F. (2000), *The Ephemeral Museum: Old Master Paintings and the Rise of the Art Exhibition*, Yale: Yale University Press.

44. Frey B.S. (1998), 'Superstar Museums: An Economic Analysis', *Journal of Cultural Economics*, Vol. 22, pp. 113–25.

45. Perchet D. & Varloot D. (1998), *La mise en valeur du patrimoine économique et industriel*, Voiron: La letttre du cadre territorial.

46. Greenfield J. (1996), *The Return of Cultural Treasures*, Cambridge: Cambridge University Press.

47. Cachin F. & Fohr R., eds (1997), *Pillages et restitution: le destin des œuvres d'art sorties de France pendant la seconde guerre mondiale*, Paris: Adam Biro & Direction des Musées de France.

48. Greffe X. (2001), *Managing Our Cultural Heritage*, New Delhi: Aryan Books International, p. 61.

49. Banxdall M. (1985), *L'œil du Quattrocento*, Paris: Gallimard.

50. Moureau N. (1997), 'Essai sur la détermination endogène de la qualité: le prix de la peinture contemporaine', Ph.D. Thesis, University of Paris XIII.

51. Frey B. & Pommerehne W. (1989), *Muses and Markets: Exploration in the Economics of Arts*, Oxford: Basil Blackwell.

52. Moureau N. (1997), 'Essai sur la détermination endogène de la qualité: le prix de la peinture contemporaine', Ph.D. Thesis, University of Paris XIII.

53.

Artist	Scope of the study	Results
Anderson (1974)	Paintings, between 1653 and 1970 (price 13 000, sub-set of Reitlinger and Myere)	4.9% including transaction costs against 6.5% for financial assets
Stein (1977)	Sales in the United States and United Kingdom between 1946 and 1968 of works of artists deceased before 1946	Nominal rate: 10.46% (United States) and 10.38% (United Kingdom) and 14.3% for financial assets
Baumol (1986)	640 separate transactions during at least 20 years in data given by Reitlinger for the period between 1652 and 1961	Average rate of 0.55% per annum; median rate of 0.85%. Very high dispersal: between −20% and +27%. French securities at 2.5%
Frey & Pommerehne (1989)	Reitlinger et al.: 1198 transactions: ı Between 1635 and 1949 ı Between 1950 and 1987	Average rate per annum: ı 1.5% against 3.3% for financial assets ı 1.6% against 2.4% against financial assets
Gérard-Varet et al. (1991)	Artists born after 1830, sales between 1855 and 1970	ı 6.5% during 1855–1970 ı 0.5% during 1915–1949 ı 12% during 1950–1970

54. Gérard-Varet et al. (1990), *Formation des prix des peintures modernes et contemporaines et rentabilité des placements sur les marchés de l'art*, Marseilles: GREQE, EHESS-CNRS.
55. Benhamou F. & Ginsburgh V. (1998), 'Copies and Markets', ICARE, Centre Venezia Universita Ca Foscari.
56. Colombet C. (1977), *Propriété littéraire et artistique et droits voisins*, Paris: Dalloz.
57. Montias J.M. (1996), 'Quantitative Methods in the Analysis of the 17th Century Dutch Inventories' in P.M. Menger & V. Ginsburgh, eds, *Economics of the Arts, Selected Essays*, Amsterdam: Elsevier.
58. The various museums exhibiting copies were not particularly successful. They were always looked down upon as second-rate museums as indicated by the number of visitors and it is only recently that there has been a renewal of interest in these museums or in exhibitions of copies.

59. If we do not consider the market for paintings, this revelation effect assumes a larger dimension, especially in the field of music where the artist benefits both by the acknowledgement of his creativity and the rights of reproduction.

60. Frey B.S. (2000), *Arts & Economics: Analysis & Cultural Policy*, Berlin: Springer-Verlag, p. 196.

61. Idem, p. 202.

Chapter 6

1. Benjamin W. (2000), *L'oeuvre d'art* (version de 1939), in *Oeuvres*, Paris: Gallimard, Folio Essais, p. 273.

2. See Chapter 1, pp. 17–18.

3. Benjamin W. (2000), *L'oeuvre d'art* (version de 1939), p. 283.

4. Rouet F. (2000), *Le livre: mutations d'une industrie culturelle*, Paris: La Documentation française.

5. Idem, p. 24.

6. Idem, p. 73.

7. Idem, p. 74.

8. This concentration of distribution can be explained by two factors, namely the coming together of the book, which is an activity that involves stocks, and the press, an activity requiring just-in-time distribution, and the attraction of the audio-visual media, which involves strengthening the margin of action.

9. Lefeuvre G. (1996), *Le producteur de disque*, Paris: L'Harmattan.

10. The royalty usually ranges from 2 to 15 per cent of the price excluding tax.

11. In France in the year 2000, the price of a CD included 7 per cent for author's royalty, 19 per cent for artists' fees, 3 per cent for recording costs, 11 per cent for manufacturing costs, 15 per cent for publicity, 22 per cent for distribution costs and 23 per cent for overheads, taxes and repayment of interest.

12. Bonnetain X. (2000), 'L'industrie du disque: un oligopole traditionnel vers le monde du numérique et de nouveaux medias', *Working Paper*, MATISSE, University of Paris I, p. 16.

13. d'Angelo M. (1998), 'L'industrie du disque', *Problèmes économiques*, No. 2068, Paris: La documentation française, pp. 23–8.

14. For some independent producers, one way out is to gain access to a distribution network, provided that they are interested only in slots that are not occupied by the major recording companies. Even an artist may appear directly on the Net and create his own market once he has got together a group of enthusiasts. There is no doubt that the major companies will intervene if a piece of music is very successful. They will then offer extremely attractive conditions, but this does not prevent the broadcasting of the piece of music, unlike what happened

earlier when it was absolutely necessary to go through the major companies. Small companies can compete with the big companies and avoid going through existing producers by signing a contract with artists that allows them to broadcast the music directly. There has been a mixed reaction from artists to these new opportunities. If it is in the artist's interest to popularize his music, it is also in his interest to ensure that he gets adequate remuneration for it. Between a totally anarchical system, further complicated by piracy, and an institutionalized system built around the major recording companies, it is possible that after a certain stage the latter will become more advantageous than the former even for the artists themselves. Given the fact that most of these sites are American, this process has serious consequences for the European markets in the form of a significant loss of markets, the immediate loss of pacesetters, the discovery of new talents and the hiatus between investments for promotion and local sales.

15. Bonnetain X. (2000), *L'industrie du disque: un oligopole traditionnel vers le monde du numérique et de nouveaux medias*, p. 20.

16. In the year 2000, CDNow had almost 300,000 albums on sale.

17. MP3 is a format for compressing audio data, created by the German Institute of Fraunhofer. It compresses the sound file 12 times without any loss in the quality of sound and can turn the PC into a veritable record library.

18. *Le Monde*, 'Les internautes cherchent déjà à contourner l'accord Napster-Bertelsman', 7 November 2000, p. 24.

19. In 1998, Universal and BMG launched their site Getmusic by extending their co-operation to two software and telephone companies, namely US AT&T and Matsushita. In 1999, Sony signed a specific agreement with Microsoft, and shortly afterwards, Sony tied up with Time-Warner to buy the on-line site CDNow.

20. *Le Monde*, 'Nouvelles propositions de Napster pour un réglement de son contentieux avec l'industrie du disque', 22 February 2001, p. 23.

21. As a matter of fact, the situation was exactly the reverse of what it is today, with the French cinema occupying in the United States the position that American cinema now occupies in France. So it was time to diversify the product.

22. The newsreel was first created to attract the public to the cinema hall and later to make the main film more attractive. A foray was also made into educational films.

23. Ch. Pathé, (1970), *Ma Vie*, p. 94, Lyon: Premier Plan.

24. It is difficult to say whether the cinema was born on 14 April 1894 at 1155 Broadway Street in New York with the first presentation of Edison's Kinetoscope, or on 26 December 1895 on the boulevards of Paris when the Lumière Brothers presented their Cinematograph. The spectators were few and difficult to identify, but they had agreed to pay a nickel to look into Edison's contraption or a few sous to watch Lumière's film in the company of others. The second invention was to prove more promising from the

economic point of view, because it allowed a large number of persons to watch moving pictures simultaneously, while the first allowed only one person at a time to see the picture. The Lumière Brothers' Vitascope thus became a point of reference. Soon the film became as important as the apparatus. The early films were based on variety shows, but the audience tired of them and it became necessary to bring in something new without further delay.

25. Created in 1908, the MPPC controlled all the patents and licenses relating to equipment, raw film, production, distribution and management and also ensured that all its members co-operated with other members of the cartel. As a result, independent film-makers had to face a lot of difficulties. From 1913 onwards, these practices were censured by the courts, and independent producers were able to make films without any constraints, and cinema theatres could hope to exhibit films on more equitable terms. After this, there was more scope for the development of the film industry.

26. From 1910 onwards, Vitagraph had 10 workshops and 10 directors in its complex in Brooklyn.

27. For example, the Lumière studios were bought by Carl Laemmle who set up the Motion Picture Company.

28. Wyatt J. (1994), *High Concept: Movies and Marketing in Hollywood*, Austin: University of Texas Press.

29. While Paramount constituted only a small part of the conglomerate's activities, Warner Bros was to play a major role. It was a part of Seven Arts Production and, following the latter's restructuring, it became a part of Warner Communication Inc.

30. Except for Fox, which made substantial profits from *Star Wars*.

31. In Augros J. (1996), *L'argent d'Hollywood*, Paris: L'Harmattan, pp. 319–31.

32.

Year	Majors	Independents	Total	Films made by independents (%)
1980	137	205	342	60
1984	81	285	366	78
1985	70	286	356	80
1986	67	463	530	87
1987	72	501	573	87
1988	72	545	617	88
1989	78	430	508	85
1990	90	387	477	81
1991	86	497	583	85
1992	67	451	518	87

Source: Joël Augros (1996), L'argent d'Hollywood, p. 126.

33. Growth in the cost of film production in the United States (1980–1992)

Year	Average cost of producing a film (in millions of US$)
1982	10.00
1983	11.50
1986	16.30
1990	22.00
1993	30.00
1996	60.00

Source: Coursodon J.-P. & Tavernier B., '50 ans de cinéma américain', *Capital*, No. 68, May 1997.

34. Thus Paramount delegated the production of several sequences as well as trailers to Kaleidoscope and Universal became the distribution pipeline for independent producers working with them.

35. In Grover R., *The Disney Touch: Disney, ABC & The Quest for the World's Greatest Media Empire*, p. 25.

36. Idem, p. 26.

37. *Titanic* is a glaring example of this type of collaboration. Its production cost of US$200 million was borne by two Hollywood companies, Fox and Paramount, with the idea of sharing the risk. Even though this arrangement proved to be advantageous to Paramount (which contributed US$65 million and recovered its investment very rapidly, while Fox contributed US$135 million). Fox could have easily trebled its investment thanks to the film's phenomenal success.

38. Columbia's (Sony Pictures & Entertainment) share of the market is 20 per cent, while that of Buena Vista (Disney) is almost 25 per cent. What is even more interesting is that they are large enough to control distribution through television, video and cable networks and take advantage of the deregulation measures introduced in the 1980s, e.g. Warner (after its merger with Time) or Paramount (after its merger with Viacom).

39. In 1986, MCA/Universal controlled 43 per cent of the distribution giant Cineplex Odeon.

40. On the non-paying channels, the majors tried to create their own programmes directly instead of handing over their entire collection. After some futile attempts, Disney decided to air a widely distributed show entitled *Duck Tales*, the first serial of which consisted of 65 episodes. It continued with a second important show, *Chip'n'Dale's Rescue Rangers*, aired by 151 television channels and watched by more than 12 million children.

41. Augros J. (1996), *L'argent d'Hollywood*, p. 263, Paris: L' Harmattan.

42. Disney now boasts of more than 20 million subscribers for its cable network, and in 1995 it took over ABC, which was then the most popular

network. In 1993, Time-Warner, owner of the second largest cable network in the United States, set up its own network, not only as a challenge to the 'big three' but also to Fox Network, which was growing stronger day by day.

43. Op. cit. in Hilmes Michele, p. 182.

44. Op. cit. in Hilmes Michele, p. 184.

45. Idem, p. 188.

46. In Grover R., p. 129.

47. In Grover R., p. 132.

48. Beringuer D. (1999), 'L'impact d'Internet sur la chaîne du livre', *Working Paper*, MATISSE, University of Paris I, p. 3.

49. Idem, p. 35.

50. Interview with Yann Queffélec on 7 January 1999, *Trente jours à tuer*, Paris 00h00.com, 1999.

51. The ancient *Yi King* or *Book of Changes*, a Confucian collection of aphorisms and divine maxims, contains a collection of 64 short texts connected by hexagrams, linked to one another by certain similarities. These texts were supposed to be read according to reference points indicated by a throw of the dice and there was no continuous story.

52. Beringuer D. (1999), 'L'impact d'Internet sur la chaîne du livre', p. 39.

53. Idem. p. 12.

54. Nora D. (1998), 'La Révolution de la cyberédition', *Le Nouvel Observateur*, 12–18 November, p. 23.

55. Beringuer D. (1999), p. 45.

56. Idem, p. 47.

57. The list of brands and assets controlled by Time-Warner, valued at US$97 billion, needs no repetition. We may mention a few examples to indicate the importance of this list:

ı 5,700 films (Warner Bros and New Line Cinema);

ı 32,000 television episodes, including the serials *ER* and *Friends*, which are popular all over the world;

ı a bunch of theme channels (thanks to its earlier merger with Turner Broadcasting in 1996): HBO, the first pay channel for movies in the United States, CNN, 150 million subscribers, Cartoon Network, the Time Group, which publishes magazines like Fortune, Time, Life, People, etc.

58. The AOL group established in 1985 had a turnover of US$4.8 billion in 2000.

59. Atomfilms provides free access to 120 titles in its catalogue of short films. The site also offers DVD compilations of the best films. Every month Atomfilms views hundreds of short films and selects about 10 per cent of them. Netizens are invited to vote on each film and they can publish critical comments.

60. Disney parks were known for the non-mobilization of their vast land resources and the non-exploitation of hotels that were dependent on the existence of the parks. Visitors to Orlando spent on average less than

2 per cent of their total expenses on the entrance fee to the park. This meant that Disney earned only 2 per cent of the total amount spent to visit the park, while the rest was spent on transport and hotels, two sectors from which Disney was almost absent. At the same time, the visitors' satisfaction index remained high, which meant that despite the genuine success of the park as a tourist attraction, it brought in very little money. The management started raising the entry fee very slowly at the rate of US$1 per year over several years, instead of a sharp rise of US$5 recommended by some experts (which would have represented a rise of more than 30 per cent in one go). The strategy employed in the hotel sector also changed gradually with Disney taking over some of these hotels as and when the opportunity presented itself (Annaheim), and it started building its own hotels within the parks (e.g. Orlando and EuroDisney). It was also necessary to modernize or renovate the attractions in the parks. The best example is the construction of a third park in Orlando on the theme of cinema (Star Tours) in collaboration with MGM. In 1987, this park was launched with a lot of fanfare and became a roaring success. In the second phase, Disney joined hands with various countries in his endeavour to build new attractions wherever possible and the Matterhorn Roller-coaster Ride was set up in collaboration with the Swiss Government.

61. Grover R., *The Disney Touch*, p. 144.

62. While other studios spent US$6.5 million on marketing and publicity, Disney spent less than US$3 million.

63. Universal adopted the same strategy shortly afterwards by declaring that merchandising should take precedence over production. Anybody can make a film, but selling it with the help of the right kind of merchandise (T-shirts, records, CDs, etc.) requires a lot of skill.

64. Lanquar R. (1992), *L'empire Disney*, p. 74, Paris: Presses Universitaires de France.

65. Novos I.E. & Waldman M. (1984), 'The Effects of Increased Copyright Protection: An Analytic Approach', *Journal of Political Economy*, No. 2, pp. 160–72.

66. Barzel Y. (1989), *Economic Analysis of Property Rights*, Cambridge: Cambridge University Press.

67. Ginsburg J. (1996), 'Putting Cars on to the Information Superhighway: Authors, Exploiters and Copyright in Cyberspace', in P.B. Hugenholts ed., *The Future of Copyright in a Digital Environment*, Den Haag: Kluwer Law International, pp. 189–220.

68. The syndicate of major American recording companies, RIAA, follows the principle of giving a bonus to those who inform them about illegal copying, and they have also opened for this purpose a website called WWW.cdreward.com.

69. Towse R. (1999), 'Copyrights and Economic Incentives: An Application to Performers' Rights in the Music Industry', *Kyklos*, Vol. 52, No. 3, pp. 369–90.

70. Kaplow L. & Shavell S. (1996), 'Property Rules versus Liability Rules: An Economic Analysis', *Harvard Law Review*, vol. 109, pp. 713–90.
71. Inchauspe I. & Menanteau C. (1998), 'Sacem: les dérives d'un monopole public', *Problèmes économiques*, No. 2574, pp. 6–9.
72. Jakubyszyn Ch. (2001), 'L'inéluctable modèle de la génération Napster', *Le Monde*, 23 February 2001, p. 20.

Chapter 7

1. In the United States, and according to Gramp, almost as many taxpayers are opposed to state intervention in cultural matters as those who support it (38 per cent against 34 per cent).
2. Cowen T. (1998), *In Praise of Commercial Culture*, Cambridge, Mass.: Harvard University Press.
3. Frey B.S. (2000), *Arts and Economics*, Berlin: Springer-Verlag, pp. 103–5.
4. By following the traditional criticism of economic analysis as developed by Galbraith.
5. Heilburn & Gray (1997), *The Economics of Arts and Culture*, Cambridge: Cambridge University Press, p. 217.
6. Lorenzi J.H. et al. (1988), 'Les déterminants de la pauvreté', *Research Paper*, Paris: University of Paris IX, IRIS and the French Planning Commission.
7. Greffe X. (1990), *L'impôt des pauvres: nouvelle stratégie de la politique sociale*, Paris: Dunod.
8. Netzer D. (1978), *The Subsidized Muse: Public Support for the Arts in the United States*, Cambridge: Cambridge University Press, p. 19.
9. Baumol W.J. & Bowen W.G. (1966), *Performing Arts: The Economic Dilemma*, Cambridge, Mass.: The MIT Press.
10. Idem, p. 164.
11. Idem, p. 165.
12. Dupuis X. & Greffe X. (1985), 'Le pot de terre et le pot de fer', in Dupuis & Greffe, eds, *L'économie du spectacle vivant face au défi de l'audiovisuel*, Paris: La Documentation française.
13. Gale More Th. (1968), *The Economics of the American Theater*, Durham, NC: Duke University Press, pp. 14–5.
14. Baumol W.J. & Baumol H. (1984), 'The Mass Media and the Cost Disease', in Hendon et al., eds, *The Economics of Cultural Industries*, Akron: Association for Cultural Economics.
15. Idem, p. 160.
16. Throsby C.D. & Withers G.A. (1979), *The Economics of the Performing Arts*, London: Edward Arnold Publications.
17. Peacock A., Shoesmith E. & Millner G. (1983), *Inflation and the Performing Arts*, London: The Arts Council of Great Britain.
18. Leroy D. (1980), *Economie des arts du spectacle vivant: essai sur la relation entre l'économique et l'esthétique*, Paris: Economica.

19. Dupuis X. (1981), 'Economie du spectacle vivant', Ph.D. Dissertation, University of Paris XIII.

20. Di Maggio P. & Stenberg K. (1985), 'Why do some Theatres Innovate More than Others? An Empirical Analysis', *Poetics*, Vol. 14, pp. 107–22.

21. Heilburn & Gray (1997), *The Economics of Arts and Culture*, pp. 140–3.

22. Ford Foundation (1974), *The Finance of Performing Arts*, New York.

23. Heilburn & Gray (1997), *The Economics of Arts and Culture*, pp. 140–3.

24. Schwartz & Peters (1983), *Growth of Arts and Cultural Organizations in the Decade of the 1970s*, Washington, DC: The National Endowment for the Arts.

25. The cost disease is not peculiar to the performing arts. Television too suffers from the same problem of productivity deficit according to Hilda and William J. Baumol. On the basis of a study which is already outdated but whose findings have been confirmed to a large extent, they have shown that the cost per programme went up by 143 per cent between 1964 and 1976 while the average price index increased by just 81 per cent. It therefore appears impossible to maintain the quality of programmes by reducing the cost of creation or acting. This conclusion ought to be revised according to the different sectors of television production. However it is quite true that television companies are obliged to reinvest continuously to meet the demands of their consumers in a highly competitive environment.

 In the case of heritage, where the problem is quite different, we notice that the cost of renovation and conservation increases continuously, while the increase in other costs is more or less comparable to the rest of the economy.

26. Greffe X. (1990), *La valeur économique du patrimoine*, Paris: Economica.

27. Donnat O. (1999), *Les pratiques culturelles des Français: Enquête 1997*, Paris: La Documentation française.

28. Abel K. & Greffe X. (2000), 'Analyse de la permanence ou de la réduction des inégalités', *Working Paper*, MATISSE, University of Paris I, IREST.

29. Maresca B. & Pouquet L. (2000), *Les dépenses culturelles des français au milieu des années quatre-vingt-dix*, Paris: Ministry of Culture, DEP & CREDOC, p. 66.

30. Urfalino (1996), *L'invention de la politique culturelle*, Paris: La Documentation française, p. 128.

31. Idem, pp. 109–30.

32. National Endowment for the Arts (1998), *Survey of Public Participation in the Arts*, Washington, DC: Library of Congress.

33. Idem, p. 15.

34. Idem, p. 23.

35. Idem, p. 56.

36. Idem, p. 23.

37. Michaud Y. (1997), *La crise de l'art contemporain*, Paris: Presses Universitaires de France, p. 51.

38. 'Les Français et l'art: sondage BVA', *Beaux Arts Magazine*, No. 200, January 2001, p. 90.
39. Idem, p. 88.
40. Millet C. (1992), 'Ce n'est qu'un début, l'art continue', *Art Press*, No. 13, p. 8.
41. Michaud Y. (1997), *La crise de l'art contemporain*, Paris: Presses Universitaires de France, p. 57.
42. The policy of providing assistance to artists for training and production is based on three factors: art schools, the fund for encouraging creation (FIACRE) and artists' workshops. Through these three institutions, the state makes its presence felt in the production sector of the art market. In France, there are eight national schools of art in addition to another 30 odd schools run by municipal bodies. They provide instruction and training in fine and applied arts (design, illustration, etc.). Teachers in these schools are usually recruited among artists for whom these jobs are a source of income and prestige, and also among art critics and art historians. Finally, they are entirely funded by public subsidies.
 FIACRE is a fund set up by the French Government for financing the printing, dissemination and distribution of publications on contemporary art, research projects and the stay of artists in France or abroad for executing projects, individual assistance for creating works of art and assistance for holding the first exhibition. No information is available about the total corpus of the fund, but the amount allotted to artists as assistance for holding their first exhibitions was about 1 million francs in 1993 for 36 projects. In addition to FIACRE, there are other schemes under different ministries (The Rome Academy, Villa Medicis, etc.) for giving direct assistance to artists. Finally, the state subsidizes foundations, some of which (e.g. Salavin-Fournier Foundation) give scholarships or awards to producers.
43. By exercising its pre-emptive rights the state can acquire a good forcibly during a public auction at the highest bid.
44. This involves a negotiation between three parties at the time of deciding the estate duty. Representatives of the tax department and the Ministry of Culture negotiate with the heir the donation of works of art in lieu of the estate duty. The best-known case is the donation of Picasso's works by his heirs leading to the establishment of a museum of his works.
45. The state can negotiate the purchase of an original work of a living artist from a private enterprise by allowing the latter to deduct its value from its taxable profits over a period of 20 years. The work of art becomes the state's property after 10 years.
46. The state commissions a work of art by signing a contract with the artist (e.g. a contract was signed in 1996 for an amount of 22 million francs for creating the Buren Columns). The amount of 1 per cent of the budget of the Public Works Department set aside for this purpose provides an almost inexhaustible source of funds for commissioning new works of art.
47. Acquisition funds are meant for the acquisition of existing goods and there are three such funds: the National Fund for Contemporary Art

(FNAC), the Regional Funds for Contemporary Art (FRAC) and the National Museum of Contemporary Art (MNAC). The FNAC was created in 1875 to acquire the works of living artists and it now owns 65,000 works of art dispersed in various museums, buildings of national importance, embassies and public buildings as well as in the storehouses of the Tokyo Palace. The FRAC were created in 1982 for the purpose of encouraging and disseminating works of contemporary art and building up collections. Unlike FNAC, the products financed by FRAC are supposed to circulate.

48. The permission to export *Les noces de Pierrette* (Pierette's Wedding), without which it would not have got a record auction price, was obtained by agreeing to hand over Picasso's *La Celestine*, whose market value was lower than the tax relief expected on the first painting had its export been banned.

49. The French Government was ordered by the courts to pay €22.1 million to J. Walter as compensation for the prejudice caused by classifying Van Gogh's *Jardin d'Anvers* as heritage. This painting was knocked down for €8.38 million in December 1992, while its estimated price in the international market was €45.73 million.

50. Idem, p. 86.

51. For an analysis of the deliberations and the composition of purchase committees, see F. Hébert (1991), 'Portrait du prince et de l'artiste dans un terrain vague avec un fonctionnaire et un jury', in E. Wallon, ed. (1991), pp. 151–60.

52. Hayek F. (1979), *Droit, législation et liberté*, Paris: PUF, p. 165.

53. Fumaroli M. (1991), *L'Etat culturel*, Paris: de Falloix.

54. Schneider M. (1993), *La comédie de la culture*, Paris: Le Seuil.

55. Banfield E.C. (1984), *The Democratic Muse*, New York: Basic Books.

56. Gauguin P., ed. (1978), *The Writings of a Savage*, New York: Viking Press, pp. 29–32.

57. Cowen T. (1998), *In Praise of Commercial Culture*, Cambridge, Mass.: Harvard University Press, p. 47.

58. Idem, p. 113.

59. Assouline P. (1990), *An Artful Life: A Biography of D.H. Kahnweiler, 1884–1979*, New York: Grove Weindefeld.

60. Cowen T. (1998), *In Praise of Commercial Culture*, Cambridge, Mass: Harvard University Press, p. 184.

61. Slominsky N. (1965), *Lexicon of Musical Invective: Critical Assaults on Composers since Beethoven's Time*, Seattle: The University of Washington Press, pp. 84–5.

62. Cowen T. (1998), *In Praise of Commercial Culture*, p. 186.

63. Posner R.A. (1995), *Aging and Old Age*, Chicago: University of Chicago Press, pp. 102–7.

64. Cowen T. (1998), *In Praise of Commercial Culture*, p. 19.

65. Idem, p. 19.

66. Posner R.A. (1995), *Aging and Old Age*, Chicago: University of Chicago Press, pp. 102–7.

67. Swift J. (Re. 1958), *A Tale of a Tub in Gulliver's Travels and Other Writings'*, New York: Random House, pp. 274–5.

68. Department of Studies and Perspective Planning, Ministry of Culture, Paris, October 2000, *Télérama*, No. 2653, 15 November 2000, p. 21.

69. Strasbourg, Saint Etienne, Toulouse and Rennes.

70. Pascale G. (2000), 'La décentralisation théatrale en France: De la libération à la fin des années soixante-dix', Ph.D. Dissertation, Saint Quentin en Yvelines: Université de Versailles.

71. Urfalino Ph. (1996), *L'invention de la politique culturelle*, Paris: La Documentation française, p. 97.

72. Idem, p. 248.

73. Sawyer S.K. (1989), *The National Foundation of the Arts and the Humanities*, Chelsea: Chelsea House Publishers.

74. Of course, there was nothing new about this idea. After the Second World War, some parliamentarians wanted the federal government to take steps in that direction and President Eisenhower made a gesture by giving federal land for setting up cultural projects.

75. Goldfarb M.A. (1995), *Art Lessons: Learning from the Rise and Fall of Public Arts Funding*, New York: Basic Books.

76. In January 1965, in his State of the Union address, he proposed the creation of a National Council for the Arts and a public foundation for their development. In fact, the concept was extended to include the humanities, which was not going to simplify matters.

77. Public funding then amounted to just US$5 million, which was very low as compared to other federal expenditure, but this amount continued to rise for at least 20 years. The limited nature of this funding (which had nevertheless quadrupled after three years) meant that the NEA escaped the perils of bureaucratization forecast by its adversaries.

78. Nevertheless, R. Stevens, the Director of the Fund, was very concerned about the unequal regional distribution of cultural activities and practices. This led him to increase the limited activities of the NEA by setting up a Council for the Arts jointly funded by the NEA and the government.

79. It goes without saying that this proposal was received very badly by the representatives of theatres, concerts, operas, etc. who felt that the film industry was quite capable of making available the resources needed for its development.

80. According to a survey whose results were published by the Ford Foundation (1970), only 30 per cent of Americans had visited a museum, 10 per cent had seen a play and 4 per cent had been to the opera or to a dance recital during the previous year. Everybody respected the arts, but like a religion.

81. In addition, specific demands continued to be made and this invariably led to the creation of new funds or new branches. As a result, the number of experts and advisers dwindled and the clout of administrators increased.

82. Livingston B. (1988), *Our Government and the Arts: A Perspective from the Inside*, New York: American Council for the Arts.

83. He also tried to formulate a plan of action for the NEA running over several years so that there could be some room for manoeuvre. He did this even though his budget was sanctioned annually. Orders were given in all sectors that artists belonging to ethnic minorities should be given extra-special treatment to the extent of making them objects of positive discrimination.

84. This idea had been advanced all through the NEA's history and there were some extremely innovative suggestions. For example, 'challenge funds' were set up for this purpose in 1976. Under this scheme the beneficiary made an initial endowment as soon as he could gain an amount that was three to four times higher within 3 years of the fund's creation. However, this ingenious idea did not produce the expected results and all it amounted to was remunerating the ability to mobilize funds.

85. Edward A. (1989), *Unfulfilled Promise: Public Subsidy of the Arts in America*, Philadelphia: Temple University Press.

86. Report to Congress on the National Endowment for the Arts (1990), Washington, U.S. Congress.

87. NEA (2000), *The National Endowment for the Arts, 1965-2000, A Brief Chronology of Federal Support for the Arts*, Washington, DC: Library of Congress 00 130341 CIP.

88. Idem, p. 65.

89. NEA (2000), *The National Endowment for the Arts, 1965–2000, A Brief Chronology of Federal Support for the Arts*.

90. Of the 157 private theatre companies counted in 1979 by the TCG, 8 were more than 30 years old, 33 were more than 15 years old and 99 had existed for less than 15 years. Between 1979 and 1984, almost 80 companies were added to this list not counting the amateur groups, especially the university groups, which had as much right to ask for federal funding as the others.

91. Rosset R. (1991), 'Art Museums in the United States: A Financial Portrait', in M. Feldstein ed., *The Economics of Art Museums*, Chicago: The University of Chicago Press.

92. NEA (2000), *The National Endowment for the Arts, 1965–2000, A Brief Chronology of Federal Support for the Arts*.

93. Idem, p. 101.

94. O'Hagan (1998), *The State and the Arts: An Analysis of Key Economic Policy Issues in Europe and The United States*, Cheltenham, UK: Edward Elgar, p. 133.

95. Idem, p. 137.

96. Idem, p. 145.

97. See Chapter 4.

98. 'Quelles régulations pour les marchés du livre en Europe?', Annals of the seminar: *L'économie du livre dans l'espace européen*, European Union Presidency, Strasbourg, 29–30 September 2000.

99. Schneider M. (1993), *La comédie de la culture*, Paris: Le Seuil.

100. In France, this process is illustrated by the situation prevalent in film-making. Because television companies are subjected to a system of financial assistance, advances, and production and distribution quotas, it is possible to finance a film without any difficulty. But having obtained these funds, it is necessary to make very precise calculations, e.g. the size of the audience for prime-time telecasts, which makes the process very difficult and risky.

101. NEA (2000), *The National Endowment for the Arts, 1965–2000, A Brief Chronology of Federal Support for the Arts.*

102. *Télérama* (2000), 'L'argent de la culture', No. 2654, pp. 12–8.

103. Netzer D. (1978), *The Subsidized Muse: Public Support for the Arts in the United States*, Cambridge: Cambridge University Press.

104. O'Hagan (1998), *The State and the Art: An Analysis of Key Economic Policy Issues in Europe and The United States*, p. 150.

105. Schuster (1994), 'Funding the Arts and Culture through Dedicated State Lotteries – Part I: The Twin Issues of Additionality and Substitution', *European Journal of Cultural Policy*, Vol. 1, No. 1, p. 39.

106. Idem, p. 39.

107. Schuster (1995), 'Funding the Arts and Culture through Dedicated State Lotteries – Part II: Opening the Way for Alternative Decision Making and Funding Structure', *European Journal of Cultural Policy*, Vol. 1, No. 2, p. 351.

108. Sauvé P. (2000), *Le traitement des produits et services culturels dans les accords commerciaux*, Paris: Agence intergouvernementale de la francophonie.

109. Rouet F. (2000), *Le soutien aux industries culturelles dans l'aire francophone*, Paris: Agence intergouvernementale de la francophonie.

110. 'Nouvelles dispositions pour la promotion du livre et de la lecture', Rome: DG X of the European Union Commission, 17 July 2000.

111. European Parliament, Resolution, 14 January 2000.

112. The expression advances on revenues implies that the production of all new French films is financed by a tax on the revenues of all films screened (whence the quip from the United States that French films are financed by the success of United States films). Quotas are production and broadcasting quotas financed by pay-per-view and public-access television stations to fund French cinema and broaden its audience.

BIBLIOGRAPHY

Adler M. (1985), 'Stardom and Talent', *American Economic Review*, Vol. 75, No. 3, pp. 561–74.

Arian, ed. (1989), *Unfulfilled Promise: Public Subsidy of the Arts in America*, Philadelphia: Temple University Press.

Ashworth J. & Johnson P. (1996), 'Sources of "Value for Money" for Museum Visitors: Some Survey Evidence', *Journal of Cultural Economics*, Vol. 20, pp. 67–83.

Aslop J. (1982), *The Rare Art Traditions: The History of Art Collecting and its Linked Phenomena Wherever these have Appeared*, London: Thames and Hudson.

Assouline P. (1990), *An Artful Life: A Biography of D.H. Kahnweiler 1884–1979*, New York: Grove Weindefeld.

Audrerie D., Souchier R. & Vilar D. (1998), *Le patrimoine mondial*, Paris: Presses Universitaires de France, Collection Que sais-je?

Augros J. (1996), *L'argent d'Hollywood*, Paris: L'Harmattan.

Banfield E.C. (1984), *The Democratic Muse*, New York: Basic Books.

Banxdall M.(1982), *L'œil du quattrocento*, Paris: Gallimard.

Barrère Ch. & Santagata (1999), 'Defining Art: From the Brancusi Trial to the Economics of Artistic Semiotic Goods', *International Journal of Arts Management*, Vol. 1, No. 2, pp. 28–38.

Barthes R. (1966), *Critique et Vérité*, Paris: Le Seuil.

Barthes R. (1967), *Système de la mode*, Paris: Le Seuil.

Barzel Y. (1989), *Economic Analysis of Property Rights*, Cambridge: Cambridge University Press.

Baudelaire Ch. (ed. 1972), in J. Charvet ed., *Selected Writings on Art and Artist*, Harmondsworth: Penguin.

Baumol H. & Baumol W. 'The Mass Media and the Cost Disease', in W. Hendon et al., eds, *The Economics of Cultural Industries*, Akron, Oh: Association for Cultural Economics.

Baumol W. & Bowen W. (1966), *Economics of Living Arts: An Economic Dilemma*, Harvard: Harvard University Press.

Bazile S. (2000), 'Le saltimbanque dans l'art et la littérature de 1850 à nos jours', Ph.D. Thesis, Université de Bordeaux III.

Becker G.S. (1997), *Accounting for Tastes*, Cambridge, Mass.: Harvard University Press.

Becker H.S. (1988), *Les mondes de l'art*, Paris: Flammarion.

Benhamou F. (1996), *Économie de la culture*, Paris: La Découverte, Coll. Repères.

Benjamin W. (1972), *Der Widerkehr des Flâneurs, Gesammelte Shriften III*, Frankfurt: Suhrkamp.

Benjamin W. (2000), *L'œuvre d'art* (dernière version de 1939), dans *Œuvres*, Paris, Gallimard, Folio Essais.

Bernié-Boissard C., Dreyfuss L. & Nicolas-Le Strat P. (1999), *Ville et emploi culturel, Le travail créatif-intellectuel dans les agglomérations de Nîmes et Montpellier*, Université Paul Valéry: ARPES.

Besen S.M. & Kirby S.N. (1989), 'Private Copying, Appropriability and Optimal Copying Royalties', *Journal of Law and Economics*, Vol. 32, No. 2, pp. 255–80.

Besen S. & Raskin L. (1991), 'An Introduction to the Law and Economics of Intellectual Property', *Journal of Economic Perspectives*, Vol. 5, pp. 3–27.

Biddle L. (1988), *Our Government and the Arts: A Perspective from the Inside*, New York: American Council for the Arts.

Bille Hansen T. (1997), 'The Willingness to Pay for the Royal Theater in Copenhagen', *Journal of Cultural Economics*, Vol. 21, pp. 1–28.

Bishop R.C. & Heberlein T.A. (1979), 'Measuring Values of Extra-market Goods: Are Indirect Measures Biased?', *American Journal of Agricultural Economics*, Vol. 61, pp. 926–39.

Bourdieu P. (1969), *La Distinction*, Paris: Le Seuil.

Burt N. (1977), *Palaces for the People: A Social History of the American Art Museum*, Boston: Little Brown.

Campbell C. (1989), *The Romantic Ethic and the Spirit of Modern Consumption*, Oxford: Basil Blackwell.

Caves R. (2000), *Creative Industries: Contracts between Art and Commerce*, Cambridge, Mass.: Harvard University Press.

Chapple S. & Garofalo R. (1977), *Rock 'n Roll is Here to Pay: The History and Politics of the Music Industry*, Chicago: Nelson Hall.

Chisholm D. (1997), 'Profit-Sharing vs. Fixed-Payment Contracts: Evidence from the Motion Picture Industry', *Journal of Economics and Org.*, Vol. 169, pp. 55–78.

Chrisitie A. (1995), 'Reconceptualising Copyright in the Digital Era', EIPR, Vol. 11, pp. 522–30.

Claire R.W. (2000), *Entertainment 101: An Industry Primer*, Beverly Hills, Calif: Pomegranate Press Ltd.

Coase R.H. (1979), 'Payola in Radio and Television Broadcasting', *Journal of Law and Economics*, Vol. 22, pp. 269–328.

Colbert F. (1993), *Le marketing des arts et de la cu*lture, Montréal: Gaëtan Morin.

Conant M. (1960), *Antitrust in the Motion Picture Industry: Economic and Legal Analysis*, Berkeley: University of California Press.

Cowen T. (1998), *In Praise of Commercial Culture*, Cambridge, Mass.: Harvard University Press.

Deardorff A. (1994), 'The Appropriate Extent of Intellectual Property Rights in Art', *Journal of Cultural Economics*, Vol. 8, pp. 121–34.

Di Maggio P. (1982), 'Cultural Entrepreneurship in Nineteenth-Century Boston: The Creation of an Organizational Base for High Culture in America', *Media, Culture and Society*, Vol. 4, pp. 33–50.

DiMaggio P. & Stenberg K. (1985), 'Why do some Theatres Innovate More than Others? An Empirical Analysis', *Poetics*, Vol. 14, pp. 107–22.

Donna O. (1999), *Enquête sur les pratiques culturelles des français*, Paris: La Documentation Française.

Dupuis X. (1980), 'Essai sur l'économie du spectacle vivant: le cas de la production lyrique', Ph.D. Thesis, Université de Paris Nord.

Dupuis X. & Greffe X. (1980), 'L'économie du spectacle lyrique: répertoire ou festival permanent', *Le Monde*, 14 Juillet.

Dupuis X. & Greffe X., eds (1985), *L'économie du spectacle vivant*, Paris: La documentation française.

Dupuis X. & Greffe X. (1985) 'Le pot de terre et le pot de fer', in X. Dupuis & X. Greffe, eds, *L'économie du spectacle vivant*, pp. 1–18.

Eco U. (1998), *Entretiens sur la fin des temps*, Paris: Fayard.

Feldman T. (1997), *An Introduction to Digital Media*, London: Routledge.

Feldstein M., ed. (1993), *The Economics of Art Museums*, Chicago: University of Chicago Press.

Filer R.K. (1986), 'The "Starving" Artist: Myth or Reality. Earnings of Artists in the United States', *Journal of Political Economy*, Vol. 96, pp. 56–75.

Foucault M. (1992), 'What is an Author ?' in Ch. Harrisson & P. Wood, eds, *Art in Theory: 1900–1990*, Oxford: Basil Blackwell.

Frey B.S. (1998), 'Superstars Museums: An Economic Analysis', *Journal of Cultural Economics*, Vol. 22, pp. 126–130

Frey B.S. (2000), *Arts & Economics: Analysis and Cultural Policy*, Berlin: Springer-Verlag.

Frey B. & Pommerehne W. (1989), *Muses and Markets: Exploration in the Economics of Arts*, Oxford: Basil Blackwell.

Fumaroli M. (1991), *L'Etat culturel*, Paris: de Falloix.

Gale More T. (1968), *The Economics of the American Theater*, Durham, N.C.: Duke Univesity Press.

Gee M. (1981), *Dealers, Critics and Collectors of Modern Painting: Aspects of the Parisian Art market between 1910 and 1930*, New York: Garland.

Gendreau Y. (1993), 'The Continuing Saga of Colourization in France', *Intellectual Property Journal*, Vol. 7, pp. 340–9.

Gérard-Varet et al. (1990), *Formation des prix des peintures modernes et contemporaines et rentabilité des placements sur les marchés de l'art*, Marseilles: GREQE: EHESS-CNRS.

Ginsburg J. (1996), 'Putting Cars on the Information Superhighway: Authors, Exploiters and Copyright in Cyberspace', in P.B. Hugenholtz ed., *The Future of Copyright in a Digital Environment*, Den Haag: Kluwer Law International, pp. 189–220.

Graham G. (1998), *Philosophy of the Arts: An Introduction to Aesthetics*, New York: Routledge.

Greffe X. (1990), *La valeur économique du patrimoine*, Paris: Economica.

Greffe X. (1998), 'Audiovisual and Employment Creation', *Introductory Report to the Birmingham Conference, European Union*, European Union, 4–5 April.

Greffe X. (1998), 'Heritage, Community and Development', *National Trust Conference 'Linking People and Place: Heritage and Community'*, London, 11–12 May.

Greffe X. (1998), 'Value of Heritage', INTACH and Indian Institute of Management Seminar, 'Sambhava', Ahmedabad, September 12–15.

Greffe X. (1999), 'El papel del empleo cultural', Ministerio de Empleo y INEM, Madrid, 30 March.

Greffe X. (1999), 'Intellectual Property Rights at the Age of Audiovisual', International Seminar: The Copying and Counterfeiting, 3–4 December, Istituto venezto di Scienza, Lettere ed Arti, Universita Ca Foscari, Venice.

Greffe X. (1999), 'Heritage Conservation and Local Development', *Working Paper*, University of Bethlehem, 22–25 January.

Greffe X. (1999), 'The Measurement of the Innovation in the Third Sector', in *The Third Sector: A Comparison between American and European Views*, Paris: OECD.

Greffe X. (1999), *Economics of Heritage* , Universita Luigi Federico II, Naples, 28–31 January and 13–18 February.

Greffe X. (1999), *L'emploi culturel à l'âge du numérique*, Paris: Anthropos.

Greffe X. (1999), *La gestion du patrimoine culturel*, Paris: Anthropos-Economica.

Greffe X. (2000), 'Pricing the Museums', *11th Conference on Cultural Economics*, Minneapolis, 29 May, International Association for Cultural Economics, Minn.: University of Saint Thomas.

Greffe X. (2001), 'Cultural Activities as a Driver for Development', *Planning for Cities: The Case for Krakow*, Paris: OECD.

Greffe X. (2001), 'European Policies Face to the Intellectual Property Rights', OECD & Harvard University Symposium, Harvard, 27 March 2001.

Greffe X. (2001), 'The Measurement of the Innovation in the Third Sector', International Forum on the Third Sector OECD–European Union, International Monetary Fund, Washington, 12 Septembre 2000.

Greffe X. (2001), 'The Role of Heritage in the Development of Cities', OECD, Forum, Cracovie, 3–4 September.

Greffe X. (2001), *Managing our Cultural Heritage*, London, Delhi: Aryan Books.

Greffe X., Nicolas M. & Rouet F. (1994), *Socio-économie de la culture: la demande de cinéma*, Éditions Antropos.

Goldfarb M.A. (1991), *The Art Biz: The Covert World of Collectors, Dealers, Auction Houses, Museums and Critics*, Chicago: Contemporary Books.

Goldfarb M.A. (1995), *Art Lessons: Learning from the Rise and Fall of Public Arts Funding*, New York: Basic Books.

Grampp W.D. (1989), *Pricing the Priceless: Arts, Artists and Economics*, New York: Basic Books.

Greenfield J. (1996), *The Return of Cultural Treasures*, Cambridge: Cambridge University Press.

Grover R. (1997), *The Disney Touch: Disney, ABC and the Quest for the World's Greatest Media Empire*, Chicago: Irwin Press.

Hanemann M. (1991), 'Willingness to Pay and Willingness to Accept: How Much Can they Differ?', *American Economic Review*, Vol. 81, 635–47.

Hansman H. & Santili M. (1997), 'Authors' and Artists' Moral Rights: A Comparative Legal and Economic Analysis', *Journal of Legal Studies*, Vol. 26, pp. 95–143.

Hart P. (1973), *Orpheus in the New World: The Symphony Orchestra as an American Cultural Institution*, New York: W.W. Norton.

Haskell F. (2000), *The Ephemeral Museum: Old Master Paintings and the Rise of the Art Exhibition*, Yale: Yale University Press.

Heidegger (1963), *L'être et le temps*, Paris: Gallimard.

Hilmes M. (1994), *Hollywood and Broadcasting: From Radio to Cable*, Chicago: University of Illinois Press.

Heilbrun J. & Gray C. (1997), *The Economics of Arts and Culture: An American Perspective*, Cambridge, UK: Cambridge University Press.

Hugenholtz P.B. ed. (1996), *The Future of Copyright in a Digital Environment*, Den Haag: Kluwer Law International.

Hurt R.M. & Schuman R.M. (1966), 'The Economic Rationale of Copyright', *American Economic Review*, Vol. 56, pp. 421–32.

Jackson R. (1988), 'A Museum Cost Function', *Journal of Cultural Economics*, Vol. 12, pp. 41–50.

Kaplow L. & Shavell S. (1996), 'Property Rules versus Liability Rules: An Economic Analysis', *Harvard Law Review*, Vol. 109, pp. 713–90.

Katz M. & Shapiro C. (1985), 'Network Externalities, Competition and Compatibility', *American Economic Review*, Vol. 75, pp. 623–45.

Keen G. (1971), *Money and Art: A Study Based on the Times–Sotheby Index*, New York: G. P. Putnam's Sons.

Kirzner I. (1978), *Perception, Opportunity and Profit: Studies on the Theory of Entrepreneurship*, Chicago: University of Chicago Press.

Kling R., Revier C. & Sable K. (2000), 'Estimating the Public Good Value of Preserving a Local Historic Landmark: The Role of Nonsubstitutability and Information in Contingent Valuation', *11th Conference on Cultural Economics*, Minneapolis, Minn.: University of Saint Thomas, 29 May.

Koboldt C. (1992), 'Intellectual Property and Optimal Copyright Protection', *Journal of Cultural Economics*, Vol. 2, pp. 135–52.

Landes W. & Posner R.A. (1989), 'An Economic Analysis of Copyright Law', *Journal of Legal Studies*, Vol. 18, No. 2, pp. 325–63.

Léniaud J.F. (1994), *L'utopie du patrimoine*, Paris: Eres.

Leroy D. (1980), *Economie des arts du spectacle vivant*, Paris: Economica.

Levy E. (1987), *And the Winner Is ... The History and Politics of the Oscar Awards*, New York: Ungar.

Litwak M. (1994), *Dealmaking in the Film Television Industry: From Negotiations to Final Contracts*, Los Angeles: Silman-James Press.

Liviantoni C. (1997), 'The Case of Spoleto in the Employment Policy of the Umbria Region', in C. Bodo ed., *New Frontiers for Employment in Europe*, Rome: Circle Publications No. 9, pp. 77–80.

Lyotard J.F. (1979), *La condition postmoderne*, Paris: Les Editions de minuit.

MacDonell V. & Greffe X. (1995), 'Local Development and Cultural Industries', *Working Paper*, Brussels: European Commission, DGV.

Malaro M. (1994), *Museum Governance: Missions, Ethics, Policy*, Washington: Smithsonian Institution Press.

Marorella R. (1990), *Corporate Arts*, New Brunswick, NJ: Rutgers University Press.

Martin F. (1994), 'Determining the Size of Museum Subsidies', *Journal of Cultural Economics*, Vol. 18, pp. 255–70.

Mazza I. (1994), 'A Microeconomic Analysis of Patronage and Sponsorship', in A. Peacock & I. Rizzo, eds, *Cultural Economics and Cultural Policies*, Dordrecht: Kluwer Academic Publishers.

Menger P.M. & Ginsburgh V. (1996), *Economics of the Arts: Selected Essays*, Amsterdam: Elsevier.

Merges Robert P. (1995), 'The Economic Impact of Intellectual Property rights: An Overview and Guide', *Journal of Cultural Economics*, Vol. 12, pp. 103–20.

Michaud Y. (1997), *La crise de l'art contemporain*, Paris: PUF.

Mill J.S. (1985), *Utilitarianism*, London: Fontana.

Montias J.M. (1996), *Quantitative Methods in the Analysis of the 17th Century Dutch Inventories*, Princeton: Princeton University Press.

Marshall (1920), *Principles of Economics*, London: Macmillan.

Mossetto G. (1992), *L'economia delle citta d'arte*, Milan: Etas.

Mossetto (1994), *An Economic Analysis of Arts*, Milan: Etas.

Negron Z. (1999), 'Francisco Pacheco: Economist for the Art World', in M. De Marchi & C. Goodwin, eds, *Economic Engagements with Arts*, Durham: Duke University Press, pp. 37–8.

Netzer D. (1978), *The Subsidized Muse: Public Support for the Arts in the United States*, Cambridge: Cambridge University Press.

Netzer D. (1992), 'Arts and Culture', in C.T. Clotfelter ed., *Who Benefits from the Nonprofit Sector?*, Chicago: Chicago University Press, pp. 174–206.

Pacheco F. (1990), *Arte de la pintura*, Madrid: Edicion Bassegoda i Huelgas.

Peacock A., Shoesmith E. & Millner G. (1983), *Inflation and the Performing Arts*, London: Arts Council of Great Britain.

Posner R.A. (1995), *Aging and Old Age*, Chicago: University of Chicago Press.

Radin M.J. (1996), *Contested Commodities*, Cambridge, Mass.: Harvard University Press.

Radway J. (1990), 'The Scandal of the Middlebrow: The Book of the Month Club, Class Fracture and Cultural Authority', *South Atlantic Quarterly*, Vol. 89, pp. 703–36.

Riegl A. (1984), *Le culte moderne des monuments*, Paris: Le Seuil.

Ritzer G. (1999), *Enchanting a Disenchanted World: Revolutionizing the Means of Consumption*, London: Sage.

Rojek C. (1997), *Decentring Leisure: Rethinking Leisure Theory*, London: Sage.

Rosen S. (1981), 'The Economics of Superstars', *American Economic Review*, Vol. 71, No. 3, pp. 845–56.

Rushton M. (1998), 'The Moral Rights of Artists: Droit moral ou Droit pécuniaire', *Journal of Cultural Economics*, Vol. 22, pp. 15–32.

Saarinen A.B. (1958), *The Proud Possessors: The Lives, Times and Tastes of some Adventerous American Collectors*, New York: Random House.

Santagata W. (2000), 'From Industrial Districts to Cultural Districts', *11th Conference on Cultural Economics*, Minneapolis, Minn.: University of Saint Thomas, 29 May.

Santagata W. & Signorello G. (1998), 'Contingent Valuation of a Cultural Public Good and Policy Design: The Case of "Napoli Musei Aperti"', *Working Paper*, University of Torino (Department of Economics) and University of Catania (Dipartimento di Scienze Economiche Agraria).

Schuster M. (1994), 'Funding the Arts and Culture through Dedicated State Lotteries – Part I: The Twin Issues of Additionality and Substitution', *European Journal of Cultural Policy*, Vol. 1, No. 1, p. 39.

Schwartz P. & Peters J. (1983), *Growth of Arts and Cultural Organizations in the Decade of the 1970s*, Washington, DC: National Endowment for Arts.

Sennett R. (1977), *The Fall of Public Man*, Cambridge: Cambridge University Press.

Simpson C. (1987), *The Partnership: The Secret Association between Bernard Berenson and Joseph Duveen*, London: Bodley Head.

Squire J.E. (1992), *The Movie Business Book*, 2nd edn, New York: Simon & Schuster.

Stanley R.H. (1978), *The Celluloid Empire: A History of the American Movie Industry*, New York: Hasting House.

Stigler G. & Becker G.S. (1977), 'De gustibus non est disputandum', *American Economic Review*, Vol. 67, No. 2, pp. 76–90.

Storper M. & Christoferson S. (1987), 'Flexible Specialization and Regional Industrial Agglomeration: The Case of the U.S. Motion Picture Industry', *Annals of the Association of American Geographers*, Vol. 77, pp. 104–17.

Takeyama L.N. (1994), 'The Welfare Implications of Unauthorized Reproduction of Intellectual Property in the Presence of Demand Network Externalities', *The Journal of Industrial Economics*, Vol. 42, pp. 54–68.

Tapscott D. (1996), *The Digital Economy*, New York: McGraw-Hill.

Tester K., ed. (1998), *The Flâneur*, London: Routledge, p. 7.

Throsby C.D. (1998), 'Economic Cicumstances of the Performing Artist: Baumol and Bowen. Thirty Years After', *Journal of Cultural Economics*, Vol. 20, pp. 225–40.

Throsby C.D. & Withers G.A. (1979), *The Economics of the Performing Arts*, New York: Saint Martin; London: Edward Arnold.

Todd R. (1996), *Consuming Fictions: The Booker Prize and Fiction in Britain Today*, London: Bloomsbury Press.

Towse R. (1999), 'Copyrights and Economic Incentives: An Application to Performers' Rights in the Music Industry', *Kyklos*, Vol. 52, No. 3, pp. 369–90.

Towse R. & Khakee A. (1992), *Cultural Economics*, Berlin: Springer-Verlag.

Vogel H.L. (1986), *Entertainment Industry Economics: A Guide for Financial Analysis*, Cambridge: Cambridge University Press.

Walle A.H. (1998), *Cultural Tourism: A Strategic Focus*, Boulder: Westview.

Wassall G.H. & Arper N.O. (1992), 'Toward a Unified Theory of the Determinants of Earnings of Artists', in R. Towse & A. Khakee, eds, *Cultural Economics*, Berlin: Springer-Verlag, pp. 187–200.

Wasson C. (1974), *Dynamic Competitive Strategy and Product Life Cycle*, St. Charles, Ill.: Challenge Books.

Watson P. (1992), *From Manet to Manhattan: The Rise of the Modern Art Market*, New York: Random House.

Weber W. (1975), *Music and the Middle Class: The Social Structure of Concert Life in London*, New York: Holmes & Meier.

Weinstein M. (1998), 'Profit Sharing Contracts in Hollywood: Evolution and Analysis', *The Journal of Legal Studies*, Vol. 27, No. 1, pp. 67–113.

Williams R. (1982), *Dream Worlds: Mass Consumption in Late Nineteenth-Century France*, Berkeley: University of California Press.

Willis K.G. (1994), 'Playing for Heritage: What Price for Durham Cathedral', *Journal of Environmental Planning and Management*, Vol. 3, pp. 267–78.

White C.H. & Withe C.A. (1993), *Canvases and Careers: Institutional Change in the French Painting World*, Chicago: University of Chicago Press.

INDEX

Réalisé en P.A.O. par STDI - Z.A. Route de Couterne - 53110 LASSAY-LES-CHÂTEAUX
Imprimé en France. - JOUVE, 11, bd de Sébastopol, 75001 PARIS
N° 316887Y. - Dépôt légal : Novembre 2002